The Patrick Moore Practical Astronomy Series

Series Editor

Gerald R. Hubbell
Mark Slade Remote Observatory, Locust Grove, VA, USA

More information about this series at http://www.springer.com/series/3192

Astrophotography is Easy!

Basics for Beginners

Gregory I. Redfern

 Springer

Gregory I. Redfern
Ruckersville, VA, USA

ISSN 1431-9756 ISSN 2197-6562 (electronic)
The Patrick Moore Practical Astronomy Series
ISBN 978-3-030-45942-0 ISBN 978-3-030-45943-7 (eBook)
https://doi.org/10.1007/978-3-030-45943-7

This Springer imprint is published by the registered company Springer Nature Switzerland AG
The registered company address is: Gewerbestrasse 11, 6330 Cham, Switzerland

For Clara
May the sky
always remind
you
of
me

Foreword

Dr. Richard Tresch Fienberg is Press Officer of the American Astronomical Society and former Editor in Chief of *Sky & Telescope* magazine. The International Astronomical Union has named asteroid 9983 Rickfienberg in his honor. Though trained as a professional astronomer, Rick remains an amateur at heart, observing the sky and taking astrophotos from his hilltop observatory in central New Hampshire.

About 15 years ago, while I was working at *Sky & Telescope* magazine, I was invited to speak at an amateur astronomy convention on any topic of my choosing. I had recently resumed taking astronomical pictures thanks to the invention of consumer digital cameras and decided that astrophotography would make a fine topic for two reasons. First, as editor of a monthly astronomy magazine, I was inundated by submissions of astro-images from our readers, some of whom were among the most talented practitioners of the art. So I had plenty of material to mine for illustrations. Second, I was really excited by the astrophotos I was shooting myself with digital cameras, sometimes through lenses and sometimes through telescopes. This meant I actually knew something about the subject! I entitled my talk "Anyone Can Take a Decent Astrophoto" and used my own experience as a newbie sky-shooter to prove my point.

I wrote that I "resumed taking astronomical pictures" because I had tried capturing images of celestial objects many times over my decades in astronomy but had always given up. It was just too difficult with film cameras. There was no way to tell while out under the stars if you were doing a good job of focusing, tracking your target as Earth turned, and choosing the right

exposure times. You had to wait 'til your prints or slides came back from your local camera shop or drugstore to know how you did. And if the results weren't to your liking — as they rarely were for me — you had to start over and go through the whole process again, and perhaps again and again. I simply didn't have the patience for it.

With digital cameras, though, you see your images as soon as you shoot them. If the focus or framing isn't perfect, you make the necessary adjustment, shoot again, examine the result, and repeat till you're happy — all within just a few minutes. And the sensors in digital cameras and built into smartphones are much more sensitive than film, making it possible to shoot attractive wide-field photos of the night sky capturing constellations and the Milky Way with your camera on a fixed tripod rather than a motorized tracking mount. Not just easy, but very satisfying!

As you work your way up the learning curve and get more ambitious, there's no shortage of computerized telescopes and electronic accessories to make things easy and virtually guarantee a successful outcome. And the image-processing software available today makes turning even a modest astrophoto into something truly stunning — perhaps even worthy of publication in a magazine like *Sky & Telescope*. This is truly a golden age of astrophotography.

Of course, whenever you try something new, you face an inevitable period of trial and error. In my case, it was often more error than trial. I'd have been very grateful for a book like Greg Redfern's when I was starting out shooting the sky. Greg, whom I've known for a long time and whose talents are well known among astronomers and astrophotographers, is a terrific guide. His advice is accurate, sensible, and grounded in his own extensive experience. As a bonus, you'll also get advice from several other leading astro-imagers whom Greg has invited to weigh in on specific topics of particular interest.

With this book as a road map, anyone can do more than just take a decent astrophoto: anyone can take many really good astrophotos and enjoy a lifetime of celestial exploration!

American Astronomical Society Richard Tresch Fienberg
Washington, DC, USA

Preface

A half-century ago there were no books that I could find in the library on astrophotography, so I basically learned by doing, with a lot of errors along the way. As a teenager who grew up in the Mercury, Gemini and Apollo era, I took my first astropic of the Moon using my Edmund Scientific 6-inch f/8 Newtonian reflector on an equatorial mount with a Praktika FX 35-mm camera body with no lens. I took a "prime focus" image – putting the camera body with an adapter into the telescope's eyepiece holder – using Kodak's fine grain 200 ASA "Plus-X" 35-mm film. There was a bracket on the telescope that held an aluminum pole that allowed for safely projecting white light views of the Sun onto a white metal plate to view. This bracket could also be used as a holder to place the camera very close to the eyepiece for "afocal" shots, using the camera's lens to focus on the image in the eyepiece, of the Moon and planets. For "eyepiece projection" shots, I used an eyepiece in a holder mated to a camera body placed in the eyepiece focuser to get a shot. I had three basic eyepieces of one inch, half of an inch, and quarter of an inch focal length with a 2x Barlow, an optical accessory that increases eyepiece magnification.

I had built a small darkroom in the family garage so I could develop my own black and white film. I eventually also added Kodak High Speed Ektachrome – 400 ASA – to my film processing capabilities. When the ultra-fast (for the day) Tri-X 400 ASA black-and-white film came out, I bought it in bulk rolls so I could make my own 36-exposure rolls. The bulk film roll went into a film cassette loader, and you would turn a crank so many times for so many exposures to be loaded into the 35-mm film

cassette. You had to place the film loader and the reusable film cassette in a lightproof changing bag, feel your way (not on the film emulsion side!) through the loading process on to a film spool. The end had to be secured with tape, and you had to make sure the reusable film cassette top was securely snapped in place and light tight. This took some practice to get right, believe me!

Once the film to be used was loaded in the camera, it then became a matter of getting everything right for telescope-camera and the astronomical object being photographed. I shot mostly lunar astropics, along with some planetary images (I did not have a camera lens so for a while did not have Camera Only capabilities). I couldn't afford one after buying all of the other equipment. I manually kept a photo log book recording each astropic's details and commentary on how it turned out. I still have the log books,

After the last exposure on the roll was taken, it then became a matter of properly developing the film and seeing how the resulting negative images turned out. I had an enlarger so I could make prints of my astropics. I eventually sold the photo gear, telescope and enlarger but I still have the Praktika camera body, enlarger lens and some of my negatives and prints. They weren't the greatest astropics, but they were mine and done lovingly from start to finish.

I finally got (and still have) a camera lens – a Vivitar 135-mm f/2.8 – so I could initially take High Speed Ektachrome color slides off the family TV set to personally record the missions of Apollo 8 and 11. I still have those slides, TV cycle lines and all.

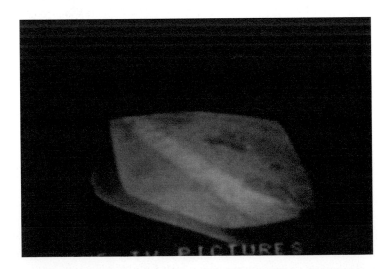

Fig. P.1. View of the Moon from *Apollo 8* TV image, December 25, 1968 (Image by the author.)

In 1974 I bought a Minolta SRT-101 35-mm film camera with a 50-mm f/1.2 lens at the San Diego Navy Exchange, which I still have. I took thousands of land, sea and some sky pics with that camera while on active duty with the U. S. Navy. I didn't take astropics in Camera and Telescope mode with it until I acquired an 8-inch f/10 Criterion Dynascope Schmidt Cassegrain Telescope (SCT) in 1980 after selling the 6-inch. I had finally acquired my first books on astrophotography in 1979 to help out my progress and kept adding to my library over the years.

I used the various Kodak and Agfa black-and-white and color films available and used commercial film processing. Lunar and planetary were my mainstays in astropics. I took mostly Camera and Telescope with a few Camera Only astropics. These two astrophotography modes are a continuing theme throughout the book and refer to the two separate means by which astropics can be taken.

I had more time to take astropics while on Adak Island in the Alaskan Aleutians, but with only three days of sunshine *a year*, sessions were far and few!

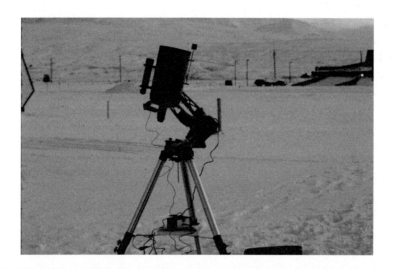

Fig. P.2. Getting ready for a rare clear day and night. Author's telescope on Adak Island, Alaska, 1984. (Image by the Author)

I think I can lay claim to being the only human being to ever photograph Halley's Comet from Adak, Alaska. I did so in between snowstorms in 1985. Not much to look at on the slide, but it is there!

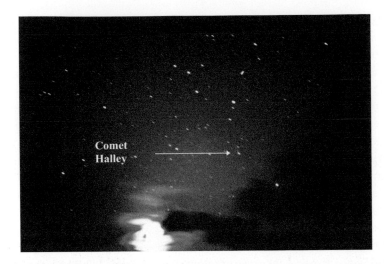

Comet
Halley

Fig. P.3. Halley's Comet. Adak Island, Alaska, 1985. Camera & Mode: Camera Only Minolta SRT 101 w/ 50-mm f/1.2 lens on a tripod. ISO: 400. Camera Only. Exposure: 10 seconds. Processing: Copied High Speed Ektachrome slide processed with Mac Photos.

In 1986 I made a quantum leap forward by selling the Criterion and purchasing a Meade 8-inch f/10 LX-3 SCT. This was the cat's meow, as Meade SCT's had (and still do) astrophotography accessories out the wazoo. I purchased the 'scope and accessories from world famous – at least to astrophotographers in the know then and now – Lumicon located in Livermore, CA. The owner was a full time physicist at Lawrence Livermore Laboratory who did astrophotography development and sales in his spare time. He patented several revolutionary (at the time) amateur astrophotography items and sold them worldwide.

Lumicon became synonymous with the technique of "gas hypersensitization" of black-and-white film to improve film speed (ASA) and to reduce reciprocity failure (see Johnny Horne's comments on this in Chapter 22). You would put your film in a baking chamber and use heated hydrogen gas under pressure to "hyper" the film. The cutting-edge astrophotographers of the day used "gas hypering" to get great results on deep sky objects (DSOs) and comets.

Lumicon was also, and still is, a big supplier of light pollution and specific wavelength filters, off axis guiders (OAGs) and other accessories for our craft. I still have my 50-mm Lumicon light pollution reducing filter and illuminated cross hair reticle eyepiece for manually guiding.

To me, the first real book for amateur astrophotographers was Michael Covington's *Astrophotography for the Amateur,* which I bought October 30,

1986, after transferring from Adak, Alaska, to California. I also joined the Astronomy Book Club, which allowed me to start building a library on the subject. In 2019 there are quite a few volumes in the library covering a wonderful range of astronomy, spaceflight and meteoritical-related topics.

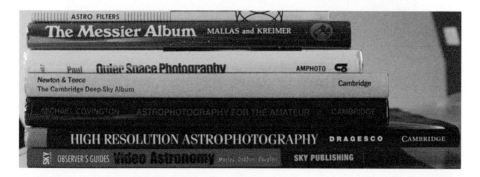

Fig. P.4. Author's Astrophotography books from decades ago. (Image by the author).

While in California I took the Meade out to various dark sky locations: Yellowstone, Mount Lassen Volcanic National Park. I started to play with deep sky objects (DSOs) somewhat.

I dragged the Meade and accessories out to the Pacific Island of Guam for three years, shooting lunar eclipses and the wonderful skies I could see at 13 degrees north latitude. My first ever astropic of the Southern Cross was taken there as was the darkest total lunar eclipse I have ever witnessed. After Mount Pinitubo catastrophically erupted in 1991 in the Philippines, so much volcanic debris and aerosols were blown into the upper atmosphere that totality was almost invisible, even in a telescope! You could barely make out the Moon's surface and a very dark brown was the dominant color. Guam was really neat, and introduced me to celestial treasures visible near the equator.

From Guam to northern Virginia the Meade was sent back to the factory for cleaning and maintenance. I took that 'scope to star parties and Shenandoah National Park. I got some pretty decent pictures of the last two great Northern Hemisphere comets – Hale-Bopp and Hyakutake using that 'scope. I kept it almost 30 years and then donated it to George Mason University Astronomy Department, where it still is used by high school students.

Fig. P.5. Author's first astropics on visit to Shenandoah National Park. (Selfie by the author). Being prepared for the weather was important to take winter night pics of Comet Hyakutake that you will see in Chapter 17. For 23 years and counting this park has been the author's favorite deep sky location.

My next telescope was my dream come true in 2007: a Takahashi Mewlon 250mm f/12 on a Takahashi EM-200 GOTO mount and wooden – yes, wooden – tripod to hold it all rock steady. This coincided with my entry into digital astrophotography using Nikon Digital Single Lens Reflex (DSLR) cameras. I started with a fixed lens model Coolpix E5700, then a D5000, D5200 and finally, the D810a. I have used the D810a Camera Only at sea and on land, and Camera and Telescope mode on land. I have taken thousands of astropics with this setup – all sky, the Milky Way, eclipses, DSOs, asteroids and comets, lunar and planetary and a video of the ISS crossing the Full Beaver Moon.

Did my comment of using the D810a to take astropics *at sea* just pass you by or did you stop and say, "What………you can't do that!" Oh, yes you can! And in 2018 Springer Astronomy published my book, *Cruise Ship Astronomy and Astrophotography* as part of its "The Patrick Moore Practical Astronomy Series." In what I believe to be the first ever book on the subject, I tell you everything you need to know about taking a cruise *and* doing astronomy and astrophotography at sea.

I was very excited when my editor, Maury Solomon, approached me in early 2019 about writing *Astrophotography Is Easy: Basics for Beginners*. I jumped at the chance and challenge to write a (hopefully) comprehensive book on astrophotography basics for beginners. As you shall see, there are

a lot of astrophotography books and Internet resources out there. But I really didn't see one that I thought fit the needs of the true beginner. So here we are.

Prior to this book I have used my Nikon D810a for all my lunar/planetary/DSO astropics in Camera and Telescope mode. For this book I needed some astrophotography equipment that I did not have to venture into areas that a beginner would. I wanted to be able to try out Camera and Telescope astropics with an iPhone. I had already taken Camera Only astropics with an iPhone 6S, as well as the Nikon D810a, successfully as you shall see, but handheld and on a tripod, respectively. I wanted to try using a device that mounts to a camera tripod and counteracts Earth's rotation to take longer exposures. I also wanted to enter the realm of autoguiding, lunar and planetary, maybe even brighter DSOs using a basic color CCD or CMOS astrocamera that might be able to do it all. I really didn't want to purchase all of this equipment, as I wasn't sure if I would make it part of my astro gear, but knew I needed it to be complete for a beginner's perspective.

I had the good fortune of previously corresponding with Joshua Taboga at Astroshop.eu, a division of nimax GmbH, located in Germany. They are a top-shelf worldwide retailer of just about anything you can think of in modern amateur astronomy and astrophotography equipment needs, a lot of which is under the Omegon brand. I was really impressed with the quality and completeness of their product lines.

We had discussed doing a review of a new astro-camera manufacturer's line of entry-level products. As luck would have it, this book came along with my associated needs, and Joshua and Astroshop.eu stepped forward to help. In correspondence with one of their technical staff, Elias Erdnüß, I got what I needed and will share the results with you.

Unless otherwise noted, all of the astropics in this book were taken by me in field conditions. Each illustration will provide the name of the object, whether it was Camera Only or Camera and Telescope; in some cases the location is provided, equipment used, all of the exposure information – Auto White Balance was used unless indicated otherwise – processing software used and any pertinent comments. That is a lot of information for each illustration. But it has a purpose. It provides you with a beginning point to try and take an astropic of your own of the object involved using the mode/equipment described. With the power of digital, you can easily adjust your camera if the end result is not to your liking.

Get used to this acronym, SAAS. It stands for Shoot, Assess, Adjust, Shoot, and it succinctly describes the astropic digital process. You SHOOT an exposure, ASSESS how it looks, ADJUST your settings and/or equipment and SHOOT your astropic again. You keep doing so until you get the

astropic you want. With digital you can take thousands of pics on one memory card, so use this to your advantage.

In the days of wet film, you had no such instantaneous capability to see how the exposure looked. You shot a whole roll of film, developed it and had to live with the results until the next time you took astropics. You may be like me and find that you need at least 10-20 astropic exposures of an object to get one that you *might* truly like. Sometimes no matter what you do, it isn't right, and that will usually be because of equipment/camera issues, weather, atmospheric conditions and/or light pollution. You'll learn to take what the sky gives you.

A major resource in this book for your use is Chapter 23 Suggested Reading and Internet Links. To get the most value out of this book, it is mandatory that you take the time to visit the Internet links and read the material. There is so much supplementary information to complement what is provided in the book. Copying the links would be tedious; hence, the book also includes an online, downloadable version of Chapter 23 that is accessible to anybody who has purchased it in any format (print or ebook).

Well, let's launch you into *Astrophotography Is Easy!*

Are you all set? The universe awaits!

Ruckersville, VA, USA Gregory I. Redfern

Acknowledgements

I wish to thank

My Springer Editors Hannah Kaufman and Maury Solomon for working with me once again.

Mia Stålnacke, Johnny Horne, Damian Peach and Sean Walker for their provided advice to the beginning astrophotographers who will read this book.

Joshua Taboga and Elias Erdnüß of Astroshop.eu, a division of nimax GmbH, for their generous support by supplying astrophotography equipment and technical assistance. Their contributions were invaluable and most appreciated.

Dr. Harold A. Geller,
Director,
George Mason University Observatory (Retired)

Fred Espenak (aka "Mr. Eclipse"),
NASA Scientist Emeritus

And especially
Dr. Richard Tresch Fienberg
Press Officer, American Astronomical Society
+1 202-328-2010 x116 | rick.fienberg@aas.org
Twitter: @AAS_Press

About the Author

Fig. P.1. Greg Redfern after the July 2, 2019, total solar eclipse in Chile

"Sky Guy" Greg Redfern has been in love with the night sky since he was five years old. He became interested in astronomy, space exploration and astrophotography when he was in high school, taking his very first astrophotograph of the Moon at age 16. He studied astronomy and history of science while in college.

While pursuing a full time career that took him around the world, Greg was able to see and photograph the night skies. His astrophotographs have been published in books, magazines, media outlets and online. He also took to writing about astronomy in 1979 and has been published in newspapers and magazines. His first book, *Cruise Ship Astronomy and Astrophotography*, was published by Springer Astronomy in 2019 as part of "The Patrick Moore Practical Astronomy Series."

He has an Internet and social media footprint that includes Twitter – @ SkyGuyinVA – Facebook and his daily blog, "WhatsUptheSpacePlace. com" which has 3.2 million views worldwide.

With experience as an adjunct professor and instructor of astronomy for five different colleges, Greg has striven to teach audiences about the Universe in which they live. This outreach has included being a NASA/Jet Propulsion Laboratory Solar System Ambassador volunteer since 2003, a cruise ship lecturer on astronomy and space, and the space reporter/contributor for WTOP.com since 2006.

Contents

Chapter 1

Introduction

Greetings!

If you are reading this book, you must have curiosity about the subject. Or maybe you are considering taking the plunge into the world of amateur astrophotography. Either way, *Astrophotography Is Easy! Basics for Beginners* is a book that can help you. It was written so that someone who wants to photograph the night sky (and in some cases the daytime sky) can do so with no prior experience following the suggestions, techniques and tips contained within this book. The astrophotographs in each of the chapters will give you a ready reference as to what different astronomical bodies look like and the camera settings used to take the astrophotograph. Unless otherwise specified, "Auto White Balance" was used for each one. *Astrophotography Is Easy! Basics for Beginners* will start you on your way to photographing the sky from scratch.

This book is designed so that the first ten chapters give you necessary background on knowledge, equipment and techniques you will need to know to take your first astrophotographs, or what we'll refer to also as astropics. It is in Chapter 11, "It's Astrophotography Time!" that we'll walk through conducting an actual astropic-taking session. It is recognized that you may just decide to start taking astropics at any time – your prerogative, of course! But the time spent reading those first ten chapters will be worthwhile. In each pertinent chapter in the book there

© Springer Nature Switzerland AG 2020
G. I. Redfern, *Astrophotography is Easy!*, The Patrick Moore Practical Astronomy Series, https://doi.org/10.1007/978-3-030-45943-7_1

will be separate "Camera Only" and "Camera and Telescope" sections to discuss and break down the subject matter of the chapter, whether it is equipment and/or astronomical object related. These two modes are a continuing theme throughout the book and refer to the two separate means by which astropics can be taken. Prose and pics will guide you through the chapters.

The book is *not* about astronomy, so you will not find a lot of astronomical details and information on the various astronomical objects you will hopefully be photographing. Usually people who have an interest in astronomy and/or everyday photographers are the ones who acquire an interest in astrophotography. While the two disciplines are obviously related, they should be tackled separately so as to be complementary. Both subjects are extensive study projects in their own right and require your investment in time and reference materials.

What exactly is astrophotography? At its simplest definition astrophotography is photography of celestial objects and events. According to Wikipedia's entry on the history of astrophotography (https://en.wikipedia.org/wiki/Astrophotography): "The first-known attempt at astronomical photography was by Louis Jacques Mandé Daguerre (1787-1851), inventor of the daguerreotype process that bears his name, who attempted in 1839 to photograph the Moon. Tracking errors in guiding the telescope during the long exposure meant the photograph came out as an indistinct fuzzy spot. John William Draper (1811-1882), New York University Professor of Chemistry, physician and scientific experimenter managed to make the first successful photograph of the Moon a year later on March 23, 1840, taking a 20-minute-long daguerreotype image using a 5-inch (13-cm) reflecting telescope."

We have come a long way in astrophotography since then – first glass plates, then film and now digital. As you shall see this modern transition from film to digital literally revolutionized professional and amateur astrophotography. This digital revolution is still going on, as new cameras and sensors continue to be developed. Some astrophotography techniques remain the same now as back then, namely using a camera and lens alone, or a camera and telescope, to take an image of an astronomical object. How the photons (light) from an astronomical object are collected and processed – film (or what is commonly called analog photography today) vs. digital - is the heart of the astrophotography revolution.

Fig. 1.1. Film to Digital. Author's 1988 Kodak Film Booklet, "Astrophotography Basics."Author's 2006 Jerry Lodriguss CD, "A Guide to Astrophotography with Digital SLR Cameras." (Image by the author)

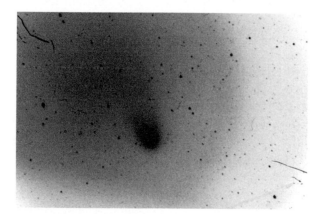

Camera & Mode: Minolta SRT 101 Camera Body Prime Focus w/reducer
8-inch SCT on motorized mount Camera and Telescope.
ISO: 400 gas hypered B&W TP2145 Film
Exposure: 15 minutes
Processing: Copied and processed in Mac Photos
Comment: This was my first comet photo taken in 1987 using "super fast"
gas-hypered B&W Kodak TP2145 film. The tail is visible.
Scratches on the film are from many moves

Fig. 1.2. Comet 1987 P1 (Bradfield) (Image by the author)

Amateur astrophotographers today can take astropics with their equipment that rivals what professional astronomers using large telescopes took decades ago. Today, serious astrophotography amateurs contribute to the science of astronomy through their images of the Solar System and beyond. Maybe you will too someday.

Professional astronomers with their space- and ground-based telescopes and cameras are continuously improving the details and extending the distances of what they photograph in the Solar System and the Universe at large. It is, in a word, amazing, as to what we see in their astropics. But amateur astrophotographers, even beginners, can capture stunning astropics using Camera Only and/or Camera and Telescope modes of astrophotography. Professional or amateur, both groups need the right equipment, techniques, location and astronomical object(s) to do so. The proper attitude – patience and persistence – on the part of astrophotographers is also a necessary requirement.

To photograph the sky, at the minimum, you need to have some type of device – a camera – that can capture and record what you want to photograph. That's it, that's all you need. See? Astrophotography IS easy! However, and this is a big point, what type of camera and how you use it determines the quality of the resulting photograph. As you shall see cameras come in a bewildering array of types, models, capabilities and cost.

In Chapter 2, we will discuss the basic types of cameras, including smartphones and tablets, that can be used to take astropics. If you already own a camera you should be able to hopefully determine where it fits in as to camera type and capabilities. Believe it or not, there are still film cameras out there, although the vast majority of cameras are digital, which is also true for astrophotography. Digital cameras rule for good reasons, as you shall see. Next up, we will, forgive the pun, focus our discussion on using cameras in entirely two different operating methods of astrophotography: using them on their own, Camera Only, or using them with a telescope, Camera and Telescope. This is the theme for each of the pertinent chapters in the book – first, describing Camera Only, and then, Camera and Telescope. If you don't already own a camera, or want to purchase one for astrophotography use, the basics provided will help you select a camera. Again, in most cases one camera can be used for Camera Only and Camera and Telescope astrophotography.

The quality of the "glass" you use to take your astropics – talking about camera lenses here with telescopes to follow in the next chapter – will have the biggest impact on the inherent quality of your resulting astropics. Chapter 3 provides the basics of camera lenses. As you will learn in the book there are just some things you can't control when it comes to taking

quality astropics. Weather, atmospheric conditions and light pollution are the main culprits. But, you *can* control the quality of the lens(es) that you will use. What kind are there, what makes a "good lens" for astrophotography, what kinds of astropics can be taken with what type of lens? Is there just one type of lens that the beginner should have above all others when starting out? All of these questions and more will be discussed in our recurring chapter theme of Camera Only and Camera and Telescope.

On the subject of telescopes, Chapter 4 goes into their basic design. Essentially unchanged for hundreds of years from Galileo Galilei's (1564-1642) refracting telescope and Sir Isaac Newton's (1642-1727) reflecting telescope, today's amateur astrophotographers have many quality telescopes to choose from. To collect light your telescope will either use a lens – a refractor – or a mirror – a reflector. Refractor and reflector telescopes come in all sizes, literally, with a wide range of capabilities, some of which are due to specialized designs. Their basic function, regardless of type or design, is simple, collect light and bring it to a precise optical focus. You use eyepieces to magnify the resulting image for visual observations.

Adding a camera to the telescope allows you to use it essentially as a really big lens (even if using a reflecting telescope) to photograph stars, the Moon, planets, galaxies and other objects in the Universe. But what kind of telescope, how big, how capable and "how much" are all factors that you need to consider before adding a telescope to your astrophotography capabilities. You may be surprised to discover that you can use your telescope and its mounting to take Camera Only astropics with amazing results. Don't worry! You'll learn all you need to know to help you make a decision about whether to have Camera and Telescope capability. Hint, you will most likely want a telescope in your astrophotography future at some point.

If you do decide to add Camera and Telescope to your astrophotography bag of tricks, it will become necessary for you to learn the basic techniques necessary to obtain images. In Chapter 5, we will discuss how you use various camera types with basic telescope imaging methods to obtain different categories of astropics. You will find that there are several methods, and each has its own place in taking astropics.

Although it is possible to take astropics handheld, you will quickly learn in Chapter 6 that you will achieve far superior results by using some kind of mounting. For Camera Only a simple tripod will suffice in most situations. But if you want to get the most out of taking astropics of the wide sky you will have to overcome Mother Earth's rotation on her axis. To counteract Earth's rotation you have to use a mechanical means to do so, which you will learn about. Camera Only may involve heavier lenses that necessitate care in the selection of what type of mounting you use. Camera and

Telescope really opens up the discussion of what mounting to use because you have to consider how you want to mount your telescope *and* how to mount your camera to the telescope.

Each of these considerations has a wide range of possibilities that leads to very enhanced capabilities. Mountings are very important because they steady your camera and/or camera and telescope. There is nothing worse than a mounting that does not do this, as your astropics will look like an EKG. Telescope mountings also can have sophisticated computer control, automatic guidance correction and can be configured in a variety of ways to accommodate your astrophotography (and visual) requirements. There are a lot of good telescope and camera mounts out there, and this chapter gives you the basics on what to look for to suit your astropic needs.

Let's face it. We live in an age where computers pretty much are a part of our everyday, if not it seems, every moment of existence. So it goes with astrophotography. Whether you will be Camera Only and/or Camera and Telescope, Chapter 7 discusses the software that can help you know what is in the sky, run your mounting/telescope/camera/astropic processing and touches on the basics you really need. Although it is possible to do astrophotography without a computer and software – essentially non-digital – why would you want to? You may use a camera that shoots film that takes software and a computer out of your astropic processing equation. But, to operate your telescope at its most efficient, using computer control is really required.

Cost may be a factor, but based on the author's decades of experience, you will want to upgrade to computer and software capability for all of your astropic and telescope requirements at some point, if not from the very start of your astrophotography pursuits. Chapter 7 also highlights the basic accessories you will need to efficiently and safely conduct your astrophotography sessions. Accessories for the astrophotographer is a seemingly never-ending acquisition of this and that for the camera, the telescope, the mounting, the computer, all of which really does add up in cost *and* capability. Beyond the bare basics that you will need it does become fun to shop around and get that latest gadget or software program for taking your astropics.

Chapter 8 will share with you the school of hard knocks, frustration, mistakes and lessons learned by the author from over a half century of photographing the sky. So much time under the sky and camera/telescope has taught "old timers" the bedrock basics of astrophotography. No one in this pursuit can ever say, "I've seen it all." But all can share what they have seen and learned in the form of easy to remember and follow "rules." Although these rules will have applicability to Camera Only and Camera and

Telescope, there will be some specifically for each method. Learning what is behind each of these rules and applying them will better prepare you for your astrophotography sessions.

Once you have completed doing what is necessary as prescribed by the foregoing chapters it is time to take your astropics. What are you going to photograph? How do you find your way around the sky and select your object(s) of astronomical interest? Chapter 9 introduces you to the basics of finding your way around the sky. Whether you do Camera Only or Camera and Telescope you are going to have to learn the basics of how the sky operates. Of course you can just point the photographic system of your choice at the sky and take a picture and get great results. But what was it you captured in that astropic? Astrophotographers in the know can guarantee you that you will have to learn your way around the sky with a Camera Only or one attached to a telescope. It isn't rocket science, but it takes time, patience and practice to navigate your way through the heavens. Once you learn the basics each astrophotography session will teach you more and expand your ability and knowledge of the sky.

Okay. You have a camera, perhaps a telescope. You feel ready to photograph the sky. But where from? Chapter 10 helps you select locations of the nearest dark sky sites. You will learn the location considerations that have to go into what you want to photograph. Each type of sky object as well as the method you will use to photograph it has to be considered in terms of the location you use. Yes, you can photograph anything in the sky from downtown New York City. But what will the resulting astropic look like? The Sun, Moon and planets are pretty much immune from the effects of light pollution unless you are under a super duper bright light. Even some of the brighter stars and deep sky objects (DSOs) can be photographed, with or without light pollution reducing filters, from major cities. But if you are on a quest for the dimmest and most challenging DSOs and/or Milky Way scenes, a dark sky is the only way to go.

You have your lens(es) and camera. Maybe even a telescope. You have determined what mounting you will use and have gotten the basic software and needed accessories. All of your equipment is ready to rock as are you. You have picked out where you want to take your astropics. You have selected the astronomical object you wish to take an astropic of and read this book's corresponding chapter about it. Now, how do you put all of this together into an actual astrophotography session that will produce astropics? Where to begin doing what? Chapter 11 describes the basics for conducting a successful astrophotography session using Camera Only and/or Camera and Telescope. We'll walk through the preparation, setup, checklists, actual

shooting session and takedown. Once you have the basics covered you can fine tune how you want to conduct your own astrophotography sessions.

Chapter 12 starts you on your way to learning about how to photograph specific astronomical objects in the sky. Our star, the Sun, is a logical and easy point to start from, as it is the brightest object in the sky from an earthly perspective. You will learn about the mandatory requirements necessary to safely view and/or photograph the Sun. Failure to follow these requirements can result in permanent damage to your eyes and camera. These safety requirements MUST be followed to the letter in each and every instance of viewing and/or photographing the Sun. Remember, *do not* attempt any type of solar viewing/photography until you have read this chapter, the supplementary resources for this chapter in Chapter 23 Suggested Reading and Internet Links, and understand completely how to do so safely.

There are a wide variety of sky phenomena associated with the Sun during daylight and twilight that can be photographed using Camera Only. Features on the solar disk itself can be seen and photographed with proper solar filters on the front of "long lenses" using Camera Only and/or up close and personal with a proper solar filter on the front/aperture of a telescope in Camera and Telescope mode. In fact, you will learn about safe solar viewing systems that allow you to see and photograph the Sun in wavelengths of light other than visible light. These specialized systems allow you to see and photograph a variety of solar features such as prominences, spicules and filaments.

The next brightest object in the sky after the Sun is the Moon. Chapter 13 tells you how to photograph our planet's nearest neighbor in space. No kidding, you can lose yourself for hours in looking at and photographing the Moon. Because it is relatively speaking so close, you can photograph a great amount of lunar detail no matter what operating mode you use. The Moon when it is full also illuminates the world around you. Photographing the rising Moon near landmarks, buildings, and natural formations allows unlimited options for creativity. And when you want to get that astropic of Luna by herself among the stars and/or planets, opportunities will abound. As you will see capturing detail on the Moon using Camera and Telescope is a true challenge but oh so worth it in the lunar astropics that you will learn how to take. You won't see the Apollo astronauts' footsteps, but you will see and photograph the geographical landing sites of their missions. The Moon captivates, and you will see why when you start to photograph it.

Lunar and solar eclipses happen every year and are always two weeks apart in the eclipse cycle. Chapter 14 gives you the basics behind photographing these grand celestial spectacles. Once again the mandatory safety requirements for solar eclipses will be covered. You will learn about the

requirements necessary to safely view and/or photograph solar eclipses. Failure to follow these requirements can result in permanent damage to your eyes and camera. These safety requirements must be followed to the letter in each and every instance of viewing and/or photographing solar eclipses. Remember, do NOT attempt any type of solar eclipse viewing/ photography until you have read this chapter, the supplementary resources for this chapter in Chapter 23 Suggested Reading and Internet Links, and understand completely how to do so safely. The good news is that if you have safely photographed the Sun using the required solar safety equipment you have all that you need for solar eclipses. In fact, during totality, when the Sun is completely blocked by the New Moon, you need no solar safety protection at all. The grandeur of totality is there in the sky for you to photograph. The onset of the Moon's dark shadow, the umbra, is another favorite solar eclipse photographic target. For lunar eclipses there is no protection required for eyes and camera, so it is much simpler to photograph these dramatic events. The color of the Moon during totality is a wonder to behold and a bit of a challenge to photograph, depending on how bright the totality phase is. But you will learn what is needed to do so.

The sky is different in its appearance every single night and will change over the course of sunset to sunrise due to Earth's rotation. The location of the Moon, planets and even the stars themselves changes from night to night. Chapter 15 tells you how to photograph the stars and planets. Your first challenge is knowing what it is you want to photograph, then determining if it is visible and then finding it in the sky. You may want to photograph constellations, individual stars and planets or beautiful scenes in the sky that combine the Moon, stars and planets. You can get great sky coverage using Camera Only. Sweeping vistas of the night sky are yours to obtain using the right lens for the job. With Camera and Telescope you can zero in on individual stars, star systems such as double/triple stars, star clusters, globular clusters and other DSOs. Individual planets can be photographed with Camera and Telescope to provide images of each planet – yes, Pluto included *if* your 'scope is big enough! Planetary photography is as much an art form as it is an exacting discipline. Each planet has its own characteristics and challenges that have to be taken into consideration each and every astrophotography session. All the planets vary greatly in brightness, visible detail and location in the sky. You will learn the basics necessary to capture very satisfying images of the stars and planets in a number of ways.

The sky is full of satellites, including the Hubble Space Telescope (HST) and the International Space Station (ISS). You can photograph them with Camera Only, and in the case of the ISS with Camera and Telescope. Chapter 16 will cover the basics for learning how to know

when the HST and ISS pass over your location as well as photographing them. The resulting astropics, especially of the ISS, can be quite stunning when taken with Camera Only. Camera and Telescope astropics of the ISS, possibly including video if your camera has that capability, can be pretty impressive as well. With some planning you can photograph the ISS crossing the Sun (using a safe solar filter) and Moon. Eventually your skills may progress to where you can obtain individual frames of the ISS with a fair amount of detail.

The Solar System is a very busy place, as you shall see in Chapter 17. Besides the Sun, planets and their moons, it is full of asteroids and comets, countless leftovers from the formation of our Solar System 4.6 billion years ago. Asteroids always present a star-like appearance whether seen on rare occasions with the unaided eye or with optical aids such as binoculars and telescopes. Asteroids always move across the sky, sometimes visibly apparent after only minutes! This happens when an asteroid comes very close to Earth, usually one that has been recently discovered. Depending on how bright the asteroid you are interested in is, you might be able to photograph it Camera Only. Or you may have to use Camera and Telescope. Regardless, you really have to zero in on the asteroid's position in the sky to photograph it.

You may be able to detect the object's presence with just one astropic and a good star chart to identify it against the background stars. Or, a better way is to take a second astropic sometime later – usually a day or two – of the same region of the sky to show its movement. This is really challenging and fun to do, as it is like a treasure hunt in following the sky map clues for your justly reward of an astropic for having doing so.

Worse than cats as to their behavior are comets. You never know what to expect or how they will behave. We might get lucky in our lifetimes and have a "Comet of the Century" flyby that spectacularly graces the heavens. More than likely, however, we will have a somewhat dim but photographable interloper that can be imaged using Camera Only or Camera and Telescope. In either case the resulting astropics can be quite colorful and aesthetically pleasing. Astropics taken over the course of days or in some cases even hours will show changes in the comet, its tail and its position relative to the stars. Using Camera Only you also can photograph meteors, fireballs, bolides and meteor showers. These events are the results of bits and pieces of comets, asteroids, and on extremely rare occasions, pieces of the Moon and Mars, entering our atmosphere and producing quite the visual show. Camera Only is used to photograph these atmospheric occurrences, but meteor showers are the only such event we usually know of in advance. Fireballs, bolides and meteors are mostly chance events that you might get

in an astropic you were taking of something else in the sky unless you set up an all-sky camera. Photographing meteor showers is very much like fishing. It takes luck and a lot of patience to land a "big one," or even a small one if truth be told. But it is relaxing and fulfilling regardless of your catch of meteor astropics!

The sky can also produce a wide variety of glows in the sky that are best captured using Camera Only, as is explained in Chapter 18. Besides the wildly wonderful, ever changing, and – depending on where you are – elusive aurora, there are other glows in the sky worth trying to photograph. Trying to image some of these sky glows is just "take your best shot" and see if you are rewarded for your efforts. Besides the aurora, *the* glows to photograph are the Noctilucent Clouds (NLCs), which are high latitude/ altitude clouds formed from ice crystals covered with meteoritic dust! They are literally electrifying in their appearance – stunningly blue-colored (usually) lacy clouds looking for all the world like electrical discharges streaming across the sky. Other night sky glows are caused by dust in the Solar System. You will definitely want to learn the basics of how to locate and photograph these phenomena.

You will learn in Chapter 19 that there really isn't anything that can compare to the raw beauty of our Milky Way Galaxy (MWG) in quality astropics. When you take an astropic of the MWG you are really taking a portrait of our home among the other galaxies. And when you consider that 80% of the humans in North America cannot see the MWG due to grossly interfering and careless light pollution, it is precious when you hopefully do find a dark sky site that allows you to do so. In both the Northern and Southern Hemispheres the MWG displays its splendor at varying times of the year, which you will learn about. The MWG is best photographed in Camera Only mode, as you want to image its broad breadth across the sky and/or landscape. Using Camera Only with "long lenses" as well as Camera and Telescope allows you to zoom in on areas of interest such as star clouds, emission and dark nebulae. You will find yourself captivated by the MWG and extremely pleased with your resulting astropics taken using the basics provided in this chapter.

Next up in Chapter 20, deep sky objects (DSOs) are the veritable "celestial zoo" of any astronomical object in the sky that is not a star or part of our Solar System. Star clusters, globular clusters, all nebulae, galaxies – both our own and others – offer an almost unlimited assortment of objects to photograph. Depending on their brightness some of these objects, primarily a few local galaxies and bright and dark nebulae in the MWG, lend themselves to being photographed using Camera Only. You will learn the basics as to what is "out there" and how best to photograph your object of interest.

Camera and Telescope can really push the boundaries of what you can photograph DSO-wise. If you have this capability you can zero in on objects in our own galaxy. What is even more amazing is that with Camera and Telescope you can photograph surprisingly well the closest galaxies to us and then collect light from galaxies way beyond. The only limiting factor is how much light your telescope can collect and how dark your sky is at the location you are using. Even a modest-sized telescope with a good camera can image galaxies millions of light years away! You will possibly find yourself wanting to keep "pushing the envelope" on how "far out there" you can go. You may even be able to photograph the death of a massive star, a supernova in another galaxy, or maybe, just maybe, in the MWG if it happens in our lifetimes! We are way overdue for a visible supernova in the MWG.

So, you've got that astropic of a lifetime. What are you going to do with it? Chapter 21 provides basics on how to process, print and post your astropic treasures. Not all astropic processing is the same as it depends on what photographic system and astronomical object you are working with. How did you take your astropic? Camera Only or Camera and Telescope? What was your astropic a picture of? Wide sky view, DSO or lunar/planetary closeup? The system you used as well as the astro-object photographed really determines how you go about processing the end result. We'll stick to basic approaches that work with freeware or the software that was supplied with the system hardware used to take the pic. You can always upgrade to highly sophisticated, and in some cases expensive, astropic processing software, but the goal here is to provide basic and inexpensive methods that work. We'll also discuss astrophotography ethics – such as "thou shalt not add color or make a composite unless thee confesses to doing so" – to improve the image; don't alter it.

Once you have your astropic processed, maybe you want to share it. What if you want to print out your astropics? That will be covered as well from your own in home capability to commercial sources. There are quite a few ways to do so in the social media world, and they will be discussed. You might even want to submit your astropic to astronomy-related publications.

In all probability you will eventually become afflicted with what the author calls the "astrophotography bug" – a never-ending desire to photograph the night sky. Each astropic you take contributes to getting the bug. Chapter 22 explains how you can live with it and really expand your capabilities and opportunities in the realm of astrophotography. Whether you are Camera Only or Camera and Telescope, we live in a "Golden Age" of astrophotography. Never before have there been so many online and printed

resources – free college astronomy classes, online astrophotography webinars, blogs, books, ebooks, magazines – to expand your knowledge of the Universe and astrophotography. In addition, the astrophotography hardware available today in cameras, lenses, telescopes, mountings, accessories, software, DIY observatories are seemingly endless.

And there is another very intriguing aspect of astrophotography: astrotourism. There are companies out there that offer you the possibility to travel the world in search of aurora, eclipses, Northern and Southern Hemisphere dark skies, and astronomical facilities. Some of these are on land and some are at sea. Yes, you may be surprised to learn that you can take astropics at sea. All of this adds up to what can become a lifetime of taking astropics. This chapter will also dwell a bit on the scientific and philosophical nature of taking astropics. You may want to contribute to science, learn the deeper philosophical meaning behind each astropic you take. It's all covered.

You will also hear advice for the beginner from four Master Astrophotographers – people recognized the world over for their amazing astrophotographs – speaking directly to you. Their words will, we think, resonate with you and inspire you to join in the pursuit of photons.

It would be pretty hard for one book to adequately cover the entire breadth of astrophotography in terms of astronomical objects, equipment, software, processing, techniques and tips. You will want to peruse the provided lists for each chapter, which contain recommended books, valuable supplemental materials, references and websites that can help you further your astrophotography capabilities.

Now let's get you started on the basics of becoming an astrophotographer! It's easy!

Chapter 2

Cameras

To take any photograph you need a camera and lens. This is even true with astrophotography, but in most instances you are dealing with very faint objects where every bit of light counts. The good news is that if you own any type of camera (digital or film) – smartphone, tablet, pocket camera, video, film single lens reflex (SLR), digital single lens reflex (DSLR), mirrorless digital, dedicated astronomical camera, you can take pictures of the day and night sky. For the most part you can take astropics using these types of cameras in Camera Only and Camera and Telescope modes. The only question becomes how good will they turn out, and there may be some limitations as to what you can shoot with the camera and/or lenses you have available as well as what mode you use.

The type of camera you own and what mode – Camera Only and Camera and Telescope modes – you will operate it in is what determines how far "out there" in the Universe you can go. There is no way we can cover each and every smartphone, tablet and camera manufactured. But what we can do is provide the basics of each type of camera and what you can do with each from an astrophotography perspective, which is a lot. You will learn the basics about each type of camera and how it can be used in each mode of operation. You will also see astropics taken with various types of cameras and in both modes where applicable throughout the appropriate chapters in the book.

© Springer Nature Switzerland AG 2020

15

G. I. Redfern, *Astrophotography is Easy!*, The Patrick Moore Practical Astronomy Series, https://doi.org/10.1007/978-3-030-45943-7_2

If you don't already own or haven't bought a camera yet, reading this chapter may help you decide what type of camera you want to consider buying, whether it is your first or an upgrade to what you already own. You really should read the whole book before buying a camera, as all of the chapters are germane to helping you decide what you want to do astrophotography-wise and what you will need camera-wise to do so. In keeping with the book's premise, we will stick to basics and work our way through the various camera options.

Cleaning Your Camera

Regardless of the type of camera you use, you will need to do some care and minor cleaning of it, as it will be out in the field and show some use. The user's manual of your camera will have recommendations on its care and cleaning. Always use the supplied lens caps and camera body cap, as they will go a long way in keeping your camera clean. We discuss lens care and cleaning in the next chapter and in Chapter 7, we will discuss what you need in a lens and camera cleaning kit.

Meet SAAS

Meet the acronym SAAS, which the author created and uses in his all of his digital based astrophotography. It stands for **S**hoot, **A**ssess, **A**djust, **S**hoot. It succinctly describes the author's recommended astropic digital process. You **shoot** an exposure, **assess** how it looks, **adjust** your settings and equipment and **shoot** your astropic again. You keep doing this until you get the astropic you want. The true power of SAAS lies in the use of digital cameras because you can do this process instantly and as many times as is required in real time to get results. This is not the case when using film cameras, because you have to wait until film is processed to see your astropic results.

Smartphones and Tablets

Smartphones and tablets are truly amazing pieces of ever-evolving technology as they combine a telephone, computer and camera (including video) all in one. Almost everyone owns a smartphone, with tablets being a very distant second. Both can be used to access the Internet almost anywhere and

can also be used to set up your own Wi-Fi network to control your camera and/or telescope as you will see later in the book.

Your smartphone and/or tablet (and personal computer) can also have astronomy applications loaded onto them that will help you in observing and photographing the sky. This is very useful, and pretty much essential to getting the most out of your astrophotography sessions. Your astronomical software will help you plan your astrophotography sessions as well as serving as a trusted astronomical reference. We'll discuss this further in Chapter 7.

As to photographing the sky with a smartphone the author has to limit comments to using the iPhone 5s and the 6s. The 6s is ancient smartphone technology, especially when it comes to camera capability, but it does work as you will see. The current generation of smartphones has amazing capabilities and actually tout their ability to photograph the night sky. And each succeeding generation/model has more gizmos, bells and whistles. But remember, all you need is a camera to take astropics, and the basic capability to do so is pretty good when it comes to smartphones.

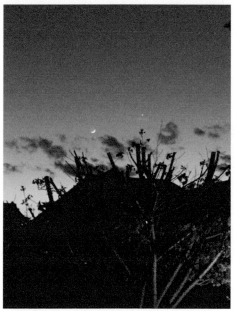

Camera & Mode: Apple Phone 6s 4.2-mm lens at f/2.2
Camera Only
ISO: 500
Exposure: 1/15 second
Processing: Mac Photo and cropped
Comment: This dinosaur iPhone was able to image
Earthshine, the Moon and Venus. The smartphones
available today with their powerful camera and available
software enhancements will be able to do so much more.

Fig. 2.1. Moon and Venus at sunset (Image by Laurie Redfern)

The author upgraded to an iPhone 11 as this book was in the final editing process and took some astropics with it in Camera Only mode that turned out surprisingly well.

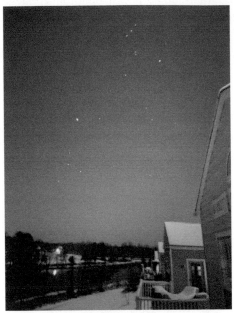

Camera & Mode: Apple iPhone 11 4.25-mm lens at f/1.8
Camera Only
ISO: 2500
Exposure: 1 second
Processing: iPhoto
Comment: This wide angle astropic was taken handheld
using Night Mode. An almost Full Moon was directly
above Orion so the upper part of the constellation was
not included.

Fig. 2.2. Lower Orion and Canis Major (Image by author)

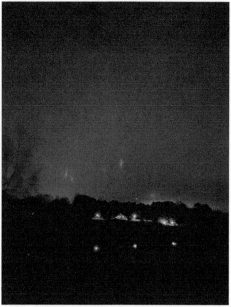

Camera & Mode: Apple iPhone 11 4.25-mm lens at f/1.8
Camera Only
ISO: 8000
Exposure: 1 second
Processing: iPhoto
Comment: This wide angle astropic was taken handheld
using Night Mode.

Fig. 2.3. Ice Pillars (Image by author)

The author has had no astrophotography experience with the iPad, Android smartphones and tablets. What turned up from researching the subject is that tablets were sort of used as rudimentary astrocameras years ago, but now that would not be your first choice (and shouldn't be) and aren't recommended for astrophotography primarily due to their size and limitations. Tablets by way of their intended purpose – an intermediary between smartphone and computer – are larger than most other types of cameras used for astrophotography. Tablets do find use as controllers for astrocameras, telescopes, astrophotography sessions and in some cases astropic processing.

If a smartphone or tablet is all you have and you can't upgrade to another type of camera, then go for broke and see what you can do using the applications and accessories and holders we will discuss in this book. The use of a tablet has severe limitations due to its size. It is large and bulky and not recommended for widespread use in Camera Only and Camera and Telescope modes.

Two suitable applications for upgrading your Android smartphone and tablet capabilities (if you have to go this way) for night sky photography are Camera FV-5 and Open Camera. These applications seem to have good features useful for taking night sky photographs. See Chapter 23 for additional resources.

For iPhone users the NightCap Camera application really transforms your mobile device into a far more capable camera for shooting the night sky. The author does not have any affiliation with the company other than as a user, so this is not a commercial endorsement. Having successfully used its predecessor NightCap Pro – the latest upgrade changed the application to NightCap Camera – to take pictures of planets, stars and constellations, it works. This application truly changes your iPhone (or iPad if that is all you have) into an astrophotography capable camera. You can change the ISO (see the following paragraph), use different modes such as stars, star trails, ISS (International Space Station) and meteor, and take time exposures, including unlimited exposure time. Plus the application uses AI (artificial intelligence) to help you.

During the reign of film the acronym ASA (American Standards Association) was placed next to a number, ASA 400, for example, to determine the film speed you were buying. The higher the number meant the greater the film's sensitivity to light, which meant it was possible to take faster exposures compared to films with lower ASA numbers and therefore slower film speed. There were films with ASA 25 all the way up to ASA 1000 or more. The general rule was that with the higher ASA films, especially the 1000+ ASA films, the grain sizes of the film's emulsion used to record the light would begin to be an issue during lengthy time exposures needed for astropics, and the quality of the image would become too grainy. Back in those days one pretty much had to live with it if you wanted longer exposures.

We now have the acronym ISO (International Organization of Standardization) to denote "speed," which applies to film (analog) and digital cameras. It is used with a number, ISO 100, for example, to show the film and/or digital speed you are using. Once again the higher the number the faster the speed and greater sensitivity to light. The problem of high film speed and grain still applies at the higher film/digital speeds, but much has been done to reduce this issue, especially in film, compared to the days of old. For the digital world ISO can reach 12,800 or higher, much higher, but once again at a cost of "grainy" pictures. High ISO effects can be reduced somewhat by post-processing; we will talk about that in Chapter 21.

There are some Internet sites in Chapter 23 about ISO and DSLRs, so you can read how this works. A higher ISO amplifies the electrical signal to improve taking pictures of dimmer astronomical objects in Camera Only and Camera and Telescope modes.

Astropics taken using a 6s iPhone will appear in various appropriate chapters throughout the book. Photographs of the setup used and the astropic results obtained will help you in your own efforts if you have a smartphone or obtain one sometime in the future.

If you want to try your hand at basic astrophotography with minimal investment, smartphones are the way to go, especially if you have one already. You will have to read the mentioned software tutorials online to get familiar with the Android and Apple applications we discussed. They will transform your smartphone into a basic astrocamera and are pretty user friendly. If you pair up these applications with a state of the art smartphone you may have some pretty amazing capabilities. You might even try taking Milky Way shots on a tripod (see Chapter 6) with the enhanced ISO speed and unlimited time exposure capabilities and/or take astropics through a telescope using a smartphone holder.

Tablets, as previous stated, are just too large and bulky for overall use. There are tripods you can buy, but you are really better off using a smartphone or other camera. Trying to put a tablet up to the eyepiece of a telescope to take a picture will be a probable experience in frustration with no astropic success. You *may* be able to use a tablet for "all sky" astropics, but that's about it.

Camera Tip: Protect Your Liquid Crystal Display (LCD) Panel

The cameras we are going to be discussing next – compact, DSLR, mirrorless compact system cameras (CSCs) – will have LCD panels incorporated into the back of their camera body. You will use the LCD panel to frame and focus your astropics, so it is a good idea for you to install a glass protector on your LCD panel. This is in addition to the hard plastic protector that should be provided by the camera manufacturer. This double protection is really necessary to avoid scratches to the LCD panel. When doing really fine focusing using the LCD panel you can take the hard plastic cover off and get a perfect rendition of the image through the glass protector. If the LCD panel gets scratched up it will really impact your ability to see and focus.

Be smart. Invest in prevention. You will be glad you did when you see all of the scratches on the plastic and glass protectors but your LCD is fine.

Pocket Cameras

Modern pocket – "point and shoot" or compact cameras – are extremely versatile and capable, easy to use and carry. They have great popularity and usefulness in the age of smartphones and tablets and carry quite a photographic punch in a small package. Although the author has never done so, they can be used in certain instances for astrophotography depending on the camera's included features.

Looking at the myriad array of compact cameras that are available for purchase is dizzying, as there are so many. Most major camera brands have several models, and price ranges weren't too bad. If you go this route there are several features your compact camera has to have to be able do astrophotography:

- Must have a manual mode (as opposed to being fully automatic only) that allows for taking different exposure times, including time exposures for at least 30 seconds. This will allow you take Camera Only mode time exposures of stars, planets and perhaps even the Milky Way.
- Must have a quality optical zoom lens as opposed to having just digital zoom capability. This will bring objects in closer, especially the Moon and eclipses, with far better image quality.
- Must be adjustable for ISO speed so that you can change ISO from low, 100 or 200, to high, 3200 or better. This will give you the ISO range necessary to cover bright and dim astronomical objects.
- Must be able to mount your compact camera on a tripod; just make sure it has the universal screw socket.

Bottom line? These cameras are Camera Only and Camera and Telescope capable but limited. If this is the only camera you have access to then by all means try to get the most out of it. You can mount this on a tripod for Camera Only mode and buy a universal camera holder to use in Camera and Telescope mode.

Film Cameras

Yes, there are still film cameras in a variety of film sizes out there, and they are making a comeback, but they are a rarity in astrophotography. There is no real difference in astrophotography technique between film and digital. The primary difference between the two is the far superior ability of the digital sensor to capture photons of light compared to commercial film. Another substantial difference is in the processing of digital images, which

uses powerful software compared to darkroom processes for film development and print production.

Used today primarily by photography professionals and purists, film cameras can be used for astrophotography just like any digital camera. Their biggest drawback is two-fold. First, you have to develop your film in order to determine the end result in your astropics. That can take some time, at least an hour if you do it yourself or much longer if you send it out for processing. You could use one of the new instant film cameras that has taken over for the defunct instant cameras of old. But these types of cameras are very limited for shooting the night sky and are not recommended, as they are designed for traditional daytime and flash photography.

With film cameras, unlike digital cameras, you will have no way to determine the quality of your astropics when you take them in order to make any needed adjustments. In the days of 'wet film,' as well as if you use a film camera today, you take a series of astropics of your object of interest in the blind, making "guesstimate" adjustments in exposure and other camera or telescope parameters hoping for that perfect shot. A related disadvantage to film cameras is that you cannot have enough film available to equal the number of shots you can take digitally – in the thousands depending on picture size and type. You would have to have a lot of 36-exposure 35-mm film cassettes on hand to equal one 64GB digital memory card for a DSLR!

All digital cameras, regardless of type, store their images on some form of digital storage medium. Astronomical video cameras and "pure astrocameras" usually download their outputs to a computer, while some models have an inherent storage capacity.

Your mobile devices have a set amount of storage capacity (some can be augmented with external storage), while digital cameras use memory cards with varying amounts of storage and features. It is imperative that you get the right memory card for use in your camera. The camera's user's manual or manufacturer's website will provide the required memory card specifications. More information on memory cards is in Chapter 7.

Now back to the second drawback for film cameras – the lack of light-gathering ability. You will need all the help you can get in pulling in light from faint and dim objects in the night sky. This is where the digital camera's sensor runs circles around film. There is no comparison. The digital camera sensor will capture far more light from dim sources than film regardless of the exposure time, lens and/or telescopes used, period.

Commercially and readily available films, as of this writing in August 2019, start at ISO 100 and have a top ISO speed of 3200 – far less than what you can obtain with digital cameras, but adequate. The 3200 is available in black and white film while the color 3200 comes from pushing an ISO 800

film 3 stops when developed. There is more information on the high ISO films later in this chapter.

Digital will also pay huge dividends over film when it comes time to the 3 P's of "Process, Print, and Post" discussed in Chapter 21. Astropic digital processing is just way easier and more efficient in terms of time, money and efficiency.

The author did not obtain any astropics using a film camera for this book. There are digital copies of astropics imaged with single lens reflex (SLR) film cameras included in some of the chapters in this book.

So, what is the bottom line on film cameras? Camera Only and Camera and Telescope modes can be used but are limited compared to digital type cameras. Biggest drawbacks are:

- Film ISO selection currently limited to maximum of 3200 in 2019 and may be hard to acquire.
- Exposures limited to film cassette capacity.
- Can't SAAS.

Digital Single Lens Reflex Cameras (DSLRs)

Now we get to a very capable camera type for astrophotography in Camera Only and Camera and Telescope modes, the modern digital single lens reflex camera, or DSLR. It is the DSLR more than any other camera type we have previously discussed that can efficiently work in both astrophotography modes *and* also be an all-around camera for general photographic use.

Having a DSLR that uses interchangeable lenses – we discuss lenses in depth in Chapter 3 – is the way to go, as you will need and want different lenses as you get farther along in astrophotography and photography overall. A fixed-lens DSLR will work, but it will limit you somewhat as to what you can achieve compared to a lens-interchangeable DSLR.

The author's 2002 introduction to the digital realm was via a Nikon Coolpix E5700 DSLR with a fixed lens. This fixed lens model was when DSLRs were just coming out and was far more affordable than a "professional grade" DSLR, which was about the only other choice. It was limited in astrophotography capability but was better than wet film! Next came a Nikon D5000 and then a D5200. In 2005 Canon came out with an astrophotography DSLR camera body, the EOS 20Da, but it wasn't around long. Nor was Canon's follow on astro DSLR EOS 60Da. In late 2019 Canon released their newest astrophotography camera, the mirrorless EOS Ra which we discuss shortly.

There are aftermarket vendors that will remove stock DSLR sensors and replace them with sensors that are astronomically useful in that they are sensitive to hydrogen alpha light, but this is not really necessary for taking basic astropics. To do that all you need is a good quality DSLR.

If you are shopping for an all-in-one DSLR camera here are the essentials that you want to get for use in astrophotography:

- Interchangeable lenses capability.
- Full control (manual mode) over exposure time, ISO, f/stop and other settings such as flash, picture size and type (RAW, JPG, TIFF).
- Bulb or unlimited time exposure capability of at least 30 seconds for time exposures.
- An ISO range from 100 to 200 up to at least 3200 or higher.
- Manual focus capability, as many objects will be too dim for autofocus.
- Shutter release capability or shutter release delay. A shutter, or cable release, physically connects to your camera through an interface that allows you to just push a button to take the exposure. This cancels out movement of the camera from having to manually push the exposure button, which would probably show up on your picture in Camera Only mode using certain types of lenses and definitely would in Camera and Telescope mode. Some shutter releases will lock in place for an extended time exposure until you release the lock. Some cameras may have a specified in seconds shutter release delay so that when you push the exposure button the camera waits for the specified time before the exposure begins, in order to minimize camera movement due to "mirror slap." This capability becomes vital when you are doing astrophotography with the Camera and Telescope mode.
 What is mirror slap? When you look through the viewfinder of a DSLR there is a mirror that reflects the image formed by the lens up to a prism that brings the view to your eye. This mirror is moved up when the shutter release button or cable release is activated, which can result in "mirror slap" – the vibration of the camera due to this movement. This is not a significant issue for taking pictures in Camera Only mode. Manually pushing the exposure button causes far more movement. But this capability becomes vital when you are doing astrophotography in Camera and Telescope mode, as you shall see later.
- LCD viewing screen (with tilt out capability if available, as it makes for far easier focusing and viewing).
- Live view with zoom. This allows you to see what the camera sees, if it is bright enough to show up on your viewing screen. You can use this feature to focus your camera and zoom in for greater precision in focusing. This really helps in planetary, lunar and stellar objects.

Here are some "nice to have" features that will extend your capabilities:

- Video. Many DSLRs are able to take HD and 4K video, which can be useful during eclipses and, as you shall see, at the telescope when doing lunar and planetary astropics.
- A "mirror up" capability if your DSLR does not have "exposure delay" capability. This moves the mirror up and prevents mirror slap. It also is used to facilitate cleaning the camera's sensor by moving the mirror out of the way.

Camera retailers usually have very decent DSLR "kits" that will include a camera bag, some cleaning accessories and two lenses, such as 18–55mm and 55–200mm or similar specification. This makes for a very capable and compact astrophotography-photography setup.

So what is the bottom line on DSLRs? They are good for both Camera Only and Camera and Telescope modes. If you have to buy just one camera for all-around use for day and night, the DSLR is the way to go.

DSLRs Modified for Astrophotography

It is also possible to purchase DSLRs from vendors and dealers that have had their original sensor removed and replaced with one that is sensitive to hydrogen alpha light and therefore better equipped to conduct astrophotography involving some DSOs in Camera Only and Camera and Telescope modes. You can do an online search for these types of DSLRs starting with https://www.astroshop.eu/astrophotography/cameras/astromodified-dslrs/15_35_10_20, which has a very extensive line up. You can learn about the different DSLR models available and the modifications made to them for astrophotography.

If you already own a DSLR you can also have it possibly modified for astrophotography. Several dealers are listed in Chapter 23 to help educate you on this process.

We'll discuss much more about what you can do with a DSLR and other cameras in Chapters 4 and 5. You will also find out what you need for your DSLR (or other type of astrocamera) in Chapters 6 and 7.

These modified cameras are good for both Camera Only and Camera and Telescope modes. They are an option worth looking into. With Nikon and Canon offering astrophotography dedicated cameras you need to look at price and full capability of these cameras against the modified versions of DSLRs. It is a nice problem to have with so many choices.

Mirrorless Cameras

Other digital camera options to consider are the new mirrorless CSCs, or compact system cameras, also known as Mirrorless Interchangeable Lens Cameras (MILC) or hybrid cameras. We will refer to these types of camera as CSCs for the remainder of the book.

These digital cameras do not use a mirror to direct light to the viewfinder, as it is sent directly to the electronic viewfinder (EVF) from the sensor. CSCs are becoming more and more popular, but it is not known if they will surpass DSLRs as the digital camera of choice for astrophotography. Only time will tell. The lack of the complex mirror system makes these cameras smaller and simpler but still offer lens interchangeability, unlike pocket cameras.

Nikon has unveiled its own mirrorless full frame CSC camera, the Z Series, with a new lens mount that is 11 mm wider than its storied "F mount." This brings up the intriguing possibility of lenses that can take advantage of that extra mount space by putting more "glass" in the lenses. Sony and Canon also offer CSCs.

Reviews by *Sky & Telescope* of mirrorless cameras for astrophotography use have been favorable. Canon announced in early November 2019 their new EOS Ra, the world's first astrophotography dedicated mirrorless camera. This camera was reviewed by *Sky & Telescope* and is provided in the supplementary resources for this chapter, found in Chapter 23 Suggested Reading and Internet Links. A detailed discussion of DSLRs vs. CSCs is also provided in this section.

The author did not obtain any astropics using a mirrorless camera for this book. Their use in astrophotography should be very similar to operating a DSLR.

So, what is the bottom line on these? They work with both Camera Only and Camera and Telescope modes. This camera technology is here to stay, and with Canon's new EOS Ra it has entered into the astrophotography realm in full force. If you are starting out and have no camera one advantage of the CSC's over all other camera types is that their lenses will be larger and more capable in gathering light in Camera Only mode. That is a major consideration if you plan on taking a lot of astropics in that mode. These cameras can be adapted to Camera and Telescope too, soooooo........ choices, choices.

Video Astrophotography

It is possible to take video of the Sun (with safe solar filters and proper procedures), Moon and planets and the brighter stars in Camera Only and Camera and Telescope modes with a video capable camera. Other than an actual video camera, DSLRs and CSCs are the best to use due to their over-all capabilities and features. The author has done this with the Nikon D810a, and it will be discussed further in Chapters 13, 14, 15, and 16.

Depending on the output capability of your camera you could possibly send live video of your astronomical object to your computer or a video monitor, where you and others could see it "on the big screen." You also could make videos and download them. Depending on your camera and available software you can also pull down individual frames from a video for processing. See Chapter 21.

There are also astrophotography-dedicated video cameras that can be hooked up to your telescope that are capable of pleasing lunar/ planetary/ DSO views. You can read more about this aspect of astrophotography Chapter 23 Suggested Reading and Internet Links.

Video astrophotography is probably a distant second to the use of "pure" astrocameras, which we discuss next.

If you are considering buying a pure video camera try to buy one that has the ability to mount regular camera lenses to give you full capability in Camera Only mode.

"Pure" Astrocameras

So far we have looked at "regular" cameras that can be used along with DSLR's – modified and dedicated – to take astropics. It is now time to get into "pure" astrocameras, those designed or modified for use in astrophotography exclusively. These cameras do not lend themselves to ordinary photography and are primarily for Camera and Telescope mode of operation. With modification some models – read the fine print on each astrocamera you are considering – can be used in Camera Only mode by attaching regular camera lenses to them.

These astrocameras are purely digital in nature and are optimized to capture and process photons from your astronomical object of interest in an exposure. These photons are subsequently digitized, processed and output-ted to a storage medium so that they can be retrieved for subsequent processing using a wide variety of available freeware or commercial software.

Pure astrocameras for amateurs can range from what would be considered having basic capability up to professional grade used in scientific research. Cost can range from the hundreds to thousands of dollars. Their

size can be from that of an eyepiece up to a rather large size comparable to a shoebox. Pure astrocameras can be specialized as to their use – autoguiding, lunar/planetary, DSOs, scientific research – and can cover varying amounts of sky according to the size of their sensor. Some can do several things well, while others are for a specific use only.

These types of cameras have a language all their own that is separate to some degree from the ordinary photography done by everyday digital cameras. It is very important that you have some basic understanding about these types of pure astrocameras so that you can intelligently decide if you want to take the plunge and how to go about doing so. You can achieve very satisfying results in astrophotography using the cameras we have already described, especially in Camera Only mode. If you add Camera and Telescope mode to your astrophotography capabilities you can get by using the cameras we have discussed, especially a good DSLR or CSC. But, and this will probably happen to you if you get the astrophotography bug – you will want to have a pure astrocamera. This capability really comes into its own in Camera and Telescope mode and will take your astrophotography to a whole new level.

Complementary Metal-Oxide-Semiconductor (CMOS) Cameras and Charge Coupled Device (CCD) Cameras

Author's Note: In late November 2019 it was announced that a major manufacturer of CCDs would no longer make them. This sent ripples through the amateur astrophotography community. The author elected not to change this section so as to include a complete discussion of CMOS and CCD-based detectors. You should read the article about this development that has been included later in this chapter, called "CCD vs CMOS."

These two types of camera – CMOS and CCD – are relatively new arrivals on the basic beginner's astrophotography scene. Astrophotography CCD cameras for professionals and very serious amateurs have been around for years but were (and still are) expensive. CCD cameras have come down in price and offer many choices for the beginning astrophotographer. CMOS cameras are even more economical than CCD cameras and are quite capable.

To be frank, CMOS vs. CCD astrocameras is an ongoing discussion that doesn't have a final answer – at least one that this author could find.

Because this is a book for beginners it defeats its purpose to launch into a full-scale technical discussion of CMOS vs. CCD astrocameras. Essentially CMOS and CCD astrocameras do the same thing, use a semiconductor-based sensor to collect photons. But how they handle and process these incoming photons is different and leads to distinct pros and cons.

One of the best explanations given as to CMOS vs. CCD astrocameras came from a manufacturer of CMOS and CCD astrocameras, ATIK, and is listed in Chapter 23. You really should read this and the other chapter listings to gain a full appreciation and understanding of the two astrocamera types. The worst thing you can do is buy a pure astrocamera without having done the research as to the various types, capabilities, cost and where all of that fits into what *you* want to do astrophotography-wise.

One other major consideration that you have to remember in the digital world – DSLR, CSC and pure astrocamera – is what computer operating system (OS) you will be using. Software and digital cameras may have a preference for the OS they can use, perhaps even what update version. So be sure to determine your computer's OS – Windows, Mac, Linux – and its compatibility with the digital camera and software you will be considering to acquire. We'll discuss this further in Chapter 7.

It is safe to say that for beginners CMOS astrocameras offer great capability at a more economical price than CCD astrocameras. They can image the full range of astronomical objects as determined by the individual astrocamera's capabilities. Some individual astrocamera models are designed to provide maximum performance on auto guiding (more on this in a bit), lunar and planetary imaging or DSOs. Some models offer a "Swiss Army knife" capability and let you do a little bit of everything but at a cost in achieving maximum performance on a particular class of astronomical object.

Because this book is for beginners, CMOS astrocameras will be covered in depth. However, to be thorough in coverage, there will be information provided on CCD astrocameras as well.

There are several manufacturers of CMOS astrocameras out there, but because the author is Mac OS powered this was the major consideration in choosing a CMOS pure astrocamera for use in writing this book. This would complement astropics taken with the Nikon D810a. After researching, the author selected the ZWO line of CMOS astrocameras due to their Mac OS capability and extensive product line. In Chapter 23 there is an excellent ZWO product line guide that not only tells you about ZWO but CMOS astrocameras in general. This is a highly recommended read for prospective CMOS astrocamera buyers.

There are other CMOS manufacturer alternatives out there for Mac users that you can explore. Also helpful in this decision was an email discussion with Elias Erdnüß, one of Astroshop.de's technical experts, as to requirements, computer, telescope and so on, for selecting a CMOS astrocamera. Astroshop.de graciously offered to support the writing of this book by loaning astrophotography equipment the author did not have.

If you are serious about purchasing astrophotography equipment, do some homework as to the manufacturers and dealers out there. Read reviews on the Internet and explore their websites. Their biggest test as to earning your hard earned astrophotography equipment dollars is when you call customer service/technical support with your questions. Ask away and see how they respond. Do they seem to know what they are talking about? Are they helpful, friendly and accommodating? Ask about their refund/return/repair/warranty policies. If you really want to be thorough call another manufacturer and/or dealer with the same questions so you can have some basis for comparison.

The author put himself in the shoes of the beginning astrophotographer as to cost and capability in choosing a ZWO CMOS camera. Criteria as to cost was "hundreds of dollars" and capability was "get as much as I can out of this camera." Specifically, I was after a color camera – more on this color vs monochrome selection in a bit – that could take lunar and planetary images and maybe, just maybe, some of the brighter and spectacular DSOs and autoguide a telescope.

If you have Camera and Telescope mode there are a number of ways you can take astropics of various astronomical objects. If you are going to want to take longer exposures of DSOs through your telescope on the order of minutes to maybe even hours, you are going to have to make corrections to your telescope's tracking system, which we discuss in detail in Chapter 6. If your telescope's mount has "autoguide" capability, usually designated by having an ST-4 port, one of the options available to you for making these corrections is using an autoguider.

An autoguider is a small (large eyepiece-sized) astrocamera that you hook up to your telescope using one of several methods that provides a small field of view (FOV), which we will discuss shortly, that encompasses some of the area of the sky your telescope is pointed at. There are several ways to do this that we will discuss in this chapter. There will be stars in this field of view that you can choose from. Choose the brightest star near the center of the field of view (FOV) that you will designate as a "guide star" and lock onto it. Using a software program of your choosing the autoguider will then stay locked onto this guide star and send commands via a cable from the auto guider to your telescope's mount to make corrections as needed.

The final choice that fit the above criteria was ZWO's Model ASI 120 MC-S. As assessed in the *Agena Buyer's Guide to ZWO Astronomy Cameras* By Brian Ventrudo and Manish Panjwani, dated February 23, 2018, here are the relative ratings compared to other ZWO astrocameras – the more stars the better.

Table 2.1. ZWO 120 Ratings

All-Sky Lens Included	Best Applications	Planetary	Solar/Lunar	Deep-Sky	All-Sky
Yes	Planetary imaging	★★★★★	★★★★	★★★	★★★

First Look: The ZWO ASI 120

The ZWO ASI 120 is well made and appears to be built to last. The CMOS sensor is protected by a clear window, and there is a dust cap on the ST-4 port. The cabling for the ST-4 and the USB 3.0 are robust. The all-sky camera has a dust cap covering it, and there is an additional dust cap for use on the 1.25" eyepiece adapter that is included. A "Quick Start" sheet, inspection document and a very small screw to lock the focus of the all sky lens are also included.

The first thing the author did was look through the "Quick Start Guide" and then go to ZWO's website to download the user's manuals for the camera and for the associated software used by ZWO. If you are an experienced computer user this is a straightforward process, and you should have no problems. The online user manuals were read and then saved as documents for later reference in the field, where there may be no Internet access. They were printed out as well and added to the author's user manual library that goes wherever the telescope and camera goes.

Downloading the latest MAC OS "ASICAP" software from the ZWO website was easy and straightforward and should be for Windows and Linux users as well. Once the software was loaded and opened the ASI 120 was connected to the USB 3.0 cable and the Mac. The software recognized the camera, and an indoors image was seen in the preview screen that was "live" via the all-sky camera. The software's features and operating procedures were run through. ASICAP is user friendly and intuitive once you start to use it. Note, this does not process images; it only captures them. You will have to use a solar/lunar/planetary or DSO processing software program to transfer and process your saved exposures into final images. As you shall see single exposures were processed successfully using Mac Photo.

You also have to download the "ASI Cameras Software Manual" for your particular OS, as it is a valuable resource for astrophotography programs that are compatible with ZWO cameras according to the OS you are using. Chances are you will have a software processing program for DSOs and

solar/lunar/planetary that works with your OS. Currently there are no satisfactory "stacking" programs for use with Mac OS, and this is a nagging issue. You will learn about stacking and processing in this book.

Read the reviews on the ZWO ASI120 by astrophotography masters Damian Peach and Sean Walker in Chapter 23. You will also read about these two astrophotography masters in Chapter 22.

As you will see in Chapter 8, Rule #1 and Rule #2 state, "Read the Manual." You really have to do this in order to make setting up and using the camera easiest and most efficient. This is not a "Plug and Play" piece of equipment. You need to invest time to learn and use the camera. Do several daylight setup only runs with your telescope and associated equipment that you will be using with the ASI 120: eyepieces, Barlow lenses, off axis guider (OAG), DSLR, etc. Get to know your way around the setup process.

You can of course buy more sophisticated astrocameras with larger and cooled sensors for enhanced performance at a much higher price tag. That is up to you. One is always tempted to buy the "top of the line" and priciest gadget, thinking it will be the best. Maybe so. But as a beginner learning the ropes of astrophotography you might be better suited to starting with basic equipment (including telescopes) and working your way forward as you gain experience. If you buy good equipment you will be able to use it some way, somehow, as you progress in your astrophotography pursuit. Keep all of the things you have bought. All of it will come in handy at some point. Buy wisely, prudently and never get rid of anything as you work your way farther out photographing the cosmos.

CCD astrocameras historically have been the "cat's meow" for serious amateur astrophotographers and were the only way to go back in the early days of digital. This is still true to a large extent today, as top of the line astrocameras for scientific research and professional quality astropics are primarily CCD sensor-based. If you want to take the plunge into going "top of the line" right off the bat and CMOS doesn't fit your bill, see the Chapter 23 links for top CCD astrocamera manufacturers.

Just make sure you consider what we said before you pour thousands of dollars into a top of the line astrocamera and more thousands into a telescope and mount capable of producing an optical image worthy of the camera. You would be the rare individual who knew with absolute certainty, without any astrophotography experience, that such a considerable financial investment was well made.

Another question the beginning astrophotographer must consider when it comes to these types of CMOS/CCD astrocameras is whether to get a color or monochrome (black and white) model. Conventional wisdom holds that

for the beginner a color astrocamera is better because it is easier to obtain color images without much sacrifice in astrocamera performance. This holds for basic cameras that can do lunar/planetary, solar (using proper solar filters and safety precautions) and brighter DSOs.

The transition to, or the initial choice of a monochrome astrocamera comes about when an astrophotographer wants to get really serious about getting as much detail as possible in an image and can dictate color or specified wavelengths of light to be added to the image. Color in the image is obtained through the use of color filters contained in a filter wheel that is either manually or computer operated to rotate the filters in sequence to take a single exposure in each color. The separate color/wavelength filter exposures are then combined using astropic processing software to comprise the final color astropic. Imaging in this manner preserves the native sensor resolution inherent in each image that would otherwise be downgraded by the use of color layering in a color astrocamera to obtain a color image.

Specific wavelength filters such as hydrogen alpha and beta, Oxygen-III, ultraviolet (UV), infra-red (IR) and light pollution reduction, can also be used to take images that highlight the specific wavelengths of light the filters are designed for. The light pollution reduction filters can remove certain unwanted wavelengths of light from an image while the other filter types enhance the light of certain wavelengths common in DSOs.

This technique can be used for lunar/planetary, solar (using proper solar filters and safety procedures) and DSOs. Use of this type of camera and the techniques necessary to obtain astropics is considered to be in the realm of advanced astrophotography. Nothing prevents you from taking the plunge immediately into this facet of advanced astrophotography if you wish. But it will cost you more for the filters, filter wheel and software necessary to compile these images. You will also need a quality telescope and mount that is capable of producing an optical image that is befitting of such a concerted effort to wring out the best possible astropic from your astrocamera.

Besides the considerable monetary investment, this upper echelon of astrophotography will require more time, a lot of patience and practice, and an ideal observing location than what would otherwise be required with a capable color camera. Like everything, the choice is yours.

Matching Your Camera to Your Optics

We have discussed much so far in this chapter on the type of cameras available for you to choose from to start your astrophotography pursuits. There is one more factor you are going to have to consider in your camera choice

and that is the optics you will be using with your camera. Your optics if you are going to be operating in Camera Only mode will be your lens(es), while Camera and Telescope mode will incorporate the optics of your telescope with your camera.

Two primary factors that need to be considered and determined when it comes to matching camera and optics are the field of view (FOV) and the resolution that your camera and optics will provide.

Simply stated the FOV is what your camera and lens or camera and telescope can "see" when they are operating together. Each of your camera lenses will have its own FOV determined by its optical design and parameters. This information will be provided in the technical specifications for your lens. The same will be true for your telescope; it will have a FOV dependent on its inherent optical design and its various optical configurations that are determined by the use of eyepieces, Barlow lenses, focal reducers, extenders, etc. When you add a camera, digital or film, it, too, will have an inherent FOV that is determined by the camera's design and film or digital sensor coverage. When you combine camera and optics there will be a resulting and specified FOV. You will have to determine what this is so you know whether your intended astronomical object will "fit in the frame." How to do this is provided in the FOV links in Chapter 23.

Pixels –picture elements – are the heart of every digital camera's sensor. At the beginning of an exposure each pixel collects incoming photons until the shutter is closed. Electronics, and possibly software as well, in your camera then process the amount of photons captured by each pixel into an electrical signal to produce an image. Your camera's sensor will contain a specified number of pixels, usually in the millions (megapixels) that are physically arranged in an actual sensor size that is measured in millimeters (mm) for height and width and diagonally.

In everyday photography the amount of pixels present in a camera's sensor is its resolution. In astrophotography the determination of the camera's resolution goes further. The sensor's pixels will also have an actual size that determines how much light they can collect and determine the resolution of your camera for a particular type of astronomical object coupled with the optics you are using.

This is not as critical in Camera Only mode but it becomes very critical in Camera and Telescope mode. Lunar/planetary vs. DSOs and your telescope's specifications and imaging configurations, especially focal length, is where the rubber meets the road for pixel size, resolution and image scale, which is the angle subtended by each camera pixel with a given telescope system. There is more information provided in Chapter 23 that allows you to calculate image scale.

It is very important that you look at each digital camera manufacturer's specifications for the sensor it uses to determine pixel resolution (how many pixels), pixel size and sensor size. For pure astrocamera manufacturers they should have product descriptions that will help you determine which camera would be best for your astro-imaging needs, as you saw in the selection criteria for the ZWO Model ASI 120 MC-S. Don't be bashful to call/email and discuss your requirements and optical (telescope) setup with the manufacturer/dealer to make sure that you get what you truly need.

In this book there are two modes of astrophotography, Camera Only and Camera and Telescope. Applicable chapters will have Camera Only and Camera and Telescope narratives and charts recommending what camera types to use.

The Camera Only and Camera and Telescope section for this chapter is contained in Appendix A: Chapter 2 Modes and Camera Recommendations. Please read this Appendix next as it will provide you with mode/ camera recommendations and accompanying table definitions used in the book.

Chapter 3

Lenses

A camera needs a lens to take a picture, and in astrophotography it is no different. Astropics can be taken using a variety of lenses in Camera Only and Camera and Telescope mode, where the telescope becomes the lens for the camera. Camera and Telescope mode can also be used to mount a camera on the telescope or its mount to take astropics.

Lenses and telescopes, which we will discuss in the next two chapters, are where the rubber meets the road, or more properly, photons from the Universe meet your camera. These photons of light come from a wide variety of astronomical objects, large and small, dim and bright, point source to extended field, and your lenses collect light from them all.

Never skimp on lens quality, as this, more than just about anything else, will impact your resulting image quality. You pay for that quality, but with proper care a quality lens should last for life. Based on experience, lenses that are over fifty years old work just as well as when they were new. But treat them well!

Nikon (and maybe some other major camera brands) has a "Refurbished" section on its website that offers lenses and cameras for sale. It is usually a 10% discount off of full price and it comes with a warranty. The author has purchased some lenses this way and has never been disappointed in the quality and reliability of the lenses bought this way. Whatever brand you decide to buy (see below) make sure you see if there is a "Refurbished" option and sign up for notifications. These notifications, usually by email, inform you of sales events and releases of new cameras and lenses. You will

© Springer Nature Switzerland AG 2020
G. I. Redfern, *Astrophotography is Easy!*, The Patrick Moore Practical
Astronomy Series, https://doi.org/10.1007/978-3-030-45943-7_3

also want to register each of your purchases with the manufacturer for warranty purposes.

You can buy cameras and lenses direct from the manufacturer or through major discount stores. It is wise to also purchase a protection policy for your more expensive items because things can happen to your precious gear, as you will see.

Whenever you get a new lens, buy a clear filter, also known as a UV or NC filter (Nikon) for it at the same time. The specifications of the lens will tell you what size, in millimeters, of the filter you need to buy. When you receive the lens inspect it for any glass surface defect or lens coating issues. If there are none put the clear filter on the front lens and never take it off. Doing this protects your lens and keeps it clean. It is a lot easier to clean dust and smudges off a filter than it is a $2,000 lens! Also make sure that you *always* use a lens cap and an end cap to protect the front and rear optics group each and every time you use a lens or change it and stow it.

The user's manual of your lenses, and maybe your filters, will have recommendations on their care and cleaning. You need to follow them. This section is for general information purposes only, as manufacturer recommendations take precedence. Even if you have the front filter in place all the time (and you really should) and use the lens and end caps your filter will acquire smudges and dust as you use the lens. Hopefully your front lens and rear lens remain free of dust and smudges, but you need to check periodically.

You do not have to clean lenses often; in fact, that is the *worst* thing you can do because it is another chance to create scratches on the optical surfaces. It is only necessary to clean when you start to see degradation in your images. Even small dust spots on an image can be removed in processing, but big smudges and lots of dust do require cleaning.

In Chapter 7 we will discuss what you need in a lens and camera cleaning kit, and there are links in Chapter 23 on cleaning lenses and filters. The number one priority is to do no harm to your optics, which means going slow and cautious in cleaning per the manufacturer's instructions.

Always clean the front lens filter first, as you may remove the whole problem before proceeding to clean the actual glass surfaces of the lens. After cleaning the front filter or lens take an overexposed picture of a bright surface such as a wall or a blue sky to see if you have any dust or problem spots in the image. You can always tell if the problem is due to the filter by simply turning it while looking in live view or taking two consecutive exposures after turning the filter.

Whether it is filter or lens you are cleaning *always* get dust off with a bulb blower first, and if necessary using a lens cleaning brush, until you see nothing. Then decide if you need to proceed further using a quality lens

cleaning fluid and lens cleaning tissues or a microfiber lens cleaning cloth. A small amount of fluid goes on the tissue (one time use only!) to work the needed area and is followed up with using another tissue or cloth to finish until clean. Lens cleaning pens have had reported success removing stubborn spots, but you do not want grind away. Slow and gentle is the order of the day here.

Always carry a supply of ziplock-type sandwich bags in your camera backpack, as they come in handy for storing things such as lens caps and other small items. The camera body cap on Nikon's DSLR's fits the end cap of their lenses, so in the field you can put the two together and then in a sandwich bag, seal it and store it in the camera backpack. This makes it a lot easier to find them and protect them from dust, dew and getting lost. It pays to have some spare lens and body caps, too, just in case.

As most photographers do, when you buy glass (lenses) for a certain camera brand stick with that brand as you upgrade to a newer and better camera body. Why? The answer is simple – cost. Camera manufacturers use their own proprietary lens mounting system. And although it is possible to get camera mount adapters for all the major camera brands – known as T-adapters – it is not "pure" and adds one more level of complexity. Even though you may be able to mount camera lens brand 'X' to a different brand camera body "Y," this does not necessarily mean having full capability of the lens, including auto focus, different program modes, etc. If you mix and match brands you have to read the fine print to make sure of full compatibility between the lens and camera.

You have to do this compatibility check between lens and camera even if you are using the same brand for both. The reason is that there is a chance that the lens and camera may not be compatible with one another. This can happen if you are using older or newer lenses or camera bodies. Remember those 50 year old lenses? They may not be compatible with modern camera bodies. As another example Nikon's new CSC Z-series requires a lens adaptor for using previous Nikon lenses. So once again you need to really read the fine print on this issue that should be on the brand's website in a lens compatibility chart and technical specifications for the lens.

Basic Lens Terminology

All lenses should have their brand name, a serial number and two very important numbers somewhere on their lens body. One number will be the focal length of the lens in millimeters and the other will be the f-number of the lens. In depth explanation of these and other basic lens terms is included in Chapter 23, and you are strongly encouraged to read the lens information at the links.

Fig. 3.1. Nikon 50-mm lens with lens specification information (Image by the author.)

Basically, the *larger* the focal length of a lens, the *smaller* the area it photographs – the angle of view – and the *larger* the objects – magnification – will appear in your astropics. Conversely, the *smaller* the focal length of a lens, the *larger* the area it photographs and the *smaller* the objects will appear in your astropics.

Your lens will have a maximum aperture that will indicate the image brightness that the lens creates on your camera's sensor (or film). Lenses that have wider maximum apertures (read larger lens diameter) will have lower minimum f-numbers and create a brighter image because they collect more light. Lenses with smaller maximum apertures (read smaller lens diameter) will have higher minimum f-numbers and not collect as much light. Lenses with f numbers f/1.4, f/2.8 and f/4 (usually prime lenses) are best (and most expensive) for astrophotography, as you shall see when we discuss night time and DSO shots, because they collect more light than lenses with f-numbers of f/3.5 and f/5.6 (usually zoom telephoto lenses).

Comment: Both of these lenses have a lens body diameter of 77 mm
and the same front lens size. The 300-mm f/4 front lens only looks
larger because the 300-mm zoom's camera body is far shorter thereby
causing the misleading perspective. The difference between an f/4 prime
(see next section) 300-mm focal length telephoto lens and an f/3.5 to f/5.6
zoom telephoto lens (28-300-mm focal length) is apparent in the two lens
optical designs. The prime has fewer optical elements and can collect more
light as a result.

Fig. 3.2. Nikon 300-mm f/4 lens – on the left – compared to Nikon 28-300-mm
f/3.5-f/5.6 lens – on the right. (Image by the author)

Looking at some lenses you will also notice a series of numbers on a movable
dial that go from smaller to larger. These are known as f/stops and are used to
control the amount of light coming into the camera. The lowest f/stop is the wid-
est aperture of the lens, while the largest f/stop is the smallest lens aperture.

Fig. 3.3. Nikon 300-mm lens with f/stops (Image by the author)

Some lenses do not have a moveable f/stop ring, as the lens-camera system does this internally and automatically (depending on your camera's capabilities and operating mode) with the lens' diaphragm. This lens-camera operability is dependent on their compatibility – which is why you must always check lens and camera specifications.

For Camera Only night time astrophotography not involving the Moon you will likely be operating your lens at the widest aperture – lowest f/stop – while during the day the Sun will likely require the smallest aperture – highest f/stop.

Basic Lens Types

When considering the purchase of a lens you must insure that it is compatible with your camera so that the camera-lens system will operate to its fullest. There is also the consideration of whether your camera's sensor is full frame or cropped, which will impact the performance of your system. Camera and lens manufacturers should have lens and camera compatibility charts on their websites as well as technical specifications for the lens you are interested in. Check these carefully before you buy.

A link to a Nikon primer on lenses has been included in Chapter 23 so you can have a trusted source to learn what is best from an astrophotography – primarily Camera Only mode – perspective. As stated previously Nikon has an astrophotography-dedicated DSLR, the D810a. Accordingly, they have good information on their Nikon website about astrophotography. A cursory check on other major camera brands revealed no such online coverage.

Lenses can be "prime," having only one focal length, e.g., 35 mm, or can be "zoom" lenses, where there is a specified focal length range for the lens, e.g., 28-300 mm. Zoom lenses usually provide a focal length that starts as a wide angle lens and zooms to a more powerful telephoto lens focal length.

Nikon considers any lens that is smaller than 35 mm in focal length used in a full frame size camera (Nikon FX) a wide-angle lens. These are superb for use in all-sky and night landscape astropics because they cover a lot of area.

Also superb in all-sky and night landscape astropics are ultra-wide lenses. These are lenses with an angle of view greater than 90 degrees and a focal length range of generally 13 mm to 24 mm for a full frame size camera. These lenses can allow for exposures on a non-tracking tripod up to 35 seconds with a 14-mm before any noticeable star trailing occurs in the astrophotograph. Compare that to the 14 seconds with a 35 mm. We'll dis-

cuss exposure times later in this chapter. Combine these exposure times with a fast focal ratio of f/2.8 to f/1.4, and you can pull in a lot of sky, such as the Milky Way, the aurora and other wide-area astronomical objects.

Generally speaking lenses that are in the 10 mm or smaller focal length are known as fisheye lenses and give even larger area views but with significant distortion. Digital processing software can help with this distortion. You might want to use this for very large sky area coverage.

Standard lenses are generally 35-50 mm in focal length and approximate what "the eye sees." The 58-mm focal length lenses are popular in this category as well. They are workhorses for capturing the night sky and all that it contains – planets, stars, constellations, satellites, DSOs, the Milky Way, etc.

Telephoto lenses generally have focal lengths 70 mm and up that provide magnified images of astronomical objects. This is very useful and necessary, as you shall see when you want to photograph the Sun/solar eclipses, Moon/lunar eclipses, several of the planets and DSOs.

Another type of lens is the tele-converter, which is usually used with telephoto lenses to increase their focal lengths/magnification by a specified amount. Tele-converters will have a value such as 1.3x, 1.7x, 2.0x, which is used to calculate the increased focal length of a lens. For example, a 500-mm focal length telephoto lens that is attached to a 1.7x tele-converter will have an increased focal length of 350 mm for a total effective focal length of 850 mm. Once again, confirmation of compatibility between the lenses is crucial to their successful use.

Fig. 3.4. Nikon tele-converter photo (Image by the author.)

"All Sky" Lenses

There are also specialty "all-sky lenses," some of which can cover 180 degrees of sky! These are used for weather and meteor/fireball monitoring and are usually self-contained units in a transparent weatherproof housing. The ZWO ASI-120 CMOS camera comes with a 150 degree all-sky lens that can be mounted on a tripod to take all-sky pics.

Smartphone and Tablet Lenses

A recommended and relatively inexpensive addition for your smartphone or tablet (Android and Apple) if you are going this route are add-on lenses that attach to your device. There are different types of lenses to choose from – fisheye, wide angle, telephoto, and 3-in-1 combining lens types. These are inexpensive and should add increased capability to your device for photographing the sky in Camera Only mode.

Although the author has never taken any astropics with these supplemental lenses, this true optical lens capability should be far superior to trying just digital methods to zoom or stretch your astropics. Before ordering you have to make sure the lens is compatible with your mobile device, especially the size of the camera lens in order to attach it to your device.

If using a smartphone is your only means of astrophotography this may be a good investment. Having this additional capability could improve your regular photographs as well.

DSLRs

Pocket cameras can't interchange lenses. Some film cameras can, but we will focus on lenses for DSLRs as your guide to Camera Only mode, although the information provided should pertain to CSCs and "pure astro-cameras that can accommodate lenses. Even if your DSLR has a fixed lens, in all probability it will have a "zoom" capability that goes from "wide angle" to "telephoto," which we explain shortly. This gives you some flexibility in what you can take astropics of.

Having an interchangeable lens DSLR camera really opens up your options for photographing the sky. You can start out with one lens only – a recommendation for what to buy will follow later in this chapter – and add on various types of lenses as time goes on. Although we will use Nikon

lenses and DSLRs, the guidance provided is applicable to any other major camera brand.

Another huge advantage to removable lenses on a DSLR is that you can remove the lens from your DSLR, and with the proper accessories, attach the camera body to your telescope for Camera and Telescope mode. Basic imaging techniques are provided in Chapter 5 and will be discussed in later chapters, as the type of astronomical object you want to photograph dictates your needed set up.

Lens Lineup

To give you an idea of what can be done in Camera Only using fixed and tracking mounts and Camera and Telescope, placing the camera and lens on the telescope tube and/or telescope mount with different lenses, the author has used his own lenses. You will see in the book how these lenses performed in the two modes on different astronomical objects. It will be useful to learn a bit more about these lenses to help you in your choices and to understand how they performed in the astropics you will see throughout the book.

Here are some lens descriptions and astropics based on the author's use of Nikon lenses with the Nikon D810a camera that works well for Camera Only astrophotography. This will give you an idea of what to expect from each type of lens and what the sky looks like in astropics taken with them.

14 mm f/2.8 Ultra-Wide Angle Lens

This lens captures a large segment of the sky, making it ideal for photographing the Milky Way and night sky scenes, including just the sky or night landscapes. This lens can collect a lot of light, take 30- to 35 -second exposures on a non-tracking tripod and provide decent detail in the resulting images.

Included among the photographs in this book, usually of the Milky Way, are those taken with a 14-mm f/2.8 ultra-wide-angle lens. They show the power of the ultra-wide-angle lens to get good Milky Way and all sky shots. Having a camera lens like this in your collection of lenses really opens up your astrophotography options and here's why.

An ultra-wide or wide-angle lens provides superior light-gathering capability with a fast focal ratio usually f/2.8, wide sky/area coverage and excel-

lent – read long – exposure times. All of this combines to help you get great astropics if using a non-tracking or tracking tripod or mount. It is highly recommended that if at all possible – cost can be a factor for these types of lenses – you make an ultra-wide or wide-angle lens part of your camera bag.

If you can afford a 14-mm f2.8 prime lens, note that it is highly recommended to have a 150-mm square lens glass filter and separate filter support system due to the very large curvature of the lens. The filter support system protects the front lens but also acts as a lens hood that cuts out stray side light far better than the original petal lens hood (Nikon design). Without this you could see bothersome lens flares in your pictures. Sure, you could try to eliminate them post processing, but why not get rid of them in the first place?

The whole filter setup was $350 for the Nikon 14-mm wide angle but is worth it for being able to get the most out of this expensive and highly capable lens while protecting it. The filter of choice was a light pollution glass filter that reduces yellow light, usually the most common form of light pollution. Light pollution from distant areas on the surrounding horizon – even in "dark sites" – can sometimes creep into your pictures, so this does help to reduce it.

35-mm f/1.4 Standard Lens

This is a gem of a lens because with its large light-collecting ability and longer focal length it can add true depth and breadth to a section of the sky or Milky Way, a constellation, the various sky glows and planetary line-ups.

50-mm f/1.4 Standard Lens

With its extra focal length this lens does everything the 35-mm can do but just brings it in a little closer with some loss of area coverage. This is an excellent lens for shooting the star and dust clouds of the Milky Way, planets and stars, and sky glows that will fit in the sky coverage.

28 to 300-mm f/3.5-f/5.6 Zoom Telephoto

This is truly an all-in-one lens. You can get a wide angle shot or "zoom" in closer to frame your shot. It can be used for shooting planetary lineups with stars or the Moon from a wide angle to a "zoomed in" perspective. Shooting the Moon, Sun and eclipses with a 300-mm and then cropping the images can produce very nice astropics.

300-mm f/4 Prime Telephoto

This beautiful lens pulls in photons from millions of light years away and produces stunning astropics. It isn't too heavy and is a nice combination of focal length/magnification and sky coverage. In Camera and Telescope mode you can use an accessory to place it on the telescope mount for tracking and getting long exposures.

200- to 500-mm f/3.5-f/5.6 Zoom Telephoto

This is a piece of glass! It is also sometimes used in combination with a 1.7x tele-converter to get the focal length to 850 mm, which makes it useful for Sun, Moon, eclipses (solar eclipses with proper solar filter and safety procedures) and some DSO astropics. It is used in Camera Only mode on a fixed tripod and mounted on a telescope mount in Camera and Telescope mode.

The following images by the author show you the size of the Moon in various telephoto focal lengths. The Sun would be the same as the Moon's image size, as they are both the same approximate size in the sky.

Fig. 3.5. Image size 200-mm lens

Fig. 3.6. Image size 300-mm lens

Fig. 3.7. Image size 400-mm lens

Fig. 3.8. Image size 500-mm lens

Fig. 3.9. Image size 850-mm lens

If push came to shove as to lens selection with money as a prime consideration and no chance of buying several lenses in the future, you should make a wide-angle/telephoto zoom lens a top purchasing priority for all of the reasons mentioned. The wide-angle/telephoto zoom lens instead of a prime lens gives you more bang for your camera lens buck. Just make sure you buy quality glass.

Lens Focusing Basics

To take any photograph, including an astropic, you will have to make sure that the lens is properly focused in order to deliver a clear, sharp photograph. Modern cameras of all types and their compatible lenses have an autofocus capability, although there are some cameras that are manual focus only. This is where the camera-lens system works to provide a clear and sharp focus to produce a photograph. This can be accomplished in a variety of lighting conditions, but night time autofocusing is probably not going to work. You *may* be able to autofocus on the Moon, bright stars and planets in Camera Only mode, but this will be largely dependent on what camera-lens system you are using. You would just have to try and see if this works using SAAS.

It is imperative that you are thoroughly familiar with both your camera and lens(es) and how they work separately and together. You can only do this by reading the user's manual for both camera and lens and then practice using them. You will be operating them as a system in Camera Only mode and when attached to the telescope in Camera and Telescope mode.

We'll discuss focusing throughout the book, but to be successful and efficient in doing so, you need to know how your camera and lens(es) operate together and separately.

Lenses, especially interchangeable ones compatible with your camera, should have some type of switch that allows you to pick a mode of focusing. This can be 'A' for automatic focusing, 'A/M' for automatic and manual focusing and/or 'M' for manual focusing. Your camera should have a corresponding switch or mode that needs to be activated for 'autofocus' or 'manual' focusing so that the camera-lens system is synchronized.

In autofocus mode your camera should give some kind of indication when it has focused so you can take the photograph. Autofocus can be used only when a lens is attached, so you are limited to primarily Camera Only mode. There are limited instances when autofocus may be used in Camera and Telescope mode, primarily by your smartphone, tablet, pocket or film camera when taking pictures using the afocal method, which we will discuss in Chapter 5.

Smartphones and tablets that have the astrophotography apps we previously discussed in Chapter 1 have the ability to manually focus. This will come in handy when operating in both modes.

Some film cameras and DSLRs have external lenses, and to use manual mode you probably have to physically move its focus ring to get sharp focus. For astrophotography and its astronomical objects, manual focus for the lens will be at 'infinity' – no pun here. Every lens has an infinity symbol, but it may not truly mark infinity focus, so you have to visually verify infinity focus when you get a new lens.

Checking your lens infinity focus setting is easiest to do during the daytime using autofocus. Just find a distant object and look in the camera's viewfinder to focus according to your camera's instructions. See how it looks; it should be clear and sharp. Now look at where the infinity mark is located. Is it perfectly split at the index line or is it a little bit to the left or right? If it is off you may want to place a small mark to indicate true infinity.

Fig. 3.10. Focus ring, infinity mark and index line (Image by the author.)

In Camera Only mode at night it is best to always verify infinity focus for each shot you take. Astronomical objects are more discriminating as to focus than daytime objects by their very nature. You can do this in several ways. The simplest way is to get a distant bright object, such as the Moon, bright planet or star, or even a terrestrial light source such as a flashing red cell phone tower light, and look in the camera's viewfinder to manually focus. Some cameras may have magnifiers for the viewfinder that you can buy to assist in focusing.

Another popular way is to use the 'Live View' and 'Zoom In View' features to look at the zoomed in live image while focusing. This *really* helps you get good focus. In Live View you see your bright object and zoom in on it for a larger image. You turn the focus ring slowly until the image is at its clearest and sharpest focus possible.

In Camera and Telescope mode you may have to do this procedure several times if the image is moving around or blurry in the eyepiece. Rarely is a telescopic image perfectly still and razor sharp. The more eyepiece magnification used the greater effect on the Live View image. This is due to a variety of factors that affect your telescope's ability to form a sharp image. We will discuss these factors in Chapter 4.

There are more sophisticated means of focusing that involve screens and other devices, but proper use of Live View should be sufficient to get you started taking astropics. If you happen to buy the ZWO ASiair unit that is described in detail in Chapter 7, it has a feature that makes focusing, at least for DSOs, a cinch. You will learn that this unit works with ZWO ASI pure astrocameras as well as Nikon and Canon cameras. It is a unit worth having.

Fig. 3.11. Lens and camera focus switches (Image by the author)

Lens Focal Length vs Exposure Time on Fixed Tripod

One last topic pertaining to lenses. When operating in Camera Only mode on a fixed tripod the focal length of the lens will affect how long of an exposure you can take before your image gets "star trails." On tracking and telescope mounts you will be able to take much longer exposures – minutes to hours instead of seconds. We'll discuss this further in Chapter 6, but let's look at a very useful rule to help you get the proper exposure time.

Using the "500 Rule" you can easily calculate an estimated exposure time for the lens you are using during Camera Only mode with a non-tracking tripod. Use of this rule should produce astropics that do not show trailing of the stars and Milky Way. This rule should work on all cameras used in Camera Only mode if you know the focal length of the camera lens you are using.

Here is the rule of 500:

$$SS = 500 / (FL * CF) \text{ where} :$$

SS is your shutter speed in seconds,

FL is the focal length of the lens expressed in millimeters (mm),

CF is your camera's sensor crop factor, i.e., the ratio between the size of a full frame sensor and yours.

The FL and CF values should be contained in the technical specifications for your lens(es) and camera. Your lens(es) will also have their focal length imprinted on them as well. Once you have these numbers it is simply a matter of doing the simple math to get your exposure time. More on the 500 Rule, including an in depth explanation and a more precise calculator, is listed in Chapter 23.

The author's suggested lens use follows, but of course, you should experiment if you so desire! Camera Only mode would also be applied to mounting the camera and lens on a telescope or its mounting.

Table 3.1. Lens Use in Camera Only Mode

Lens Type	All-Sky	Planetary/Lunar	Solar	DSOs/MW	Eclipses
Smartphone	Yes	Yes	No	MW	Yes *
Tablet	Yes	Yes	No	MW	Yes *
Fisheye	Yes	No	No	MW	Yes *
Ultra & Wide Field	Yes	No	No	Yes	Yes *
Normal	Yes	Yes	No	Yes	Yes
Telephoto	No	Yes	Yes	Yes	Yes
All Sky	Yes	No	No	MW	Yes *

*Solar Eclipses –Totality Only. See Chapters 12 and 14

Table 3.2. Lens Use in Camera and Telescope Mode

Lens Type	All-Sky	Planetary/Lunar	Solar	DSOs/MW	Eclipses
Smartphone	Mount Only	Afocal*	Afocal*	Afocal*	Afocal*
Tablet	No	No	No	No	No
Fisheye	Mount Only	Mount Only	Mount Only	Mount Only	Mount Only
Wide Field	Mount Only	Mount Only	Mount Only	Mount Only	Mount Only
Normal	Mount Only	Mount Only	Mount Only	Mount Only	Mount Only
Telephoto	Mount Only	Mount Only	Mount Only	Mount Only	Mount Only
All Sky	No	No	No	No	No

*See Chapter 5

Bottom Line on Lenses for Camera Only and Camera and Telescope

- Buy quality lenses.
- Check and double check lens-camera compatibility.
- Get a clear filter to protect your lenses.
- If you could have only one lens to start with it should be a wide-angle to zoom telephoto lens, as you would get the best flexibility for your astropics having a decent wide angle and zoom to telephoto capability.
- Camera brands and lens manufacturers offer pretty much the same line up and capability in lenses, so it is your choice as to what brand you purchase. Just make sure on the compatibility issue!

Chapter 4

Telescopes

When you take a picture of any astronomical object you are going back in time. Even a pic of the Moon captures it as it was about 1.3 seconds before you took the exposure. This is because the speed of light – roughly 186,000 miles or 300,000 km per second – has a finite and not infinite speed. The farther out you go with your camera the farther back in time you are photographing.

In Camera Only mode on a fixed tripod with a normal lens you can reach out beyond the Solar System and Milky Way Galaxy to about 2 to 3 million light years – a light year being how far light travels in a year, which is about 6 *trillion* miles! This puts you in the realm of nearby galaxies. Your astropics of galaxies will be small, but there in a 35-mm to 50-mm lens. If you have a tracking mount that can carry a telephoto lens you will be able to get larger and much better astropics of these nearby galaxies.

But it is only with a telescope that you can venture farther out into space and time, and see with your own eyes and camera the splendor of the universe.

Choosing a Telescope

If you are reading this book you may already have a telescope and are looking to venture into astrophotography with it. Great! You have come to the right place for the basics in doing so. But if you don't own a telescope, and

© Springer Nature Switzerland AG 2020
G. I. Redfern, *Astrophotography is Easy!*, The Patrick Moore Practical
Astronomy Series, https://doi.org/10.1007/978-3-030-45943-7_4

are a true beginner in astrophotography looking for basics, we strongly recommend starting with Camera Only mode. The reason for this is quite simple – to see if you like taking astropics. Learn the sky, acquire some basic astrophoto experience and equipment, take a test drive of the universe with camera and lens. This simplest but very effective mode may satisfy your astrophotography bug. Try it for a while and see. But if you are like most who have the astrophotography bug you will probably want to use a telescope to take astropics *and* see the universe with your own eyes.

Buying Your First Telescope

Please read and heed the following: If you haven't done so already don't buy a telescope until you have read this book, its references, and considered all that we will discuss in this chapter and the next. The biggest mistake you can make in buying a telescope is buying one that you will end up hardly ever using because it is either too big, too complicated, too hard to set up and take down, never have the time to use it, or the view isn't what you expected. These are all common factors in many a 'scope purchases gone bad. Let's work together to avoid all of them and get you to "First Light" – the moment when your telescope sees its first photons from the universe. It is a moment you will never forget.

 Where to start? Why, with the basics of course! And the most basic question of all when it comes to telescopes is, which one is for me? But before we explore that question please take some time to consider the following questions as they will go far in helping you to choose the right telescope. There are also some excellent references in Chapter 23 to help you.

Decision Factors to Consider

1. What is your level of experience? Are you a true novice to astronomy, astrophotography and telescopes? Hopefully as suggested you spent some time in Camera Only mode getting some experience and equipment. If not, then you really need to take the time and have the patience to learn the ropes in Camera and Telescope mode. It is a steep but not insurmountable or unpleasant learning curve. You literally get to see your progress in your astropics. You don't have to be a professional astronomer to use a telescope, but you have to choose one that fits your initial level of experience and also allows for you to grow in capability. There are telescopes that are beginner friendly and powerful instruments, as you shall see.

If you have access to a nearby telescope dealer or a local astronomy club you are in luck because you can probably arrange for a "test drive" of different telescopes. A worthwhile telescope dealer should be more than happy to show you around and answer your questions. If there isn't one nearby use the advice provided in Chapter 2 regarding the selection of a dealer and check them out on the telephone. Telescope dealers carry a large selection of telescope brands and types, so once you have narrowed in on what you are interested in purchasing it pays to shop around.

A local astronomy club should welcome you with open arms and help you get started in selecting a telescope by inviting you to one of their "star parties" if they have them. This is where members gather at an observing site and bring their telescopes and other astro-goodies, including in all likelihood astrophotography gear. You can attend and get to look through various telescope types and "talk shop." This is invaluable for prospective telescope buyers.

2. *Cost*. Sure, we would all love to have the historic Hale 200-inch telescope at Palomar Observatory, but how much you can afford is a big consideration for most of us. There are people who have spent tens of thousands of dollars (and more!) on a telescope, its mount, equipment, cameras, and an observatory to house it. It is amazing to see some of the setups "amateur" astronomers have acquired and put into operation.

However, for the majority of people beginning in this pursuit a realistic budget is probably the most important factor in choosing a telescope. The good news is that a quality telescope and mounting that can last a lifetime can be purchased for several thousand dollars. If you are already operating in Camera Only mode you probably have the basics necessary to become operational in Camera and Telescope mode with the addition of some equipment.

It is recommended that you establish a realistic budget to determine what you can truly afford and work with those numbers to see what is available. Remember, the beauty of the astrophotography bug is that you can always add equipment and capability as you go along gaining more experience. Once you have established a basic camera-telescope setup that allows you to take astropics that may be all you need. It is pretty much an axiom that "quality costs but can last a lifetime" when it comes to buying a telescope. Remember that your quality telescope purchase requires a good mount, which we discuss in Chapter 6.

OK. You have a budget and you are moving ahead. What else do you need to consider?

3. *Where Will The Telescope Be Located?* Where will you house your telescope? Will you build a permanent structure for your telescope so all you have to do is open it up and you are ready to go? Or will you have to keep it in a closet, room, basement, garage, etc.? And don't forget to consider whether your selected purchase will *fit* in your selected storage area!

If not in a permanent setup your telescope, mounting and equipment will require lugging all of it in and out to use it. This can be quite the process that requires physical exertion and multiple trips to and fro, especially if you have a "large" telescope and lots of equipment. Fortunately most telescopes break down to component structures, but even those single components can easily weigh 30+ pounds if you are talking about a robust equatorial mount plus counterweights and tripod. Can you lift, carry, and contort a piece of gear that weighs "X-number of pounds"? Be realistic with yourself – you do not want a back injury.

Also, it can easily take over a half-hour to 45 minutes and some real sweat to load the car from the basement to go mobile. This is another factor to consider if you want to transport your telescope to a dark sky site. And will your telescope and equipment safely fit in your vehicle?

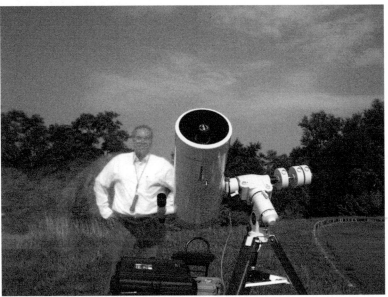

Camera & Mode: E5700 w/ 8.9mm lens on a tripod
ISO: 400
Exposure: 8 seconds
Processing: Mac Photos
Comment: This ghost selfie – the author was briefly in the shot – was taken during the full Moon just before a total lunar eclipse viewed and photographed at Shenandoah National Park in 2007. All equipment was transported by vehicle and set up on a roadside turnout.

Fig. 4.1. "Ghost selfie" with telescope (Image by the author.)

4. *How Often Do You really Think You Will Use Your Setup?* Be honest with yourself. How often do you really think you will use your telescope? Are you still working or retired? Single, married, "in a relationship," new parent, saving for a house? Move around a lot? Crummy weather – read lots of clouds lots of days and nights. Health?

Do an honest assessment of how much time you have to devote to the use of a telescope. If you seriously think you will use it a lot, fine. Even if there are long periods where it is idle for whatever reason, it is there for when you want to use it.

5. *What do you want to do with your telescope?* Finally, the $64,000 question. Think hard and long about this, because it will factor in to what aperture (size of a telescope's mirror or lens) and type of telescope you will want to consider and weigh against the previous considerations.

Do you want to use your 'scope visually and photographically? A pretty common requirement.

Do you want to specialize in one type of astronomical object? Is lunar and planetary your primary interest? Solar? Deep sky objects? Do you want to see and photograph a little of everything?

Aperture and telescope type weigh in to all of the above: cost, logistics of storage and setup/takedown, amount of use and what you want to do with your telescope.

Work on providing yourself true and realistic answers to questions 1 through 4; we can help you find an answer for number 5.

Until you can provide yourself the realistic answers to all of these questions you are not ready to buy a telescope. But with truth and time you will get there. If you can't make up your mind or decide to pass on telescope ownership, there is an option you may find of interest.

Rental Telescopes

Here is a serious option for you to consider if you do not want to buy a telescope but still would like to pursue astrophotography with a telescope – rental telescopes. This is a relatively new industry that appeared a few years ago and has become popular with astrophotographers.

There are companies that for a fee offer remote use via the Internet of top of the line refractor and reflector telescopes coupled to state of the art CCD/CMOS cameras (monochrome and color), located in pristine and desirable viewing locations in the Northern and Southern Hemispheres. After you join and become familiar with the pricing structure for use of the telescopes, you have to see where the telescopes are located, their specifications and learn how to operate them using your Internet connected computer. These telescope and camera systems range from set ups for beginners to serious research grade instruments. The fee you pay is tied to the telescope used and the length of your session.

There is a learning curve on how to make a reservation for telescope time, telescope and camera operation and how to go about selecting your astronomical object to photograph.

When you join one of these companies for all intents and purposes you are operating a telescope like a professional astronomer. You select the astronomical object of interest that you want to photograph, apply for time on a specific telescope that will meet your location and photographic requirements, and set up the camera run. For advanced users you can even write a script for your session. You can learn how to do this by reading *Using Sequence Generator Pro and Friends: Imaging with SGP, PHD2, and Related Software*, by Alex McConahay. See Chapter 23 for more information.

This option is also something to consider for people who may not be able to use a telescope of their own due to age or disability considerations. At some point all astrophotographers who have to set up and take down will be unable to accomplish hefting of telescope and camera. Getting time on a remote top of the line telescope and camera may be the ultimate solution.

Even if you get your own telescope, joining one of these companies and getting time on their telescopes is a highly rewarding experience.

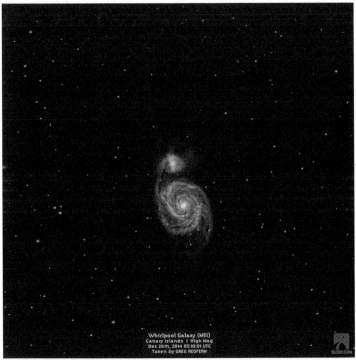

Location: Canary Islands
Camera & Mode: Slooh Rental Camera and Telescope with astronomical CCD
Exposure: 5 minutes
Processing: Done by CCD automatically
Comment: This is a rental telescope remote image.

Fig. 4.2. M51, the Whirlpool Galaxy (Image taken by author)

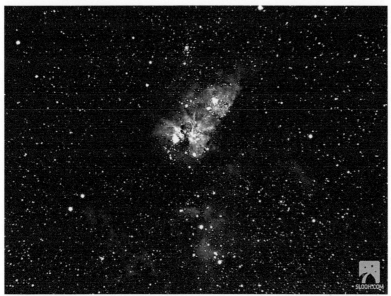

Location: Canary Islands
Camera & Mode: Slooh Rental Camera and Telescope with astronomical CCD
Exposure: 5 minutes
Processing: Done by CCD automatically
Comment: This is a rental telescope remote image.

Fig. 4.3. Eta Carinae (Image taken by author)

Basic Telescope Terminology

To make your telescope buying choice you need to learn some basic telescope terminology before we discuss the three main types of telescopes. This section is not by any means all-inclusive, but it will give you what you need to know when starting to consider telescopes.

If you buy a telescope it will come with a user's manual and contain vital information on safety, use and probably the specifications for all of the terms we will be discussing next. You will see this said again and again in this book. Always read the manual!

Aperture

The heart of the telescope you decide to buy, regardless of type, will be either an objective lens or a mirror. Their sole purpose is to collect light and bring it to a precise focus so that the resulting image can be viewed visually, photographed, or in some rare instance be directed to a scientific instrument (rare for beginners).

The amount of light that can be collected is determined solely by the aperture – diameter – of the lens or mirror. Put in its simplest terms, the bigger the aperture of your telescope, the more light that can be collected. A larger aperture means a brighter view, a more powerful optical system and of course, requires a bigger telescope tube and mounting. Aperture plays a major part in determining the optical characteristics and thereby capabilities of your telescope.

Focal Length

Remember our discussion of focal length last chapter and how it affected the image the lens produced? The same applies to telescopes in that the longer the focal length – the actual distance from the lens or mirror to the focal point - the larger the image and the smaller the field of view.

Focal Ratio

We also discussed this last chapter. For telescopes, focal ratio – f/X – is the ratio of focal length (in mm) of the telescope to its aperture (in mm). To determine focal ratio you simply divide the focal length (mm) of a telescope by its aperture (mm). For example, a telescope with a focal length of 2,000 mm and an aperture of 200 mm would be f/10.

The focal ratio of a telescope gives you an idea of its capabilities as to field of view and what type of astronomical objects are generally best viewed and photographed with it. Regardless of a telescope's focal ratio you can see and to some extent photograph all astronomical objects.

Telescopes that have a small or "fast" focal ratio – generally f/3.5 to f/6 – provide brighter photographic images and require shorter exposure times than telescopes with longer focal ratios. Visually these telescopes will provide a wider field of view than longer focal ratio telescopes. As a general rule these fast focal ratio telescopes are used for viewing and photographing deep sky objects. The reason becomes obvious for astrophotography when you consider that an f/8 telescope would require four times the exposure time of an f/4 telescope.

Medium focal ratio telescopes are in the range of f/7 to f/11. They provide a good compromise between fast and slow focal ratio telescopes. They can be used to effectively photograph all astronomical objects.

Slow focal ratio telescopes are in the range of f/12 and longer. These telescopes are optimized for use on the Sun, the Moon and planets. They provide excellent magnification (power) visually and photographically.

In Chapter 7 you will learn about focal reducers that can optically reduce the focal ratio of a telescope and focal extenders that can optically increase a telescope's focal ratio.

Magnification (Power)

Telescopes, regardless of design, provide an image that is either viewed visually with the use of eyepieces or photographed with a camera in a variety of ways we will discuss in the next chapter. People new to telescopes may concentrate on determining "the power" (or magnification) of a telescope and consider that to be the most important characteristic of the telescope – "higher power is better and required." Truth is that the magnification or power of a telescope is not the most important factor for you to consider in buying a telescope. Here's why.

Any telescope will be limited to a theoretical maximum magnification that is solely determined by its aperture. As a general rule any telescope regardless of type will have a maximum limit of about 50 to 60 power per inch of aperture. A 4-inch telescope would be 240x maximum (the "x" denotes magnification or power), while an 8-inch telescope would be 480x maximum. This is the theoretical magnification limit and it is *very* different from the realistic magnification limit that will be determined by real world factors we will be discussing later.

Eyepieces provide magnification based upon the focal length (in mm) of the eyepiece being used and focal length (in mm) of the telescope. To calculate the power of an eyepiece is simple: divide the focal length (in mm) of the telescope by the focal length of the eyepiece (in mm). For example, a telescope with a focal length of 2,000 mm using a 20-mm focal length eyepiece will give you a magnification or power of 100; a 10-mm focal length eyepiece will be 200x.

Optical Performance of Telescope and Eyepieces

When we discuss the three types of telescopes next, you will see that each one has distinct factors that affect their optical performance – the formation of that image we see visually and photograph and the degradation of their

performance in creating that image. Some of these factors you can control, some you cannot.

When you use an eyepiece it becomes part of the telescope's overall optical performance. Think of eyepieces for your telescope just like lenses for your camera – they are responsible for forming the image that you see visually and in some cases photographically. The mantra "buy quality" is just as true for eyepieces as it is for lenses. You can have the most optically perfect telescope in the world but ruin the view/photographs using crummy/inferior eyepieces.

We'll discuss eyepieces further in Chapters 5 and 7. We'll also introduce you in these chapters to accessories that optically increase or decrease the focal length and focal ratio of your telescope and eyepieces.

Atmospheric Conditions

The light from the Universe that your telescope forms into an image had to travel through the many layers (and miles) of Earth's atmosphere. Each of these layers affected that light due to its own temperature, density, water vapor content, wind speed, clarity, etc., all of which determines the steadiness and transparency of the atmosphere.

We're not talking about just clouds here. We're talking about the quality of seeing, based on how the atmosphere is at any given moment. Next to a telescope's inherent optical specifications and quality, these two factors, steadiness (seeing) and transparency, will affect your telescopic view and photographs more than anything else.

However, steadiness is not really a factor in Camera Only mode because the focal lengths of lenses aren't as susceptible to its effects as telescopes are. On the other hand transparency can be a factor in Camera Only mode, as it can limit the number of stars visible or the appearance of the Milky Way.

Have you seen the stars "twinkle" at night and on other nights they appear to be solid points of light? Their appearance is determined by the steadiness of the atmospheric layers and seeing cells in your location.

Our atmosphere is an ocean of air that is affected by its many layers as is your observing location. Consider, too, that if you are observing with your telescope straight up, the zenith, there is less air that light waves have to travel through then if your telescope is pointing somewhere towards the horizon.

Seeing cells can be of all sizes, and the aperture of your telescope can determine how the quality of your seeing is affected. As a general rule larger

apertures are affected more than smaller apertures simply due to the difference in size. Odds are better for a smaller aperture being able to find steady air than a larger one.

Seeing is measured by many astrophotographers and telescope users on a scale from 1 to 10, with 1 being the worst and where the image in your telescope's eyepiece is dancing around and 10 being a rare night of rock solid images in the eyepiece. There are several seeing scales in use, but the Pickering Seeing Scale is what many like to use. Here is the scale: 1-2 is very poor; 3-4 is poor; 5 is fair; 6-7 is good; 7-8 is very good; and 8-10 is excellent. This scale depends a lot on your location and the weather during your telescope session. You will find most nights you are lucky to get to 5-7 and very grateful for anything beyond that and deeply frustrated when seeing is worse.

Transparency is how clear the atmosphere is. Transparency is affected by dust, smoke, haze, water vapor (humidity), volcanic eruptions (true!) and light pollution. Many observers use the Astronomical League's transparency scale. It is based on the constellation Ursa Minor – the Little Dipper – to gauge how good the sky is. This scale of 1 to 7 is dependent on how many stars you can see in the constellation, with 1 being the worst (you can't see Polaris) and 7 being the best (where you can see dim stars near the Little Dipper). *Sky & Telescope* has a reference card you can carry with you that has the stars of the Little Dipper and their magnitudes listed so as to gauge the sky.

If you are in the Southern Hemisphere (below the equator) you will not be able to see Ursa Minor. Consider using the large and visible constellation Centaurus as a gauge to transparency. There are a number of stars that represent brighter magnitudes as well as dimmer ones in Mu, Phi, Chi and Psi Centaurus.

To an extent your own visual acuity will also affect how well you can see the stars in the sky and in your telescope. Old eyes simply do not see as well as young eyes do.

If you wear eyeglasses keep them on when looking at the sky. When transitioning to visual observations with a telescope try taking your eyeglasses off and see if you can get a clear image focusing the telescope. If not, then put your eyeglasses back on to focus and take in the visual view. Be careful not to "bump" your eyeglasses into the eyepiece. You will want to wear your eyeglasses when you are taking astropics so you can see the camera clearly and focus.

An eyeglasses neck strap that readily attaches to eyeglasses makes it easy to remove them and know where they are to put back on. You do not want to take your eyeglasses off in the dark and set them down "someplace" –

that has disaster written all over it. To offset "Murphy's law" – if it can happen it will – carry a second pair of eyeglasses with a current prescription as part of your astronomy and travel gear.

To finish on this topic here's a perfect analogy to visualize seeing, transparency and how they affect what we see and photograph in our telescopes. Think of a lake. When there is no wind or active bugs on the surface, the lake's surface can be so "smooth" as to form a perfect image of sky and shore, a perfect 10 for "seeing." But the slightest wind or bug can distort this view and become worse with ever bigger ripples, degrading from 10 all the way down to 0. As to transparency of the water, can you see fish or turtles swimming below the surface, sunlight streaming downward in the water, or even the lake bottom clearly? Or is it so murky you can't see anything below the surface?

So what can you do to judge the quality of the atmosphere?

- When outside at night always give the sky a judging glance. Twinkling stars means bad seeing and probably good transparency.
- The day's weather will have had an influence on the sky. If it was hot and humid and the night sky still is, seeing will probably be good and transparency bad.
- If it was raining or windy and the sky breaks clear at night it will probably be bad seeing and good transparency.
- In an urban setting that has lots of haze (smog maybe) you will probably enjoy really good seeing and lousy transparency.
- Setting up on concrete or asphalt is a no-no, as the heat from the day will affect your local seeing for quite some time. Set up on grass if at all possible.

For help in determining the forecasted seeing, transparency and other factors that can impact an observing session, an indispensable aid is Clear Sky Chart (CSC). This is a free website that provides a forecast for your location and is a recognized resource.

More on seeing and transparency is listed in Chapter 23. Be sure to read the links.

Resolution

Resolution – or resolving power – of a telescope is its ability to see detail in astronomical objects. Once again aperture is the important factor, as larger means better resolution.

Resolving power, also known as the Dawes Limit, is a telescope's ability to resolve double stars (two stars that are positioned very close to one another either by gravity or chance placement in the sky) into two separate and distinct images. This is determined by aperture as well, with larger apertures able to resolve ever smaller separations. Resolving power is very dependent on the seeing, and a telescope is rarely able to meet its theoretical limit due to seeing conditions.

Limiting magnitude is the dimmest star a telescope can theoretically allow you to see. As you have learned this is affected by seeing, transparency and visual acuity.

Limiting photographic magnitude is the dimmest star a telescope can theoretically photograph. The general rule is that this is two magnitudes fainter than the visual value. Of course this, too, is affected by seeing, transparency, camera setup and visual acuity.

Collimation

Collimation is the last, but certainly not least, term we will consider before getting into telescope types. Simply stated collimation is how well the optics and their supporting mechanical components that comprise your telescope's optical system are "tuned" so as to perform at its very best. Proper collimation will provide a good image – again dependent on seeing conditions – while poor collimation will not. As you shall see telescope types have different collimation techniques and issues.

Telescope Types

There are three main types of telescopes. Refractor, reflector and compound (also known as catadioptric). There are quite a few telescope brands out there, with many "models" to choose from. If you have a bought a car before it is a very similar process to buying a telescope: researching, test driving (if possible), selecting, finding a dealership and finally purchasing.

Like all cars have their basic purpose to take you from point a to point b, all telescopes have a basic purpose – collect light and let you see and photograph the resulting image. Car brands can have their loyal fans, and different models can improve the ride and have more bells and whistles – at a corresponding increase in price. So it goes with telescopes.

The Internet (with the links in this book) will help you find reviews on telescope types, brands, models, pictures taken with telescopes, dealers and prices. It is so much easier telescope shopping now than in the past. As to "test driving" we covered that earlier, and if you have the opportunity to do so you will be so glad you did.

Let's get to it.

In the 410 years since Galileo first used his crude astronomical refractor telescope to make fundamental observations of the heavens that changed astronomy forever, the refractor telescope has come a long way. Fifty-plus years ago the beautiful (and expensive) Unitron 4-inch refractor with its gleaming white telescope tube and sturdy gloss black mount was all the rage.

Present-day refractors are incredibly capable telescopes that can deliver razor sharp images of any manner of astronomical object visually and photographically. They are more expensive per inch of aperture than the other two types of telescopes but are rugged and easily adapted to any manner of Camera Only or Camera and Telescope astrophotography. The refractor's focuser is at the end of the telescope tube and in high-quality refractors is quite robust and capable of handling a wide variety of visual and photographic setups.

Refractors today are mostly apochromatic in design as compared to achromatic. Apochromatic refractors have multiple lenses that combine to cancel out annoying color variations that the less expensive two-lens design achromatic doublet refractors may suffer from. Refractors have no obstructions in the light path that mirror and catadioptric telescopes do, which makes them "pure" to refractor aficionados. The other two telescope types have central obstructions that can introduce to some extent light loss and some contrast degradation but is usually minimal depending on optical design.

Refractors can come in a variety of apertures, focal lengths and focal ratios. They are renowned for delivering visual views that can be stunning against a jet-black sky background. Refractors used to be *the* way to visually observe the Sun (with proper filters), Moon and planets because they tended to have longer focal lengths and f/ratios, which also meant longer telescope tubes. Today's refractors can be found in a wide array of focal lengths and f/ratios suited to the desires of the buyer.

The world's largest refractor is the 40-inch at Yerkes Observatory in Williams Bay, Wisconsin. It was built through the efforts of Dr. George Ellery Hale (1868-1938) and became operational in 1897. It is now closed to the public and no longer a fully functioning observatory. The University of Chicago is currently considering the observatory's future, and there were

efforts underway in November 2019 to reopen this storied facility to the public.

The 40-inch was the last of the great refractors and Sir Issac Newton's reflecting telescope design that uses mirrors and bears his name – the Newtonian reflector – became the basic design for the next great observatory, Mount Wilson Observatory, in the San Gabriel Mountains just outside Los Angeles. Also built by Dr. Hale, Mount Wilson Observatory had 60-inch and 100-inch reflecting telescopes – the world's largest – when it went into operation to great fanfare in 1917. Mount Wilson's Hooker 100-inch telescope (named for the donor who contributed funds to build it) was responsible for astronomical observations from 1900 to 1930 that literally changed our understanding of the Universe as we knew it.

The beauty of the Newtonian reflector design (and reflectors in general) was and still is two-fold. The primary mirror could be very large and completely supported by a mirror mount, and light rays only had to reflect off of the mirror's front optical surface to be intercepted by a 45-degree diagonal secondary mirror. As a result of this design the focuser is located high up and on one side of the telescope tube, allowing for visual and photographic capabilities.

Contrast that to refractors whose lenses could only be supported on their circumference and the light rays had to go completely through multiple lenses. This fact of refractor life meant there could be no refractor larger than Yerkes, as anything larger would sag and ruin the light path.

These differences still exist today in the refracting and reflecting telescope types and help explain why refractors are more expensive than the other two telescope types. Refractor glass objectives have to be optically perfect, while only the optical front surface of the reflector has to be. However, you can still find some 8-inch refractors and 20(plus)-inch reflectors being used by amateurs.

Newtonian reflectors were the mainstay of do it yourself (DIY) telescope makers for centuries. The design is still popular today and is capable of delivering excellent images visually and photographically. Twelve-inch Newtonians were considered the top of the line for reflectors back in the day of the Unitron refractors. Today Newtonians can be found far larger in the form of the Dobsonian telescope, named for its inventor, the late John Dobson (1915-2014). These telescopes can show up at star parties in the realm of 24-inches and larger! They have fast focal ratios to cut down the size of the supporting structures for the primary and secondary mirrors. Oh, and to also keep the size of the ladder you have to climb to get to the eyepiece to a less than scary height. Dobsonian telescopes and their large

primary mirror brethren are primarily used to pull in DSOs and faint aster-
oids and comets. You can actually buy 40-inch reflecting telescopes!

There are several other reflecting telescope designs, but we will only
discuss two of them, the Cassegrain and Cassegrain Dall-Kirkham (CDK).
A Cassegrain reflecting telescope has a primary mirror at the bottom of the
telescope tube that reflects the collected light to a secondary mirror mounted
near the top of the telescope tube that then reflects the light back to the
primary mirror, which has a hole in its center allowing the light beam to
pass through. At the rear of the telescope is the focuser – like a refractor –
that can be a variety of designs to accommodate visual and photographic
setups.

The CDK design is a variation of the Cassegrain and both are generally
used for long focal lengths and high focal ratios for the Moon and planets.
These are more expensive than the Newtonians.

The beauty of these two reflector designs is that they can have longer
focal lengths and focal ratios but due to the optical design their telescope
tube lengths are essentially halved from what a refractor or Newtonian of
same optical specification would require.

Compound or catadioptric telescopes use a combination of mirrors and
lenses in their optical design. The design uses a specific type of a lens at the
top of the telescope tube to direct the light beam to a primary mirror at the
bottom of the telescope tube. The primary mirror reflects the light beam to
a secondary mirror that is positioned in the objective lens, which reflects the
light beam through a hole in the primary mirror to the focuser attached to
the rear of the telescope – usually part of the mirror cell housing.

Maksutov telescopes use a thick correcting lens with a highly reflective
"circular spot" as the secondary mirror, which is located on the interior side
of the curved surface of the correcting lens. The light beam is reflected back
through a hole in the primary mirror to the focuser on the back of the tele-
scope. Maksutovs can be purchased, but they tend to be expensive, espe-
cially when compared to the following telescope design.

Schmidt-Cassegrain telescopes (known as SCTs) use a thin correcting
lens that houses the secondary mirror and its holder to send the light through
a hole in the primary mirror to the focuser on the back of the telescope. This
is a very popular design, as you shall see.

SCTs were revolutionary to the amateur astronomy community when
they were first mass produced in the early 1970s by Celestron. An 8-inch,
f/10 SCT (and larger apertures), complete with a decent mount, could be
bought for a very reasonable price. What's more, the SCT as purchased
offered a compact telescope tube, tripod, a decent mount with a built-in
clock drive (more on this in our chapter on mountings). Another huge plus
was that it could be broken down in manageable sections for easy storage

and transport. SCTs were also very customizable with a wide variety of accessories for visual and photographic use. SCTs are still very popular.

Now that we have discussed basic telescope types – there are more designs out there, some specifically for astrophotography, but these are considered to be advanced – let's take a look at some of the common issues telescopes share.

For any telescope, regardless of design, its optical system has to be in as perfect an alignment as possible in order to perform at its best. Collimation is the process by which this is achieved. Telescopes are collimated at the factory before they are sent out, and this usually involves an artificial star (laser) test. But telescopes can get out of alignment when they are shipped from the factory. Even though some dealers may test them to re-collimate them, they will probably be shipped as opposed to being picked up by the buyer – you. So you will at some point have to test the collimation of your telescope.

Although not immune to getting out of collimation, refractors and Maksutov compound reflectors have fairly rigid support systems. Quality refractor and Maksutov makers place their lenses and mirrors in solid cells and may have collimation capability.

Reflectors and compound telescopes are more susceptible to needing collimation, as moving them, using them in the field and especially during shipping, the secondary and primary mirrors for Newtonians, SCTs, CDKs and Cassegrains can get out of collimation.

We talked about how seeing can affect a telescope's performance. Well, collimation is the other big elephant in the room regarding a quality-built telescope's performance. Although you can hope for the best when you receive your telescope, you have to be ready to analyze your 'scope's image during first light.

Your telescope's user's manual should have a section on the view your telescope provides when collimated as opposed to being out of alignment. It should also have a section on how to properly collimate your telescope. *Read the manual* and follow the directions to the letter. You don't want to make things worse or, heaven forbid, have an "accident" by loosening screws too much and having "something" fall out of its mount.

Hint – you have to have good seeing conditions to determine whether your 'scope is properly collimated! If you try to do this on a bad seeing night you will probably not be able to tell what is due to dancing stars and what is due to optical quality. Use a bright star as far overhead as possible, so you are looking through less of that pesky atmosphere. Do this viewing over several nights. Before you make any adjustments make sure you understand what you need to do. It wouldn't be a bad idea to call your dealer and check with them before proceeding.

Fig. 4.4. This is what the view of a collimated CDK telescope looks like in an eye-piece. (Image taken by author.) Comment: The three visible vanes support the secondary mirror which is centered in the image. The other "circles" are dust on the mirrors which do not affect the overall image quality of the telescope.

Cleaning Your Telescope and Its Optics

You can have a perfectly collimated optical system, but if it is dirty and also in the case of mirrors, in need of renewing its reflective surface, your telescope will not perform as well as it should.

Whether your telescope has an open or closed tube you *always* should protect your telescope tube and/or mirror(s) with their supplied coverings. With refractors, Maksutovs, SCTs, and closed tube reflectors, you can seal up both ends of the telescope. With open tube reflectors you cover up the

mirrors. Cassegrain and CDKs with a solid telescope tube have a cover that goes over the top end of the telescope. Telescopes in the field and even at home should be covered up to protect them. You should also have sturdy carrying cases – see Chapter 7 – for your telescope, its components and accessories.

Telescopes and their optics will get dirty over time, and mirrors can lose their reflectivity over decades. Once again your user's manual will tell you how to care and maintain your telescope and its optics.

Think of eyepieces as lenses for your telescope. They are very similar to camera lenses in their care and cleaning. The manufacturer's website should have instructions on care and use of your eyepieces. These should be very similar to the cleaning of camera lenses that we previously discussed. Always use the container or covers that came with your eyepiece to protect them.

Tube Currents

The lenses of a refractor, the thick front lens of a Maksutov and the primary mirrors of reflecting and compound telescopes have to reach temperature equalization with the outside air to perform at their best. How long this takes is dependent on the air temperatures involved. Obviously the difference in the air temperature from where you have had the telescope located/ stored to that of your observing location will determine how long it will take to equalize. The greater the temperature spread the longer it will take. Some reflecting telescopes have fans built into the mirror cell to pull air out to get to equalization faster and will monitor the temperature difference while the telescope is in use.

If your telescope tube is closed – refractors, Maksutovs, SCTs – you also have to allow time for the tube's interior to reach the temperature of your observing location. If you do not do this when you are preparing for a viewing/photography session, you will likely introduce tube currents that can be seen as wiggly apparitions in your eyepiece when viewing astronomical objects.

Finder Telescope

Your telescope should come with a finder telescope (also known as a finder 'scope), a small telescope that is usually attached to a bracket or small tube rings to hold it in place. It may come with an illuminated red reticle that will

have some form of crosshairs so that you can center an object in them. Your telescope's user's manual will have instructions on how to align the finder so that when an object is centered in the finder's crosshairs it will be visible in an eyepiece. Precise alignment of the finder to your telescope will make your visual and photographic sessions much more enjoyable and efficient.

Be sure to turn the illumination off when the finder is not being used to conserve your batteries, and use the supplied lens caps to cover your finder. Follow the care and cleaning instructions in your user's manual for the finder. Also have the proper size spare batteries available.

Focusing

All telescopes will have a focuser to bring the image produced by the optics into as sharp and clear a focus as the seeing and quality of the optics will allow. When it comes time to focus you should check the collimation and also determine that there are no tube currents present. As you learned these are factors that affect image quality and must be mitigated, or image quality will suffer.

You will either be focusing with an eyepiece – seeing conditions will determine what magnification you can use – or a camera attached to the focuser. Quality telescopes, regardless of type, come with robust focusers and methods of attaching eyepieces and cameras. Your focuser can be electric, where you push buttons on a control box to focus, or mechanical, which means turning a focusing knob to obtain focus.

Your trusty user's manual will have instructions on how to attach visual and photographic items to the focuser and should have a system chart. The system chart is usually a schematic diagram that shows how a variety of visual and photographic set ups can be accomplished with your telescope. For some setups there may be specific parts that need to be purchased.

Just like when you had to check lens-camera compatibility to make sure everything would work, so it goes with your telescope and what kind of setup, which we discuss next, you want to use and make sure it will work. If you have questions this is where your telescope maker's website can come in handy as well as your tried and true telescope dealer. Research and question before you buy – especially the Warranty and Return Policy – to insure the setup you want to use will work and that you have the right components for it to do so.

Table 4.1. Telescope Types and Their Uses All Are Suitable for Visual and Astrophotography

Telescope Type	All Sky	Planetary/ Lunar	Solar	DSOs/ MW	Eclipses
Refractors	Yes	Yes	Yes	Yes	Yes
Newtonian	Yes	Yes	Yes	Yes	Yes
Dobsonian	Yes	Yes	Yes	Yes	Yes
SCT	Yes	Yes	Yes	Yes	Yes
Dall-Kirkham, Cassegrain	Yes	Yes	Yes	Yes	Yes
Maksutov	Yes	Yes	Yes	Yes	Yes

Smart Telescopes

Now that you have a basic understanding of telescopes and cameras here is something for you to consider in your purchasing decisions of both – especially if you are looking for a fully automatic telescope-astrophotography option. We now have "smart telescopes" coming available – compact telescopes that literally are fully automatic, technology enabled and designed for personal use in a city or on the road.

First up is the Vaonis Stellina Smart Telescope. This amazing system from Astroshop.eu was announced in November 2019. A French company has developed and is currently marketing an 80-mm f/5 refractor that is on a fully automatic alt-az GOTO tripod mount that works exclusively with Android and iPhone smartphones and tablets to automatically take astrophotographs.

The Vaonis Stellina Smart Telescope is controlled by an app on your phone or tablet via WiFi that uses your phone's GPS to know where it is, does automatic star alignment and has an internal battery that lasts five hours to power the telescope and CMOS sensor. The software shows what objects are available to photograph and tracks the motion of the sky to continuously update the astrophotography targets available. Each object is already calibrated for focus and exposure, so you really only have to select and shoot for your astropic.

The telescope takes astropics of deep sky objects, the Moon and planets and is not capable of visual observing; you can't use eyepieces. It takes its astropics using a CMOS sensor to produce 6.4MP images in JPEG and RAW. The internal processor "stacks" accumulated images – we discuss this technique later in the book – and you can see the image on your device's display and share via social media.

The Vaonis Stellina Smart Telescope also comes with a light pollution filter and dew heater, is water resistant and 21st century in design. The price is $3,999. If you are looking for full auto astrophotography for home and the road you may want to look into this.

Next is the Hiuni Smart Telescope, which is a Kickstarter project that features a 152.44-mm aperture, 1,544-mm focal length Cassegrain telescope mounted on a fully automatic alt-az GOTO mount. This smart telescope has an app that works via WiFi with Android and iPhone smartphones and tablets. It, too, does not use eyepieces but has a sensor to capture, view and share images that are displayed on your device. As of late November 2019 the Hiuni Kickstarter page is still active.

See "Smart Telescopes" in Chapter 23 for this chapter for more information.

Bottom Line on Telescopes

- Before you decide to buy a telescope, give serious consideration to the decision factors provided in this chapter. You want to buy a telescope that you will use and not allow to collect dust because it is too big, too heavy or too complicated.
- If at all possible test drive the type of telescope you are interested in.
- Buy quality that will last a lifetime.
- Consider rental telescopes as a first step to taking astropics using telescopes.
- Smart telescopes may be just the ticket if you are looking for fully automated and highly mobile astrophotography capability

Chapter 5

Imaging Methods with Your Telescope

To help you finalize the selection of your camera and telescope it would be helpful to know what imaging methods can be used in Camera and Telescope mode.

Before you are ready to start taking astropics with your telescope you will have had to accomplish the requirements for checking the weather, choosing your location, setting up and aligning your telescope's mount, attaching the telescope, and knowing what is up in the sky.

Each of these imaging methods requires some way to mate camera and telescope together so that an astropic can be taken. Chapter 7 in particular will help you in obtaining the necessary accessories for mounting your camera type to your telescope.

Not knowing what type and brand of telescope or camera you will purchase or already have presents a bit of a challenge as to discussing astrophotography methods with a telescope. But this book is about basics, and that is what we are going to concentrate on – basic setups for taking astropics with a telescope.

Afocal Method

We are going to start out with the simplest way to take astropics – the afocal method. This method was used extensively a half-century ago when amateur astrophotography was really just beginning and telescope/camera/

© Springer Nature Switzerland AG 2020
G. I. Redfern, *Astrophotography is Easy!*, The Patrick Moore Practical Astronomy Series, https://doi.org/10.1007/978-3-030-45943-7_5

photography options were limited. Nowadays the afocal method is also called digiscoping.

Then, as now, you set up your telescope as though you were using it visually, i.e., with an eyepiece in the focuser and center the astronomical object you want to photograph. Start with your lowest power eyepiece. You can try higher powers if the seeing and the afocal set up you have allow it. Focus the eyepiece to get the best image.

Using a universal camera mount that is suitable for your telescope and camera (check for compatibility!), you then position any camera that has a lens directly next to the eyepiece. It is highly recommended that you only use a smartphone or pocket camera for the afocal method, as these are lighter and far more suitable than other camera types. DSLRs and other cameras will be heavier, bulkier and more suited for other methods, as you shall see.

You adjust the position of the camera to get the best and brightest view of the image in the eyepiece. When you are satisfied you have done so, take an exposure and SAAS.

The Moon, Sun and bright planets are best for taking astropics using the afocal method, although you may be able to photograph bright stars and DSOs – it will depend on your setup. If you have a smartphone you are in luck because there are a number of smartphone holders designed for astrophotography.

This book will describe multiple techniques on how to take astropics. Some of the techniques can be used with any camera, while others will require special equipment or adapters to be used. Regardless of technique or equipment being used, it is highly recommended (mandatory, really) that you get familiar with and test each of these techniques and equipment scenarios indoors first. Doing so will give you plenty of light to see what you are doing and allow you to practice in order to become proficient before going "dark" – taking astropics.

The most basic and easiest way to take an astropic using the afocal method is using a smartphone. You could try holding the smartphone up to the eyepiece to take an astropic but chances are the result will be less than satisfactory. You need a way to hold the smartphone precisely positioned at the eyepiece and rock steady. Fortunately there is an accessory that does this very, very well.

The NexYZ smartphone holder made by Celestron comes fully assembled and with an instruction sheet that is useful and accurate as to how to use it, so make sure you read it. However, it is highly recommended that you become familiar with it first off of the telescope.

For the NexYZ, make sure that your telescope mount is locked in both axes before putting the NexYZ on it. If you don't it will be near impossible to attach the NexYZ. And focus your telescope first before attaching the NexYZ. Make sure that if your eyepiece has a rubber attachment at the top that you do not fasten the NexYZ on it. Doing so will not provide a fully solid surface for the device, and it may damage the rubber attachment.

The NexYZ is robust and well thought out. It operates like a pair of vice grips in that you use a clamp to fasten the device onto an eyepiece and lock it down by use of the copper colored lock down knob. Make sure that it is tight.

Inserting your smartphone is straightforward. Just make sure your camera lens is pointing in the right direction towards your eyepiece. Turn your smartphone on and get into camera mode to make sure it is working. If you have installed the photo boosting apps described previously you will not need them for daytime and possibly at night shots.

Use the X-Y-Z axis knobs to get your smartphone aligned. You will have a rough alignment when the light cone from your eyepiece is visible and centered in your smartphone camera's view.

Fig. 5.1. Close-up view of NexYZ attached to eyepiece with 6s smartphone attached. Diagonal is attached to the setup. (Image by the author.)

When you place the NexYZ with an eyepiece and smartphone attached onto your telescope it will in all likelihood require rebalancing the mount's counterweights. Making sure your mount's axes are locked, carefully attach the NexYZ to the eyepiece you are using and lock the unit in place. With a good grip on your telescope, perhaps the focuser if it is robust in construction, unlock the R.A. and dec axes one at a time to assess the mount's balance. Get the proper mount counterweight balance and then proceed to taking your first pic.

With the mount balanced pick a distant object outside using your finder 'scope. When you have one, lock the axes and then look at your smartphone. Is the object visible in your camera? If not, check to see if the smartphone is properly aligned with your eyepiece. Once you have the live image, monitor it while you double check the focus of your eyepiece.

Fig. 5.2. Close-up view of smartphone live view image using NexYZ attached to eyepiece. Focus, check. Image centered, check. Exposure next, check. Once you have achieved focus take your image and assess the results using SAAS. (Image by the author.)

Fig. 5.3. First smartphone image taken with NexYZ attached to eyepiece. Not bad for a first image. (Image by the author.)

Using the photo editing software on your smartphone can greatly improve the results.

Fig. 5.4. Edited first smartphone image taken with NexYZ attached to eyepiece. Processing really helps all images become better. With the daytime practice completed it was time to take the first astropic using this setup. (Image by the author.)

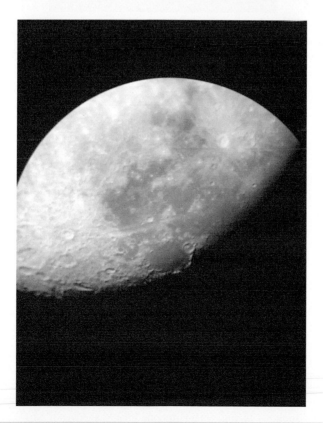

Fig. 5.5. First Moon 6s smartphone image taken with NexYZ attached to eyepiece. This wide-angle view shows the maria and craters Tycho (L) and Copernicus (R). (Image by the author.)

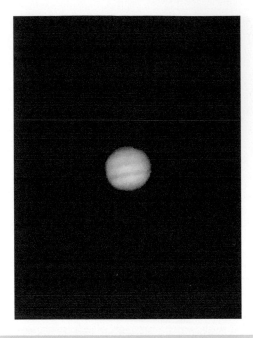

Fig. 5.6. First Jupiter 6s smartphone image taken with NexYZ attached to eyepiece. The equatorial belts are visible. (Image by the author.)

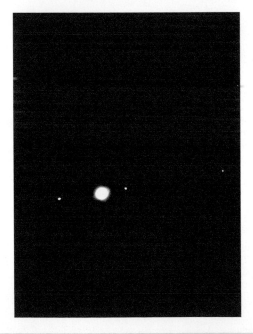

Fig. 5.7. First Jupiter's moons 6s smartphone image taken with NexYZ attached to eyepiece. Three moons are visible. Using *Sky Safari Pro* they were identified as, L-R: Io, Europa and Ganymede. There are also freeware apps on Sky & telescope.com and Astronomy.com that can help you identify the main Jovian moons. (Image by the author.)

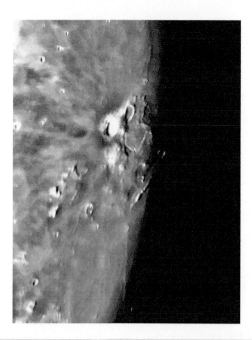

Fig. 5.8. First Aristarchus and Plateau 6s smartphone image taken with NexYZ attached to eyepicce. Quite a bit of detail visible in this most interesting crater and its immediate surroundings. (Image by the author.)

Prime Focus

This method is another basic imaging technique that simply attaches your camera to the prime focus of your telescope. It will provide the largest and brightest field of view of any telescope imaging method as the light from the telescope's optics pass directly to your camera – unless you use a reducer, which we will discuss shortly.

The location of prime focus is dependent on the type of telescope you have. For a Newtonian it will be at the focuser on the telescope tube located near the top and on the side. For refractors, compound and catadioptric mirror systems the telescopes' prime focus is at the rear of the telescope at the focuser. Quality telescopes will have a robust focuser assembly that can handle eyepieces, accessories and cameras while providing adequate focuser travel, i.e., how far the focuser can move to achieve focus.

There is no insertion of an eyepiece into the focuser when using prime focus. Your camera is attached directly to the telescope focuser or focal point using an accessory that you must research before buying to make sure your camera type and telescope brand are compatible. DSLRs, SLRs and pure astrocameras should have accessories available for use with the

different major telescope brands. This is where your telescope's system chart and online research must be put to good use.

Some telescope makers will have an optical reducer that is inserted into the prime focus light path to reduce the focal ratio a set amount to provide a larger and brighter field of view. This is of use when you want the fullest possible coverage your telescope's optics can provide. This is useful in photographing the complete disks of the Moon/lunar eclipses, Sun/solar eclipses (using proper solar filters), star fields and DSOs.

When you progress in your astrophotography expertise there may come a time when you want to employ the use of an auto guider, which we discuss in detail in the next chapter. It will be used with the prime focus technique when you are taking astropics of DSOs. Your camera will be at Prime Focus and your Auto Guider will be attached to either an off axis guider (OAG) or guide 'scope. It will keep your telescope centered on a guide star using software that communicates with your motorized telescope mount (next chapter), which allows for longer and higher quality exposures.

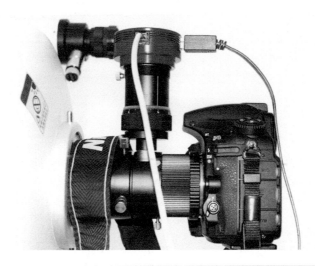

Fig. 5.9. Prime focus set up with DSLR Omegon Off Axis Guider (OAG) and ZWO 120 camera functioning as an auto guider. (Image by the author.)

Barlow/Extender

This method is another basic imaging technique that simply inserts a Barlow lens or extender into your telescope's focuser. Your camera is attached to the Barlow/extender using an accessory that you must research

before buying to make sure your camera type and Barlow/extender/ telescope are compatible. DSLRs, SLRs and pure astrocameras should have accessories available for use with the different major Barlow/extender/ telescope brands. Once again your telescope's system chart and online research must be put to good use to insure compatibility.

These optical lenses will provide a magnification factor to your telescope's focal ratio. This increased magnification is essential to bringing out more detail and larger image size. This in turn is useful when photographing features on the Moon, Sun and planets.

Using the Barlow/extender technique will create high magnification and a small field of view, which will lead to the issue of finding and centering your object of interest. Yes, your finder 'scope will help you, but unless it is very precisely centered and has enough magnification, it will not be sufficient to center your target in the camera. This is where it really helps to employ an accessory that allows you to see what the Barlow/extender/eyepiece projection (next section) sees by flipping a mirror. You then flip the mirror up to allow the camera to intercept the image. Your telescope set up may include a smaller telescope attached to your main telescope. If so, you may be able to use it to precisely center your camera.

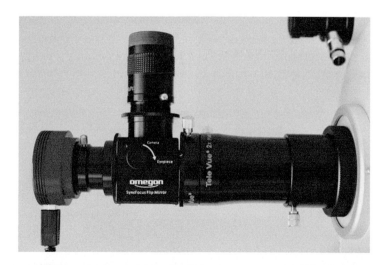

Fig. 5.10. A 2-inch 2x Barlow mated to an Omegon SyncFocus Flip Mirror and a ZWO-120 camera. (Image by the author.)

Fig. 5.11. Smartphone and extender mated to a smartphone and NexYZ. (Image by the author.)

Eyepiece Projection

This final basic imaging technique is similar to the afocal method except it involves a different camera mating system. While the afocal technique projects the image from the eyepiece to a camera held in some manner near the eyepiece, eyepiece projection uses a solid accessory body to hold the eyepiece and camera together while attached to the telescope focuser or focal point. This rigid setup allows no outside light and in some designs the eyepiece can be moved to increase the projection distance and magnification. This also increases the image scale, which in turn makes the image received by the camera dimmer. The rigidity of the eyepiece projection system designs allow for longer exposures when used in conjunction with a telescope's motorized mount.

Because of the higher magnification and small field of view you need to use a flip mirror or guide scope to precisely center your camera on your object of interest. This would be the same set up you used for the Barlow/extender method.

Using this technique the features on the Moon, Sun (with proper filters) and planets can really be magnified and photographed. Your eyepieces have to be of top optical quality and the atmosphere – seeing – has to cooperate to allow for the higher magnifications. Later in the book you will learn about using processing software for stacking your planetary/lunar and solar images, which helps to offset seeing effects.

Table 5.1. Camera and Telescope Mode Basic Imaging Methods

Imaging Technique	All-Sky	Planetary/ Lunar	Solar	DSOs/MW	Eclipses
Afocal	Comets, asteroids, ISS	Yes	Yes	Possible*	Features close up
Prime Focus	Comets, asteroids, ISS	Yes	Yes	Yes	Yes
Barlow/ Extender	No	Yes	Yes	No	Features close up
Eyepiece Projection	No	Yes	Yes	No	Features close up

Possible* If astronomical object is bright enough.

Bottom Line

This chapter's basic introduction to imaging methods with your camera and telescope will start you on your way. You will learn more about this topic in the chapters that follow in this book. As time goes on you will learn the ins and outs of working with camera and telescope and in the process obtain some pretty neat astropics. You may end up wanting to concentrate on one technique and one type of astronomical object. Or you may want to develop the ability of being able to use all of these techniques equally effective. The choice will be yours.

Chapter 6

Mountings

You can have a quality camera and lens combination and a quality telescope for taking astropics. But unless you have a quality mounting for both Camera Only and Camera and Telescope modes neither will be able to deliver what they are capable of doing. Why? Simple. Your camera and lens as well as your telescope have to be adequately supported and easily manipulated in order to take quality astropics. If your mounting for either is flimsy or of poor mechanical design it could be a nightmare. Buying quality astrophotography gear as we have discussed so far continues to be the case with mountings.

Camera Only Mountings

Because of the exposure times involved and variety of lenses you will use for taking astropics in this mode it is essential to have a sturdy mounting to support camera and lens. There are essentially two categories of mountings – tripod and tracking mount. We'll discuss each of these at length, and the good news is that if you have the former it is easy to upgrade to the latter.

Tripods and tracking mounts have a payload limit, telling you how much weight they can reliably support. Get a tripod whose payload limit exceeds the weight of your heaviest camera and lens combination and, if separate from the tripod itself, the weight of the tripod head.

Tripods

A tripod does not track the sky in order to counteract Earth's rotation. It just supports camera and lens pointed at whatever you chose. Tripods can be aluminum or carbon fiber. Carbon fiber tripods have good strength and are lightweight, especially when compared to aluminum tripods. Collapsible tripods are a must for convenience of storage and transportation.

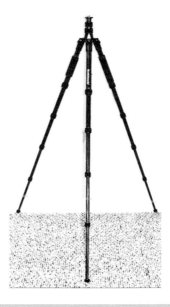

Fig. 6.1. Multi-section collapsible carbon fiber tripod. Strong but light carbon fiber tripods are a good choice. (Image by the author.)

SAFETY NOTE: Tripods can cause a severe pinch injury when you are spreading the legs and when collapsing the individual tripod leg segments. Keep your fingers and hands clear of the very top of your tripod where the three legs engage their mechanical locks to keep them properly extended.

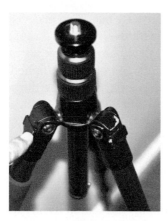

Fig. 6.2. Potential mechanical lock pinch point. Avoid painful injuries by keeping fingers and hands away from this. (Image by the author.)

To safely collapse the legs, the best way to close each of them is to use the palm of your hand on the leg's footpad to push them closed after unlocking each segment. This keeps your hands and fingers away from the individual leg segment pinch points.

You may leave your tripod fully assembled so you can just grab it and go take pics or you may leave it collapsed. Either way there are some checks you have to perform each and every time you prepare to use it. Failure to do so could lead to a very nasty collapse with your camera and lenses attached. A tripod collapse could also injure you or others, so do these checks.

- Consult your tripod user's manual to learn how to properly and safely operate your tripod.
- Being mindful of your surroundings when you fully extend the tripod's legs. You don't want to knock anything or anybody over.
- Check to insure that the mechanical locks that hold each individual tripod leg in proper position are fully engaged. If they aren't, the leg will move freely, and your tripod can't be set up.
- Check to insure that each tripod leg segment is fully extended and locked. Do a hands-on verification, not a visual one.
- Check to insure that all tripod leg footpads are fully screwed in so the tripod will be level when set up. They can be adjusted as needed.
- Check to insure that the tripod head you will be using (see discussion in next section) is securely fastened to the tripod's mounting screw. The tripod head should be flush with the tripod and tight. Be careful during use that you do not unscrew the tripod head while operating in azimuth

mode. Occasionally verify by hands-on and visual checks that the tripod head is flush and tight with the tripod.

- Your camera body will likely have to have a tripod adapter plate so it can attach to a head. Is it tight and properly aligned with your camera body? The plate can become loose during use, so during your astrophotography session check it occasionally visually and with a slight push on your camera to make sure it is tight while holding the camera's neck strap.
- Verify that the tripod is level and all three legs are extended to desired length and are fully spread.
- Attach your camera to your tripod. Make sure it is properly seated and secured.
- While holding the camera's neck strap lightly tug on the camera to verify proper attachment to the tripod.
- You may want to attach some red reflective tape to the tripod's legs so it is easier to see at night.

Camera straps are an integral part of the safe use of your camera. They help prevent dropping your camera. But they can get in the way when attaching to a tripod or a telescope, as you will learn from experience. Use Velcro or a strong rubber band to secure the strap in a tight bundle; this minimizes the strap's length and allows it to be tucked out of the way when conducting an astrophotography session. The strap can still be used to hold the camera if needed.

Changing Lenses While Using a Tripod

When your camera is mounted on a tripod and you need to change lenses the author recommends doing the following steps keeping a hand on your camera at all times and wear a red headlamp to illuminate the process.

1. Place the front protective cap on the lens. You should keep the protective cap in a sandwich bag to protect it and keep it clean; this also makes it easier to find in the dark.
2. Remove the lens hood and reverse attach it to the lens body. Nikon allows this for their lenses. Free up the camera strap, keeping the Velcro or rubber band handy.
3. Take the camera off of the tripod and put the camera strap around your neck.
4. The camera body cap and the rear cap for the lens you are changing out need to be readily available to put in place as you change the lens.

5. It is highly recommended that you have the camera strap around your neck and be seated when changing out lenses, preferably over a table or camera bag. This helps prevent a dropped camera or lenses and provides them a nice spot to land if it happens.
6. Remove the lens that is on the camera and put in place the camera body and rear lens caps.
7. Place the removed lens in its storage place.
8. Retrieve the lens to be used and remove its rear cap; put the cap in a plastic sandwich bag.
9. Remove the camera body cap. Put the cap in a sandwich bag with the lens cap and zip up.
10. Put the new lens on the camera, check for a correct fit.
11. Place the camera back on the tripod and test for a secure fit by trying to move the camera. There should be no movement. Remove the camera strap from your neck.
12. Place the lens hood on.
13. Bundle up the camera strap with Velcro or rubber bands.
14. Store the sandwich bags with the protective caps where you can easily find them.

Do this procedure each time, and your lenses will live a long time.

Tripod Heads

There are several types of tripod heads out there, some of which come already attached to a tripod or they can be ordered separately. Tripod heads can be swapped out from a tripod, and having several types available is a real plus and recommended. Which one you need depends on your camera type, lens being used, payload and, to some extent, whether you will be using both tripods and tracking mounts.

Tripod heads may provide or require a tripod plate adapter that mates with your camera body's tripod socket. Have a backup tripod plate adapter for each tripod head that uses one so if you lose it you do not suffer a single point of failure for a Camera Only astrophotography session. Also be sure to check that the plate remains tight to the camera body, as they can become loose due to extensive use.

Smartphone/Tablet Tripod Adapter

Adapters are available for your smartphone/tablet that allow it to be mounted on a tripod. You want to make sure that the adapter-tripod combination allows for complete coverage of the sky. Payload really isn't a

consideration here, as smartphones/tablets aren't heavy, but pointing convenience and sky coverage are.

Locking Ball Heads

This type of tripod head is what you need attached to your tripod if you aren't using very heavy payloads and cameras that use a camera body tripod socket – pocket, film, DSLR, CSC. You will be shooting the sky at all kinds of angles, and you want to minimize camera movement when photographing at horizontal or high angles. Having two separate locks for altitude adjustment is much better than just one lock, which is what you get with a two-way locking ball head. For azimuth adjustment one lock is sufficient.

Typical three-way locking ball heads will have a camera body adapter plate that will screw into the tripod socket at the bottom of your camera body. This plate has ridges that fit into grooves at the top of the ball head, which acts like a vice. You tighten the plate by turning a knob, which closes the vice for a nice, secure fit.

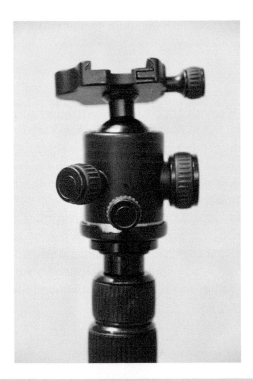

Fig. 6.3. Three-way locking ball head. A very useful and necessary accessory. (Image by the author.)

Three-Way Geared Tripod Head

If you think you will have a heavy camera-lens combination or want something more secure than a three-way locking ball head another option to consider is using a three-way geared tripod head. With a heavier lens-camera combination even the best three-way locking ball head will have some play when locking down the axes. There could even be some slippage.

To overcome this tendency the three-way geared tripod head is much more precise in positioning the camera, as it uses gears on all three axes to position the camera. Use of this heavier head will require a more substantial tripod, so check the combined weight of all of your components. The overall advantage of the three-way geared tripod head to the three-way locking head is precise positioning and a more secure locking of the three axes.

Three-Way Pan Head

A three-way pan head is necessary for using the Omegon Mini Track LX2 NS tracking mount which we will discuss shortly. The Omegon three-way pan-head is well made and well designed. The handles for the two axes are a joy to use and the 10-kg payload is a plus.

Fig. 6.4. Three-way pan-head for a tripod. (Image by the author.)

Gimbal Head

For large and heavy telephoto lenses the gimbal head is the only way to go. Its design allows for the attachment of long and heavy lenses positioned so that the camera and telephoto are balanced. When properly balanced the camera and lens stay in place without having to be held. The gimbal head also allows for wide coverage and easy movement. We'll talk more about this setup in Chapter 14.

Fig. 6.5. Gimbal head. This is a very necessary accessory for a tripod if you are going to be using long and heavy lenses. The ease of use and pointing is extraordinary. (Image by the author.)

Fig. 6.6. Gimbal head with camera and long telephoto. If you are going to use a long lens like a telephoto you are going to want (and need) a quality gimbal head. It works like a charm for eclipses and in the field. (Image by the author.)

When conducting an astrophotography session, especially if you become a bit fatigued, it is very easy to turn the wrong knob on your tripod/head combination if you go by feel alone. If you mistakenly loosen the camera adapter plate knob that holds your camera in place, instead of the various locking knobs on your particular type of tripod head, your camera and lens have a very good chance of falling off the tripod. Some tripod adapter plates have a safety groove or a quick release lever to help prevent this from happening. Usually the camera adapter plate knob is smaller than the locking knobs, but why take a chance? Use your red headlamp to visually confirm what knob you are loosening.

Tracking Mounts

You can get great astropics with a tripod, and that may be all you need for your Camera Only astrophotography. You should gain some experience in taking tripod astropics before considering getting a tracking mount. The lessons learned and the experience gained will help you take better astropics using a tracking mount. You may also want to just use your telescope and its mount if you have this capability.

In recent years there has been a revolution of sorts as tracking mounts – camera mounts that follow the stars – have become readily available. These tracking mounts can be very elaborate (and expensive) or quite simple. The more elaborate tracking mounts can rival the mounts for smaller telescopes in their size and complexity, with counterweights, computer controls, and decent payload capacity.

Regardless of the design of tracking mounts – and there are a number of designs – their common purpose is to do two things: securely hold a camera and lens, and track the stars to allow longer exposure times and elimination of star trails.

There are quite a variety of tracking mounts for you to choose from, and you really have to figure out your payload, requirements, budget and do some online research – just like you possibly did for selecting a telescope. Some tracking mounts have incorporated polar alignment devices that allow you to get a fairly precise alignment with them, and these mounts require electrical power to operate. There are tracking mounts that can be attached to a sturdy camera tripod that has the proper payload capacity, while in some models the tracking mount requires a sturdier, bulkier and heavier tripod – almost like a small telescope mount.

The Omegon Mini Track LX2 NS uses a regular camera tripod and a spring-powered wind up mechanism; no electrical or battery power is needed in the field. The NS version allows the Mini Track to be used in the Northern and Southern Hemispheres, which is a big plus, as there are no power requirements. The Omegon Mini Track LX2 NS was a Sky & Telescope Hot Product for 2019.

To use the Omegon Mini Track LX2 NS is pretty simple, and the online instructions (print them out for reference in the field) are straightforward. You will need to attach a three-way pan-head to your tripod and attach the Omegon Mini Track LX2 NS to it. This allows you to roughly align on the north or south celestial pole using the supplied polar finder, which is nothing more than a plastic sighting tube. This rough alignment is sufficient for getting longer exposures with a variety of lenses than would be possible with just a tripod.

Fig. 6.7. First step in set up of Mini Track attached to three-way pan-head (Image by the author.)

Next step is to attach a three-way locking ball head to the Mini Track.

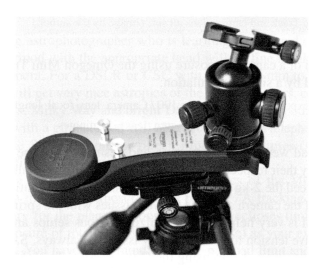

Fig. 6.8. Second step in set up of three-way ball head attached to Mini Track (Image by the author.)

Camera and Telescope Mounts

For Camera and Telescope mode, mounts become very important, as they must be able to hold your platform rock steady, allow ease of telescope movement and precise positioning. You can have the best camera and telescope optics in the world, but an inferior and shaky mount will render them useless.

A telescope mount can come in a variety of configurations, but there are two basic types – altitude and azimuth mounts (alt-az for short) – and equatorial mounts.

Manual or Motorized?

Before getting to telescope mount types we have to provide some background information for your consideration. Just like tripod versus tracking tripod in this chapter's Camera Only section, telescope mounts can be manual or motorized in operation. Both types of telescope mounts can be manually operated where you move the telescope to find and center your astronomical object and keep it centered manually. This is usually found on alt-az mounts.

Alt-az and equatorial mounts can also be equipped with motors to move the mount on its axes – more on this in a bit – as well as track the planets, stars (this includes DSOs), Sun and Moon. For motorized alt-az mounts a computer is used to control and move the mount's two axes and then keep astronomical objects centered in the eyepiece.

Motorized equatorial mounts have a clock drive. The clock drive moves the telescope at a precise rate to counteract the rotation of Earth so that astronomical objects remain motionless (almost) in the eyepiece or while taking astropics. Equatorial mounts may also have a second motor to move the other axis. Equatorial mounts, like alt-az mounts, can also be computer controlled. We'll discuss that shortly.

We said "almost motionless" for several reasons.

Motorized mounts track at the sidereal rate – the motion of the stars in the sky due to Earth's rotation – while the Sun and Moon have a slightly different rate of motion. Some mounts will have sidereal, lunar and solar tracking rate capability, while less expensive and less capable mounts will not. This slight difference in tracking rates should not impact taking astropics of the Sun and Moon or planets because the exposure times involved will be short. There can be some noticeable movement in the eye-

piece if you are doing visual observing for a long period of time, but this is easily compensated for by moving the telescope by use of the mount's controls.

Motorized mounts and GOTO computer mounts need to be aligned in some manner to work properly and adds a level of complexity and resultant capability. If not properly aligned the mount will not track the sky nor be able to find astronomical objects. We'll have more on polar alignment later in this chapter.

GOTO Computer Mounts

Adding computer control to motorized alt-az and equatorial mounts allows you to tell the computer to "go to" a specified astronomical object. The computer can be either your own hooked up to the telescope via a cable or Wi-Fi network, or contained in the mount's own electronics.

If your GOTO mount allows for use of your own computer it may provide proprietary software for use and/or allow for other software use – we'll get back to this in Chapter 7. Using this software you can pick your astronomical object on your computer screen, hit GOTO and the mount (if aligned properly) will automatically slew (move) on both axes. You'll learn the sounds of your mount as you gain experience using it, and it can tell you a lot.

Telescope Driving Tip

With a GOTO mount in automatic mode, i.e., you have commanded a move to an astronomical object or coordinates, or with you driving the telescope whether it is motorized or not, you have to be alert to any problems that might arise. First and foremost like any driving situation you have to make sure you don't hit anything or anybody. Make it a habit to always visually check the area around the mount using your red LED headband before moving it. The telescope and any attachments are going to be moving as well, and the slewing movement may be quite lengthy. You want the area of intended movement free and clear of people, obstructions such as observing chairs, equipment boxes and oh, look out, cables and cords.

If you have a GOTO or motorized mount in all likelihood you will have at least one if not more cords and cables leading from the mount to a power source, computer, control box, camera and maybe even an autoguider. That

is a lot of stuff that can get tangled up with your telescope and themselves, especially with multiple movements to different sections of the sky. Cable management is keeping your mount's cords and cables out of the way and ensuring free movement of the mount in all directions. If these get tangled they may become too short, which could impede mount movement or even cause damage to the cables/cord(s) and/or their input jack(s) on the mount. They can be put together with Velcro, tied together or kept free and clear in what manner you choose. Just check that the mount can move freely to all parts of the sky unimpeded. Do this check as part of your setup and before every movement of the mount.

When moving the mount in computer control mode or even if you are driving the telescope, problems such as the mount moving past its intended target, speeding up uncommanded or going haywire in some manner can occur so know how to kill the power instantly. This can be an on/off mount switch or pulling the power cord. Know how to do this!

Know your mount's user's guide backwards and forwards and be prepared. The sound of your mount will also tell you how a move is progressing.

GOTO mounts that contain their own computer will have an interface, usually in the form of a control keypad, that allows you to access numerous astronomical databases, identify objects and help in the mount's alignment procedure. The control keypad will also allow you to move the mount using the motors on the two axes. When you are doing this you are "driving the telescope," which is cool to see and hear.

Alt-Az Mounts

These mounts have two axes. An altitude axis for moving the telescope up and down from 0 degrees (on the horizon) to 90 degrees directly overhead (also known as the zenith), and an azimuth axis for moving 360 degrees along the horizon. This type of mount is the simplest to use and is popular with entry-level telescopes as well as Dobsonian reflectors. To use a manual alt-az mount you find your astronomical object of interest, center it in your eyepiece and move the telescope manually. This can be accomplished through the use of knobs that may be connected to gears on each axis or just by moving the telescope by hand.

Manually operated alt-az mounts can be used efficiently in visual observations, although at higher magnifications it requires some skill to keep objects centered in the eyepiece. For taking astropics an alt-az is fine for lunar, planetary and solar astrophotography, as the exposure times will be

short. If higher magnifications are to be used, which will require longer exposure times, blurriness due to Earth's rotation and movement of your astronomical object of interest could be an issue. Astropics of DSO's taken at prime focus probably could not be longer than a few seconds, depending on your telescope's optical system and camera type used.

Fork Mounts

Telescopes usually come with a mount as part of the purchase, especially the big brand name SCTs. These telescopes generally use fork mounts, which are alt-az type mounts, to hold the telescope between one or two fork arms. Some telescope models use a single fork arm, but the two fork arms are superior in terms of stability and payload, and also for telescope set up for astrophotography.

SCTs can be purchased that are GOTO or with just a clock drive in the base of the mount. The fork mount can be either an alt-az-type mount or with the incorporation of an equatorial wedge be an equatorial mount. The equatorial wedge is an optional accessory that can be attached to the mount's tripod or pedestal. It can be set for a location's latitude and allow for polar alignment and eliminate field rotation, both of which are discussed shortly.

SCTs can also be purchased as an optical tube assembly (OTA), that is, just the telescope, and placed on the mount of one's choice, usually an equatorial mount.

Fork mounts do not have counterweights on the fork arms but can be incorporated on the telescope tube. These mounts, like the telescope they carry, are really compact, easy to handle, store and use – all a big plus.

Equatorial Mounts

These mounts have two axes as well but with different names and manner of operation than alt-az mounts. The declination (dec) axis moves the mount north and south on the celestial sphere, while the right ascension (RA) axis moves the mount east and west on the celestial sphere. We'll discuss all of this in Chapter 9. Budget-priced equatorial mounts should have a clock drive to move the RA axis and may have an option for a dec axis motor.

Equatorial mounts will also have a counterweight on the dec axis, which is used to balance the mount. When properly balanced the mount will not

move when you let go of it. If improperly balanced it might very well take off when you let go of it! Balancing the mount takes experience, patience and the right amount of counterweights. The heavier the telescope and all of its accessories the more weight you will need to balance the mount.

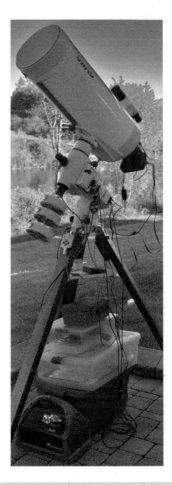

Fig. 6.10. A GOTO equatorial mount with counterweights. Counterweights are essential to proper balancing of your telescope and the various camera setups you will employ. Make sure *beforehand* you have enough counterweights on hand for all of your camera setups. (Image by the author.)

Balancing the Mount

Your telescope and mount, if purchased as a package together or separately, will have a user's manual that will describe balancing a telescope on the

mount. This is very important and involves the safety of the telescope system and yourself. You will be moving weights (possibly heavy ones), telescope and accessories in the dark – using your red LED headlamp of course – during an observing/astropic session. It is always best to set up during daylight or near dusk so you can see what you are doing and let the telescope start to cool down.

As we discussed previously you should have practiced setting up and taking down your telescope and mount, using all of the accessories, cameras and lenses, numerous times in the comfort of your home to gain total familiarity and proficiency. This includes balancing the mount. Every time you add, move or remove something on your telescope this could change the balance.

When you set up your mount your user's manual probably told you to make sure that the axis locks were engaged prior to placing your telescope on the mount. This ensures the axes won't move. Always verify with a slight tug that they are indeed locked. Whenever you are going to move the counterweights the following procedure is suggested.

Your user's manual should guide you through the telescope-mount set up and counterweight placement process. Always have the two axis locks engaged/verified, and the counterweights ready for placement. Be careful handling the weights, as they are heavy and can slip out of your hand if it is sweaty or the weights are wet with dew. Try to keep your feet clear of the "drop zone" when moving counterweights – your toes and feet will thank you.

Once the telescope is securely on the mount visually verify and give a slight tug. With the counterweight(s) in place on the dec axis get a good grip on the telescope and unlock the axes one at a time. See how the telescope responds and balance accordingly. With experience you will be able to place your counterweights at the proper position during set up and as you change out accessories.

Besides the dec axis counterweight(s) your telescope may need additional weights that attach to the telescope tube itself to help achieve balance when using accessories. If this is an option that you can get, it is highly recommended that you do so because it will come in handy at some point. When using accessories that attach to the back of a telescope it adds weight that is hard to balance using just the dec axis weight. Placing a counterweight along the telescope tube really helps.

Equatorial mounts are currently the mainstay for serious astrophotographers, because they are very capable of carrying heavy payloads and tracking astronomical objects precisely. Equatorial mounts can be configured in seemingly endless ways with multiple telescopes and cameras attached and very sophisticated control programs.

There are however extremely capable alt-az mounts available for larger telescopes that can carry heavy payloads and have sophisticated control systems. These are usually used by serious astrophotographers that have an observatory with a large telescope and heavy payloads of cameras and associated equipment. The newest and largest professional astronomical telescopes use alt-az mounts.

Mount Polar Alignment

Unless you use a simple alt-az mount with no motors so you essentially point the telescope at your object of interest, take short exposures, and go from there, you will need to do some kind of alignment of your mount. To take astropic exposures of minutes to hours (yes, really for some) you need a motorized mount, preferably an equatorial mount, that is properly aligned with the celestial pole of the hemisphere you are operating in.

Equatorial mounts have the advantage over most alt-az mounts for long exposures because the alt-az mounts, even when computer controlled, get to a point where field rotation – sometimes called frame rotation – will show up in images. Field rotation is a result of the alt-az mount not following the stars in their path across the sky. Long exposure images will show stars that have "rotated."

This happens because alt-az mounts can't follow the sky the way equatorial mounts can. If you don't want to, or can't use the equatorial wedge we discussed previously in this chapter, there is an accessory you can buy to counteract alt-az field rotation. A field de-rotator attaches to your camera and rotates it so it is in synch with the sky.

So if you think you will be eventually doing long exposure DSO astropics, equatorial mounts may be the way to go. However, if you want the simplicity that computer controlled alt-az mounts offer, adding a field de-rotator might be just the ticket for you.

As always, determine your current and future requirements and then research what will best fulfill them.

Your mount's user's manual, unless it is a simple manual alt-az mount, will have instructions on how to align your mount so that all of its features can be used. Alignment can be done using selected stars (you have to know how to locate the stars in the sky) that you point your mount to, center in the eyepiece and then push an input button. Several stars are used in this method, which is usually found on alt-az GOTO mounts. The mount's computer will tell you when it is aligned and off you go into the universe.

Equatorial mounts, especially more capable (and expensive) ones, will incorporate a polar alignment telescope inside the mount's RA axis. You

remove two protective caps and look through the eyepiece at the end of the RA axis to see a red LED lighting up a large reticle system. Mounts can vary in how they accomplish polar alignment using their proprietary reticles and procedures, but they all will zero in on date, time, your longitude and latitude at the time of alignment so that your mount gets centered on either the north or south celestial pole. This alignment technique uses the star Polaris in the Northern Hemisphere and the star Sigma Octantis in the Southern Hemisphere to help in the alignment procedure.

There is also the drift method, which uses the observation of stars to determine if your mount is properly aligned. To really get precise polar alignment some will use their mount's prescribed method of alignment followed by further adjustments using drift alignment. For most, especially beginning astrophotographers, getting alignment as prescribed by your mount's user's manual should suffice for the majority of your astropic needs.

Daytime Polar Alignment

There may be instances during the daytime where you will want to observe and photograph the Sun, planets and solar eclipses. This will require at least a rough polar alignment. All of your photographs will have short exposures due to the bright sky conditions and relative brightness of these astronomical objects of interest, so trailing shouldn't be too big of a problem.

You may be able to set up the night before, polar align and leave everything in place for the next day. Your GOTO mount might have special instructions on how to leave your mount synched and possibly daytime polar alignment as well.

There is software in Chapter 7 that can help accomplish daytime polar alignment.

Guiding the Telescope

Even with perfect alignment of the mount there will be movement of the astronomical object you are trying to photograph in long exposures. The source of these movements are caused by mechanical imperfections in your mount's gears that drive the telescope. Even the most expensive mounts can have some periodic error – a repeating movement that is the result of driving gear imperfections. Serious astrophotographers map their mount's periodic error so they can apply periodic error corrections (PEC) to their mount.

The other source of movement is our good old friend, the atmosphere. Seeing conditions can cause the stars in an image to move around and "bloat" or elongate and show up in the image. Atmospheric refraction affects star images also and varies by height above the horizon. The closer to the horizon your telescope is the more air light has to travel through, which refracts (bends) the light waves. This can produce discernible movement in star images.

If you have good polar alignment, seeing conditions and a high altitude astronomical object you should be able to get decent DSO astropics without guiding. SAAS will be your guide as to how they turn out. But if you are going all in, wanting long exposure capability, guiding the telescope is in your future.

There are two basic ways to guide your telescope. If your telescope and mount setup can accommodate a second, and probably much smaller telescope, called a guide 'scope, you can use the guide 'scope method. Using a guiding eyepiece that probably contains a double crosshairs reticle illuminated by a red LED, you align the crosshairs so that a guide star you select from the field of stars that surrounds the astronomical object you are imaging is centered.

You have to check to see that the DSO is properly framed in your camera using your selected guide star. You may have to do this several times to get a proper guide star and photo target properly framed in their respective fields of view.

Once properly framed in the field of view you use your mount's control box to move the telescope to keep the guide star centered as best you can.

However, this is tedious and not as efficient as replacing the guiding eyepiece with an autoguider. The auotguider does the same thing as you did except much, much faster. The autoguider is used with guiding software of your choice – see Chapter 7 – and a connection to your telescope's mount, usually an ST-4 cable. When the system is properly set up and working, it is a marvel.

The only problem with the guide 'scope method is that not all telescopes and mounts can accommodate a second telescope. There might be a possibility of using your telescope's finder with an autoguider. You just have to research what your system can accommodate with what is available. Guide 'scopes can also suffer from flexure, which is the guide 'scope flexing and moving with the mount's motions.

The other solution is to use an off axis guider (OAG) that attaches to your telescope at its prime focus, with the back end accommodating the camera of your choice – film, SLR, CSC, DSLR or pure astrocamera – as you are taking long exposures. You saw this setup in Fig. 5.9.

The OAG has a small prism that allows you to designate a guide star in the field of your astronomical object, which you can then view with a guiding eyepiece or in the software of an autoguider. The field of view is small and stars can be dim, but this is a pretty efficient system. The autoguider will react far quicker than you can to changes in your guide star and send the correction to your mount faster than your manual input. When this system is up and running you basically set the exposure time on your camera and just monitor the mount.

Piggyback

Depending on your mount and telescope set up there may be a very powerful option available to you that allows you to mount your camera on to the telescope tube or mount. It's called "Piggyback" and it uses the telescope tube or mount to carry the camera and any of its lenses, including long focal length (heavy) telephoto lenses. This really opens up the sky to your camera and lenses as your mount should easily carry the extra weight. The author's mount allows for different mount heads to be switched out simply by the use of bolts. Without any tube rings or any way of attaching a camera to the telescope tube this is a very handy option that can be put to good use.

You will have to research your system chart and the telescope/mount manufacturer's website to determine if the piggyback option is available to you. SCT fork mounts, telescopes with tube rings and mounts with interchangeable heads should allow for piggybacking.

The following table shows Camera and Telescope mode capabilities according to type of mount, camera and astronomical object. Except where indicated, all imaging methods are available. This is a basic guide to get you started.

Table 6.2. Camera and Telescope Mode Alt-Az Mount = AA Equatorial Mount = EM Piggyback = PB

Camera Type	All Sky	Planetary/ Lunar	Solar	DSOs/MW	Eclipses
Smartphone	AA,EM Afocal Asteroid, Comet; ISS PB*	AA,EM Afocal	AA,EM Afocal Features	AA/EM Afocal; MW, DSOs PB*	AA,EM Afocal Features
Tablet	No	No	No	No	No

(continued)

Table 6.2. (continued)

Camera Type	All Sky	Planetary/ Lunar	Solar	DSOs/MW	Eclipses
Pocket	AA,EM Afocal Asteroid, Comet; ISS PB*	AA,EM Afocal	AA,EM Afocal Features	Bright DSOs Afocal; MW PB*	AA,EM Afocal Features
Film	AA,EM PB*	AA,EM	AA,EM	AA,EM PB*	AA,EM
CSC	AA,EM PB*	AA,EM	AA,EM	AA,EM PB*	AA,EM
DSLR	AA,EM PB*	AA,EM	AA,EM	AA,EM PB*	AA,EM
Video	AA,EM PB*/**	AA,EM	AA,EM	AA,EM PB*/**	AA,EM
CCD/ CMOS	AA,EM PB*/**	AA,EM	AA,EM	AA,EM PB*/**	AA,EM

*Most cameras can mount on the telescope mount or telescope tube using accessories to do so if they are available for your camera and telescope type. This is a very effective way to get longer exposures of the sky, Milky Way and DSOs. This can be used very successfully with heavier and longer focal length lenses.
**If regular lenses can be attached.

Bottom Line on Camera and Telescope

If you are making the jump to Camera and Telescope Mode capability there is a lot for you to consider, especially with regard to your mount. One may come with your telescope, and you will be all set once you read the user's manual and practice daytime setup to prepare for the real deal at night. If you are selecting a mount, remember, quality counts. You should go for a motorized mount to make your astrophotography and visual observations life easier. All mounts need to be aligned in order to use their tracking and GOTO capabilities. Software and accessories really make this far easier than in days gone by.

Alt-az mounts are capable, especially those that are computer controlled. You can use a de-rotator to take longer exposures. Equatorial mounts have the edge in payload capacity if you want to use a guide 'scope and add accessories to the telescope. And once aligned both can track the stars for longer exposures.

Both types of mounts for longer exposures will require some means to guide the telescope. An autoguider attached to either a guide scope or an OAG is highly recommended.

Cameras with lenses, especially heavier and longer focal length lenses, can "piggyback" on the telescope mount or telescope tube.

Chapter 7

Software and Other Vital Accessories

Half a century ago there were no computers, telescopes were hand guided and wet film was how astrophotography was done. Shoot it, develop it, print it – *if* the image was worth doing so. How things have changed!

We now live in a time when computers dominate our lives, and astrophotography is no different. Smartphones, digital cameras, pure astrocameras, mounts, astropic processing and astronomical software are all the name of the game these days.

There are types of software that are really necessary to have if you are going to get the most out of astrophotography. We will leave astropic processing software out of the discussion, as that will be covered in Chapter 21. We also will not spend time looking at the software that is used to operate DSLRs, pocket cameras and pure astrocameras, as that is covered in your camera's user's manual. We will cover astronomical software that is useful for learning about the sky and mount set up.

All software is dependent on some type of computer to run it. And the two dominant computer operating systems (OS) currently are Windows OS and Mac OS. Yes, there is Linux, but that is not a dominant OS in commercial software. There is freeware out there in the astronomy realm as well that works on multiple operating systems.

© Springer Nature Switzerland AG 2020 113
G. I. Redfern, *Astrophotography is Easy!*, The Patrick Moore Practical
Astronomy Series, https://doi.org/10.1007/978-3-030-45943-7_7

The first thing you always have to look at when considering any type of astronomical software is what OS does it run on. Windows OS has far more programs available than Mac OS, but it is getting better for Mac users. Some pure astrocameras will not run on Mac OS but ZWO does. If you are a Mac user you will probably find software or freeware that is available to suit your astrophotography/astronomical requirements.

The only astrophotography software deficit found for Mac OS involves "stacking" software used for processing planetary, lunar and solar images from pure astrocameras. The software pulls the best quality images out of a stack of images taken with a pure astrocamera like the ZWO 120 and then processes the stack to a final image. There currently are no reliable native Mac OS stacking programs available. You may want to use software that will allow use of Window OS stacking programs, but this is beyond the realm of basics. We discuss stacking in later chapters.

A link has been provided in Chapter 23 for this chapter that gives a very good listing of astronomical software that is broken down by OS, the purpose of the software and includes smartphones, tablets and PDAs.

Software for Camera Only and Camera and Telescope

Besides the image processing and pure astrocamera-related software, the most important software you need is a program that shows the sky in real time, can run your GOTO mount and can serve as an astronomical reference while at the telescope. Usually called "planetarium software," this category of astronomical software really is crucial for today's astrophotographers and telescope users.

With it you can see the sky represented in real time for anywhere on Earth's surface (and in some programs elsewhere in the Solar System) and for anytime past, present and future. This is really helpful in planning a photographic or visual session whether Camera Only or Camera and Telescope. Of course you have to research what would be best for your needs and select your software. What you select could be freeware or provide a trial period so you could try the software.

Whatever software programs you select, always read the user's manual first and thoroughly understand it. Make sure you download a copy of your manuals from the Internet to your device(s) so you will have access in case the Internet is not available. You may want to print out the most important sections of the user manuals you use to make sure they are available in the field for reference.

Sky Safari Pro is available for the Mac OS and can be run on a computer, iPhone and iPad. It is also available for Android users. There are other similar software programs out there for Mac OS and Windows OS so you need to check them out before you decide which one is right for you.

Sky Safari Pro can also control telescope mounts, which is a very important feature. You determine your location either by a list of cities/countries, manually inputting longitude (long) and latitude (lat), or having the program do it via Global Positioning Satellites (GPS). Using GPS is most efficient and accurate, but there may be remote areas that you cannot get GPS coverage and have to do things the old-fashioned way – using a map to get latitude and longitude. You also need to know what time zone you are in so you can manually input that if GPS is not available.

Once you have inputted your location and set up your parameters for display options, you really can see the sky as it truly is for a specified time. A "gyroscope" and "compass" mode allows your portable device to follow your motions while pointing at the sky, which aids in identifying astronomical objects. We'll revisit this in Chapter 9, as this is a huge help.

Mount Control with Sky Safari Pro

There are loads of features in this software program, but controlling a telescope using it is a big plus. Depending on the type of motorized mount you have, chances are there is software out there that can control it. Some of the commercial GOTO telescopes and mounts have their own software, as we have explained, but other mounts can benefit from this type of software.

You have to have your mount polar aligned. We discuss some software to help do this next. You will need to connect the mount to the software, which when connected means they are "communicating" with each other. Then, using the software, you highlight the star your mount and telescope are pointing at to "align" or "synch" the telescope and software. The software now knows where the telescope is pointing. Once you have gotten to this step successfully, you can tell the mount where to go in the sky simply by picking a point or astronomical object. When you hit GOTO the mount's motors should move to the designated point and stop. You will see a cursor move on your display screen.

If you are lined up on the celestial pole, connected and aligned between software and mount, the sky is yours to roam. It is pretty cool to move about the sky without having to touch the telescope.

Wi-Fi Mount Control

You can also create your own Wi-Fi network using a Sky Safari accessory to control software and mount using any Mac device, such as the iPhone. So you can be some distance from your telescope to control it – say in the warmth of a room while the telescope and mount are out in the cold. Always be near the telescope when moving it just to make sure all goes well. With this capability the sky is yours to see and photograph.

Sky Safari Pro and other software like it will have data, descriptions and databases on the multitude of astronomical objects in the sky. You can identify what you are looking at, learn about its physical characteristics and then read a descriptive narrative, perhaps even with accompanying photographs. The included databases allow you to look up objects, select and then find them. This is very useful for lesser known objects. Solar System data including planets, moons, satellites, comets and asteroids are also included. In fact, your software should allow you to update Solar System objects at any time to get the latest information on new satellite launches and asteroid and comet discoveries.

Polar Alignment and Daytime Polar Alignment

A key to being able to control your mount to find and photograph objects in the sky is being polar aligned. There is polar alignment software out there that can help you do this, and one very nifty and powerful program for smartphones is *Polar Shop Align Pro.* There are also databases, a daytime polar alignment process and astronomical weather information for your location. A very useful program.

Another novel and powerful polar alignment software tool is *Pole Finder*. It uses a camera mounted in the polar alignment telescope housing for a large number of equatorial mount brands to send an image to a software program. The software projects the celestial pole for your designated hemisphere, which you then use the image from the camera to align. When image and software line up you are aligned. You can get extra-precision alignment if you want. This process is fast, easy, precise and fun to use.

Fig. 7.1. *Pole Finder.* The camera is in its housing with protective cap in place. (Image by the author.)

Both of these programs work with the polar alignment reticles of a number of mounts to show you where to place Polaris or Sigma Octantis in the reticle to achieve polar alignment. There are other polar alignment programs out there, including what might have come with your equatorial mount. You will just have to see over time and use what works best for you.

For observing/photographing the Sun and solar eclipses, daytime planets and the Moon, it is advisable to have at least a rough polar alignment. *Polar Shop Align Pro* can help. If circumstances and location permit, you can set up and polar align the night before and leave your set up properly covered and protected to use the next day.

ZWO *ASiair*

This mini-computer runs on Windows and Mac OS. Currently designed for deep sky objects (DSO) it combines several astrophotography functions that can be performed using an application controlled via smartphone or tablet. Similar products are *StellarMate* and *Primaluce Labs EAGLE*, which the author did not research or review.

Fig. 7.2. Closeup of *ASiair* unit attached to telescope. (Image by the author.)

Fig. 7.3. DSLR attached to the telescope in prime focus mode with ZWO120 as an auto guider attached to Omegon OAG. *ASiair* computer is visible. (Image by the author.)

Here are some of the highlights of what *ASiair* does. It is not a complete list:

- Application interface via smartphone or tablet.
- Images can be taken without the use of a laptop.
- Controls main and autoguider cameras via USB interface.
- The computer controls Nikon, Canon DSLRs and ZWO cameras, which are usually the main camera and a ZWO auto guider.

- Works via Wi-Fi with *Sky Safari* and serial cable-USB interface to control GOTO functions for a wide variety of equatorial mounts.
- Plate solves (determines RA and dec position) for an image.
- Performs guiding function using a ZWO auto guider camera.
- Provides focusing function using real-time image from main camera – very useful!
- Controls electric focusers if compatible.
- Controls ZWO electronic filter wheels (EFW).
- Saves images to a mini-memory card and can transmit images to a computer via Wi-Fi.

Downloading the user's guide, printing it out and reading it is your first step if you are considering buying it and using it. The instructions are pretty straightforward, and the unit is typical ZWO, i.e., well made with quality components.

This very impressive product is still developing additional capabilities.

Clear Sky Chart

This freeware is a recognized standard for determining a specified location's astronomical and weather conditions for several days. It is color coded to give you an at-a-glance view of cloud cover, seeing, transparency, wind, humidity and temperature – all vital to planning a Go-No Go for an astropic session. You can look up your general location or one nearby and even register to have your own. This is a got to have for all of your astropic sessions.

You can find software for just about every purpose, and as you have seen run them from a variety of devices for both modes of taking astropics. Software enhances your capabilities, but you will need a variety of other accessories to facilitate taking your astropics.

Other Accessories

Eyeglasses

If you wear eyeglasses it is a good idea to carry an extra set of eyeglasses, especially if you can't see well without them, when you go mobile. You never know when the primary pair may get damaged beyond use or lost. Insure that the prescription for the backup pair is current, as a pair of

glasses/contacts that are several prescriptions removed from your current one may do you no good at all. Carry them in a hard shell case preferably with your camera gear.

Buy an eyeglass strap for holding your glasses if you can take them off when looking at your camera viewfinder/Live View as well as looking through your telescope. This keeps them handy for putting back on and helps prevent their loss or getting damaged.

Camera Backpack

Camera. Lenses. Tripod. Heads. How are you going to haul all of this stuff around? Even if you do not plan on going mobile and are just going into the backyard, you are still going to have to cart everything in and out. Plus, you want to have something to keep all of your gear easily accessible, safe and secure.

Consider getting a camera backpack. It is a variation on a camera bag but is truly a necessity that all astrophotographers need both in Camera Only and Camera and Telescope mode. A camera backpack can go anywhere and is far easier to carry than a traditional camera bag. A good camera backpack also organizes your camera, associated gear and lenses, and allows you to carry everything securely on your back, shoulder or hand. It also allows you to easily access and store items. You want your gear safe and secure in the field.

Camera backpacks should be of sturdy construction, be able to carry a tripod, have a storable rain flap and multiple compartments. ThinkTank Airport Essentials has two compartments – one upper for computer and tablet, the lower for camera(s), lenses and much more. This backpack fits under airline seats and has withstood the test of time, distance and (ab)use.

Quality Red/White LED Headband

This is an essential accessory. A good LED can be used as a regular hand-held flashlight in red and white mode as well as placed on your forehead when you need both hands free, which will be almost always. You want a headband unit that can have its LED pointed downwards at different angles and not stationary.

In red mode the LED preserves night vision and illuminates everything quite well. The bright white LED on a quality unit can illuminate quite a distance and be useful for movement at night or safety purposes. Some units will also blink "SOS." These are battery powered so make sure you have extra batteries for the LED. Wherever you go your LED should go as well.

Batteries and Power Supply

If you use anything that needs batteries to function make sure you have fresh replacements. Besides clouds, nothing can kill an astropic session quicker than no power to a critical component like your camera or your telescope mount. If you operate in the field away from electrical power sources you will need a rechargeable power supply with several electrical outlets. Your mount, computer, smartphone, pure astrocamera, Wi-Fi network, etc., will all need power. Having a robust and rechargeable power supply – namely a large battery unit with electrical and USB outlets – is a must. Some can be recharged using today's vehicles with electrical outlets. Some accessories needing power can run off of USB ports to your computer or other USB-equipped power supplies. Make sure you have the recharger for your power supply when you go mobile.

Optics Cleaning Kit

Have some camera, lens and eyepieces cleaning gear as recommended by your user's manuals. These items will get dirty from use, especially eyepieces. A cleaning kit containing a camel hair brush, microfiber cloths, Q-tips, blower bulb/brush, quality lens tissues and lens cleaner are a must have.

Camera Memory Cards

Your digital camera will need the appropriate memory card before you can take images. Your camera's user manual will specify the type of memory card needed and instruct you on how to format it so it can store images. There are a whole lot of memory cards out there with different storage sizes, throughput speeds and other considerations. You have to make sure that you buy a compatible memory card for your camera. When you get a memory card test for fit with your camera, format it, and take test exposures with it to insure complete compatibility with your camera. Make sure you have at least one spare memory card formatted and ready to go in your camera gear. This is in case something goes wrong with your memory card (pretty hard to do as they are very simple and sturdy in construction) or if you exceed its capacity – highly unlikely with today's high-capacity memory cards.

Camera LCD Protection

Do yourself and your camera a favor. Buy GLASS protectors for your camera's LCD panel as soon as you buy the camera. Your camera may come with a PLASTIC LCD protector but this will get scratched and even if it doesn't, it will make focusing so much harder. Glass panels last and they provide a true view of what the LCD is displaying so focusing is easier. If you DON'T protect that LCD the day will come when it is so messed up you will regret not having done so.

Cable/Shutter Release

A cable or shutter release is a necessary accessory to keep you from having to press your camera's shutter or exposure button. Touching the camera in any way when taking an exposure, especially at the telescope, will introduce motion and blur your image. A shutter release that is compatible with your camera is attached to an input jack on the camera body. When you are ready to take the exposure, press the shutter release making sure you do not inadvertently tug on the camera when doing so. Your shutter release may have a lock feature that allows for the camera to take a long exposure. You engage the locking mechanism for the length of your exposure and then unlock it to end the exposure.

 If you lock open the shutter release for a long exposure, make sure that you either hold the shutter release steady in your hand or place it carefully where you can reach it to end the exposure. The point is to avoid tugging on the shutter release or its catching it on something to jar the camera and ruin the image.

Observer's Chair

It can be quite fatiguing and downright uncomfortable to spend hours, even a whole night, standing while taking images with a camera. You will want to sit down at some point, and depending on your telescope, it may even be a requirement to be able to do so in some observing conditions. Getting a robust and transportable observer's chair goes a long way for creature comfort and enjoyment of an astropic session.

 The Stardust Observer Chair is no longer made but can sometimes be found for sale. Vestil CPRO-600 appears to be very similar to the Stardust

chair in that it has the ladder rung seat adjustment locking system and a footrest. This is preferred, as it is a positive seat lock system that is very easy to change in the dark and will not slip – a big safety factor. There are friction locking chairs available if that is your preference. Do an Internet search on "telescope observing chairs," and you can read the commentary on types of chairs.

Regardless of the type of chair you buy, be sure to put some reflective tape on it so you can see it in the dark. Even if your chair is painted white this is a good thing to do. When you set up your chair, carefully test it to make sure the chair is locked on a rung or otherwise locked and that the chair is stable on the ground before sitting on it.

Folding Table

If you are going to be changing lenses (yes, you will), using a computer (maybe you will), having assorted knickknacks lying about, you need a folding table. This is a very necessary accessory when using the computer in conjunction with the ZWO 120 camera, as the computer powers the camera and receives the images. The table also can provide easy access to books, charts, observer's log (if you keep one) and other items. The metallic foldup camping tables readily available online work well; just make sure they have locks for the legs.

Like your chair, be sure to put some reflective tape on the table's sides and legs so you can see it in the dark. When setting up make sure the legs are locked so they cannot fold. To test, physically press on the legs. Be careful what you put on the table so as to not overload it or have items on it that could roll off and fall or be knocked over. Keep items in their protective cases until ready for actual use.

Hard Copy Sky References, Star Charts, User Manuals

Even though we have become reliant on the Internet, our computers and mobile devices for our astronomical information, it pays to have a good old-fashioned book of star charts and references. There are a number of books out there, we recommend that beginners (and everyone, really) carry a copy of the *Royal Astronomical Society of Canada's (RASC) Observer's Handbook* for what is happening in the sky for a given year. It is full of astronomical and observational information on the Sun, Moon, eclipses,

planets, comets, meteor showers, aurorae, constellations, stars and deep sky objects and much more. Its most important feature, however, is the monthly sky guide that details what is happening in the sky for each month of the year. This is an invaluable reference to have.

Yes, we all have gone digital for just about everything, but in addition to the hard copy *Observer's Handbook* there is one more hard copy reference you should have. And that is a handy star chart, especially in a user friendly size and format. One that has stood the test of time – half a century – and is easy to use is Sky & Telescope's *Pocket Sky Atlas* by Roger W. Sinnott. Small at 6x9 inches, it is chockful of easy to read information. You will be glad you have this to supplement your software and *Observer's Handbook*.

Don't forget all of those user's manuals, system charts and specifications sheets for each software program, camera, lens, accessory, telescope, mount, tripod and gadget you bring to the Camera Only and Camera and Telescope astrophotography table. You can carry them all in a three ring binder – copies where possible to protect the originals – except for the 400-plus page manual for the Nikon D810a, which is in the camera backpack. Everything else is in a plastic bin.

Clothing, Bug Spray, Sunscreen

Always dress for the expected climate and be prepared for the unexpected. There is no such thing as bad weather, only bad clothing. For summer, sun-protective clothing and long leg pants are recommended in addition to a strong sunscreen and lip balm. Nothing like sunburn to ruin taking astropics, and you can burn fast at higher altitudes or desert locations. You can also use a wet bandana around the neck to help keep cool during the heat of the day when solar observing or on a solar eclipse day.

The long sleeves and pant legs – tucked into robust style white socks – also offer protection against bugs and ticks. Bug and tick spray is also liber-ally applied to exposed skin, shoes and socks. Wear quality shoes – no sandals! Unless you are in Death Valley, the Atacama or Sahara Desert, flying insects and ticks will likely be an issue.

Gloves (one insulated pair that fits inside a larger glove mitt pair that can be peeled back to allow use of fingers) are recommended even for use in summer, as the desert and mountains can get cold at night. A wool head cover as well as a whole face cover is also carried. Hand warmers are part of the winter weather gear, as are insulated boots for snow and cooler temps.

Dress in layers for cold weather starting with full length silk underwear and working your way up in layers. Remember, you will be sitting still

while taking astropics or observing. Stomping the feet is a no-no, as it could make your mount vibrate and add blur to your image. If you can, get up and walk around to keep warm and loose. Add a nice foam cushion to your observer's chair to help mitigate the cold.

Light Shield for Face

Yes, this is an accessory for use in both modes because chances are wherever you set up there will be some bothersome light. You can use an old dark colored light cotton shirt to cover your face when doing solar work to cut out that pesky daylight to see the Sun better. At night there may be a neighbor's light on, or one in the distance or a light pollution cone on the horizon that is bothersome. Put the shirt over your head to block out the light. It really works and makes a difference.

Camera and Telescope

We now turn our attention to special camera and telescope accessories, and there are a few of them!

Eyepieces

You are going to need eyepieces to use your telescope visually and with a camera, as we have discussed already. There are many types of eyepieces out there in terms of optical design and focal lengths. You are going to have to research what is best for your telescope's optical design. Regardless of eyepiece type there are some common considerations.

First is the size of the eyepiece barrel. Is it .975, 1.25 or 2 inches in diameter? The .975-inch eyepieces are usually of lower optical quality and are not recommended. If the telescope you are looking to buy has these as eyepieces, you really need to reconsider your purchase. Better quality telescopes use 1.25-inch eyepieces as a standard and are used for eyepiece projection. The 2-inch eyepieces are big hunks of glass and give wide and impressive views. They are usually not used for astrophotography purposes.

Regardless of eyepiece type, you will want at least three eyepieces that give you low power, medium power and high power. This combination of focal lengths will be very useful for visual and astropic applications.

Quality eyepieces are expensive so keep each of them in a clean ziplock bag contained within a plastic eyepiece storage case. The eyepieces should always be kept in their protective case if they are not being used. By the way, the eyepiece case itself should be kept in a protective transport case, which we will discuss in just a bit.

Reducer

You can buy an accessory that optically reduces the focal length of your telescope. It usually attaches to the prime focus of your telescope, and the eyepieces are mounted behind it. As was explained previously this reduces the focal length of your telescope by a set amount, allowing shorter exposure times and a wider field of view. This is a necessary accessory for anyone desiring to take DSO astropics, as reduced exposure time and wider field of view are big pluses.

Extender/Barlow

This accessory optically increases the focal length of your telescope. It usually attaches to the prime focus of your telescope, and the eyepieces are mounted behind it. As was explained previously this increases the focal length of your telescope by a set amount, giving your eyepieces more magnification (power). It can be used without eyepieces attached to your camera to take advantage of the increased focal length. This accessory is a must for anyone desiring to take solar, lunar and planetary astropics.

NOTE: Most quality telescopes can accommodate 2-inch eyepieces. If you are going to buy 2-inch eyepieces you may want to consider buying a 2-inch size Barlow so you get more utility out of those expensive 2-inch eyepieces. It should come with a 1.25-inch adapter so you can use these size eyepieces with it as well. A 2-inch Barlow is a big hunk of glass and is a good match for hooking up your DSLR full frame or pure astrocamera to it for taking solar, lunar and planetary astropics.

You can also buy Barlows of 3x, 4x and even 5x magnification factor. These are very useful for placing them at prime focus and then plugging in your camera for taking solar, lunar and planetary astropics.

Diagonals

For telescopes other than the Newtonian design you will want to have a diagonal for visual observing. A diagonal attaches in some manner to the focus or focuser of your telescope. Depending on your telescope and accessories with a diagonal you can view at prime focus, with a reducer, Barlow or extender that the diagonal fits into. This is primarily with a 1.25-inch diagonal.

The diagonal takes the image from your telescope's optics and through the use of a prism or a mirror mounted at a 45-degree angle directs the image into an inserted eyepiece or camera if you desire., You want to use a lightweight camera like the ZWO 120 – no heavy camera gear here. Diagonals allow the observer to look into the eyepiece at a 90-degree angle to the optical axis of the telescope, which is very, very convenient. You would have to be a yoga master to contort yourself to the eyepiece without a diagonal, especially when observing objects high above the horizon. If you are going to use 2-inch eyepieces you will need a 2-inch diagonal. It will have an adapter that allows for use of 1.25-inch eyepieces. Buy the highest quality diagonal you can because it will hold your expensive eyepieces and transmit the image from the telescope to them. A poor quality diagonal will make a best quality eyepiece image poor in performance.

Camera to Telescope Attachment Accessories

In the various pertinent chapters of this book you will find Camera and Telescope mode tables that list all of the camera types and how they can be utilized with a telescope to take astropics of the chapter's astronomical object(s) of interest. All camera types are listed for completeness, but their successful use is dependent upon being able to mount them to your telescope or mount. With all of the different telescope, mount and camera types it is imperative you research whether you will be able to mount your camera type to your telescope and/or mount.

Your type, and even brand of telescope, will determine how you physically attach your camera type to the telescope or mount to take astropics. The astropic method you use – prime focus/reducer, afocal, eyepiece projection, Barlow/extender, camera attached to telescope or mount, piggyback – will require a means of attaching your camera type to the telescope. Consulting the user's manual of your telescope and its system chart will go a long way in helping you get the accessories you need to take astropics with the camera and imaging method(s) of your choice.

You can browse the Internet by listing your camera and telescope type to see what pops up. Go to the various telescope and astronomy dealers to search their astrophotography adapters and accessory sections to see what is available. They usually have some guidance to assist you. If in doubt, call, as we have discussed.

Smartphone users will need the Celestron NexYZ or other smartphone telescope adapter of your choice. A tablet is deemed too unwieldy for telescope use, but hey, if you want to, you can probably use a tablet adapter on a tripod from Camera Only mode that you put right up next to the eyepiece for the afocal method.

With so many pocket cameras available, if this is your camera type, you will have to search the web for a suitable adapter, but you should check out Celestron's universal digital camera adapter, which requires your pocket camera to have a universal tripod thread in order to attach it. It will allow for afocal images.

Your DSLR, film SLR and CSC will most likely require a T-adapter that is specific to your camera brand that inserts into the camera body just like a lens does. The other end of the T-adapter will have a universal thread that astropic accessories will attach to.

Another valuable astropic accessory is a 1.25-inch nosepiece that screws into the T-adapter or the thread of a video and pure astrocamera that allows it to be inserted into any 1.25-inch accessory. These camera types might already have this included.

For mounting your camera to the telescope or mount for piggyback mode it will come down to if your telescope has tube rings or other means to attach the camera to the telescope tube or mount. You really want to make this work, as it is a powerful addition to your options for taking astropics.

Storage/Transport Cases

Telescope, mount, tripod, eyepieces, accessories, computer, power supply. A lot of stuff! You really have to consider getting transport/storage cases for all of your gear. Unless you have a permanent set up in an observatory, having a safe, secure and transportable means to move your gear around is necessary. Cases make it easier to store and move gear. Having to carry equipment piece by piece is a pain, and your gear isn't protected.

Your telescope may come with a case, but your mount and tripod probably won't. If your telescope doesn't come with a case you can shop the Internet to find soft or hard cases, cases with wheels and custom case makers. You basically pair up your telescope to what is available – and there is

a lot out there. Depending on your telescope you may need a case for your mount, which can be found also on the Internet or custom built. You might even use a snowboard bag to store and carry metal or wooden tripods – very convenient and very sturdy.

It is hard to beat Pelican cases to store and transport eyepieces and telescope photographic accessories. They are durable and have a foam lining that can be tailored to your requirements. The foam is pre-cut, so you basically pull out a section of foam (save the foam for future use) to make a space for your item.

Fig. 7.4. Pelican cases are virtually indestructible. Also note the plastic eyepiece and large accessory storage containers that are a must have. (Image by the author.)

For larger items that do not need as much protection, plastic bins can be used to put gear in. These are very cheap to purchase and hold up well. They stack nicely under the telescope tripod and serve to hold the power supply for the mount. They also fit nicely in a vehicle and are easy to move around with their built-in handles. Don't overload a bin, as if they are too heavy they can be difficult to carry. Bins should be marked on the outside as to what they carry and are in a variety of sizes. It all neatly stacks to take up less space and be accessible.

Dew Shield and Reflective Protective Cover

Depending on your type of telescope you will want to have a dew shield, which helps prevent the formation of dew on telescope optics. Refractors will have a built-in dew shield, while Newtonian and Cassegrain telescopes are fairly protected. But SCTs and Maksutov telescopes are notorious for dew forming on the front lens. A dew shield helps prevent dew build up, but it can still form on "wet" nights. You can buy a heating element that wraps around the front lens to ward off dew. Dew shields also prevent stray light from entering into the telescope, which can affect image contrast and show up in your images – kind of like a lens hood for your telescope.

If you go into the field with your telescope you will need a reflective cover to protect the telescope from the heat of the Sun during the day and to cover it at night. This is for when you are doing a stretch of clear days and nights and you do not want to take the telescope down and set it back up.

You should consider always covering the telescope and mount (with the electronics) in a large white plastic garbage bag before putting on the reflective telescope cover, This is done to add a layer of water resistance in case a pop-up rain shower or heavy dew comes along. After making sure the garbage bag and cover are pulled down as far as they can go, a bungee cord can be wrapped around the outer cover to resist wind. All other gear can be stored in the car if in the field or inside the house if at home. This is to prevent things from getting wet and any possible thieves.

Bottom Line

Software and accessories are a must to be able to take astropics. We tried to limit the discussion to items that are necessary for the beginning astrophotographer. There are some items you may be able to improvise from things you already have around the house, especially if you are into camping and hiking – red/white LED, folding table, clothing, storage bins. But the camera and telescope software and accessory hardware will have to be purchased. Shop around and look for sales on everything – it does pay to shop.

Chapter 8

Astrophotography Rules to Live By

"Astrophotography Rules to Live By" are derived from the author's earlier book *Cruise Ship Astronomy and Astrophotography*. These rules are good ones to incorporate into your astrophotography philosophy. They will help you take better astropics.

These astrophotography rules are based on hard knocks, mistakes, frustration and success experienced by the author during over half a century of taking astropics from locations all over the planet. Adhering to them will go far in helping you take astropics that you can be proud of.

These rules are applicable to both Camera Only and Camera and Telescope Modes.

Here are the rules:

Rule #1: Read all your user's manuals.

Rule #2: Per rule 1: Know your camera, lenses, telescope, mount and all of your equipment.

Rule #3: Keep a hand on your camera at all times

Rule #4: Have a red headlamp for nighttime.

Rule #5: Take what the sky gives you.

Rule #6: Focus, focus, focus.

Rule #7: Use the highest ISO feasible.

Rule #8: More is better – shoot, shoot, shoot pictures.

Rule #9: Keep the color real.

Rule #10: Learn from each astropic.

© Springer Nature Switzerland AG 2020
G. I. Redfern, *Astrophotography is Easy!*, The Patrick Moore Practical Astronomy Series, https://doi.org/10.1007/978-3-030-45943-7_8

Now that you've read the rules, let's examine them in detail to see how they came about and why you need to follow them.

Rule #1: Read All User's Manuals

DO NOT USE ANY PIECE OF GEAR OR EQUIPMENT UNTIL YOU HAVE READ AND THOROUGHLY UNDERSTAND ITS SAFE AND PROPER USE. If you violate this rule you risk possible injury to yourself and others as well as damage to your gear and equipment.

Your camera, lenses, tripod, telescope, mount and just about everything else you will use in astrophotography will have a user's manual that lays out safety precautions (if any) and how to use and care for the item at hand. Read the manual and get thoroughly familiar with it and the item it pertains to. Take all of your manuals with you for each session regardless of location.

At first glance this rule seems like a logical must do, but sadly many people do not do it.

Odds are you will have a camera before any other type of astrophotography gear. No matter what your camera type is, you have to read the camera manual before you use it. Whether the camera manual is online at the manufacturer's website – be sure to download and save it – or in printed format, you need to take the time to read it, understand it and put it to practical use.

Reading many pages about your camera may not be the most pleasant thing to do. The Nikon D810a's manual is 407 pages thick and has an additional insert for the camera's astronomical features. Regardless of its bulk, the manual goes in the camera bag or in a case in the camera backpack. Never leave home without it. More capable cameras will be more complex and have a larger page count manual, all of which means more time to read it and become familiar with your camera. The first section and pages of your camera manual will have safety warnings.

First up will be solar safety. In its first pages the Nikon D810a manual has these solar safety warnings:

- Keep the Sun well out of the frame when shooting backlit subjects. "Sunlight focused into the camera when the Sun is in or close to the frame could cause a fire."
- There is also a warning to not look at the Sun through the viewfinder: "Viewing the Sun or other strong light source through the viewfinder could cause permanent visual impairment."

These warnings must be heeded as you *never* point your camera at the Sun unless a safe and approved solar filter is on the front lens and if applicable, viewfinder. See Chapters 12 and 14 for more solar safety notes. If doing daytime lunar/planetary work, keep the Sun at a safe distance so that there is no way it can enter the field of view of telescope or camera. Block the Sun with a hill or building.

We must all be wise and follow remaining safety notes in camera manuals, as they will discuss the safety of others as well as infants and the safety of our cameras, too. The safety warnings in your camera's manual – in addition to all of your other manuals you will accumulate – need to be committed to your memory and practiced without exception.

Your camera's user's manual will likely have a "Getting to Know the Camera" section that will have a detailed drawing of the camera body that will show the location of the interfaces, dials, and buttons. This drawing should have a number assigned to each listed feature that corresponds to a sequentially numbered list in the manual. This list will show the name of the numbered item and then the corresponding page number(s) in your manual that will explain its operation and function. Your manual should also provide a diagram of the camera control panel, liquid crystal display (LCD) and viewfinder. Each of these features will display what the camera's settings are as you prepare to take an image and additional useful information about your camera's status.

It is this section of your camera's manual that will help you most in learning how to operate your camera. Read this section first and several times to get very familiar with it. Then place the camera's strap around your neck to prevent you from dropping it. Take the camera in your hands and physically touch each feature listed in the manual and say out loud its name. This is a proven "train your brain" method that will work. Over a period of time practice in daylight until you feel comfortable enough to go "dark" and operate your camera.

Using Rules 3 and 4 repeat the previous procedure in the dark, which is where you will be taking the majority of your astropics. As a bare minimum you should know:

- Location of the shutter release button and how to attach a cable release.
- How to mount your camera to a tripod and telescope if you have one.
- How to change lenses if your camera has this capability.
- Setting ISO, f-stop, white balance, exposure time, flash off, and file type if digital.
- Focusing the camera with lens attached or at the telescope.

You can see where we are going with Rule #1, because if you are operating in Camera Only and Camera and Telescope modes, you will need to peruse your telescope's user's manual, that of your telescope mount and all accessories from both modes to make it all one seamless effort. That will take some time and effort, which is why learning to operate first in Camera Only mode pays big dividends and is highly recommended. What you learn doing that carries directly over into using a telescope and camera.

Rule #2: Per Rule #1: Know Your Camera, Lenses,

Rule #1 is so vital to success and safety that Rule #2 is there to gently remind you about how important it is. Not following them will hinder you from becoming a proficient astrophotographer and could result in damage to your equipment or injury to yourself or others. Read and heed. Following Rules 1 and 2 are worth your time and effort, as this will save you grief and frustration.

Rule #3: Keep a Hand on Your Camera at All Times

This rule has origins from fatigue that led to a dropped and therefore ruined $4,000 camera. It also shows why you should insure your high dollar items against accidents and possible theft.

If your camera is not in its storage location – remember that camera backpack we discussed – the camera strap should be around your neck and hand(s) on the camera body. When attaching a camera to tripod or telescope always make sure that the screws or threads used for completing the attachment are firmly and securely in place. Double check with a slight tug to insure all is tight and secure. Place the folded-up camera strap someplace where it is out of the way but still might help mitigate the camera coming detached. When coming off the tripod or telescope the strap goes around the neck or wrapped around a hand until the camera is stored safely.

If you slew (move) your telescope while your camera is attached it is a good idea to keep an eye and a hand on it. You want to always check that the slew path is free of cables/cords and any potential obstructions before initiating the telescope's movement. Checking to insure that the camera is secure and tight is always a prudent precaution, as is watching the whole slewing movement from start to finish.

Rule #4: Have a Red Headlamp for Nighttime

We previously discussed getting a red/white LED headlamp, and now you will see why. You need red light to operate safely and efficiently in the dark. It takes about twenty minutes for your eyes to get fully dark adapted (when you are young) and a split second to lose your night vision if exposed to white light. So when it is dark, red light is the rule, even on your computer and other devices. Astronomical software should have a night vision provision so you can preserve your night vision. The headlamp keeps your hands free, so Rule 3 can be followed as well as handling all of your other gear plus taking astropics. Keep your red light on whenever moving about, getting gear, and operating the camera and telescope. The light goes off when sitting and/or taking exposures.

The white light is for emergency use only or when night vision is no longer required, such as when packing up if you are alone. If others are present and still observing/photographing, red light it is. You will want to scan the area where you were after a session to make sure nothing has been left behind.

Make sure you have spare batteries for the LED.

Rule #5: Take What the Sky Gives You

Unless you have perfect seeing and transparency, no cloud cover and no light pollution, chances are you will have to contend with one, some or all of these in each astropic session you have. That's okay. As you develop your astrophotographer's eye, learning to read sky conditions and fine tuning the processing of your astropics, you will be able to make the most of each astropic session.

If the seeing is bad, and transparency is good with the Moon not too bright, try for all-sky pics or the Milky Way if it is up in Camera Only mode. Same conditions for Camera and Telescope mode could be a DSO session.

Reversing the above conditions could still lead to an all-sky session with Camera Only, it would depend on how bad transparency conditions are. Camera and Telescope mode would be prime time for lunar and planetary.

Cloud cover is usually the deciding factor for a Go-No Go decision to set up. This is where *Clear Sky Chart* is invaluable, giving you an hour by hour forecast. If there is some big sky event coming up, unless it is 100% overcast, it is worth monitoring the sky. If the cloud cover is down in the 50% overcast range with improving conditions it is worth considering setting up.

It becomes a personal choice of convenience at that point, as there will be other nights (and days) to conduct an astropic session. For routine astropic sessions, i.e., no big astronomical event occurring, look for one to two days of clear skies forecast. This makes setting up in Camera and Telescope mode worthwhile. Camera Only mode is a cinch to set up, so any stretch of clear skies can easily be enjoyed.

Rule #6: Focus, Focus, Focus

Operating in either Camera Only and Camera and Telescope mode, Rule #6 is critical for getting good astropics. Without the best possible focus your resulting astropic image will suffer. The majority of focusing, regardless of camera type and operating mode, will be done manually, as autofocus just doesn't work most of the time.

Focus is easier to obtain in Camera Only mode, as the focal lengths of your lenses and atmospheric conditions do not severely impact your ability to get a sharp focus. Using Live View and Zoom Mode, which hopefully your digital camera has, allows you to focus on the Moon, a bright star or planet. Work the lens focusing ring back and forth while looking at the image on the LCD panel. Be sure to remove the LCD plastic protection cover for best viewing and replace when done. You will see a best focus where the astro-object you are looking at is sharp and crisp. The beauty of digital is that you can take a test shot to confirm focus – Rule #8 and SAAS at work here.

For film cameras you do the same procedure but look through the camera viewfinder. There are magnifiers for camera viewfinders that can help in getting a better view and thereby better focus.

If you are using a CCD pure astrocamera hooked up to one of your lenses you will be seeing the view on your computer. The same procedure applies except you will have a bigger screen to view. Make sure your display brightness is at maximum and use full screen. You may be able to expand the view depending on your computer OS and CCD's software.

Once you have that focus you can frame your shots and take your astropics. You have to be careful not to change focus by accidentally nudging the focus ring on your lens. A small piece of clear tape can be placed on the lens barrel-focus ring if you desire. Just don't use duct tape, which will leave a residue.

In Camera and Telescope mode focusing is impacted by what you are trying to photograph – Sun, Moon, planets, stars, DSOs – and by what method. For instance, prime focus images will be far less magnified than

eyepiece projection or Barlow/extender images. Seeing will be a much bigger factor in the latter than the former due to increased magnification. This is where Rule #5 really comes into play. If the seeing is no good at high magnification, does lower magnification help? If it does, maybe it is a prime focus only session. If not, maybe it is a visual only session.

The focusing method for each camera type is the same at the telescope as it is in Camera Only mode. The only exception is that you are probably not using a lens for the afocal method with digital, film or pure astrocamera; your smartphone should autofocus okay on bright astronomical objects in the eyepiece.

Prime focus, eyepiece projection, Barlow/extender method will require that you use the telescope's focuser to achieve best focus while monitoring via the camera LCD panel or computer screen. It will take much more time at the telescope for you get a good focus as you watch the shimmering image of the Sun (with proper filters), Moon or planets. How much shimmering will be dependent on seeing conditions and how much magnification you are using.

You will work the telescope's focuser back and forth to get the best focus. Remember, seeing conditions may not provide a solid, focused image. Reducing magnification can help but so can taking multiple frames via video on your DSLR if it can or using a pure astrocamera to get lots of frames – hundreds or even a thousand. This single image versus many images technique will be discussed in Chapter 21.

Dim DSOs at prime focus may not even be visible in your camera LCD or computer display. Focusing on a bright star will help you achieve focus in the telescope. If you have an *ASiair* use the focus mode – it *really* works! Starting out you will likely take just one image of a DSO, but multiple images can be taken to enhance a final image product, as you will see in Chapter 21.

A final thought. When you think you have best focus just check it again via SAAS to make sure. A quick confirming image, even for DSOs (use just enough exposure time to get some stars), goes a long way to focusing success.

Rule #7: Use the Highest ISO Feasible

This rule is pretty self-explanatory, as in Camera Only mode a higher ISO can provide more detail for all-sky pics and the Milky Way. You just have to trade off noise in the form of granular-looking images from too high an ISO to one that is too low to pull out image details. A good starting point to

SAAS all-sky pics and the Milky Way, taken with ultra, wide and medium focal length lenses, is 3200. When you get above 5000 granular noise becomes readily apparent. Some image processing software has noise reduction tools to help mitigate the problem. But too high an ISO with a long exposure will probably overwhelm the ability of these tools to render a truly decent image.

In Camera and Telescope mode taking lunar and planetary images with a higher ISO may help reduce exposure times, which in turn can possibly mitigate seeing effects. Higher magnification will mean less light, which a higher ISO might help. For DSOs ISO 3200 is a good starting point. In all images – SAAS.

Rule #8: More Is Better – Shoot, Shoot, Shoot Pictures

In both operating modes and all camera types (even film cameras but with limitations already described previously) the world of digital lets you take lots of astropics. Get the setup you want, achieve best focus and SAAS. Rarely will you get the pic you want on the first exposure. But that is okay when you SAAS. Seeing conditions rapidly change, so if shooting single frames at the telescope in eyepiece projection, with a Barlow or extension, you may get lucky for good seeing. Video and pure astrocameras improve your "best pic" odds substantially because of the sheer number of exposures.

Rule #9: Keep the Color Real

We'll discuss this again later, but let's be crystal clear here about "astrophotography ethics" rules all astrophotographers should abide by to "keep it real" in our astropics. Far too often there have been published astropics that have been processed to the point where they do not truly represent the astronomical object imaged. If you are doing a work of art, fine, say so up front. Never add color to an image – never! Processing an image using accepted tools to improve contrast, white balance, etc., that is acceptable. But adding color and additional images to make a composite, especially without saying so to the viewing audience, is a no-no. Do not attempt to improve upon the Universe.

Rule #10: Learn from Each Astropic

With each image you take of the Universe, regardless of what astronomical object it is, you are capturing an instant of time that will never occur again in your life or the life of the Universe. When you see each image for the first time, take a few moments to realize what it is you have photographed. Even if the image is not that good, it is still unique in space and time never to be repeated. As you will see later it is possible to take images that "don't look that good" and resurrect them. Your "astrophotographer's eye" will develop in looking at your images and help you determine which ones to keep and which ones to delete. Take time to look at each of your images and be impressed at what it took for you to obtain it. Photons of light had to travel through space and time to reach the sensor of your camera. Whether the image is of an object in the Solar System, from within the Milky Way, or a distant DSO, each has a story to tell.

Learn something about the astronomical objects you photograph. Look at your image and view a reputable reference regarding it. Compare what is said to what is seen. A story is being told at a moment never to be again. Take the time to relish it.

Chapter 9

Getting Acquainted with the Sky

It is time to put the *astro* into astrophotography, as so far we have only been discussing the photography side of the subject. There are some basics you need to know about the sky in order to be able to take astropics. With our unaided eyes – assuming they are healthy – from a dark sky site you can see several thousand stars. It has been estimated that there are 9,096 stars visible to the unaided eye using a very dark sky site model that uses stars to magnitude (we discuss this next) +6.5, which is the limit of unaided eye visibility. This roughly equates to 4,045 stars in each hemisphere. How many you can see from your location will be mostly determined by light pollution, your own visual acuity and how much of the sky you can actually see from your viewing location.

Twilight

The Sun rises, the Sun sets, days and nights come and go. True. But now that you are in the world of astronomy and astrophotography, it isn't that simple. There are types of twilight that occur before sunrise and after sunset. Your astronomical software will compute the times for these events – sometimes dusk is substituted for twilight – based upon your lat/long/time zone inputs. This information should be part of your "Sun" data in your planetarium software.

© Springer Nature Switzerland AG 2020 141
G. I. Redfern, *Astrophotography is Easy!*, The Patrick Moore Practical
Astronomy Series, https://doi.org/10.1007/978-3-030-45943-7_9

Civil Twilight

Begins in the morning, or ends in the evening, when the geometric center of the Sun is 6 degrees below the horizon. Therefore morning civil twilight begins when the geometric center of the Sun is 6 degrees below the horizon, and ends at sunrise. Evening civil twilight begins at sunset, and ends when the geometric center of the Sun is 6 degrees below the horizon. Under these conditions absent fog or other restrictions, the brightest stars and planets can be seen, the horizon and terrestrial objects can be discerned, and in many cases, artificial lighting is not needed.

Nautical Twilight

Begins in the morning, or ends in the evening, when the geometric center of the Sun is 12 degrees below the horizon. In general, the term nautical twilight refers to sailors being able to take reliable readings via well-known stars because the horizon is still visible, even under moonless conditions. Absent fog or other restrictions, outlines of terrestrial objects may still be discernible, but detailed outdoor activities are likely curtailed without artificial illumination.

Astronomical Twilight

Begins in the morning, or ends in the evening, when the geometric center of the Sun is 18 degrees below the horizon. In astronomical twilight, sky illumination is so faint that most casual observers would regard the sky as fully dark, especially under urban or suburban light pollution. Under astronomical twilight, the horizon is not discernible, and moderately faint stars or planets can be observed with the naked eye under an unpolluted sky. But to test the limits of naked eye observations, the Sun needs to be more than 18 degrees below the horizon. Point light sources such as stars and planets can be readily studied by astronomers under astronomical twilight. But diffuse light sources such as galaxies, nebulae, and globular clusters need to be observed under a totally dark sky, again when the Sun is more than 18 degrees below the horizon.

As you can see, depending on the category of astronomical object you are interested in, the type of twilight present will impact when and what you can see in the evening and morning skies. It is important to know what they are so you can plan your astrophotography session accordingly as you will see in Chapter 11.

Star Color and Brightness

Stars can be seen and photographed in a variety of colors and brightnesses. Their color is an indication of their surface temperature, and just like the colors of a match – red, orange, yellow, blue indicating increased temperature – so it goes with the color of the stars, with white colored stars being the hottest. As you can see in this astropic, star colors and different star brightnesses abound in the sky.

Camera & Mode: D810a w/28-mm f/6.3 lens on tripod. Camera only.
ISO: 3200
Exposure: 9 Minutes, 27 seconds
Processing: Mac Photos

Fig. 9.1. The Polaris Vortex at the Shenandoah National Park in Virginia. Differing star colors and brightnesses along the Milky Way create trails as they rotate around Polaris, the North Star. (Image by the author.)

Common sense would dictate that the brightness of stars in the sky indicate which ones are closer, i.e., brighter ones are closer than dimmer ones. Astronomical reality is far more complicated when it comes to stellar brightnesses.

The brightest star at night is Sirius in the constellation Canis Major. Sirius is a wondrous sight to behold, especially when it twinkles near the horizon when rising or setting. It is this property of scintillation that gave the star its name, which means "glowing fiery" or "scorching" in Greek. Quite a few unidentified flying object (UFO) reports result from Sirius and

the planet Venus when they are very near the horizon because to novice observers they seem to move and change colors. That's the atmosphere and seeing at work, as you have previously learned.

A light year is defined by how far light travels in a year at the speed of light, which is 186,000 miles per second or 300,000 km per second. This makes a light year almost 6 trillion miles. Sirius is 8.4 light years from Earth, so when you look at Sirius subtract 8.4 years from the current date to determine the year the light you are seeing left the star. This book is being written in 2019, so seeing Sirius at some point means the light from Sirius left in the year 2011 traveling a distance of over 48 trillion miles.

The light from each star that we see at night enters our eyes to travel along our optical nerves to stimulate the visual cortex of our brains. Each of these stars is part of our Milky Way Galaxy, since we can see no individual stars outside of it with our unaided eyes.

The star nearest our planet beyond our star, the Sun, is located in the constellation Centaurus, which is best seen from the Southern Hemisphere. It is a red dwarf star called Proxima Centauri. It is 4.23 light years from Earth and cannot be seen with the unaided eye – it's pretty faint. Proxima and its two brighter companion stars Alpha Centauri A and B form a triple-star system, the closest star system to Earth.

Comparing the brightness of Sirius and Proxima to one another in the sky does not allow us to determine how close those stars are to us or how luminous (a star's energy output) they are just by looking at them.

Astronomers use a system of apparent and absolute magnitude to bring order to the brightness of stars and all astronomical objects. Apparent magnitude, known by "m," was instituted by the Greek astronomer Hipparchus (190 to 120 B. C.) around 129 B. C. to denote the levels of brightness of the stars in his star catalog. The brightest stars were designated 1st magnitude and the dimmest observable were 6th magnitude. The prominent astronomer Ptolemy (A. D. 100-170) adopted this system in A.D.140 for his own star catalog but also included the words "greater" and "smaller" in order to distinguish between stars in the same range of magnitude.

This magnitude system was used for 1,400 years until Galileo (1564-1642) observed stars with his telescope that could not be seen with the unaided eye. He designated these "stars of the seventh magnitude." With telescopes getting bigger and better through the years astronomers were seeing dimmer and dimmer stars, which had to move the magnitude scale down the numerical line. Not surprisingly the magnitude system was modified.

In the mid-nineteenth century astronomers established that a first magnitude star was approximately 100 times brighter than a 6th magnitude star. Accordingly each stellar magnitude equated to a brightness difference of approximately 2.5 times.

Several stars and Solar System objects were determined to be zero magnitude and brighter, with Sirius being −1.4 magnitude, Venus −4, the full Moon −13 and the Sun −26.

The Hubble Space Telescope (HST) can image 31st magnitude objects and dimmer. Remember, these are all apparent magnitudes (m). James Webb Space Telescope (JWST) and the monster 30+ meter ground-based telescopes will detect even dimmer objects.

In order to calculate the true brightness or luminosity of stars – comets and asteroids have their own absolute magnitude system – modern era astronomers devised a system of absolute magnitude – "M." Luminosity, or true brightness for stars, was calculated using a standard distance of 10 parsecs, or 32.4 light years.

Comparing stellar brightness using absolute magnitude (M) versus apparent magnitude (m) is revealing. Sirius would lose its title as the brightest star in the night sky, becoming +1.4 apparent magnitude. Our Sun would be barely visible at +4.5. Bright Rigel would become −8, so brilliant it could cast your shadow on a moonless night. Betelgeuse comes in at second place at −7. Your planetarium software will provide m and M values, surface temperature and size and mass of stars. Some stars will also have detailed descriptions. The Sun is a pipsqueak compared to some of the giant stars we know of.

Knowing the apparent magnitudes of astronomical objects as provided by your software and printed references will really help you find and identify stars and planets in the sky. But there is a far more precise way to navigate your way around the sky, especially when in Camera and Telescope mode.

Celestial Coordinates

The biggest astronomy and astrophotography requirement on your part is knowing your way around the sky and being able to identify and find your intended astronomical objects. There is a system of celestial coordinates that astronomers use to get around in the sky, and you will need to know how to do this as well.

Here on Earth we primarily use a system of coordinates based on latitude and longitude to mark or find a specific location on the planet. If you look at a detailed map of Earth you will see horizontal lines of latitude that go from 0 degrees, the equator, to 90 degrees, north or south, to Earth's poles. The equator is the dividing line for being in either the Northern or Southern Hemisphere of our planet.

While looking at your global map you will also see vertical lines that go from the North Pole to the South Pole and move around the planet in lines of longitude measured from 0 to 180 degrees east or west. The prime meridian is the historical line of reference for longitude and is located in Greenwich, England, at the Royal Observatory. Established in 1884 all positions on Earth were measured east or west from this reference point (Fig. 9.2). This marks the eastern and western hemispheres of our planet.

Fig. 9.2. The prime meridian, the Royal Observatory in Greenwich, England. (Image by Laurie Redfern.)

A position on Earth will be stated in degrees, minutes and seconds north or south latitude, degrees, minutes and seconds east or west longitude. (The minutes and seconds are not a function of time.) There are 60 seconds in one minute and 60 minutes in one degree for both latitude and longitude. An example is the latitude and longitude location of Palomar Observatory in San Diego, California, at 33°21′23″ N latitude, 116°51′54″ W longitude.

Our planet has an axial tilt of 23.5 degrees from the plane of its orbit around the Sun. In other words the planet is tilted 23.5 degrees from being at 90 degrees, or perfectly vertical. It is this tilt that gives us our seasons.

Celestial Sphere

The way astronomers find their way around the sky mimics the way we do here on Earth. Earth is positioned at the center of the celestial sphere, an imaginary sphere that encompasses the entire sky as seen from Earth. There

is a north celestial pole (NCP) and a south celestial pole (SCP) that are aligned with Earth's corresponding poles. There is the celestial equator – Earth's equator projected on to the celestial sphere – that divides the sky into parallel lines of north and south declination (Dec) that is measured from "+" (north) or "–" (south) 0 to 90 degrees from the celestial equator. North and south declination is measured in degrees, minutes and seconds.

From the NCP to the SCP there are vertical lines of right ascension (RA) that move eastward only from the Vernal Equinox, the point in the sky where the Sun is on the first day of spring. This is 0h RA, the prime meridian for the celestial sphere. It currently is in the constellation of Pisces the Fish; it used to be in Aries the Ram. RA is measured in hours, minutes and seconds. This allows astronomers to measure the RA location of a star by timing its passage through the meridian. For observers the meridian runs from due south through the point directly overhead, the zenith, to due north. Being on the meridian marks the highest possible point in the sky for any astronomical object. That is why we want to observe and photograph astronomical objects when they are closest to or on the meridian; being at their highest gives us a better chance to view and photograph them at their best by hopefully limiting the effects of seeing, as we have discussed previously.

Every astronomical object will have its position on the celestial sphere given in right ascension and declination. The famous Andromeda Galaxy (or to be precise its actual center, because it is elongated) is RA 0h 42m 44s, Dec +41° 16′ 9″.

This is how star charts – charts that show the stars and DSOs in the sky – are laid out, in RA and Dec. Star charts can be in printed form or electronic as is your planetarium software. Equatorial telescope mounts can have setting circles, RA (hour and minute marks) on your polar axis and Dec (degree and minute marks) on your declination axis to find or identify an astronomical object in the sky. These have to be set according to the mount's user's manual, which generally requires polar alignment and then sighting on a known star using its RA and Dec to align the setting circles accordingly. GOTO and computer-controlled mounts will display the RA and Dec in their interface.

All of this is fine and good, but what does this mean for the true beginner trying to find astronomical objects to view or photograph? It means that you still need to know the sky so you can tell what you are looking at that exact moment.

Finding Your Way in the Sky

Sure, you can rely on all of your technology – planetarium software and gyro and compass mode on your mobile device, GOTO telescope mounts – to find your way around the sky, but you really still should invest some time in learning the night sky. This isn't hard, and it can be quite relaxing (honest) and rewarding.

Set aside a few nights when the Moon is out of the sky, get a comfortable chair and set up where you have a good view of the sky from your home. Even if you are in downtown Los Angeles or New York City, the brighter stars, the Moon and the visible planets will shine through. Having only the brighter stars visible makes the process of learning the night sky easier, as the brighter constellations will be more apparent.

Even with your planetarium software it is a *really* good idea to have a trusted printed reference to go to. Earlier, the *Observer's Handbook* was recommended, as it is chock full of information on all things astronomical for a given year. You name it, you will probably find it in there, including rudimentary sky maps for each month as well as a break out for what is happening in the sky for each month. That is a big plus for determining when the Moon is not in the sky, what planets or sky sights might be visible, etc.

Another printed resource you should have is a subscription to either *Sky & Telescope* (S&T) or *Astronomy* magazine. Each month's printed and digital editions for these magazines provide the latest on astronomical research and news, space missions, various product reviews, astrophotography submissions and details on the sky for the month. Both magazines provide an excellent monthly star chart as well as a calendar of sky events, some of which are highlighted by diagrams. Each magazine also has an excellent website with a myriad of apps, news and tips you can use.

Using your trusty red headlamp and planetarium software in night vision mode and set to your location's Lat/Long, Date, Time and Time Zone, kick back and take in the sky. It is best to face east if possible, so you can see the stars as they rise. Ideally you will be able to see north and south as well. Determine where these cardinal points are on your horizon using the compass app (you should have one) on your mobile device. Try to align them with something on the horizon so you know at a glance the direction you are facing.

Turn your gaze to the north. If you are in the Northern Hemisphere the star Polaris will be anywhere from very near the horizon if you are near the equator to directly overhead if you are at the North Pole. Your location's

latitude will determine how high Polaris is above the northern horizon – they will be the same. Polaris is visible all night and all year round, as it is less than a degree from true north and the NCP. The night sky will revolve around Polaris from east to west.

If you are in the Southern Hemisphere you do not have a bright star such as Polaris to guide you to the SCP. You have to find Sigma Octantis, a dim star, but visible in a dark sky or with optical aid. The Southern Cross can help you, as it always points along its long axis to the south.

When you have your respective pole established, use your planetarium software in gyro or compass mode so the app "follows you" as you wander the sky. Use your app along with a star chart to look around the sky, working your way down from the zenith to the north, south, east and west. There are 88 constellations – officially established star patterns and their boundaries – that cover the entire sky, and you can only see them all if you are directly on the equator.

The time of year determines what constellations and stars are visible in the night sky. Earth goes through four seasons annually – winter, spring, summer and fall, and you may recall that they are caused by the 23.5 degree tilt of our planet's axis and our yearly orbit around the Sun. An interesting point to consider is that if Earth had zero axial tilt there would be no seasons at all, and each day would be exactly like every other one, with 12 hours of daylight and 12 hours of night.

We only experience this occurrence of equal hours (nearly so) of night and day each year on two days. One is the vernal equinox, which occurs on or near March 21 and marks the beginning of spring in the Northern Hemisphere and fall for the Southern Hemisphere. The other day is the autumnal equinox, which occurs on or near September 21 and marks the beginning of fall for the Northern Hemisphere and spring for the Southern Hemisphere. In Latin equinox means "equal night," and so the two equinoxes signify the almost equal hours of day and night. We say almost equal, as slight variations due to atmospheric refraction can vary the actual hours of day and night.

Winter starts on the winter solstice, on or around December 21 in the Northern Hemisphere, while it is the summer solstice for the Southern Hemisphere. In the Northern Hemisphere, summer starts on the summer solstice on or around June 21, with the winter solstice starting for the Southern Hemisphere. For both hemispheres the winter solstice is the shortest day of the year because the Sun is at its lowest point in the sky for the year as it crosses the meridian. Summer solstice is the longest day of the year for both hemispheres, as the Sun is at its highest point in the sky as it crosses the meridian.

This is not critical to your sessions, but if you have a clear view of the eastern horizon you can watch the progression of the Sun rising along the horizon each day of the year. In each hemisphere use the appropriate seasonal date to mark where the Sun is and watch it shift its position along the horizon. It will move along the eastern horizon either north or south depending on what season it is, as is explained next.

After the winter solstice the Sun moves towards the north, reaching due east at sunrise on the vernal equinox. It then continues north until reaching its farthest point north on the summer solstice. The Sun then starts to move along the horizon towards the south.

The Sun will rise due east on the autumnal equinox and then move farther south along the horizon until it reaches the winter solstice. This same progression is visible along the horizon at sunset, with the Sun setting due west on the equinoxes.

This can become a daily habit to visually watch the motions in the sky, all of which you can see easily in your software. As you become familiar with the sky, the stars and constellations that are visible can tell you what season it is just by looking at them!

Earth orbits the Sun every 365.25 days, which defines a year. This orbital motion causes Earth to move a little less than a degree a day on average, which in turn causes the stars to rise in the east a little earlier each night by approximately four minutes. Once again you can see this happen using your software. Just pick a bright star in your hemisphere's sky on the date and time of your choice. Try to pick one that is near the eastern horizon. Have your horizon view as wide as you can make it, so that you can see your selected star in the east (left), with the meridian – south – in the center of the sky view.

Using the "date and time" feature choose "Day" and click on the arrow that moves the sky one day at a time or continuously. As the date changes look at the star's motion from night to night, and you will see it move across the sky from east to west to eventually disappear into the Sun's glare. This is how the stars and constellations change in the sky as we orbit the Sun.

The Sun, Moon and planets move across the sky in a path called the ecliptic, which is comprised of thirteen constellations, twelve of which make up the astrological zodiac. In order from west to east in the sky we have:

- Aries the Ram
- Taurus the Bull
- Gemini the Twins
- Cancer the Crab
- Leo the Lion

- Virgo the Virgin
- Libra the Scales
- Scorpius the Scorpion
- Ophiuchus the Serpent Bearer (not an astrology zodiac constellation) just barely touches the ecliptic during the summer months
- Sagittarius the Archer
- Capricornus the Sea Goat
- Aquarius the Water Carrier
- Pisces the Fish

The Sun spends roughly one month in each of the constellations of the zodiac, while the Moon moves roughly 12 degrees across the sky each 24-hour period. The motion of each of the planets across the sky varies significantly due to their orbital periods around the Sun. Mercury moves the fastest in the sky, while Pluto is the slowest.

On any given day or night you will find these Solar System objects in the ecliptic. It may be a surprise to you, but you can see the Moon and bright planets during the day. The Moon is quite easy to see visually, but the bright planets require that you know where to look precisely. Binoculars or better yet a telescope will help you zero in on Mercury, Venus, Mars and Jupiter.

SAFETY NOTE: Never get too close to the Sun when looking for and observing/photographing the daytime Moon and planets. Keep the Sun far away, so there is *zero* chance it will enter your field of view – the farther the safer. Always block the Sun with a building or hill. If you can't, try another day when you can. Remember, the Sun, Moon and the planets are moving, as is your telescope if it has a clock drive, so don't get close to the Sun! Eyes exposed to sunlight in any manner, no matter how briefly, will injure them. If in doubt, look another day, and don't take chances! As an added safety precaution close or cap your camera viewfinder and use Live View Only.

As your skywatching skills improve with the help of your software, printed resources and actual time spent watching the sky this will significantly help you in your Camera Only and Camera and Telescope sessions, as you will see in the next chapter.

Because we live on a spherical planet Earth determines what you can photograph and see in the sky. At the North or South Pole you will see the stars moving from east to west during the night and never rise or set. The stars you see are from + or –90 degrees declination to 0 degrees declination.

If you are on or near the equator you could possibly see simultaneously Polaris and Sigma Octantis, each marking the area of the NCP and SCP. They would be hard to see if exactly on the northern and southern horizons,

due to any haze present and the thick atmosphere. At the equator the entire sky of both hemispheres is visible, and it is really something to see.

Most of us will not be living at the poles or exactly on the equator, so we need to figure out what will be visible in the night sky from your location. From an ideal location with a perfectly clear view of the horizon we could see 360 degrees in azimuth and 0 to 90 degrees in altitude – horizon to directly overhead at the zenith. When you look at the stars from your location you can only observe a portion of the sky that is defined by your latitude.

In the Northern Hemisphere the North Star, Polaris, shows your location's latitude for all intents and purposes, as it is so near the NCP. And when you know your location's latitude you can establish how far south you can see stars. Here are two ways to figure this out. You can input your location's latitude and longitude into your planetarium software. Be sure you have the meridian and horizon features turned on and aligned in order to be looking due south in horizon view. Next zoom in so that you can see any stars that are directly on the meridian. If there aren't any, advance the sky using the minutes or seconds button on your date/time feature until there are stars on the meridian. Choose a star that is on the meridian and very close to or right on the horizon and then select "info" for that star.

The software will provide information and data on the star. This will include its altitude in degrees above the horizon and its azimuth in degrees along the horizon. This information tells you where it is in your location's sky. The star's "Celestial Coordinates" in right ascension and declination – we discussed this earlier in the chapter – provide the position of the star on the celestial sphere. The declination coordinate is the key to what you can see in your sky, as it marks the horizon limit for stars having that declination. Any star with a declination that is less than this limit as measured towards the celestial equator can't be seen, as it will always be below the location's horizon.

For the Southern Hemisphere you do the same procedure except you work from Sigma Octantis and the SCP towards the Northern Hemisphere. Stars with a greater declination than the declination limit, as measured towards the celestial equator, will always be below your northern horizon.

The second method simply takes your location's latitude and subtracts it from 90 degrees. For a Northern Hemisphere location put "−" in front of the result, thereby showing how far south you can see objects on the celestial sphere. For the Southern Hemisphere add a "+" to your answer to determine how far north you can see objects on the celestial sphere. Knowing this becomes very important in our next chapter, as it determines what you can see and photograph in the sky.

The Big Scheme of Things in the Sky

In your astrophotography, whether it is Camera Only or Camera and Telescope you will come across an astronomical zoo of objects. We will look at them individually in later chapters, but it might be helpful to have a "sense" of what we see and photograph in the sky. This will be a basic orientation, but hey, that is what this book is all about.

From your location on Planet Earth you look out into the sky. During the day the Sun, our star, dominates, but the Moon and some bright planets can be found, as we have discussed. As night approaches the stars begin to appear with obviously the brightest ones first followed by those we can see according to the conditions in the sky, the Moon's phase and of course light pollution. When it is completely dark the constellations, visible planets and perhaps even our Milky Way Galaxy will be in the sky.

The view with your unaided eyes will mimic what you can photograph in Camera Only mode, except that your camera and lenses will be far more sensitive and therefore capture more sky detail. In this mode our Solar System and its planets, comets, asteroids and our Moon take center stage. In this mode you can also image our home galaxy, the Milky Way, some of its individual stars as well as some of the star clusters and nebulae within our galaxy. Depending on your camera setup and location it is possible to photograph a few galaxies, especially the Andromeda Galaxy and the Magellanic Clouds.

When you operate in Camera and Telescope mode all of the objects in Camera Only mode are accessible but with more magnification and a smaller field of view. But what this mode does that you can't do with Camera Only mode is go *way* farther back in time to view and image galaxies that are many millions of light years away. How far back in time you can go will be determined by your location's sky conditions and latitude, which determines what DSOs are in your viewing range as well as the size of your telescope and the camera set up you use.

The astrophotograph shown in Fig. 9.3 is of the Quasar 0957+561, which is a whopping 8.7 billion light years from Earth. It was remotely imaged using a Slooh rental telescope located in the Canary Islands. A quasar is a galaxy that has an active (feeding) supermassive black hole at its center, making the galaxy extremely bright and visible at great distances in the Universe. This quasar has great significance in the history of astronomy, as it was the first discovery (1979) of a gravitational lens, a warping of space caused by the presence of a great amount of matter that causes light to bend around it, which was predicted by Einstein's General Theory of Relativity.

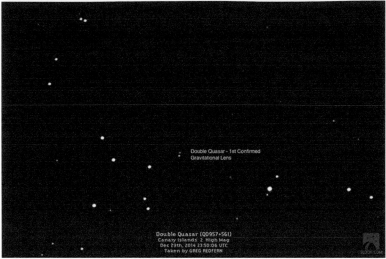

Double Quasar - 1st Confirmed
Gravitational Lens

Double Quasar (QQ957+561)
Canary Islands 2 High Mag
Dec 29th, 2014 23:50:06 UTC
Taken by GREG REDFERN

Camera & Mode: Remote Slooh telescope
ISO: 3200
Exposure: 5 minutes
Processing: Automatic

Fig. 9.3. Quasar 0957+561, first confirmed gravitational lens. (Image by the author.)

Bottom Line

Pushing the distance of your galaxy images farther and farther back may be one of your astrophotography goals. Or it may be getting the best possible pictures of the Milky Way, nearby DSOs in our galaxy or members of our Solar System. The point to all of this is that you can do whatever you want to do in photographing the sky in either mode. But, you have to know what is in the sky at a given date and time and then where to find your astronomical object of interest. Hopefully we have prepared you well enough that you can start doing so.

There is one more piece to the astrophotography puzzle that you need to consider before you embark on taking that first astropic, and that is, where will you take your astropics? This is the subject of our next chapter.

Chapter 10

Location Matters

We have come far in our preparations for taking that possibly first ever astropic, but we aren't there quite yet. If you have followed the chapters you know about the hardware side of astrophotography, some good rules to follow and you are beginning to learn your way around the sky. But what about the "Where do we do this?" of our shared pursuit? The good news is it is possible to take astropics anywhere – sea, air, land and space. The bad news is that it is tough to get locations that fit all the requirements for getting good images.

You have already learned about how seeing and transparency can have a significant effect on your astropics and what mode you are trying to operate in. Light pollution can be a big problem if you are reaching for the faint DSO fuzzies, all-sky astropics and the Milky Way in either mode. Lunar and planetary astropics can blow through light pollution easily, even in downtown New York City, but need good seeing for decent images, which a city location can provide by the way.

It helps to know the level of light pollution at your desired location. Knowing what light pollution you may encounter will help you decide if your proposed location will be suitable for the type of astronomical object(s) you want to observe and/or photograph. This is useful to determine if you need to get a light pollution filter for visual and astropic use. A very useful tool for checking this out has been provided in the Chapter 23 links for this chapter.

© Springer Nature Switzerland AG 2020
G. I. Redfern, *Astrophotography is Easy!*, The Patrick Moore Practical Astronomy Series, https://doi.org/10.1007/978-3-030-45943-7_10

Home Observatory

Your home, whether it be a house, apartment, condo or other form of domicile can be your "observatory." We are not talking about a real observatory structure, although you may build one someday. Odds are that you will do most of your observing and astrophotography in Camera Only or Camera and Telescope modes at your "home observatory," where you set up, take astropics and then take everything back inside. You really want to break in to astrophotography from the comfort and convenience of your home because it is a forgiving and easy access environment. You have ready access to phone, toilet and power in a location where you can be relaxed and concentrate on learning your new craft. As you shall see, there can be exciting times to be had at away from home locations. But when starting out don't venture far from home because the lessons you learn there will be applicable to the field, and your learning curve with all of its challenges will be far easier to manage.

If you have a garage or well-built storage shed it is possible to make your telescope mobile by placing it on a mobile platform that can be wheeled in and out. There are manufacturers as well as "do it yourselfers (DIY)" who make these, and they are quite nifty if you have a storage area, a decent observing/imaging area and a telescope that lends itself to being placed on such a platform. These mobile platforms are pretty much restricted to use on level surfaces.

Try to have your Camera Only and Camera and Telescope gear stored near the exit you will use for set up and take down. This makes it easier, especially if you are in the basement with a walk out, or near a first floor exit. Try not to store your gear in the garage because it can get awfully hot and cold as well as be home to insects that can find their way into anything.

Fig. 10.1. Having shelves to stow your gear keeps it off the floor, compact and easier to handle. Note the observer chair, blue telescope and mount head transport/storage cases and stacking of plastic bins. (Image by the author.)

Your set up spot should be on grass and not concrete or asphalt, as the heat of the day will radiate away from these manmade surfaces, causing a local poor seeing cell. When you set up make sure your gear is clear of the sprinkler system if you have one!

Fig. 10.2. Author's telescope setup in backyard. Stone paver is level and will temperature adjust after several hours. (Image by the author.)

Hopefully you will not have any annoying neighbor lights or other sources of light pollution. If you do, and you cannot mitigate it any other way, it may be useful to consider getting a astro-tent – yes, such items are out there. There are two dealers listed in Chapter 23. They can also be useful if you go mobile with your observing. Maybe at some point you want a permanent setup, a real observatory. That is beyond the scope of this book, but there are companies and do-it-yourselfers (DIY) out there that build observatories and supply observatory domes if this is on your mega-wish list.

If your camera or telescope mount needs polar alignment for each session obviously you will need to have a view of the respective polar region of the sky to do so. In the Northern Hemisphere you want to be able to see Polaris, while for the Southern Hemisphere it is Sigma Octantis. If at all possible, regardless of whether it is in the Northern or Southern Hemisphere, you want a clear view of the meridian north to south. This would be essential as the Sun, stars, comets, asteroids, DSOs, Milky Way, Moon and planets all are at their highest in the sky and at their potentially best viewing when they are on the meridian.

Naturally you would like to have a clear 360 degree view of the horizon so you could see astronomical objects as they rise in the East and set in the

West. This is pretty hard to find unless you are in a rural area, and even then there may be obstructions on the horizon. It is possible to operate in both modes even if your horizon is completely obscured as long as the sky view is clear at some point. It is worth repeating that the best seeing conditions will probably be experienced the higher an object is in the sky. So unless you have a canopy of trees or tall skyscrapers obstructing all but a small area of the sky you should be fine.

Going Mobile

When and if you decide to go mobile to an observing site there are things you have to consider. First and foremost is, how will you get there? Will you be going by car or air or rail? The former will probably allow you to pack all of your gear into a vehicle, while the latter two will severely curtail what you can take, probably limiting you to Camera Only mode. There are telescopes that can be "stowed away" in airline overhead bins, but you have to decide if it is worth the hassle.

Going mobile in a car requires that all of your gear will fit and be safely stowed while in transit. You do not want astro gear boxes flying around the car in a panic stop or, heaven forbid, accident. So when you pack make sure that everything is stowed securely. Try to pack your vehicle so that items you need for your set up sequence are accessible in the same order necessary for that sequence. What you want to avoid is the first piece needed for your setup is way in the back where you can't get to it. Rule of thumb, if at all possible when packing is first needed, last packed. That may not work due to the layout of your car and gear geometry, but it is a worthy goal to strive for.

Fig. 10.3. Going mobile. All gear is secured and rear view mirror is not blocked. (Image by the author.)

The primary "going mobile" question is, where? Here are some considerations.

Star Parties

If you have joined an astronomy club or live near a university or museum that is into astronomy, you may be able to partake in regularly conducted star parties. Star parties are when a group of people with telescopes get together at a prearranged site and date – usually around the time when the Moon is out of the sky so DSOs will be visible – to observe and photograph the sky. These can be for one night or can go on for several nights. There are a number of national level star parties in the United States that are held annually and attract people from all over the world. If you have a monthly subscription to *Astronomy* or *Sky & Telescope* they publish events like these months in advance. Star parties are usually held in dark sky sites and can be a great time even during the day with talks, raffles, astronomical chit-chat, buying/swapping gear and solar viewing (with the proper filter and procedures). Be sure to check this out as an option.

Designated Dark Sky Sites

You may live near a designated dark sky site as determined by the International Dark Sky Places program, which is administered by the International Dark-Sky Association (IDA). The program offers six types of designations, and as of June 2019 there are 115 designated sites worldwide. Check out the IDA link in Chapter 23 to learn more about the program and see their interactive map for a possible site near you.

National and State Parks

Another great mobile option is going to a national or state park, if there is one in your area. You should be able to do an Internet search for your area to determine if you are fortunate to have access to such a place. Generally these locations are rural and have good skies. Some may even have campgrounds or cabins you can rent, places to eat and gas stations. It really is wonderful to be in such places by day and enjoying their skies at night. There usually is an access fee, and you may get some curious looks by

people passing by, perhaps even asking to look through your telescope if you are in that mode. Some of the curious looks may be from law enforcement or the wildlife.

Do check in with the local law enforcement if possible to let them know you will be set up at some location. At the same time it is prudent to find out about the current conditions of nocturnal wildlife. Incidents involving bears are usually posted and at times a section of a park may be closed temporarily to keep distance between humans and wildlife. Also make sure you are cognizant of any criminal activity that has occurred in the area that you will be accessing.

Make sure you check about these items before heading out. Do not go to isolated and off the beaten path places without making sure you know what you are getting into and that someone knows where you are and your plans. Cell phone reception usually isn't reliable in the wild, either. Be aware and be prepared.

The National Park Service (NPS) hosts Night Sky Events at its parks across the United States and has an excellent website full of astronomy, light pollution, astrophotography and night sky resources plus event listings that you can peruse. Parks are a natural beacon for astronomy and night sky enthusiasts to flock to. Make sure you check the NPS link in Chapter 23.

Beaches

If you decide on a beach location try to make it one free from water and sand encounters. Neither of these is good for astro gear. If there is a wind up you also might have the issue of sea spray, which would be death to optics with salt crystals settling on coated and delicate surfaces.

Camera Only mode can offer some stunning astropics with moonlight or the Moon rising over a distant sea horizon. Substitute stars for the Moon and you have the potential for some really beautiful astro-sea pics. You have to be careful of your site selection for the reasons described, but it is much easier to set up and take down camera and tripod then it is telescope, camera and gear. Check out the tide tables too if on the beach.

Location Tips

So, you have decided upon your location. Regardless of where it is, be it home or mobile, there are some things you need to know and consider for each Camera Only or Camera and Telescope session. We will incorporate this into our next chapter, but we need to get into some details here.

Operating Mode

How you intend to operate can make a big difference in site selection and should be your first factor in site selection. Each operating mode has its own requirements as to the amount of space required and the layout of the ground itself. Camera Only needs less space and is more forgiving of land terrain than Camera and Telescope, which takes much more space and level ground is required.

Private Property and Fee Access

Do not go onto private property unless you have the permission of the land owner! Without having permission to be on private property this can lead to some dire consequences legally and personal safety wise. Don't do it! If in doubt, drive on until you are sure of the legal access to a site.

You may have to pay a fee to access a park. Fee collection may be on the honor system. That doesn't mean you can ignore it. Make sure you pay up.

Latitude/Longitude/Time Zone and Amenities

Your astronomical software will need this information in order to properly operate. Lat/long can be determined from apps on your smartphone and tablet. Your software should have an "Auto Location," which inputs directly and automatically this required information. If this can't be done due to lack of a signal (i.e., you are out in the boonies with no coverage) you can get it from a printed map *if* you have one with you or get the information before leaving home.

It is helpful to determine other information about your intended mobile location(s), such as available food, gas, lodging, medical assistance, police and fire station locations, access restrictions, wildlife present, safety notices. If you are going to a federal, state or county park or forest, this should all be online and updated regularly. There may even be an information brochure available when you get to a park.

If you really are heading out to the boonies you may need to get a USGS topographical map, which can be accessed via the link provided in Chapter 23. If headed to the boonies, for your safety take someone along or have a

check in/check out person that knows where you will be and your schedule. For safety's sake don't go it alone!

Once the latitude is known for your location do the quick calculation we previously discussed to ascertain the declination limit for astronomical objects you can see.

Light Pollution

Try to ascertain what the light pollution level is and where light cones (areas of concentrated light) will be located along your horizon. This could affect the astronomical object you are interested in if it is going to be smack dab in the middle of a light cone zone.

Physical Layout of Site

This comes into play more for a mobile location that you have not visited before. You would want to know where the horizon is, the sky view and the cardinal directions of N, S, E, W. You probably won't be able to determine this exactly until you are actually on site. You might be able to get a satellite view of the area or other information to help you zero in on an area.

This is so important it bears repeating. Know where emergency facilities such as hospitals, fire/police/ranger stations and telephones are located. A bad fall, a snake bite, a medical emergency and who knows what else may occur that requires immediate assistance. Know the 911 or emergency contact number for your location.

Not to get too personal, but in doing your site survey you will have to factor in restroom facilities. When Mother Nature calls know where to go, so to speak. If you have to go totally natural, be mindful of best hygiene practices and clean up the area and yourself. Having a roll of toilet paper is worth its weight in gold if there is none available!

It is best to do this on-site survey in daylight so you can see everything and learn your way around before the onset of night. Visualize your site set up in your mind as you walk the ground. This is really helpful to do. You will thank yourself that you did so, although your trusty red LED will come in handy at night to help with any issues.

Keep Notes

It really helps to keep notes on a mobile site that you use. Write down how the sky was, the facilities, the results of your session(s). Include lat/long and light pollution notes as well. This is done so that you can refer to your notes if you decide to use the site again.

Special "Going Mobile" Sites

We now live in an era where astrotourism – astronomy themed travel on land, sea, air and space – is thriving. No kidding, you can currently undertake travel on sea, land and air to do astronomy and astrophotography. Several space companies already have customers lined up to rocket into space, and in 2019 NASA announced that it would take paying passengers on the International Space Station (ISS)! More power to you if your travel budget can afford space-based astrophotography adventures, but you should check out land, sea and air travel jaunts. We'll explore this further in Chapter 22.

Site Selection Survey Checklist

It might be useful to use this checklist or something like it when you are surveying potential home and mobile sites.

SITE SELECTION SURVEY

TYPE:	(Home or Mobile)
NAME:	(Name of Site)
INTENDED MODE:	(Camera Only/Camera and Telescope)
PHYSICAL ADDRESS:	(Street Address or Reference)
PROPERTY STATUS:	(If Private, Permission Obtained; Public)
FEES:	(Cost for Access, Method of Payment)
HOURS OF OPERATION:	(Determine If Any Restrictions)
LAT/LONG:	(List In Degrees, Min, Sec; Provide Source)
TIME ZONE:	(List and Provide Source)
DECLINATION LIMIT:	(Sky Visibility Based on Latitude)
LIGHT POLLUTION:	(Estimated Magnitude & Sky Appearance)
MAP:	(Have a Detailed Map For Sites)

SITE REFERENCES:	(Internet, Site Brochures)
EMERGENCY LOCATIONS:	(Police, Fire, Medical Addresses & Phone)
AVAILABLE FACILITIES:	(Gas, Food, Lodging, Restrooms, Electricity Access)
CELL PHONE RECEPTION:	(Yes/No)
CHECK IN POC:	(For Solo & Mobile Have a Check In POC)
ON SITE SURVEY:	(Locate N, S, E, W on Horizon)
	(Any Sky View Obstructions)
	(Any Light Sources)
	(Determine Best Set Up Location)

Bottom Line

Whether at home or going mobile, the location where you want to observe and photograph the heavens is a very important consideration. Both operating modes have their own considerations but are perfectly suited to same site use. Doing a site section survey is a prudent step to take before committing to a specific location. You will be glad you did.

Well, we have reached the point where we are ready to put what we have learned and discussed to the ultimate test. It's astrophotography time!

Chapter 11

It's Astrophotography Time!

If you have been patient and reading the chapters in order, and you have the equipment to operate in Camera Only or Camera and Telescope mode, you should now be ready to conduct your first astrophotography session. Chapters 12 through 20 will provide specifics on photographing the different types of astronomical objects using these modes. This chapter addresses the necessary considerations you need to take into account in order to plan for and conduct a successful astrophotography (or viewing) session.

In this chapter we'll take it step by step and provide a checklist for you to follow. Feel free to modify the checklist to your liking, but use it as you are starting out.

Astronomical Object(s) of Interest

What do you want to photograph? It may sound like a simple question, but it really takes some thought. As you shall see next each type of astronomical object has its own special requirements to consider when planning a session. The selection of the object(s) you want to photograph is the "long pole in the tent" that drives session planning as you shall see.

Is there a specific astronomical event associated with your object(s) of interest, such as an eclipse, a satellite viewing, a lunar occultation, a moon of Jupiter coming into view, etc.?

© Springer Nature Switzerland AG 2020
G. I. Redfern, *Astrophotography is Easy!*, The Patrick Moore Practical
Astronomy Series, https://doi.org/10.1007/978-3-030-45943-7_11

Of course you can always conduct a "just get out under the sky and see what is there" session. These are fun to do but still require some planning. Your software may have an "Evening Best" option that is based on location and date and will provide you with a listing of what's up in the sky and further details.

Here are some special requirements for each type of astronomical object.

The Sun

Do not attempt any solar viewing or solar photography until you have checked out all of the warnings and safety procedures on viewing the Sun in this book. Failure to follow the rules will cause eye injury and damage to your equipment.

Do not leave your solar viewing and photography equipment unattended, as someone – especially a child – might try looking through it.

You will need to know the position of the Sun in the sky, altitude and azimuth, for your projected session start and end times. This is to insure there are no obstructions and to time your session so the Sun is at its highest altitude – transiting the meridian – for better seeing conditions. The Sun will have more favorable viewing conditions in your hemisphere's summer season and the weeks before and after due to its highest possible altitude in the sky for your site latitude.

It's very important to be set up away from concrete and asphalt surfaces and structures with roofs. These will radiate heat and probably produce degraded seeing conditions that will impact viewing and photographing the Sun.

You will be out in the Sun so be prepared with proper clothing, water and sunscreen. A sun hat with a wide brim that can be folded back is recommended. When in the sun the brim is down; at the eyepiece or camera it is folded up and out of the way.

Do not leave your camera or telescope gear out in the Sun! Doing so could damage it. Try to keep your gear in the shade or at a minimum, inside your gear transport cases. Consider covering your gear with your reflective telescope cover.

The Moon

Sunlight continuously moves across the surface of the Moon, and changes can be seen over a short period of time. Your software will tell you the percentage of lunar surface in sunlight. Knowing the phase will allow you to

determine if your specified crater or feature will be visible. Lunar map software or a Moon map will help locate and identify craters and lunar features.

You will need to know the position of the Moon in the sky, altitude and azimuth, for your projected session start and end times. This is to insure there are no obstructions and to time your session so the Moon is at its highest altitude – transiting the meridian – for better seeing conditions.

The Moon will have more favorable viewing conditions in your hemisphere's winter season and the weeks before and after due to its highest possible altitude in the sky for your site latitude.

Eclipses

Solar and lunar eclipses are covered in Chapter 14, as they have their own detailed requirements and checklist.

Planets

Specify which planet(s) and any particular feature(s) of interest, e.g., the Martian polar caps, Jupiter's Great Red Spot, or moons. Are you interested in a planet's phase? Software will provide you orbital data and other specifics.

The current year *Observer's Handbook* can provide background on each planet for its observing season and the position of any moons. This information can also be obtained by software and online resources at Astronomy. com and Sky and Telescope.com.

Planets will be their most visible at night when they are at opposition – directly opposite the Sun. The planet will rise at sunset and be visible all night. This will also be the time when they are at their brightest and closest, or within days of being so, from Earth.

Planets will be found within the 13 constellations of the ecliptic. Accordingly they will be high or low in the sky, depending on the constellation and your site's latitude. Once again your software and the *Observer's Handbook* will help you with details. You will want to see the planet at its highest altitude – transiting the meridian – for better seeing conditions. This can be during the day (being careful about avoiding the Sun) or at night for the brighter planets.

Unless you are planning to include the Moon in your astropics you want the Moon out of the sky when shooting all-sky.

You will want to determine the transparency (darkness) forecast of the sky to reach a good magnitude limit for your all sky session.

This class of astronomical objects is not as sensitive to position in the sky as are the previous classes. Meteor showers and aurorae can appear in various and changing positions in the sky. Constellations, stars and satellites will have a set motion in the sky that your software can take into account.

Constellations

Your software will provide the location in the sky of constellations you are interested in. It will also contain details about the constellations and highlights contained therein.

Stars

Individual stars can be located in the sky with your software as well as their data and description. Take note of the star's color and magnitude.

Meteor Showers

These events have specific date ranges that can vary from days to weeks with a predicted maximum. The *Observer's Handbook,* the American Meteor Society, Astronomy.com and Sky and Telescope.com can give you details on the shower.

Aurorae

Depending on your latitude these may be visible. There are a number of Aurora websites we discuss in Chapter 18 that provide aurora alerts and forecasts.

Sky Glows

The zodiacal light has specified times during the year when it is visible and the *Observer's Handbook* will note these. Noctilucent clouds (NLCs) have an observing season and are dependent on latitude and certain conditions needing to be present in order to be visible. Like the aurorae there are forecast sites to help monitor whether NLCs will be visible.

Other sky glows that we will discuss in Chapter 18 will be sensitive to transparency and Moon phase as they are very dim.

Satellites

The visibility of satellites will be noted on your software. Some software and websites will actually send you an alert when the desired satellite is rising.

DSOs

For DSOs you want the Moon out of the sky. You will also want to determine the transparency (darkness) forecast of the sky to reach a good magnitude limit for your session.

Although not as critical for seeing, you still want your DSO as high in the sky as possible – transiting the meridian – so the atmosphere is at its minimum thickness from your site.

What are you planning for your session? One DSO, several, a marathon? Make a list in the order that they will reach their best position in the sky. Your software can be a big help here in setting up an observing list or "best objects of the night" list.

The Milky Way

For the Milky Way you want the Moon out of the sky.

You will want to determine the transparency (darkness) forecast of the sky to reach a good magnitude limit for your session. In dark skies the Milky Way is very prominent.

Although not as critical for seeing, you still want the Milky Way as high in the sky as possible – transiting the meridian – so the atmosphere is at its minimum thickness from your site.

The Milky Way is a very large object and can sweep across the entire sky depending on your site's latitude and the time of year in your hemisphere. We discuss optimum times for viewing and photographing the Milky Way in Chapter 19.

Pre-Astrophotography Session Planning Checklist

Listing Astronomical Objects of Interest

What do you plan on photographing/observing during your session? It is helpful and efficient to list your intended objects in the order you will be photographing/observing them. It is best to start with when your objects will be at their highest – preferably on the meridian – and arrange them in order of their transiting.

Date

After selecting your astronomical objects of interest and reviewing associated requirements you can pick a proposed date(s) for your session.

Weather Forecast

What is the weather and the astronomical conditions forecast for your planned session? Make a Go-No-Go decision for the date(s) of your planned session. If Go, continue. If No-Go, determine alternate date(s).

Session Mode

Will you be operating in Camera Only or Camera and Telescope mode?

Astrophotography Technique

For each astronomical object category determine what astrophotography technique(s) you will be using for your session.

Equipment

Once you have decided what mode you will be operating in and the astrophotography technique to be used, you will need to determine what equipment is necessary to do so.

Solar, lunar and planetary will be very similar in equipment and astrophotography technique as will all-sky, DSOs and Milky Way.

Where will you conduct your session? Review your site surveys for necessary information, including longitude and latitude and time zone. Decide actual physical location where you will set up. Include travel time to your site. Your software should tell you when astronomical twilight occurs, after which night begins or when the night is ending. Check the times for the Moon rising or setting.

You will need to factor in the time necessary for actual set up in order to establish your session start time. You should know how long set up takes based upon the practice runs you would have conducted. Session timing should coincide with the best possible position of your astronomical object(s) in the sky, i.e., transiting the meridian or whatever specific photographic requirements you have. This timing should also take into consideration astronomical event time. Is there a specific time associated with your object of interest? Be sure to start set up well in advance so everything can be checked out and, if applicable, the telescope cooled down.

Astrophotography Session Checklist

If this is your first session, consider taking a selfie or having someone take a picture for you, of you and your gear set up. This is a memorable occasion for you, and as time goes on you will be glad you did. If solo set up your camera on a tripod and use the timer.

If going mobile pack and load your gear as previously discussed. If at home have everything set to take outside.

On Site Setup

Set up your gear slowly and methodically. Don't be in a hurry your first few times out. Think about what you are doing. This is where your prior practice sessions pay off. Don't hesitate to refer to user manuals if necessary. If possible set up well in advance of session start time and during daylight.

Equipment Check

- Camera
- Lenses
- Tripod
- Telescope
- Mount
- Power
- Spare batteries (at full power) and chargers available for all cameras, equipment and accessories
- Computer
- Software
- Cabling and network connections
- Accessories used in proposed astrophotography method

Taking Astrophotographs

1. Find, frame and verify your astronomical object of interest
2. Focus and re-check focus
3. Estimate Camera Settings for ISO, exposure and use Auto for White Balance and RAW for Image Quality and input them to camera
4. Take exposure
5. SAAS until satisfied with exposures
6. If desired, process exposures on site
7. Proceed until session is completed

If continuing for another and later session, secure gear in their containers or cover telescope/mount. Shut down power. Don't leave anything exposed to the Sun or possible weather.

If completed, carefully take down gear and stow in their containers. If mobile, securely load in vehicle and thoroughly check that nothing is left on the site, then check again. At, or when home, secure gear in storage area.

Make notes or comments on the session as desired.

Congratulations!!! You have completed your first astrophotography session! This is something you will remember, especially with the astropics you have taken, regardless of what they look like! There will never be a "first astropic" for you ever again.

Bottom Line

Prior proper planning prevents poor photography. Practice like you will execute, execute like you practiced. Get those selfies and first astropic and keep them for memory lane years from now.....you will be glad you did.

Chapter 12

The Sun

This chapter is all about safely viewing or safely photographing our very own star, the Sun, using eyes only, Camera Only or Camera and Telescope modes. This chapter is intended as a basic introduction only, as whole books have been written on viewing and photographing the Sun. See the Chapter 23 section on this chapter for additional information. Information on solar eclipses is provided in Chapter 14.

There is no information in this chapter on how to safely photograph the Sun using tablets, as there is so little information available. Do not use tablets for solar photography. They really wouldn't be able to show much anyway.

As you shall see, we recommend using only DSLR, film SLR, digital mirrorless cameras with electronic viewfinders (EVFs) and pure astrocameras in Camera Only and Camera and Telescope mode, as these are the safest and most efficient ways to photograph the Sun.

Sun Safety

Failure to follow these solar safety procedures will cause permanent eye damage as well as ruin your camera.

© Springer Nature Switzerland AG 2020
G. I. Redfern, *Astrophotography is Easy!*, The Patrick Moore Practical
Astronomy Series, https://doi.org/10.1007/978-3-030-45943-7_12

Eyes Only

1. NEVER look at the Sun with your eyes unless you have approved solar viewing glasses with certification ISO 12312-2 bought from a dealer recommended by the American Astronomical Society (AAS). These are also informally known as solar eclipse glasses. Follow all manufacturer guidelines and procedures including how to check them before each use. These solar eclipse glasses are for your eyes only and are never to be used for any other purpose.

NOTE: "Approved" means your solar eclipse glasses and solar filters were purchased from a dealer recommended by the American Astronomical Society (AAS). "Certified" means your solar eclipse glasses from an AAS recommended dealer meet the required ISO 12312-2 standard. For your solar filters, "certified" means that an AAS recommended solar filter dealer sells solar filters manufactured to industry standards. During the 2017 Great American Solar Eclipse some solar eclipse glasses were being sold as certified ISO 12312-2, which they weren't. This caused a major safety concern.

A link to the AAS list of reputable vendors for purchasing approved and certified ISO 12312-2 solar eclipse glasses and solar filters for your camera, viewfinder if applicable, lenses, telescope, telescope finder scope, binoculars and any other optical aids has been listed in Chapter 23.

2. As an extra safety precaution, even when using your safe solar viewing glasses, do not stare for long periods at the Sun. Look through the glasses briefly (seconds) and then look away. By doing so, any tiny hole or imperfection that is present is not likely to cause you any harm.
3. Never leave your solar viewing glasses unattended in order to prevent others, especially children, from attempting to look through them.

Camera Only

1. Never photograph or view the Sun with a camera unless you have a safe solar filter bought from a dealer recommended by the American Astronomical Society (AAS) that properly fits the front of the lens you are using. Follow all manufacturer guidelines and procedures, including how to check the solar filter before each use. If your camera has a viewfinder see #2, following.
2. Never photograph or look at the Sun through a camera viewfinder unless you have over the front of the viewfinder (sunward facing side) a properly fitting safe solar filter bought from a dealer recommended by the American Astronomical Society (AAS). Follow all manufacturer guide-

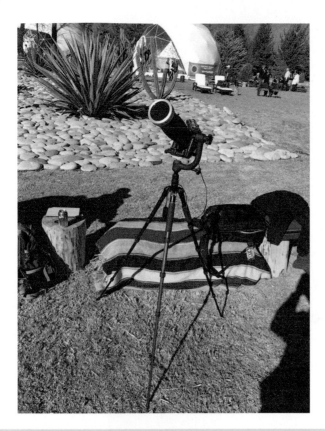

Fig. 12.1. This is the author's setup for Sun and solar eclipse astropics in Camera Only mode: a Nikon D810a with 200-500-mm f/3.5-5.6 zoom telephoto with Orion Telescopes glass solar filter over the front of the lens. The setup is mounted on a carbon fiber tripod with gimbal head. A 1.7x tele-converter is also used at times. (Image by the author.)

lines and procedures, including how to check the solar filter before each use. The viewfinders of digital single-lens reflex cameras, film single-lens reflex cameras and digital mirrorless cameras (CSCs) with electronic viewfinders (EVFs) are made safe by the use of a safe solar filter properly fitted on the front of the camera's lens.

3. As an extra safety precaution, do not stare at the Sun for long periods through your camera's viewfinder, even with an approved and certified solar filter on the viewfinder and/or camera's lens, again in case of holes or other imperfections in the solar filter. Look through it briefly (a few seconds) and then look away. If available use your camera's Live View function.

4. NEVER leave your equipment unattended in order to prevent others, especially children, from attempting to look through it.

Camera and Telescope

1. Never photograph or look at the Sun through a telescope unless you have a safe solar filter for the front/aperture of the telescope bought from a dealer recommended by the American Astronomical Society (AAS). Follow all manufacturer guidelines and procedures, including how to check the solar filter before each use.

Fig. 12.2. This is the author's setup for Sun and solar eclipse astropics in Camera and Telescope mode. There is a Thousand Oaks glass solar filter over the front/aperture of the telescope. (Image by the author.)

2. Never photograph or look at the Sun through a telescope finder 'scope unless you have a safe solar filter for the front/aperture of the telescope finder scope bought from a dealer recommended by the American Astronomical Society (AAS). Follow all manufacturer guidelines and procedures including how to check the solar filter before each use. If you do not have a solar filter for the telescope finder 'scope make sure it is covered and secured so that no sunlight can enter.

3. As an extra safety precaution, do not stare at the Sun visually or with a camera's viewfinder for long periods through your telescope or telescope finder 'scope with a safe solar filter on each, again in case of holes or other imperfections in the solar filters. Look through them briefly (a few seconds) and then look away. If using a camera attached to your telescope use your camera's Live View function or computer screen viewing if available. Digital mirrorless cameras with electronic viewfinders (EVFs) are safe to look through.

4. Never leave your telescope unattended in order to prevent someone, especially children, from attempting to look through it.

Binoculars or Other Optical Aids

1. Never photograph or look at the Sun through any optical aid such as binoculars or spotting 'scopes unless you have a safe solar filter for the front/ aperture of the optical aid (two solar filters for binoculars) you are using, bought from a dealer recommended by the American Astronomical Society (AAS). Follow all manufacturer guidelines and procedures, including how to check the solar filter before each use.

2. As an extra safety precaution, do not stare at the Sun for long periods through your optical aids with a safe solar filter(s), again in case of holes or other imperfections in the solar filters. Look through them briefly (a few seconds) and then look away.

3. Never leave your optical aids unattended in order to prevent others, especially children, from attempting to look through them.

Read and print out the information contained in the solar viewing and photographing safety listings in Chapter 23 to take with you in case you cannot access the Internet. If some of the link(s) are not operable when trying to access them, refer to https://eclipse.gsfc.nasa.gov/SEhelp/safety.html and https://eclipse.aas.org/eye-safety. The AAS link has active links for solar eclipse photography.

Camera Only Mode

Solar safety as we discussed at the beginning of this chapter is first and foremost.

It is strongly recommended using only DSLR and digital mirrorless cameras with electronic viewfinders in Camera Only mode, as these are the safest and most efficient way to photograph the Sun. If you choose to use a different camera type you do so at your own risk. These cameras can mount long focal length lenses with proper solar filters on the front of the lens and

capture detail on the Sun's disk. Being digital you can employ SAAS, which film cameras cannot do.

The proper solar filter, securely fitted on the front of the camera's lens, allows safe viewing (seconds only) through DSLR viewfinders and makes digital mirrorless cameras with electronic viewfinders completely safe. Both cameras should also have Live View capability that allows you to look at the Sun using the camera's LCD panel instead of through the viewfinder.

To see any detail on the Sun you need at least a 200-mm focal length lens. The longer your lens' focal length, the larger the solar disk will be and thus easier to see sunspots and solar transits which we discuss shortly. You can get an idea of focal length and solar disk size by some of the astropics in this chapter, but see Chapter 13, Fig. 13.5 a-e for a more detailed comparison. The Sun and Moon are both similar in apparent size in the sky so how the Moon appears in a certain focal length lens will be what you see with the Sun.

Here's now our Camera Only checklist:

1. Never point your camera at the Sun or have it pointed near the Sun unless a proper solar filter is securely on the front of the camera lens. This applies to camera viewfinders also if using camera types other than SLR, DSLR or mirrorless digital cameras, which is not recommended.
2. Never leave your solar viewing glasses, camera, telescope and optical aids unattended in order to prevent others, especially children, from attempting to look through it.
3. Complete the astropic session checklist from Chapter 11.
4. Be mindful of being out in the Sun. Remember to follow the special considerations for the Sun we discussed in Chapter 11.
5. Set up camera tripod. Use the tripod checklist and setup procedures from Chapter 6. Use the gimbal head described in Chapter 6 if you are using long focal length lenses. The solar filter on the front of your lens will make the lens-camera setup heavier, so check for proper balance of the gimbal or other tripod head. Your exposures will be fast, so image trailing and the resulting blur should not be an issue.
6. Check your solar filter before use, according to the manufacturer's guidelines.
7. Securely mount your proper solar filter over the front of your camera's lens (and viewfinder if not using a SLR, DSLR or mirrorless digital camera). Check for proper and secure fit with a slight tug. If windy conditions apply, add tape to solar filter-lens body (and viewfinder if applicable), making sure that all lens features are clear of tape so that they will function properly.
8. Attach camera to gimbal head or other tripod/mount. While holding the camera check for proper balance if using gimbal head. Adjust balance until camera remains steady when positioned.
9. Find the Sun, using safe solar viewing glasses to assist, and with a proper solar filter on the front of the lens (and viewfinder if applicable). Point

the camera at the Sun using Live View or your viewfinder (made safe with a solar filter if applicable) to center it in the frame.

10. Focus, using the zoom feature of Live View if available. Focus on the limb of the Sun or a sunspot until it is sharp.
11. As a starting point use the camera settings provided in the accompanying figures for this chapter. You can use auto mode on your camera to see how it does. Take an exposure and SAAS for focus and exposure settings. If focus is good, consider applying tape to "lock" the focus ring, especially if you are working a telephoto lens back and forth in focal lengths. If you are not satisfied with auto, go to manual mode and adjust lens f/stop and exposure using SAAS.
12. Take down setup when finished unless you will be photographing sunrise or sunset.

Photographing Solar Features

To see the Sun and any solar features that may be present – sunspots, solar flares, faculae – requires a safe solar filter over the front of a long focal length lens (and viewfinder if required) or a safe solar filter over the front/ aperture of a telescope and telescope finder (if the finder is used; if not it should be securely covered). The Sun in mid-2019 is at the minimum of the eleven-year solar cycle, with the Sun displaying no sunspots on most days through at least 2020 if predictions are correct.

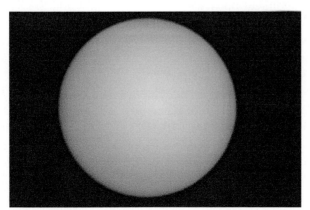

Camera & Mode: Nikon D810a Takahashi 250-mm prime focus w/reducer f/9.2. Camera and Telescope.
ISO: 400
Exposure: 1/500 of a second
Processing: Mac Photos

Fig. 12.3. No sunspots are visible in this 2019 white light view of the Sun taken through an approved and certified glass solar filter. The lack of spots is probably due to solar minimum. (Image by the author.)

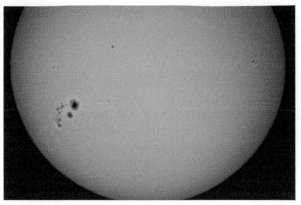

Camera & Mode: Nikon D810a Takahashi 250-mm Prime Focus w/reducer
f/9.2. Camera and Telescope.
ISO: 400
Exposure: 1/500 of a second
Processing: Mac Photos

Fig. 12.4. Sunspots and faculae are visible in this white light view of the Sun taken January 4, 2014, through an approved and certified glass solar filter. Note the sunspots. (Image by the author.)

Photographing Solar Transits

When an astronomical body passes between Earth and the Sun, and it can be seen crossing the Sun's disk as seen from Earth, it is called a solar transit. The three astronomical objects that have predicted solar transits are the planets Mercury and Venus and the International Space Station (ISS). We'll discuss ISS solar transits in Chapter 16.

To safely see and photograph a solar transit requires a long focal length lens equipped with a safe solar filter or a telescope and telescope finder 'scope equipped with a safe solar filter.

There was a solar transit of Mercury on May 9, 2016. There was also a solar transit of Mercury on November 11, 2019. The next Mercury solar transit will be on November 13, 2032, and the one after that, seven years later on November 7, 2039. There will be additional information available in the astronomical community months before each of the Mercury transits, so make sure you stay informed.

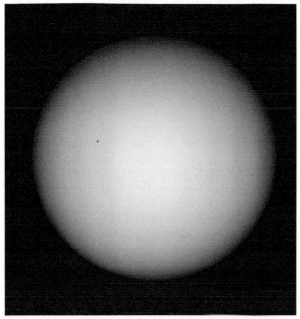

Camera & Mode: Nikon D810a with 200- to 500-mm telephoto and 1.7x
tele-extender for 850-mm at f/9.5 with glass solar filter. Camera Only.
ISO: 200
Exposure: 1/400 of a second
Processing: Mac Photos

Fig. 12.5. Mercury transit on November 11, 2019. Picture taken on the *Queen Elizabeth* at sea in the Atlantic Ocean off the east coast of Africa. This was a very difficult shot to take, as the Sun was high and the heat oppressive from being near the equator. Seeing was affected by the heat radiating off of the steel deck, and focusing on Mercury was very, very difficult, as the planet could not be seen in the LCD. Focus was finally achieved by autofocusing on the distant horizon and carefully framing the Sun for the shot. Black and white was used to offset color variances caused by extended processing to highlight Mercury. (Image by the author)

The author was fortunate to photograph in Camera Only mode two transits of Venus, which are much more rare solar transit events.

Venus has transits in 2117 and 2125, which none of us will be around for in all likelihood.

Camera & Mode: Nikon E5700 w/ 142-mm focal length, f/4.2, handheld.
Camera Only.
ISO: 400
Exposure: 1/60 of a second
Processing: Mac Photos

Fig. 12.6. Venus transit June 8, 2004. Shot taken with approved and certified solar filter. Very first digital camera that used one lens only. (Image by the author.)

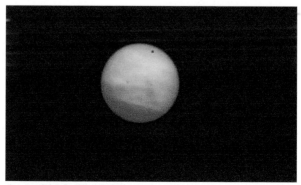

Camera & Mode: Nikon D5000 w/ 190-mm focal length zoom telephoto,
f/5.6, handheld. Camera Only.
ISO: 200
Exposure: 1/200 of a second
Processing: Mac Photos

Fig. 12.7. Venus transit, June 5, 2012. Taken on roadside on cloudy day, with breaks. Approved and certified solar filter used. (Image by the author.)

Photographing Sunrise and Sunset

Solar Safety: NEVER photograph the Sun's disk at any time including sunrise and sunset without a solar filter over the front of your camera's lens and, if applicable, covering your camera's viewfinder. Even at sunrise or sunset the Sun remains very, very bright and dangerous to your eyes and camera.

To photograph sunrise and sunset you do not need a solar filter as you will NOT be pointing your camera at the Sun, which will be below the horizon. This is a special time, as night is either ending or beginning, and it can make for some lovely astropics especially if there is sky color, clouds, planets, stars and/or the Moon present.

For extra solar safety use Live View and NEVER look through the camera viewfinder during sunrise/sunset. Just close or cap the viewfinder during sunrise/sunset. If your camera does not have LIVE VIEW just point it in the general area of sunrise/sunset.

For sunrise/sunset you will need to focus at Infinity and you can use your lens' Infinity mark' or better yet, a bright star. You can also use a planet, or the Moon, if they are visible. As a last resort—focus on a distant landmark.

For sunrise and sunset, use your camera's Auto mode, or even a sunrise/sunset mode that some cameras have for a recommended exposure. Try it and SAAS. You can always go to Manual Mode and SAAS away. A wide-angle lens, to capture as much of the sky as possible, is recommended.

With sunrise you will go from dark to increasing light, so if you are in "Manual," use ISO 800 to 1,000 while still somewhat dark, and then use a lower ISO as dawn approaches. Dawn will be in ISO 100 to 200 range for recommended exposures such as 1/125 second at f/8. SAAS applies.

At sunset you will have opposite conditions of sunrise with ever-decreasing light as night approaches so you have to adjust accordingly. You can try Auto Mode but, you will probably end up in "Manual" Mode to get the right exposure. With deepening twilight try 800–1,000 ISO with exposures at 1/2 to 1 second in deep twilight. SAAS.

Earth's Shadow

You have seen the Earth's shadow if you have ever seen a lunar eclipse—see Chap. 14. Our planet's shadow stretches out to almost a million miles. About 30 minutes before sunrise or sunset the Earth's shadow starts to develop on the horizon opposite to the Sun as a grayish-blue tint to the sky. At some point along the horizon there will be a pinkish band at its top

known as the Belt of Venus. The Belt of Venus is the last or the first of the Sun's rays of the day passing through Earth's atmosphere.

Earth's shadow is best photographed using a wide-angle lens such as a 14-mm f/2.8 prime or wide angle telephoto lens, to image as much of the horizon as possible. Less focal length and wider aperture is the name of the game, for the shadow and pinkish Belt of Venus. A tripod and shutter cable

Camera & Mode: D810a w28-300 telephoto zoom lens @ 28-mm f/7.1 on tripod. Camera Only.
ISO: 200
Exposure: 1/125 of a second
Processing: Mac Photos

Fig. 12.8. Earth's shadow, Belt of Venus, some haze and full Moon rising at Shenandoah National Park. (Image by the author.)

Table 12.1. Sun With Camera Only

Camera Type	Solar Surface Features	Solar Transits
Smartphone	NO	NO
Tablet	NO	NO
Pocket	NO	NO
Film SLR	YES	YES
CSCs	YES	YES
DSLR	YES	YES
Video	POSSIBLY*	POSSIBLY*
CCD/CMOS	POSSIBLY*	POSSIBLY*

* If equipped with lens capability.

release, or delayed shutter release option if your camera has it, is needed to minimize camera movement.

For pre-dawn Earth's shadow and Belt of Venus use lowest f-stop, start at ISO 1,000 with an exposure of 5 seconds. SAAS.

For sunset use ISO 800 highest f-stop and try half a second. SAAS.

Photographing the Sun: Camera and Telescope Mode

Solar safety, as we discussed at the beginning of this chapter, is first and foremost. Do not proceed unless you have read and fully understand solar safety as described earlier.

In Camera and Telescope mode the front/aperture of the telescope is covered with a proper solar filter that enables the safe use of a wide variety of camera types, which we discussed in Chapter 2. The front/aperture of your telescope finder 'scope will need its own solar filter or be securely covered so that no sunlight can come through.

A proper solar filter securely fitted on the front/aperture of the telescope (sunward facing) allows safe viewing (seconds only) through film SLR and DSLR viewfinders, while digital mirrorless cameras with electronic view-finders and smartphones are safe. Some camera types will have Live View or a computer screen viewing capability that allows you to look at the Sun using the camera's LCD panel or your computer screen. This is always the preferred method when photographing the Sun. Always cover up your camera viewfinder for safety and use the Live View. Pure astrocameras will likely send the Sun's image to your computer screen for viewing.

Here, now, is your checklist for Camera and Telescope:

1. Review solar safety procedures. Do not observe or photograph the Sun unless you have read and completely understand them. Never point the telescope at or near the Sun unless a safe solar filter is securely on the front/aperture of the telescope and telescope finder 'scope. If no solar fil-ter is used on the telescope finder 'scope make sure it is securely covered, so no sunlight can enter. Never leave your telescope unattended in order to prevent others, especially children, from attempting to look through it.
2. Complete the checklist from Chapter 11.
3. Be mindful of being out in the Sun.
4. Set up telescope. Conduct daytime polar alignment as discussed in Chapters 6 and 7. If applicable, use solar rate for mount's tracking speed. Lock axes.
5. Allow for telescope adjustment to outside temperature.
6. Check your solar filter before use, according to the manufacturer's guide-lines. Securely mount it over the front/aperture of your telescope and

telescope finder 'scope. If not using a solar filter over the telescope finder 'scope, securely cover it so no sunlight can enter. Check for proper and secure fit with a slight tug. If windy conditions apply, add tape to the solar filter on your telescope and telescope finder 'scope. Check telescope balance.

7. Find the Sun. If you don't use a solar filter on the telescope's finder 'scope, or a GOTO mount to find the Sun, here is a method to find the Sun that works with practice. With a solar filter in place on the front/aperture of your telescope use the shadows of the telescope tube and telescope finder 'scope on the ground to find the Sun. When their shadows are very elongated you are not very near the Sun. Move the telescope by hand or with your hand controller to make the shadows move toward being perfect circles on the ground. When you see circular shadows on the ground, using a low power eyepiece look at the telescope image. You should see the Sun's limb or some brightness in the view. Slowly move the telescope until you have the Sun in the field of view and then center. This takes some practice and time but it works.

You can also buy "sun finders" that attach to your telescope that help find the Sun using a solar projection method. You do not look through them. Follow the manufacturer's guidelines and procedures if you purchase such a unit.

Here's a tip: Before attaching your camera, with your solar filter over the front/aperture of your telescope, after finding the Sun view it at lowest mag-

Fig. 12.9. Elongated shadows of telescope and telescope finder on the ground. The larger the elongation the farther from the Sun the telescope is. (Image by the author.)

Fig. 12.10. Circular shadows of telescope and telescope finder on the ground. When you get a perfectly concentric circle you are very close to the Sun. You should be able to see it in a low power eyepiece or in the camera/computer display. (Image by the author.)

nification. Center the Sun to see as much of the solar disk as possible. Look for any surface features that may be present and get an idea of what you want to photograph and where it is on the Sun. If you want to photograph something center it and lock the telescope axes. Then proceed to attach your camera. Doing the visual check first at low power is easier than with a camera, although it can be done; it just takes more time.

Here's another tip: Attaching your camera with the necessary accessories may unbalance your telescope. Make sure you lock the mount axes when you are doing this, and be prepared for sudden telescope movement even if the axes are locked. Your telescope may be severely out of balance.

8. Use necessary accessories to attach a camera for the astrophotography method desired, i.e., afocal for smartphone, prime focus, Barlow, eyepiece projection.
9. Test for secure fit of camera to accessories and then on telescope.
10. Balance telescope.
11. Focus using the zoom feature of Live View or computer display if available. Focus on the limb of the Sun or your solar feature of interest until it is sharp.
12. As an exposure starting point use the author's settings provided in the accompanying figures for this chapter. You can use auto mode on your camera to see how it does. Take exposure and SAAS for focus and exposure settings. If you are not satisfied with auto, go to manual mode and adjust exposure using SAAS.
13. Take down setup when finished or cover up telescope with reflective cover.

Specific Wavelength Viewing of the Sun

It is possible to safely photograph and view the Sun in wavelengths other than white light. Although this a more advanced topic and capability for beginners, primarily due to cost and some complexity, it is being included for your edification. You must follow all manufacturer instructions and solar safety procedures when using these advanced systems.

There are a variety of solar telescopes designed and manufactured to only view and perhaps, depending on the telescope's capability, photograph the Sun in a specified wavelength. There are also specific wavelength solar filters available that allow you to use them with your telescope.

Hydrogen alpha wavelength telescopes and filters are very popular as they zero in on the fiery Sun in dramatic red light. The Sun is truly amazing to see in hydrogen alpha light. See the *Observer's Guide to the H-Alpha Sun* listed in Chapter 23.

Camera & Mode: Meade 200-mm SCT LX3 at Prime Focus Minolta 700x
High Speed Ektachrome film. Camera and Telescope.
ISO: 400
Exposure: Unknown
Processing: Mac Photos

Fig. 12.11. Solar prominences in hydrogen alpha. This is a copied slide that was processed. Prominences are visible on the limb of the Sun. (Image by the author.)

Some of the new units are powered to maintain a constant temperature and give views of both prominences and surface features. The use of an off axis energy reduction filter (ERF) may be required. The ERF has to be bought separately and must be matched with the type of telescope you have to insure proper and safe compatibility. This is straightforward to do on the Daystar website. You will also need a proper power supply to run the Quark Combo filter.

Setup must be done according to the Quark Combo's user's manual for proper safety and operation. It takes 5 to 15 minutes for the filter to reach operating temperature, which is dependent on the outdoor temperature. If the tuning knob is changed an additional amount of time is required to reach operating temperature.

Fig. 12.12. Daystar ERF with off axis optical window over front of the telescope. (Image by the author.)

Visually the view of the Sun with the Quark Combo is pretty amazing. A 32-mm Tele Vue eyepiece is recommended by Daystar for use with the filter, and it works perfectly. On days of good seeing a lot of surface and prominence detail is visible. You would have to research if your telescope setup could accommodate a diagonal, and as you shall see, the type of camera you plan on using. Not having the use of a diagonal makes for some "Yoga-type" contortions if the Sun is high overhead.

Fig. 12.13. Quark visual setup. The Quark combo can be set up for visual studies using the recommended Tele-Vue 32-mm eyepiece. (Image by the author.)

You cannot come to a focus using the Nikon D810a DSLR and the Quark Combo due to insufficient focuser travel on the author's telescope. The ZWO 120 can come to a focus, and the view on the computer screen is pretty awesome. Truth be told it is far easier to focus and observe the Sun with the ZWO unit with computer display than with a DSLR. Your DSLR may also be able to hook up to your computer display by using a video/HDMI/USB cable.

Using the ZWO 120 camera actually gives a better view of the Sun than with the 32-mm eyepiece. The image is far larger – thanks to the computer screen – and is much more comfortable viewing than having to contort to the eyepiece due to the lack of a diagonal.

Fig. 12.14. Quark with ZWO AS120. (Image by the author.)

Camera & Mode: ZWO AS120 Takahashi 250-mm prime focus. Camera and
Telescope.
ISO: N/A
Exposure: 30 ms
Processing: Mac Photos

Figs. 12.15 and 12.16. Solar prominences. These were the first pics ever taken by the
author with the Quark Combo. They are single exposures that were imported into Mac
Photos for processing. Fig. 12.15 exposure data is provided below for illustrative purposes.
The ZWO AS120 camera control system allows for a wide variety of exposure settings.
You set the exposure parameters while viewing the live image to get a "best image" you
then take. This can be a single frame or a specified number. (Images by the author.)

ZWO Image Data for Fig. 12.15
[ZWO ASI120MC-S]
Auto Exp Max Exp = 30ms
Auto Exp Max Gain = 50
Auto Exp Target Brightness = 100
Bin = 2

Brightness = 0
Capture Area Size = 640 * 480
Color Format = RAW8
Debayer Preview = ON
Exposure = 46645us
Flip = None
Gain = 68
Hardware Bin = OFF
High Speed Mode = OFF
Mono Bin = OFF
Output Format = *.PNG
OverClock = 0%
Raw Format = OFF
StartX = 0
StartY = 0
Temperature = 22.2 C
Timestamp Frames = OFF
Turbo USB = 40
USB Port = 3.0
White Balance (B) = 100
White Balance (R) = 38

There are other specific wavelength filters and solar telescopes from Daystar Filters and Lunt Solar Systems. You will have to research carefully the specs on filter units to insure that they will work with your telescope's optical system or for a solar telescope your current mount.

Table 12.2 Sun With Camera And Telescope

Camera Type	Solar Surface Features	Solar Transits
Smartphone	YES, Afocal	YES, Afocal
Tablet	NO	NO
Pocket	YES, Afocal	YES, Afocal
Film	YES	YES
CSCs	YES	YES
DSLR	YES	YES
Video	YES	YES
CCD/CMOS	YES	YES

Bottom Line

By the time this book is published the Sun should be coming out of its minimum of the current solar cycle. That should make for some interesting solar astropics using Camera Only with long lenses and Camera and Telescope. Specific wavelength viewing will get a lot more interesting as well.

Just stay solar safe each and every session with the Sun.

Chapter 13

The Moon

Our Moon goes through primary phases of new, first quarter, full and last quarter each lunar month of 29.5 days. The Moon is a very inviting astronomical object to observe as well as photograph while going through its phases. We see the Moon due to sunlight on its surface being reflected back into space.

The line between the light and dark of the Moon is called the terminator. In a telescope you can actually see it advance across the Moon's surface most notably by watching crater peaks pop out of shadow when the Moon is waxing towards full Moon or disappear into darkness when the Moon is waning after full Moon. The Moon also undergoes lunar eclipses, which we will cover in Chapter 14.

Using your software you can determine the Moon's phase and its percentage of illumination, location in the sky and times of Moon rise and set. The altitude of the Moon in the sky will be dependent on your site's location and the time of the year. Each 24 hours the Moon moves approximately 12 degrees (a little over a fist-width at arm's length) moving west to east in the sky along the ecliptic.

Just as the Sun appears higher and lower in the sky depending on the time of year so does the Moon. For the Northern Hemisphere the Moon will be at its highest in the night sky when transiting the meridian in the fall and winter months and lowest in the night sky when transiting the meridian during the spring and summer months. This also applies in the Southern Hemisphere for their respective seasons.

© Springer Nature Switzerland AG 2020
G. I. Redfern, *Astrophotography is Easy!*, The Patrick Moore Practical
Astronomy Series, https://doi.org/10.1007/978-3-030-45943-7_13

If you travel and cross the equator to visit the other hemisphere for the first time you are in for a surprise. The Moon will look "upside down" compared to how it appears in your home hemisphere, and it will be near the opposite horizon you are used to. Sailing towards the equator is also a treat in terms of how the Moon changes its orientation and location in the sky.

Compare the lunar views taken at nearly the same lunar phase from each hemisphere (Figs. 13.1 and 13.2) to see what this looks like.

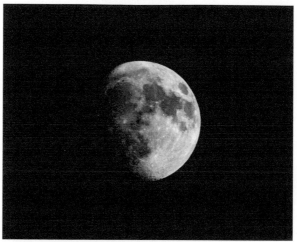

Camera & Mode: D810a w/200- to 500-mm telephoto zoom lens w/1.7x tele-extender lens at 850 mm f/9.5 on a tripod. Camera Only.
ISO: 200
Exposure: 1/200 of a second
Processing: Mac Photos

Fig. 13.1. Waxing Gibbous Moon in Virginia, the Northern Hemisphere. For Southern Hemisphere viewers compare to Fig. 13.2. For you the Moon is upside down in this astropic. (Image by the author.)

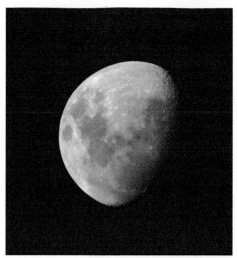

Camera & Mode: D810a w/28- to 300-mm telephoto zoom
lens at 300 mm f/5.6 on a tripod. Camera Only.
ISO: 200
Exposure: 1/640 of a second
Processing: Mac

Fig. 13.2. Moon viewed at sea off the coast of Fremantle, Australia, in the Southern Hemisphere. For Northern Hemisphere viewers compare to Fig. 13.1. For you the Moon is upside down in this astropic. (Image by the author.)

We will address each photographic mode separately as they pertain to the Moon later in the chapter, but there are some shared considerations we want to discuss first.

When the Moon is new there will be no moonlight at all in the night sky, so this is the best time to photograph "all-sky" in Camera Only mode with stars, the Milky Way (if it's visible), meteor showers, etc. In Camera and Telescope mode DSOs are at their very best and there is no interference from moonlight.

These conditions will hold for a few days after the new Moon with the waxing crescent Moon visible in the west after sunset, or a few days before the waning crescent Moon in the east before sunrise reaches the next new Moon. The Moon's thin crescent is quite a sight to see and photograph in both modes. At these times in the lunar phases you will want to look for the presence of Earthshine on the dark disk of the Moon, where no sunlight is present.

Earthshine

There are few sights more beautiful in the sky than an Earthshine crescent Moon above the horizon.

Earthshine is the reflection of sunlight off of Earth's clouds (primary source) and, to some degree, its oceans that causes the dark lunar surface to be visible to the unaided eye. Major lunar surface features can be seen and photographed in both modes. When the waxing or waning crescent Moon is at perigee, its closest approach to Earth for the lunar month, Earthshine will be more prominent. The *Observer's Handbook,* your software and astronomy magazines will advise when perigee occurs. If this coincides with the crescent phase of the Moon, it is worth looking for and photographing Earthshine.

Camera & Mode: 810a w/ 200- to 500-mm lens at 500 mm at f/5.6 on a tripod. Camera Only.
ISO: 1000
Exposure: 1 second
Processing: Mac Photos

Fig. 13.3. Waxing crescent Moon with Earthshine in Chile, three days after the total solar eclipse on July 2, 2019. (Image by the author.)

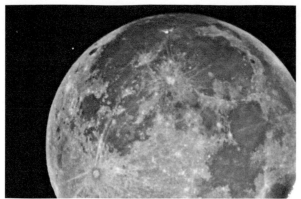

Camera & Mode: D5000 Prime Focus w/Reducer f/9.2 – camera is not full frame. Camera and Telescope.
ISO: 200
Exposure: 10 seconds
Processing: Mac Photos

Fig. 13.4. Earthshine in Virginia. Author's best telescope Earthshine astropic to date. Plans are to retake with an FX camera when Moon-sky conditions allow. (Image by the author.)

The puzzle of what causes Earthshine was solved by Leonardo da Vinci (1452–1519) when he published his Codex Leicester, circa 1510. The Master thought the planet's oceans caused the bluish-gray colored ashen glow. In his honor Earthshine is also known as the "Da Vinci glow."

The best time to look for Earthshine is when the Moon is a few days old after the new Moon or when the Moon is a few days before the next new Moon. To help you in finding the thin crescent Moon your software will tell you the Moon's altitude and azimuth, which will help. The Moon might be in bright skies after sunset or before sunrise, so binoculars will assist you in your search.

Bright Planets and Moon Astropics

When the Moon is near any of the planets this can present some lovely and interesting photographic opportunities, especially the brighter planets – Venus, Jupiter and, when closest to Earth, Mars. That being said Venus paired with a thin crescent Moon resplendent with Earthshine is a "must do" photograph. There are times when a planet is close enough to the Moon so that a telescope operating in prime focus with a reducer can encompass both in the field of view. You have a better chance of this happening with a smaller aperture and wide-field telescope, but these opportunities are worth searching for and photographing.

Star Clusters, Milky Way and Moon Astropics

The crescent Moon – and other phases also but then strong moonlight becomes an issue – might join star clusters such as the Pleiades and Hyades in Taurus, the Beehive in Cancer, and even the Milky Way in the sky as it makes its way across the ecliptic during the lunar month. Each of these would be an excellent photographic opportunity.

Moon Photography Tip

Each lunar month it's a good idea to look at where the Moon will be in the sky as it goes through its phases. This is where the *Observer's Handbook* and the monthly astronomy magazines really pay off, because they will highlight when the Moon will pass close to planets and other objects in the sky. A conjunction is when any two astronomical objects get close to one another in our sky. Conjunctions can be the Moon and planets, planets themselves, or even involve either the Moon or planets getting close to DSOs like star clusters. At a glance you can see what might be worth trying to photograph and plan accordingly. This also helps you in establishing "dark of the Moon" nights when DSOs will be front and center in the sky for both modes.

Do not confuse this with lunar conjunction, which is when the Sun, Moon and Earth are in a straight line – better known as new and full Moon.

Lunar Occultations

There will be instances where the Moon can actually get so close to a planet or star(s) that it will occult or actually cover it. When this happens it is a lunar occultation. Lunar occultations as viewed and photographed in a telescope are impressive. The Moon's phase can be a hindrance because if there is a lot of strong moonlight this may overwhelm your ability to easily see and photograph the occultation, especially in the following circumstances.

If you are lucky you might even get to see a grazing lunar occultation where a star or planet moves along the lunar limb, "winking" in and out as it passes behind crater rims, mountains or valleys. In times past and to some extent even recently grazing lunar occultations were used to update the Moon's topography along the lunar limb.

If you have a long focal length lens you may be able to see and photograph lunar occultations of brighter stars and planets. The best way to find

out is to get out and try to photograph the event – that's the only way you will know for sure.

As you shall see it is possible to photograph lunar occultations of the bright planets, notably Venus, in the daytime. Be aware of this possibility if it arises in your references. As always, you have to make sure that the Sun is a safe distance away from your camera and telescope so there is *zero* chance it cannot enter the field of view and is blocked by a building or solid structure.

Photographing the Moon

Whether you are in Camera Only or Camera and Telescope mode photographing the Moon presents some unique issues caused by its ever changing illumination – phases – and composition with the coexistence of pure black and brilliant white color in the same frame, along the terminator.

As the Moon progresses through the lunar month, with its phases from a slim crescent Moon positioned in a dusk sky to a brilliant full Moon and then back to a slim crescent again in a dawn sky, photographing in both modes is challenging. The biggest hurdle is the simultaneous presence of black and white, getting just the right exposure to bring out details on the Moon without over or under exposing. We'll deal with this more in each mode.

When operating in Camera Only mode for the Moon you have to first consider and then decide what will be the main focus of your photographic session. Is it the Moon and its phases, the Moon near a planet or constellation/object in the sky, lunar occultation? Remember, we will discuss lunar eclipses in Chapter 14. Once you have made your choice you can then proceed to plan your session.

Any camera can take pics of the Moon in Camera Only mode. It just becomes a matter of how good will they be. Smartphones will be able to photograph the Moon with zoom, but detail will be minimal. They are good for capturing the Moon and its surroundings. Tablets would be the same. Pocket cameras with an optical zoom capability can be quite good at capturing the Moon through its phases, with some detail depending on your lens. Once again, DSLRs, mirrorless and SLR film cameras with their wide array of lenses will do the best job.

Regardless of what you plan to photograph Moon-wise a big factor will be the focal length of the lens you intend to use. At this juncture it is a good idea to show you what the Moon looks like in a variety of telephoto focal lengths, which you will need to photograph Moon phases and perhaps lunar conjunctions or occultations. These pics are from Nikon lenses. Of course you can have shorter and longer focal length lenses, but this will give you an idea of what the Moon will look like in your photographs.

a. 200 mm
Camera: D810a w/ 200- to 500-mm lens f/9 on tripod.
ISO: 100
Exposure: 1/200 of a second

b. 300 mm
Camera: D810a w/ 200- to 500-mm lens f/9 on tripod.
ISO: 100
Exposure: 1/200 of a second

c. 400 mm
Camera: D810a w/ 200 to 500-mm lens f/9 on tripod
ISO: 100
Exposure: 1/200 of a second

d. 500 mm
Camera: D810a w/ 200 to 500-mm lens f/9 on tripod.
ISO: 100
Exposure: 1/200 of a second

e. 850 mm
Camera: D810a w/ 200 to 500-mm lens (w/1.7x extender) f/9.5 on tripod.
ISO: 100
Exposure: 1/200 of a second

Figs. 13.5a to 13e. This series of Moon pics shows the difference in apparent size of the Moon using a zoom telephoto lens. It shows the need for a long lens when photographing the Moon (and Sun with a proper filter and procedures), especially during an eclipse. These Camera Only astropics were not cropped. (Images by the author.)

For best results you should use a tripod when employing a long focal length lens with either a cable release or shutter delay to avoid blurring your exposure. For your long focal length lenses a gimbal head would be ideal to mount on your tripod due to their heavier weight and the potentially high altitudes of the Moon above the horizon.

Moon Pic Tip

If you have a telephoto zoom lens such as a 28- to 300-mm it is very useful when it comes to the Moon. Most importantly the wide range of zoom focal length capability allows you to frame the Moon with planets or stars to achieve that "perfect" composition. Additionally, being able to zoom to 300-mm focal length will give you enough lunar detail, especially if you crop the image as part of your processing.

Moon Phases

If photographing the Moon's phases is your objective this isn't too hard and can produce nice lunar astropics. But as we discussed previously you will need a long focal length lens to do so. Yes, a 35-mm or 50-mm lens will show the Moon's phase, but it will be small, with very little detail.

Waxing/Waning Crescent Phase

When the Moon is in a waxing/waning crescent phase and you want to photograph Earthshine you will have to take a longer exposure to do so. The challenge will be that there may be somewhat bright dusk conditions present, which might overwhelm Earthshine. At sunset and a waxing crescent Moon you may be able to wait until the sky gets darker, and of course the Moon gets closer to the western horizon. For a waning crescent Moon the opposite is happening, as the Moon is rising in a dark sky close to the horizon with an ever brightening sky.

Regardless of your focal length if the sky is somewhat dark try ISO 800 to 1000 with the lens wide open, 1/60 of a second exposure.

SAAS as needed.

Camera & Mode: D810a w/ 200- to 500-mm f/3.5-5.6 at 500-mm f/5.6 braced. Camera Only.
ISO: 400
Exposure: 1/40 of a second
Processing: Mac Photos cropped

Fig. 13.6. In this Moon astropic of a very young (31-hour-old) waxing crescent Moon, you can see "gaps" along the slim 2.4% illuminated limb caused by lunar features. (Image by the author.)

Waxing Crescent to First Quarter Phase

More of the Moon's features are revealed with each passing day in the lunar month, and the Moon gets brighter as well. At first quarter the Moon is half day and half night and perfectly split. This is a good phase to photograph the Moon, especially along the terminator, where there are many craters and features showing deep shadows and details. The Moon is in the night sky until it sets at midnight.

Try ISO 400 to 800, 1/250 of a second. SAAS.

Camera & Mode: D810a w/ 28- to 300-mm at 300-mm f/5.6 on a tripod.
Camera Only.
ISO: 640
Exposure: 1/60 of a second
Processing: Mac Photos

Fig. 13.7. First quarter pic of Moon. A bit blurry due to high winds. (Image by the author.)

Camera & Mode: D810a w/ 28- to 300-mm at 300-mm f/5.6 on a tripod.
Camera Only.
ISO: 400
Exposure: 1/1,000 of a second
Processing: Mac Photos cropped.

Fig. 13.8. First quarter to full Moon phase. The Moon becomes ever brighter each night to reach full Moon. (Image by the author.)

Full Moon

At full Moon the whole lunar disk is brightly illuminated, and quite frankly, beautiful. A full Moon rising above the horizon at sunset has lots of photographic potential. Do you have landmarks, nature scenes, unobstructed horizon, gorgeous sunset colors and Earth's shadow? The possibilities are limited only by your imagination! And the full Moon itself can take on a myriad of colors in the low horizon atmosphere – golden, yellow, red, orange – caused by weather, atmospheric conditions and the seasons themselves (time of moonrise, position of Moon on the ecliptic).

Your software will give you the time of full Moonrise at your location and what the Moon's azimuth will be. Knowing these two items you can plan your set up in advance so you are ready to photograph the Moon as close to the moment of moonrise as your location's horizon allows.

The full Moon will rise near sunset so it may be deep dusk, and maybe even Earth's shadow and the Belt of Venus will be present, so be on the lookout for this.

Camera & Mode: D810a w/ 28- to 300-mm at 48-mm f/4.2 on a tripod. Camera Only.
ISO: 200
Exposure: 1/1,250 of a second
Processing: Mac Photos

Fig. 13.9. Earth's shadow and the Belt of Venus in this Shenandoah National Park pic of the full Moon. (Image by the author.)

A full Moon low on the horizon can be visibly distorted and can also exhibit a wide range of colors caused by Earth's atmosphere. This happens because the Moon's light has to travel through the thick atmosphere when low in the sky, and this creates these effects. For a Moon photographer in Camera Only mode this is not a bad thing!

For a full Moon on the horizon this is tough to estimate camera settings, due to not being able to see it. If the Moon seems "dull" – high humidity or a "thick atmosphere" – you will need to try a longer exposure; try 1/250 of a second ISO 400 to 800. SAAS.

Camera & Mode: D810a w/ 200- to 500-mm with 1.7x tele-converter for 850-mm f/9.5 on a tri-pod with gimbal head. Camera Only.
ISO: 2500
Exposure: 1/1,250 of a second
Processing: Mac Photos

Fig. 13.10. On the *Queen Elizabeth* at sea in the North Atlantic off the coast of west Africa less than 50 miles from the equator. A very colorful full Moon is seen rising and low on the horizon. High ISO was used so a fast exposure could be taken to offset the ship's motion. (Image by the author.)

For a full Moon high in the sky start with ISO 400 to 800, 1/500 of a second. SAAS.

Take full advantage, pun intended, to include surroundings along the horizon with the Moon in your astropics. If there is water this is a real plus! You may be able to get the Moon's reflection in the water as well. Lakes and beaches or being at sea will really add to your astropic.

Camera & Mode: D810a w/ 28- to 300-mm at 28-mm f/3.5 on a tripod. Camera Only.
ISO: 1000
Exposure: 1 second
Processing: Mac Photos

Fig. 13.11. The *Eurodam* at sea off the coast of Maui, Hawaii, with a beautiful full Moon. (Image by the author.)

Waning Gibbous Moon

After full Moon phase the waning gibbous Moon is up next and will rise later each night following sunset. The amount of sunlight illuminating the surface of the Moon will decrease each night, moving closer and closer to last quarter. Try ISO 400 to 800, 1/250 of a second. SAAS.

Camera & Mode: D810a w/ 28- to 300-mm at 300 mm f/5.6 on a tripod.
Camera Only.
ISO: 2000
Exposure: 1/125 of a second
Processing: Mac Photos

Fig. 13.12. Aboard *Seven Seas Explorer* a very colorful and distorted waning gibbous Moon just rising above the Caribbean Sea horizon. (Image by the author.)

Last Quarter Moon

Once again the Moon is at half phase, with an even split of light and dark but on the opposite side from first quarter. Rising at midnight and later each night in this phase, the terminator will be full of splendid surface features, with craters in light and shadow. Each night will present new opportunities. Try ISO 400 to 800, 1/250 of a second. SAAS.

Camera & Mode: D810a w/200- to 500-mm at 500-mm with 1.7x
tele-converter for 850-mm f/9.5 on a tripod. Camera Only.
ISO: 200
Exposure: 1/125 of a second
Processing: Mac Photos cropped.

Fig. 13.13. Last quarter Moon, (Image by the author.)

Waning Crescent Moon

In this phase the Moon is "old" in the lunar month and working towards the new Moon and the start of a new lunar month. This phase is beautiful in the hours before dawn, and once again Earthshine should be present. The crescent will show less illumination with each day and move towards brighter dawn skies until it is no longer visible as a new Moon.

Camera & Mode: D810a w/ 28- to 300-mm at 300-mm f/5.6 on a tripod.
Camera Only.
ISO: 3200
Exposure: 1/4 of a second
Processing: Mac Photo

Fig. 13.14. On the *Azamara Pursuit* at sea in the Pacific Ocean off the coast of Chile. For this Southern Hemisphere waning crescent Moon a high ISO was needed to capture Earthshine while using a fast shutter speed to avoid blurring. (Image by the author.)

The Moon and Planets

In order to photograph the Moon and visible planets you have to know when and where they will be close together. Checking your software can be tedious doing this, as you have to cycle through days, weeks and months depending on how your software works. Handy references, such as the *Observer's Handbook* and *Sky & Telescope* magazine, speeds up such a search, as they have already done it for you. You just look up the time frame you are interested in and see what is happening in the sky.

Any phase during the lunar month that has planets nearby, or in conjunction with the Moon, can produce beautiful astropics. Crescent phase with planets, especially Venus, does add the most eye appealing view, as you can see.

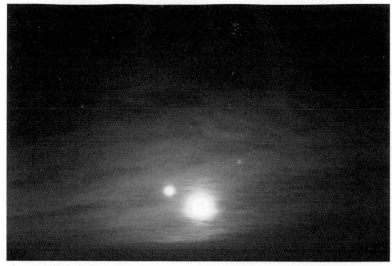

Camera & Mode: D810a w/50-mm f/1.4 on a tripod. Camera Only.
ISO: 1600
Exposure: 1.6 of a second
Processing: Mac Photos

Fig. 13.15. A 26.2-day-old waning crescent Moon. Clouds nicely accent the bright Moon and Venus in this pic, which shows Aldebaran, Pleiades (Seven Sisters) and Taurus the Bull. (Image by the author.)

As always with a crescent Moon you have to plan on a potentially bright sky at sunset or sunrise. Getting the right exposure to capture crescent Moon, Earthshine and planet will take a lot of SAAS, but it will be worth it with your "perfect" astropic.

Your best bet once again is a zoom telephoto lens to take this type of astropic, as a 35- to 50-mm or wide-angle lens will have very small image scale. You might be able to image the Moon, but the planet will be very hard to see in the image.

Use the settings from each of the provided astropics in this chapter that best matches what you are trying to photograph as a starting point, then SAAS. You can also try using the recommended setting from a particular Moon phase to see if that helps. As time goes on your developing astrophotographer's eye will get you in the ballpark pretty quickly.

The camera settings that correspond to the Moon's phase for your astropic are a good starting point. But to image any planets with the Moon, especially if they are not Venus, Mars when it is bright, or Jupiter, will require a bit more exposure time. SAAS.

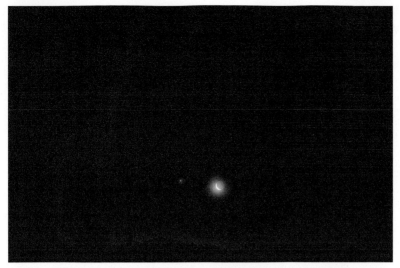

Camera & Mode: D5200 w/55- to 200-mm at 55-mm f/4 on a tripod. Camera Only.
ISO: 800
Exposure: 2.5 seconds
Processing: Mac Photos

Fig. 13.16. A 26.8-day old waning crescent Moon with Venus and Earthshine. The Pleiades add a nice touch to this pic. (Image by the author.)

Lunar Occultation of a Planet or Star

The recommendations from the preceding section apply here even more so because you really have to go "long" in your lens focal length if you want to image a star or planet winking out behind the Moon and then reappearing. An occultation is easier to image than a grazing occultation because the object disappears and reappears as opposed to an ongoing event that can last a period of time depending on the circumstances.

The *Observer's Handbook* and other references will provide the circumstances of the occultation event. The phase of the Moon and the brightness of the object being occulted will dictate what settings will apply. If the Moon is full that will be a lot of light to contend with in trying to frame your image. To image your occulted object next to a really bright Moon will be a challenge, so SAAS. If the Moon will be "dark" next to the occulted object you will have a much easier time. If you are lucky enough to have a bright planet with an Earthshine crescent Moon type of event it will be a wonderful opportunity to get a "keeper" astropic. Use the settings that have been provided for each phase and SAAS.

The following sequence is of a daytime occultation of Venus by a 26-day-old waning crescent. The Sun was near the meridian, while the Venus-Moon duo was in the western sky and a very safe distance from the Sun, with zero chance of entering the field of view. The Sun was also blocked by a building.

Camera & Mode: D810a w/300-mm f/4 at f/6.7 on a tripod. Camera Only.
ISO: 100
Exposure: 1/320 second
Processing: Mac Photos with cropping.

Fig. 13.17. A 26-day-old waning crescent Moon just before occulting Venus. (Image by the author.)

Camera & Mode: D810a w/300-mm f/4 at f/6.7 on a tripod. Camera Only.
ISO: 100
Exposure: 1/200 of a second
Processing: Mac Photos with cropping.

Fig. 13.18. Another pic of 26-day-old waning crescent Moon just before occulting Venus. Here Venus is very close to the Moon's limb. (Image by the author.)

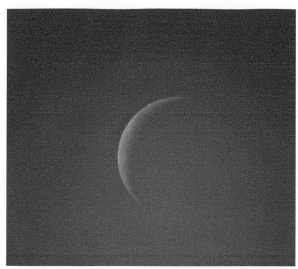

Camera & Mode: D810a w/300-mm f/4 at f/6.7 on a tripod. Camera Only.
ISO: 100
Exposure: 1/200 of a second
Processing: Mac Photos with cropping.

Fig. 13.19. Seconds before Venus was occulted by the Moon. A video would be a nice way to record an occultation. Clouds precluded the photographing of the re-emergence of Venus from behind the Moon. (Image by the author.)

Table 13.1. Moon with Camera Only

Camera Type	Moon Phases	Lunar Surface Features	Lunar Occultations	Lunar Conjunctions
Smartphone	With Zoom	No	No	Yes
Tablet	With Zoom	No	No	Yes
Pocket	With Zoom	With Zoom	No	Yes
Film	Yes	Long Fl	Long Fl	Yes
CSCs	Yes	Long Fl	Long Fl	Yes
DSLR	Yes	Long Fl	Long Fl	Yes
Video*	Yes	Long Fl	Long Fl	Yes
CCD/CMOS*	Yes	Long Fl	Long Fl	Yes

*If equipped with lens capability

The Moon is exquisite to observe visually and photograph. Any telescope of good optical quality will reveal surface detail easily. With the progression of the lunar month, new features come into view throughout the whole cycle, making the Moon an ever-changing sight in the eyepiece and camera.

The Moon is a challenging object to photograph in a telescope, as it will be bright with areas of dark shadow. These two extremes make it difficult to get an astropic that shows an object along the terminator that may be in light and darkness at the same time. You can use the settings in this section as a starting point and then SAAS.

The Moon can be photographed with any of the camera types, excepting tablets, as we have discussed. You can also use any of the Camera and Telescope imaging methods described previously – afocal, prime focus, eyepiece projection, etc. We'll discuss each method as it pertains to the different types of Moon shots.

Earthshine

As you saw in Fig. 13.4 photographing Earthshine with a telescope is very easy when using prime focus and perhaps a reducer as well. The idea is to be able to image the entire lunar disk and its accompanying Earthshine. How much of the lunar disk you can image will be dependent on the optical characteristics of your telescope. The field of view at prime focus would have to be at least 31 minutes of arc or half of a degree – the average size of the lunar disk. The camera you use would have to be able to image the telescope's entire field of view as well, which may not be possible. The easiest way to find out if your telescope and camera can image the whole disk is to set up in prime focus and take a test exposure. If the Moon doesn't quite fit, try again with a reducer, if you have one. This will provide you your setup's field of view for the Moon, which is important when it comes to eclipses in our next chapter, as you shall see.

The sunlit portion of the Moon will be bright, so perhaps you can keep it out of the field of view. Your primary objective is to image Earthshine, and if the sunlit portion of the Moon is present it will be greatly overexposed in order to get a long enough exposure for the Earthshine.

If you want to get just one area or feature on the Moon that is in Earthshine you can use eyepiece projection or a Barlow/extender. Depending

on how strong the Earthshine is will dictate your exposure. Try an initial setting estimate from the Fig. 13.4 Earthshine astropic and then SAAS.

Bright Planet or Star Conjunctions

Once again, depending on your Camera and Telescope setup, you may be able to image a star or planet that is near the Moon. This would probably be a prime focus and reducer set up to achieve the largest field of view possible. If you have a smaller aperture telescope with a fast focal ratio you will be able to do this more readily than a large aperture, long focal length telescope. This, too, would be camera-type dependent.

Lunar Occultations

What setup you want to use will depend on what type of occultation is occurring grazing versus full occultation – and what you want to image – close up using eyepiece projection or Barlow/extender or wide-angle view using prime focus with possibly a reducer. The brightness of the object being occulted and how the phase of the Moon will interact with the event will also be a consideration as to the setup you will want to use.

If you know far enough in advance during what the phase of the Moon the occultation event will occur it would be worthwhile to conduct a practice run prior to the real deal. Just set up the camera and telescope in the same manner you plan on using for the occultation event. Take some images using the settings provided for the astropics in this section and SAAS.

Once you have the settings for the Moon at the phase anticipated for the occultation event, you will have to adjust them, probably in a longer exposure or higher ISO to image the object being occulted. During the occultation event start off with the Moon phase setting and SAAS. You will probably have to work quickly in order to successfully image the event. If a grazing occultation you may want to consider using video to image it and then pull individual frames if your software allows.

Moon Phases and Surface Detail

Of all the objects in the sky the Moon is the one where you can see the most surface detail regardless of your telescope's aperture – as long as it has quality optics and a steady mount.

As the Moon goes through its lunar month and corresponding phases each day, literally hour by hour more lunar details come into view, from new to full phase and then recede into blackness from full to new. Craters, maria, wrinkle ridges, rays, faults, mountains – really the outline of huge impact basins – are all beckoning you.

To find lunar features and truly appreciate and understand what you are seeing and photographing, you will need a few resources. Your software and the *Observer's Handbook* can give you lunar data as to phase, distance, coordinates, etc., but you need an additional resource, a map, really, to find your way around the Moon.

The author has provided in Chapter 23 two excellent resources. One is a lunar map that is laminated and comes in two versions to match the type of telescope you use. The other is a spiral-bound lunar atlas that provides detailed information on selected lunar features. Both are easy to use at the telescope and will help you find your way around the Moon. These are indispensable resources for lunar observers.

As a reminder here are the Moon's phases once again.

- New
- Waxing Crescent
- First Quarter
- Waxing Gibbous
- Full
- Waning Gibbous
- Last Quarter
- Waning Crescent
- New

As the Moon goes through its lunar month and phases, for each surface feature there will be lunar sunrise – from new to full – and lunar sunset – full to new. It is really something to see and photograph lunar features undergoing this cycle of lunar sunrise, noon and sunset as they are ever changing in light, shadow and appearance.

You can use prime focus to get the lunar phase and surface appearance as well as close up views using eyepiece projection or a Barlow/extender just like for Earthshine. There may be some limitations of your camera for imaging the whole lunar disk, as we previously discussed, but any type of camera – except a tablet – should afford a closeup capability.

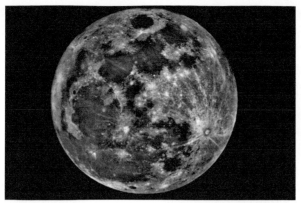

Camera & Mode: Nikon D810a prime focus with reducer f/9.2. Camera
and Telescope.
ISO: 160
Exposure: 1/125 of a second
Processing: Mac Photos

Fig. 13.20. High contrast full Moon pic. The myriad of maria, crater rays and surface features really stand out. (Image by the author.)

Use the settings provided that best match the phase you are interested in as a starting point. SAAS.

Tip for Close-up Lunar Imaging

What we are about to discuss is considered really beyond basic astrophotography techniques but still necessary for your information and growth as an astrophotographer. If you progress beyond wanting to "just take an astropic of the Moon" to really trying to get the most out of each shot, you will probably end up utilizing the following.

When you are zeroing in on lunar features to photograph them using methods that provide magnification, the optical quality/collimation of your telescope and seeing conditions really come to the forefront. If you have telescope issues it will become readily apparent, as will bad seeing conditions, because you won't be able to achieve a sharp, crisp focus. Even if your telescope is perfect the seeing can degrade your intended lunar feature into a shimmering blur. You can try using less magnification or trying again a bit later to see if seeing conditions improve.

Using a camera to obtain a single exposure of a lunar (or planetary disk, see Chapter 15) is most affected by seeing. The reason? You are taking a single exposure that was subject to seeing conditions at the time it was taken. It may be a great astropic, but more often than not it is so-so.

One way around this is to shoot video using your camera – if it has that capability. The camera's video will acquire a set number of frames per second dependent on your camera's capabilities and the settings you use. A video capable DSLR, video camera and pure astronomical camera like the ZWO120 will provide video imaging that will be better with each type of camera described. The secret is that video gives you more frames over a period of specified exposure time, which increases the odds of getting better seeing in some frames.

The software provided with your camera may provide you the ability to see each frame of video and allow you to pick and choose a frame to further process, as we will discuss in Chapter 21. But if you have anything beyond a few dozen frames, and you likely will, this can become tedious and inefficient. A powerful processing tool for handling lunar (as well as planetary and solar) images is called stacking. You use software to import and process video that when all is said and done will provide you an astropic comprised of multiple frames that have been stacked and processed into one final image. This increases contrast, sharpness, detail and hopefully overcomes seeing to give you a really nice end product.

To start taking lunar close ups you should concentrate on using what camera you have available and get used to taking single exposures while always striving to get the best image possible at the telescope and in processing. This will develop valuable experience using Camera and Telescope mode and provide you with some very pleasing astropics.

Get the basics down pat first, then work your way forward. Of course you may want to jump into the more advanced stacking method right away…. The choice is yours.

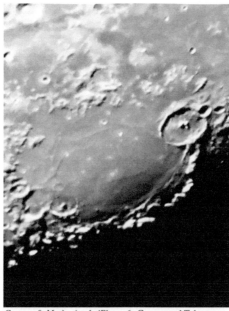

Camera & Mode: Apple iPhone 6s Camera and Telescope
afocal method using Celestron NexYZ with 25-mm
eyepiece and 250-mm CDK.
ISO: 25
Exposure: 1/60 of a second
Processing: Mac Photos

Fig. 13.21. A nice pic of crater Gassendi and Gassendi A on the Moon, using an
iPhone. The telescope was visually focused first. The iPhone automatically did expo-
sure settings and focus with no intervention by the author. (Image by the author.)

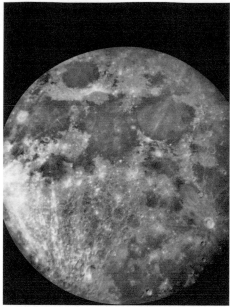

Camera & Mode: Apple iPhone 6s Camera and Telescope
afocal method using Celestron NexYZ with 25-mm
eyepiece and 250-mm CDK.
ISO: 25
Exposure: 1/193 of a second
Processing: Mac Photos

Fig. 13.22. A very nice image showing lunar maria and the crater Copernicus. The telescope was visually focused first. The iPhone automatically did exposure settings and focus with no intervention by the author. (Image by the author.)

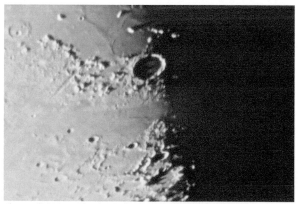

Camera & Mode: Nikon D5200DX Camera and Telescope eyepiece
projection method with 25-mm eyepiece and 250-mm CDK.
ISO: 800
Exposure: 1/2 of a second
Processing: Mac Photos

Fig. 13.23. Plato Crater with shadows and the Alpine Valley. (Image by the author.)

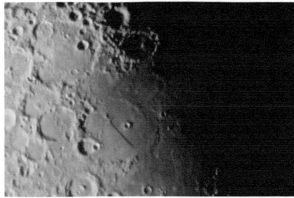

Camera & Mode: Nikon D5200DX Camera and Telescope eyepiece
projection method with 25-mm eyepiece and 250-mm CDK.
ISO: 800
Exposure: 1/3 of a second
Processing: Mac Photos

Fig. 13.24. The "Straight Wall" on the Moon (Image by the author.)

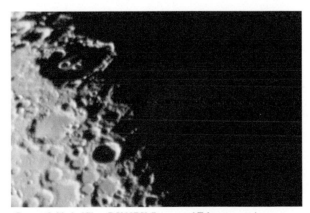

Camera & Mode: Nikon D5200DX Camera and Telescope eyepiece
projection method with 25-mm eyepiece and 250-mm CDK.
ISO: 800
Exposure: 1/3 of a second
Processing: Mac Photos

Fig. 13.25. The peak of Tycho sticks out from shadow (bottom) and Clavius in
shadow (top). (Image by the author.)

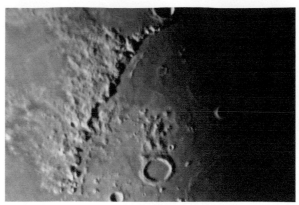

Camera & Mode: Nikon D5200DX Camera and Telescope eyepiece
projection method with 25-mm eyepiece and 250-mm CDK.
ISO: 800
Exposure: 1/3 of a second
Processing: Mac Photos

Fig. 13.26. The magnificent Apennine Mountains on the Moon with Archimedes.
(Image by the author.)

Table 13.2 Moon with Camera and Telescope

Camera Type	Moon Phases	Lunar Surface Features	Lunar Occultations	Lunar Conjunctions
Smartphone Afocal	Yes	Yes	Yes	Possibly*
Tablet	No	No	No	No
Pocket	Yes	Yes	Yes	Possibly*
Film	Yes	Yes	Yes	Possibly*
CSCs	Yes	Yes	Yes	Possibly*
DSLR	Yes	Yes	Yes	Possibly*
Video	Yes	Yes	Yes	Possibly*
CCD/CMOS	Yes	Yes	Yes	Possibly*

*Depends on how close the object is to the Moon and your telescope and setup,
i.e., focal reducer with prime focus for largest field of view.

Bottom Line

Whether you employ Camera Only or Camera and Telescope, the Moon
beckons you to explore its ever changing panorama visually and photo-
graphically. The view will mesmerize you, as will your astropics.
 Enjoy.

Chapter 14

Eclipses

Now that we have discussed the Sun and Moon, we can talk about solar and lunar eclipses. In this chapter you will learn the ins and outs of how to view and photograph eclipses. Use of "eclipses" in this chapter will refer to both lunar and solar eclipses unless otherwise specified.

Eclipse Basics

All upcoming eclipse events tend to be covered extensively in the *Observer's Handbook* and astronomy resources such as *Sky & Telescope*, which include information on observing, photographing, and eclipse coverage details. You can use the provided references in Chapter 23, especially the AAS, NASA and EclipseWise.com websites, to see all upcoming eclipses that will be occurring in the years to come. For solar eclipse events, all of these references will also include solar safety information to protect your eyes and equipment.

In addition, your astronomical software will be invaluable to you, as once you input your viewing location's latitude, longitude and time zone, you will be able to determine the particulars of the eclipse event. This will include where in the sky – altitude and azimuth – the eclipse will occur. This is very important to know, as an eclipse can last for hours and will physically move across the sky. You also want to match up the details of the eclipse to your viewing location to make sure you know how the eclipse will

© Springer Nature Switzerland AG 2020 229
G. I. Redfern, *Astrophotography is Easy!*, The Patrick Moore Practical
Astronomy Series, https://doi.org/10.1007/978-3-030-45943-7_14

interact with your physical surroundings and your horizon as you view and photograph the event over time.

Solar eclipses take place when the new Moon passes between the Sun and Earth and its shadow falls upon the Earth's surface. Solar eclipses can be total, annular, hybrid (also known as annular-total eclipses due to each event occurring) or partial.

Lunar eclipses take place when Earth passes between the Sun and the full Moon and its shadow falls upon the Moon's surface. Lunar eclipses can be total, partial or penumbral.

We will discuss each of these eclipses in detail later in the chapter.

Both the Moon and the Earth project their shadows into space as a result of being in constant sunlight. Because the Moon is a smaller spherical body than Earth, its shadow is smaller and shorter than Earth's. The Moon and Earth's shadows have two components known as the penumbra, the lighter outer shadow, and the umbra, the dark inner shadow.

The orbit of the Moon is inclined 5 degrees relative to Earth's orbit around the Sun. If the Moon were perfectly aligned with the Earth's orbit, each lunar month a total, annular or hybrid solar eclipse would occur at new Moon, followed two weeks later by a total lunar eclipse at full Moon. Every year there are a variety of solar and lunar eclipses that take place within two weeks of each other. Your references will give you the necessary dates and detail in order to plan accordingly.

Eclipse maps for each eclipse event are published well in advance and are mandatory reading. See Chapter 23 for further resources on how to learn how to read and interpret these maps. They will provide essentials such as eclipse details, obscuration percentage and times of key eclipse events for your specified location.

For solar eclipses other than partial solar eclipses, NASA and EclipseWise. com publish interactive Google maps, which require Internet access to use. Input your specified location to see what the eclipse will look like along with timing and positioning in the sky for key eclipse events. NASA also provides the Javascript Solar Eclipse Explorer, which computes solar eclipse details for a specified city or longitude-latitude.

For lunar eclipses, information will be published by NASA that shows the involved hemisphere – essentially the night side of Earth – with timing for eclipse events.

Camera Only or Camera and Telescope?

The first determiner for viewing an eclipse is, most obviously, the geographical location of the eclipse and where can it be seen? Lunar eclipses

allow an entire hemisphere to see at least some portion of the event. Solar eclipses are much more constrained in geographical coverage. You may be lucky enough to have an eclipse occur close to home, but most often, solar eclipses probably will involve some traveling.

The author has used Camera Only and Camera and Telescope modes for lunar eclipses and partial/annular solar eclipses that were close to home, where it wasn't a major logistics issue to transport a telescope. The annular eclipse was Camera and Telescope mode via a multi-state road trip from Virginia to Erie, Pennsylvania and back in one day! For at-sea and long-distance eclipses, it was Camera Only mode all the way.

If you decide to go to a solar eclipse, how you get there largely determines what you will take with you. If you can travel by your own car you may decide to take all of your gear, including your telescope. Some total solar eclipse chasers invest in a small telescope, usually a small refractor, to take with them. These "stowaway telescopes" are small enough to carry aboard an aircraft in overhead bin stowage and provide excellent visual and photographic capabilities in Camera and Telescope mode.

For the astrophotographer/total solar eclipse chaser novice, simplicity is key. No matter how long totality lasts, it will be over before you know it. Establishing an eclipse plan (later in this chapter), sticking to it and using one mode only whether it be a single lens and camera setup (Camera Only mode) or one Camera and Telescope method (prime focus is highly recommended) will give you the highest chance of getting good astropics. More on mode recommendations in just a bit.

Astrotourism

People, including the author, travel the world over to see total solar eclipses. The author has been on cruise ships to see a total solar eclipse and also saw a 95+% partial solar eclipse at sea, and has also traveled to Cookesville, Tennessee and Chile for total solar eclipses. The author was going to sea for the December 2020 total solar eclipse off of Argentina but cancelled due to Covid-19 concerns. The author has enjoyed four lunar eclipses at sea and quite a few on land.

Years in advance of a major solar eclipse event, tour and travel companies will advertise opportunities to take part in the experience. The author has partaken in several of these both as a participant and staff member. They do cost money but are well worth it if you can afford it, as logistics like travel, food, housing, transportation and the eclipse itself are all taken care of. Plus, the experience of being with other like-minded individuals is a

wonderful addition. The author previously served as a staff member with Scientific Expeditions-Sky and Telescope for a 1998 total solar eclipse cruise as the youth coordinator. The author has also travelled as a paying customer with Insight Cruises-Sky and Telescope "December 2010 Total Lunar Eclipse and Geminids Cruise" and Sky and Telescope "July 2019 Total Solar Eclipse." Both companies are well known and established, and they are excellent in value and the quality of their offerings and service. They are highly recommended as part of your search for upcoming astro-tourism events.

Comment: A selfie after the eclipse was over.
There was still much more to come with the Atacama Desert.

Fig. 14.1. Sky and Telescope Banner Selfie (Image taken by author)

Solar Eclipses

The author has observed and photographed three total solar eclipses to date, one at sea and two on land. In addition to these, the author has also observed and photographed one annular eclipse and about a dozen partial solar eclipses over the decades. The camera setup for each of these solar eclipse events had a safe glass solar filter that covered the front/aperture of the camera lens and/or telescope being used.

For the solar eclipse events prior to the digital photography era, the author used a 35-mm single lens reflex (SLR) film camera with a 50-mm lens, and in addition for the at-sea total solar eclipse, an 8-mm tape video

recorder. Both were used successfully and handheld for the 1998 total solar eclipse at sea.

For the other solar eclipse events, the film SLR was attached to various telescopes that had a proper glass solar filter attached to the front/aperture of the telescope which was used in prime focus mode. A Nikon D5000 DSLR was used with a 50-mm lens for an at-sea deep partial eclipse that was imaged using the pinhole projection method, which we will discuss later in the chapter.

A Nikon D810a with 200 to 500-mm f/3.5-f/5.6 focal length zoom telephoto lens and 1.7x tele-extender with a proper glass solar filter on the front of the lens was mounted on a telescope mount for one total solar eclipse 500 miles (one way) from the author's residence, while a regular camera tripod with this same camera and just the telephoto lens was used for the Chile total solar eclipse. In addition, an iPhone 6s took astropics during totality for both total solar eclipses on land.

As you can see, distance can determine to a large part your eclipse imaging setup.

2013 while at sea was the author's first use of a digital single lens reflex camera (DSLR) – a Nikon D5000 DX with various DX lenses – to photograph a solar eclipse. This was during a 95+% partial solar eclipse that was very close to the centerline for a rare hybrid eclipse. Having no solar filter or solar eclipse glasses, the author photographed pinhole projection images (see more below) of the eclipse using the ship's white painted superstructure as the projection surface.

Solar Eclipse Tip – Pinhole Projection

If for whatever reason you find yourself at a solar eclipse without a solar filter and/or solar eclipse glasses, there is a very simple and safe technique for viewing solar eclipses, called "pinhole projection." All that is required is a stiff 3x5 card although just a sheet of paper will work. You make a small hole using a pencil or pen in the card or paper. Position yourself so that your back is towards the Sun. *Never* look directly through the pinhole at the Sun! Hold the card/paper in front of you with the Sun behind you. Move the card/paper so that the Sun's projected image becomes clearly visible on a flat surface like a wall. You will see the eclipsed Sun quite nicely. You can take a pic of the image with your other hand.

See "Pinhole Projection" in Chapter 23.

Camera & Mode: D5000 DX w/18-55mm f/3.5-5.6 DX lens at 18mm f/11
handheld Camera Only.
ISO: 200
Exposure: 1/500 second
Processing: Mac Photos
Comment: Two small holes have been made in a stiff card and sunlight is
projected through them on to the ship's white paint. Other cruise guests
were doing the same.

Fig. 14.2. Pinhole solar eclipse. Always keep your back to the Sun, and *never* look
directly at it through the pinhole. (Image taken by author)

Camera & Mode: D5000 DX w/18-55mm f/3.5-5.6 DX lens at 55mm f/7.1
handheld Camera Only.
ISO: 200
Exposure: 1/200 second
Processing: Mac Photos
Comment: Three thin solar crescents are visible using pinhole projection.
Note that the author's cusped fingers also produced a solar crescent!

Fig. 14.3. Pinhole solar eclipse (Image by author)

The 2017 and 2019 total solar eclipses were travel expeditions to Cookeville, TN and La Serena, Chile, respectively. For logistical convenience and desired photographic coverage, the author used Camera Only mode for these events. You will learn what both modes entail for observing and photographing eclipses so you can decide how best to proceed.

Solar Eclipse Safety

You read about solar safety in Chapter 12, of this book and we will expound upon that with the following discussion on solar eclipse safety.

Regarding solar eclipses, it is mandatory that you practice solar eclipse safety for each and every solar eclipse regardless of the type of event. You only have two eyes, and failure to follow safe solar eclipse viewing and solar eclipse photography procedures may cause permanent eye damage and ruin your camera. You and you alone are responsible for practicing proper solar eclipse safety procedures.

There is little information available on how to safely photograph solar eclipses using tablets. The author recommends using a tablet *only during totality of a total solar eclipse* in Camera Only Mode. You should be able to photograph the Sun's corona and sky color and/or the surrounding landscape in the Moon's umbra. Use the Smartphone references in Chapter 23 as a guide. If you undertake any other solar eclipse photography with your tablet, you do so at your own risk and will likely damage your tablet's camera. Don't do it.

The best and safest cameras to use for photographing solar eclipses are either a DSLR with live view or mirrorless CSC with EVF. Their features, especially if they have video and interchangeable lenses, make them perfect for safe solar eclipse photography in Camera Only and Camera and Telescope modes. It is highly recommended that you use only these cameras. Use of other camera types is possible, but you do so at your own risk. The following solar eclipse photographic sequences are for DSLR and CSC mirrorless with EVF camera types only.

Make sure you read and then print out the solar eclipse safety links for this chapter that are in Chapter 23. Remember to take these printouts with you so you have them in the field, as you may not be able to access the Internet. If you find any inoperative or removed link(s), access:

- https://eclipse.gsfc.nasa.gov/SEhelp/safety.html
- https://eclipse.aas.org/eye-safety
- https://www.nasa.gov/content/eye-safety-during-a-total-solar-eclipse

If you do not understand something or have questions, contact an appropriate organization for further clarification before trying to view or photograph a solar eclipse event yourself.

Eyes Only:

- Except during totality, never look at any solar eclipse unless you are wearing approved and certified solar viewing glasses, also known as solar eclipse glasses, with certification ISO 12312-2.
- Only during the period of solar eclipse totality when the Moon completely covers the Sun can you remove your solar eclipse glasses. You must put them back on when totality ends.
- Follow all manufacturer guidelines and procedures for your solar eclipse glasses, including how to check them before each use.
- Solar eclipse glasses are for your eyes only and are *never* to be used with optics or for any other purpose.
- As an extra safety precaution, do not stare at a solar eclipse for long periods through your approved and certified solar eclipse glasses. Look through them briefly for a few seconds and then look away. This is done in case of holes or other imperfections in your solar eclipse glasses that might have been missed when you inspected them before use.
- Never leave your solar eclipse glasses unattended in order to prevent someone, especially children, from damaging or attempting to look through them.

Note that "approved" solar eclipse glasses and solar filters means that they were purchased from a dealer recommended by the American Astronomical Society (AAS). "Certified" solar eclipse glasses meet the required ISO 12312-2 standard. "Certified" solar filters means that an AAS recommended solar filter dealer sells solar filters manufactured to industry standards. During the 2017 "Great American Solar Eclipse," solar eclipse glasses were being sold falsely as ISO 12312-2, which became a major safety concern.

A link to the AAS list of reputable vendors for purchasing approved and certified ISO 12312-2 solar eclipse glasses and solar filters for your camera, lenses, telescope, telescope finder scope, binoculars and any other optical aids has been provided in Chapter 23.

Camera Only (***See Baily's Beads and Diamond Ring Sections**):

- Except during totality*, never photograph or view with a camera any solar eclipse unless you have a safe solar filter that properly fits the front of the lens and if applicable, viewfinder you are using that was bought from a dealer recommended by the American Astronomical Society (AAS).

- Only during totality* when the Moon completely covers the Sun can you remove the solar filter on the front of your lens and if applicable, viewfinder. You must put them back on when totality* ends.
- Except during totality, never photograph or look at a solar eclipse through a viewfinder if your camera lacks through-the-lens viewing unless you have over the front of the viewfinder (sunward-facing side) a properly fitting safe solar filter bought from a dealer recommended by the American Astronomical Society (AAS).The viewfinders of digital single lens reflex cameras (DSLRs), film single lens reflex cameras (SLRs) and mirrorless CSCs with electronic viewfinders (EVFs) are made safe by an approved and certified solar filter on the front of the lens.
- If available, use live view only and cover or close your viewfinder.
- Follow all manufacturer guidelines and procedures for your solar eclipse filter(s) including how to check them before each use.
- As an extra safety precaution, do not stare at a solar eclipse for long periods through your camera's viewfinder unless it is an EVF. Look through it briefly for a few seconds and then look away. This is done in case of holes or other imperfections in your solar filter that might have been missed when you inspected them before use.
- Never leave your equipment unattended in order to prevent someone, especially children, from damaging or attempting to look through it.

Camera and Telescope (***See Baily's Beads and Diamond Ring Sections**):

- Except during totality*, never photograph or view any solar eclipse unless you have a safe solar filter that properly fits the front/aperture of the telescope and/or telescope finder scope you are using that was bought from a dealer recommended by the American Astronomical Society (AAS).
- Except during totality, never photograph or look at a solar eclipse through a telescope finder scope unless you have a safe solar filter for the front/aperture of the telescope finder scope bought from a dealer recommended by the American Astronomical Society (AAS). If you do not have a solar filter for the telescope finder scope, make sure it is covered and secured so that no sunlight can enter.
- Only during the period of solar eclipse totality when the Moon completely covers the Sun can you remove the solar filter on the front of your telescope* and/or telescope finder scope. You must put them back on when totality ends*.
- If using a camera attached to your telescope, use your camera's live view function or computer screen viewing if available and cover or close your viewfinder.

- Follow all manufacturer guidelines and procedures for your solar eclipse filter(s), including how to check them before each use.
- As an extra safety precaution, do not stare at a solar eclipse for long periods visually or through your camera's viewfinder, unless it is an EVF, while using the telescope and telescope finder scope with a safe solar filter on each. Look briefly for a few seconds and then look away. This is done in case of holes or other imperfections in your solar filter that might have been missed when you inspected them before use.
- Never leave your telescope unattended in order to prevent someone, especially children, from damaging or attempting to look through it.

Binoculars or Other Optical Aids:

- Except during totality, never photograph or view any solar eclipse unless you have a safe solar filter that properly fits the front/aperture of the binoculars (requires one solar filter for each lens), spotting scope or some other optical aid you are using that was bought from a dealer recommended by the American Astronomical Society (AAS).
- Only during the period of solar eclipse totality when the Moon completely covers the Sun can you remove the solar filter on the front of your binoculars or optical aid. You must put it back on when totality ends.
- Follow all manufacturer guidelines and procedures including how to check the solar filter(s) before each use.
- As an extra safety precaution, do not stare at a solar eclipse for long periods through your binoculars or optical aid. Look briefly for a few seconds and then look away. This is done in case of holes or other imperfections in your solar filter that might have been missed when you inspected them before use.
- Never leave your telescope unattended in order to prevent someone, especially children, from damaging or attempting to look through it.

Solar Eclipse Phases (*See Baily's Beads and Diamond Ring Sections)

All solar eclipses begin with First Contact, also known as C1, when the Moon covers the very first bit of the Sun's disk to begin the partial solar eclipse phase. What we see is the Moon's outer shadow, the penumbra, covering a percentage of the Sun as determined by the circumstances for each solar eclipse event and its solar eclipse type.

This C1 partial solar eclipse phase that occurs during each type of solar eclipse requires use of approved and certified solar eclipse glasses for your

eyes, solar filters on the front of all camera lenses, non-through-the lens camera viewfinders, telescopes, telescope finders and optical aids.

For total solar eclipses, hybrid solar eclipses and annular solar eclipses, Second Contact, also known as C2, is the moment that totality (when the Moon completely covers the Sun) or annularity (when the Moon is completely within the solar disk to form an annulus or ring) begins. Only during totality can solar eclipse glasses and solar filters* be removed. During annularity and the entire annular solar eclipse, solar eclipse glasses and solar filters must be used.

For total solar eclipses, hybrid solar eclipses and annular solar eclipses, Third Contact, also known as C3, is the moment that totality or annularity ends. When totality ends, solar eclipse glasses and solar filters* must be in place for the following partial eclipse phase. Again, during the entire annular eclipse event, solar eclipse glasses and solar filters remain in place.

All solar eclipses end with Last Contact, also known as C4, when the Moon uncovers the last bit of the Sun's disk to end the partial eclipse phase and the solar eclipse event. Solar eclipse glasses and solar filters must be in place until you stop looking at the Sun with your eyes and move your camera and/or telescope completely off of the Sun.

Solar Eclipse Maps

Here are some of the major data points that are provided by solar eclipse maps. While this list is not all-encompassing, it does provide you with a solid orientation of what a solar eclipse map entails:

- A diagram of Earth centered on the specific geographical region of visibility where the eclipse can be seen. This diagram will encompass the entire viewing area.
- The type of eclipse event – partial, annular, total, hybrid – and Universal Date and time for each major eclipse event, tailored to the type of eclipse taking place.
- The beginning and ending geographical points; the upper and lower limits of the partial eclipse phase; the path of totality and/or annularity. Once again, the type of eclipse that is occurring will determine the makeup of the solar eclipse map.
- Area of eclipse magnitude, which is the fraction of the Sun's diameter occulted by the Moon expressed as a percentage.
- Area of eclipse obscuration, which is the fraction of the Sun's area covered by the Moon, also expressed as a percentage.
- A Google Map interactive feature that allows you to click on a position to see particulars of the eclipse at that location.

Totality (and All Solar Eclipses) Tip For Both Modes

Prior to solar eclipse day, you need to have practiced inspecting and using (placing, removing and focusing with) your solar filter(s) according to the manufacturer's instructions. This would include doing so for each solar filter for your camera, camera viewfinder if required, lenses, telescope, telescope finder scope and optical aids. Always insure that your solar filter(s) are properly placed by checking them with a slight tug. A safe practice is to check them often for proper placement especially if windy conditions are present. If wind is an issue, use tape to secure them. ONLY practice removing solar filters AWAY from the Sun!

Remember, as an added solar filter eye safety precaution in case of undetected pinholes or scratches, do not to look at the Sun for long periods of time through your camera's viewfinder, telescope, telescope finder scope, optical aid(s) or solar glasses. Instead, look just a few seconds at a time to be solar safe.

In Camera Only mode, when placing and removing a solar filter, care must be taken to not move the focus of a lens or move your setup off of the Sun. With sufficient practice this can be achieved.

In Camera and Telescope mode, practice placing and removing a solar filter as well. You probably won't change the focus of your setup but you might move your telescope, which you do not want to do when totality is upon you.

If you have not practiced previously to the eclipse event, point your setup, be it Camera Only and/or Camera and Telescope, on the opposite side of the sky away from the Sun and try removing and placing your solar filter(s). This practice should help you avoid changing lens focus and also changing sky positioning due to "on and off" solar filter movements.

In both modes it is best to achieve a precise focus before totality starts as you do not want to waste precious totality seconds doing so. Focusing on a sunspot and/or the "horns" of the Moon as the partial solar eclipse deepens will help. If your camera has live view with a zoom in feature, use it to try to achieve a sharp focus.

The author has found, as has many other "umbraphiles" (people who have experienced totality), that getting sharp focus is the most difficult part of the total solar eclipse. It pays to recheck that focus for a few seconds at totality's start before exposing. The author was off just a hair in focus in 2017 and was better in 2019. Take some astropics well before totality to check the focus. Use your live view and zoom if they are available to closely check focus. It helps immensely to block out the surrounding bright sunlight to see your camera's LCD screen or computer display. You can use a dark cloth-hood covering your camera and head to do this. The author uses an

old, dark-colored cotton shirt to place over the camera and his head to improve the view. It is light and easily taken on and off. You might look goofy but it works to get better focus.

After getting your best focus in Camera Only mode, check to see where the "Infinity" symbol is on the lens focus ring and maybe even mark it with a small piece of tape in case you need to refocus. Some lenses may not line up precisely with their infinity marks so having this marked can help.

Depending on your lens and eclipse astropic sequence, you may want to put a piece of black electrical tape (leaves no residue and is easily removed) partially around the lens focus ring to avoid any change in focus especially during totality. Applying tape to a telephoto zoom ring to help lock it in at a specified focal length can be useful unless you will be working the zoom lens during the solar eclipse. Using the tape as described might help you keep focus or regain it quickly if focus is lost when removing or replacing your solar filter.

You will want to capture the inner and outer corona, any prominences present and perhaps even the disk of the New Moon. This will require changing your exposure setting. Use the following astropics as beginning points in your eclipse plan and SAAS. You want to take as many exposures as you can for each feature to maximize getting good pics.

Consider taking an exposure sequence, which some cameras can do. This involves setting a pre-determined number of exposures at different exposure settings, which the camera then executes automatically when the cable release or exposure button is pressed. This is considered an advanced method, but nevertheless you may want to consider it. Check your camera's user manual to see if it is an option.

Total Solar Eclipse Photography Sequence – Camera Only and Camera and Telescope

Perhaps the most dramatic astronomical occurrence one can ever see and photograph is a total solar eclipse. In this event the New Moon moves across the face of the Sun for hours, covering more and more of the Sun's disk. For total solar eclipse watchers this can seem to take forever and does entail a lengthy period of time.

How long the Sun remains totally eclipsed can last from literally a fraction of a second to a maximum time of about 7.5 minutes. Every location on the Earth's surface that lies within the precisely defined path of totality (which is the actual movement of the Moon's dark umbra shadow across the Earth) will have a specified length of totality that will last for seconds and/or minutes.

An observer's time of totality experienced will thus depend on where they are within this path. Being on the center line of the path of totality will provide a longer duration of totality. There is only one specific point on the path of totality that will experience the greatest duration of totality, which is provided in the solar eclipse map data and eclipse illustration.

If your observing location is within the totality upper limit line or the totality lower limit line, which is positioned north or south respectively of the totality center line, your time of totality will be reduced. Observers located beyond the path of totality and within the geographical area of the solar eclipse map will experience a partial solar eclipse. The solar eclipse map will show areas experiencing the highest percentage, 90+%, of the Sun eclipsed just outside the path of totality, with ever-decreasing amounts occurring the farther away you are either above or below the path of totality.

Maximizing the time of totality available requires efficiency and discipline, which an eclipse plan can help you achieve. We will discuss that later in this chapter.

For your initial settings for Camera Only mode, total solar eclipse pictures that were taken at Cookeville, TN on August 21, 2017 and Casa Molle, Elqui Valley, Chile with the *Sky and Telescope* tour group on July 2, 2019 are provided. The camera setup in TN was a Nikon D810a FX DSLR with a 200-500mm f/3.5-5.6 telephoto zoom lens with 1.7x tele-extender on a telescope mount. For Chile it was a Nikon D810a FX DSLR with a 200-500-mm f/3.5-5.6 telephoto zoom lens on a camera tripod with gimbal head. An approved glass solar filter was used to cover the front of the lens.

The author has no total solar eclipse Camera and Telescope mode astropics. The photographic sequence is the same for both modes, however. Resources for total solar eclipse Camera and Telescope mode recommended exposure settings can be found in Chapter 23.

The entire partial solar eclipse that occurs before totality, C1 to C2, and after totality, C3 to C4, requires an approved and certified properly sized solar filter on the front of each camera lens and, if required, camera view-finder, and telescope/telescope finder/optical aids used. Use approved and certified ISO 12312-2 solar eclipse glasses for your eyes only.

Location: Chile
Camera & Mode: D810a w/ 200-500mm lens at 500 mm f/5.6 on gimbal
head tripod with glass solar filter Camera Only.
ISO: 200
Exposure: 1/640 second
Processing: Mac Photos
Comment: Moments after C1, the Moon is visible against the Sun.

Fig. 14.4. Moments after C1 First Contact (Image by the author)

Location: Chile
Camera & Mode: D810a w/ 200-500mm lens at 500mm f/5.6 on gimbal head tripod with glass
solar filter Camera Only.
ISO: 200
Exposure: 1/320 second
Processing: Mac Photos

Fig. 14.5. Moments before C2 Second Contact (Image by the author)

Diamond Ring

In the seconds before C2, the remaining crescent of the Sun shrinks ever smaller and the Sun's corona begins to appear around the Moon. At approximately 15 to 20 seconds before totality, a brilliant flash of sunlight along with the emerging corona causes the "Diamond Ring." It is so named as this partial eclipse event really looks like a bright diamond ring in the rapidly darkening sky.

The Diamond Ring repeats a few seconds after totality ends, at C3. The Author has no pics of the first Diamond Ring due to watching and refers you to Figure 14.14 to view a pic of this second Diamond Ring. Camera settings would be the same for both events.

First Diamond Ring Solar Eclipse Safety

Eyes Only:
- For safe solar eclipse viewing, solar eclipse glasses are still required during both Diamond Ring events.

Optical Aids:
- For safe solar eclipse viewing, solar eclipse filters are still required over the front lenses of your optical aids during both Diamond Ring events.

For Camera Only and Camera and Telescope Modes:
- Unless you can completely cover your camera's viewfinder with a viewfinder cap or physically close the viewfinder so no light comes through, a safe solar filter is still required over the front of your camera lens, camera viewfinder if required and telescope.
- If you cannot completely cover or close your camera's viewfinder, you cannot safely photograph the Diamond Ring, so do not try.
- If you have a mirrorless CSC with an electronic viewfinder (EVF) you can safely photograph the Diamond Ring.
- If your camera's viewfinder is completely covered or closed so no light can come through, or you are using a mirrorless CSC with EVF, you may remove your solar filter covering your lens or telescope seconds before C2 to image the Diamond Ring.
- Use live view, computer screen if applicable or EVF only to frame and SAAS. Your telescope finder 'scope is covered or has a safe solar filter in place.

Baily's Beads

Baily's Beads are another partial eclipse event that occurs after the Diamond Ring and just seconds before C2 and totality, as the last visible sunlight

comes through valleys and craters on the limb of the Moon. They can look like bright spots and appear to be moving as the Sun finally enters totality. Bailey's Beads repeat a few seconds after totality ends, at C3.

Baily's Beads Solar Eclipse Safety

Eyes Only:
• For safe solar eclipse viewing, solar eclipse glasses are still required during both Baily's Beads events.

Optical Aids:
• For safe solar eclipse viewing, solar eclipse filters are still required over the front lenses of your optical aids during both Baily's Beads events.

For Camera Only and Camera and Telescope Modes:
• Use the same procedures as those for Diamond Ring Solar Eclipse Safety Camera Only and Camera and Telescope Modes to safely photograph both Baily's Beads events.

Location: Cookeville, TN
Camera & Mode: D810a w/200-500mm lens w/1.7x tele-extender at 850mm f/9.5 on telescope mount Camera Only, with camera viewfinder closed and glass solar filter removed using live view.
ISO: 200
Exposure: 1920x1280 video shot at 60 fps with exposure determined by watching live view. The author worked the exposure in real time to get the best view; live SAAS while shooting video. Exposure information is not recorded in the video metadata.
Processing: A single frame was copied from the video and processed in Mac Photos.
Comment: Just a few seconds after the Diamond Ring, multiple Baily's Beads became visible and "danced" in the original video, only to disappear with the onset of C2. This frame shows a number of Baily's Beads as well as the Sun's red chromosphere.

Fig. 14.6. Baily's Beads after the Diamond Ring and before C2

C2 Totality

After the Diamond Ring and Baily's Beads have occurred, the Sun becomes totally eclipsed by the Moon and C2 totality begins. Only during totality, when the Sun is completely covered by the Moon, can all solar filters and solar eclipse glasses be removed. Keep them readily available for quick use when totality ends.

At C2 totality, observers are physically in the Moon's dark inner shadow known as the umbra, and the Sun's glorious corona becomes visible in its entirety. If this is your first totality experience, congratulations – you are now an umbraphile!

The author recommends continuing to use live view during C2. All of the following images were taken using live view.

Location: Chile
Camera & Mode: Apple 6s at f/4.5 handheld Camera Only.
ISO: 200
Exposure: 1/25 second
Processing: Mac Photos
Comment: The totally eclipsed Sun is overexposed. The sky view and earthly shadows and terrain bathed in the umbra are spectacular. iPhone did exposure settings automatically.

Fig. 14.7. Totality (Image by the author)

Location: Chile
Camera & Mode: D810a w/ 200-500mm lens at 500mm f/5.6 on gimbal head tripod Camera Only.
ISO. 200
Exposure: 1/125 second
Processing: Mac Photos Cropped
Comment: The corona is visible in all its glory,

Fig. 14.8. Totality (Image by the author)

Location: Chile
Camera & Mode: D810a w/ 200-500mm lens at 500mm f/5.6 on gimbal head tripod Camera Only.
ISO: 200
Exposure: 1/160 second
Processing: Mac Photos

Fig. 14.9. The Sun's inner corona (Image by the author)

Location: Chile
Camera & Mode: D810a w/ 200-500-mm lens at 500 mm f/5.6 on gimbal
head tripod Camera Only.
ISO: 200
Exposure: 1/30 second
Processing: Mac Photos

Fig. 14.10. The Sun's outer corona (Image by the author)

Location: Chile
Camera & Mode: D810a w/ 200-500mm lens at 500mm f/5.6 on gimbal head
tripod Camera Only.
ISO: 200
Exposure: 1/800 second
Processing: Mac Photos
Comment: Cropped pic to show the numerous prominences in greater detail.
These weren't readily visible in the camera's LCD panel.

Fig. 14.11. Solar prominences (Image by the author)

At mid-totality, you may want to try and photograph the New Moon itself. This requires a longer exposure to image the Earthshine that might be visible. To image this was the author's prime photographic objective for the 2019 Chile solar eclipse.

Location: Chile
Camera & Mode: D810a w/ 200-500mm lens at 500mm f/5.6 on gimbal head tripod Camera Only.
ISO: 200
Exposure: 1 second
Processing: Mac Photos
Comment: Earthshine on the New Moon clearly reveals major lunar surface features. Details are also visible in the overexposed corona.

Fig. 14.12. Earthshine on the New Moon (Image by the author)

As totality progresses towards C3, the end of totality, you will begin to notice a brightening along the lunar limb opposite to where you might have seen the first Diamond Ring and Baily's Beads. This signifies that totality is ending, and you *must* put on your solar eclipse glasses and all solar filters* immediately to be solar eclipse safe.

*C3 Second Baily's Beads and Diamond Ring**

Just seconds after C3, Baily's Beads and the Diamond Ring will appear again.

Solar Eclipse Safety

Eyes Only:
* For safe solar eclipse viewing, solar eclipse glasses are required after totality ends at C3 and during the second Baily's Beads and Diamond Ring.

Optical Aids:
* For safe solar eclipse viewing, solar eclipse filters are required over the front lenses of your optical aids after totality ends at C3 and during the second Baily's Beads and Diamond Ring.

For Camera Only and Camera and Telescope Modes:
* Follow the same solar eclipse safety procedures previously discussed for photographing the first Diamond Ring and Baily's Beads seconds before C2.
* If you are photographing the second Diamond Ring, a solar filter needs to be put over the front of the camera lens and viewfinder if applicable or telescope front/aperture *immediately after* you have taken the second Diamond Ring pics as the partial solar eclipse is occurring. Failure to do so will result in damage to your camera.
* If you open the camera viewfinder and look through it without a solar filter over the front of the camera lens or if applicable camera viewfinder, or telescope front/aperture, you will injure your eyes.

All of the following images were taken using Live View.

Location: Chile
Camera & Mode: D810a w/200-500mm lens at 500mm f/5.6 on gimbal head tripod Camera Only, with camera viewfinder closed and glass solar filter removed.
ISO: 200
Exposure: 1/50second
Processing: Mac Photos
Comment: Just a few seconds after C3, the corona is still visible with the onset of Baily's Beads. The author used live view only and did not look through the camera viewfinder, which was closed.

Fig. 14.13. A few seconds after C3, with the corona still visible and Baily's Beads

Location: Cookeville, TN
Camera & Mode: D810a w/200-500mm lens w/1.7x
tele-extender at 340mm f/9.5 on telescope mount Camera
Only, with camera viewfinder closed and glass solar
filter removed.
ISO: 200
Exposure: 1 second
Processing: Mac Photos and some cropping
Comment: Just a few seconds after C3 and the second
Baily's Beads, the second Diamond Ring appears. The author
put a solar filter over the front of the camera lens
mmediately after this pic was taken. The author used live
view only and did not look through the camera viewfinder,
which was closed.

Fig. 14.14. Second Diamond Ring and corona. The author put a solar filter over the front of the camera lens immediately after this pic was taken.

Only after you have placed a solar filter over the front of your viewfinder if applicable, lens or front/aperture of your telescope may you resume using your camera's viewfinder looking for seconds at a time as has been stated previously. The author recommends keeping the viewfinder closed and using live view only or computer screen (if applicable) as an extra solar safety precaution.

Location: Cookeville, TN
Camera & Mode: D810a w/200-500mm lens w/1.7x
tele-extender at 340mm f/9.5 on telescope mount Camera
Only, with glass solar filter over the front of the lens.
ISO: 200
Exposure: 1/320 second
Processing: Mac Photos
Comment: C3 partial solar eclipse underway.

Fig. 14.15. Moments after photographing the second Diamond Ring (Image by the author)

C4

At C4, the second partial solar eclipse phase and the total solar eclipse event end with the Moon moving completely off the Sun. Solar eclipse glasses and solar filters can be removed when you stop looking at the Sun and you have moved your camera, optical aids and/or telescope completely off of the Sun.

Annular Solar Eclipses

Annular solar eclipses are comprised of partial eclipse phases at C1 to C2 and C3 to C4. C2 to C3 is annularity, when the Moon is completely positioned within the Sun's disk and forms a ring or annulus.

Annular Solar Eclipse Safety

Eyes Only:
* For safe annular solar eclipse viewing, solar eclipse glasses are required for the entire annular solar eclipse event, C1 to C4.

Optical Aids:
* Solar eclipse filters are required over the front lenses of your optical aids during the entire annular solar eclipse event, C1 to C4.

For Camera Only and Camera and Telescope Modes:
* For the entire annular solar eclipse event, C1 to C4, an approved and certified solar filter for the front of your camera lens, camera viewfinder if required, telescope and telescope finder scope is required.
* For extra safety, it is recommended that the camera viewfinder be closed or capped and live view or computer screen if applicable only be used.

Location: Erie, PA
Camera & Mode: Minolta SRT 101 SLR mounted prime focus to Meade
SCT 8-inch with ERF and Hydrogen Alpha Daystar filter Camera and
Telescope.
ISO: 400 High Speed Ektachrome slide film
Exposure: 1/125
Processing: Slide copied and processed in Mac Photos
Comment: Moments before C2 and annularity. This was an attempt to get a
Hydrogen Alpha view of the Sun during annularity. As you can see it, didn't
work out, as there were a lot of internal reflections in the telescope-ERF-filter.

Fig. 14.16. Moments before C2 second contact (Image by the author)

Location: Erie, PA
Camera & Mode: Minolta SRT 101 SLR mounted prime focus to Meade
SCT 8-inch with ERF and Hydrogen Alpha Daystar filter Camera and
Telescope.
ISO: 400 High Speed Ektachrome slide film
Exposure: 1/125
Processing: Slide copied and processed in Mac Photos
Comment: C2 and annularity. This was an attempt to get a Hydrogen Alpha
view of the Sun during annularity. As you can see it didn't work out, as there
were a lot of internal reflections in the telescope-ERF-filter.

Fig. 14.17. C2 second contact (Image by the author)

The annular solar eclipse map is essentially identical to a total solar eclipse map. The path of annularity will be provided along with the percentages of partial eclipse experienced within the geographical region of the annular eclipse.

We see an annular solar eclipse when the new Moon is at or near apogee, its farthest distance from Earth during the lunar month. The annular solar eclipse begins as a partial solar eclipse – C1 – with the Moon covering more and more of the Sun as it moves across the solar disk.

Because the Moon is at apogee and has a smaller disk size in the sky compared to the Sun's, it cannot totally eclipse the Sun. The Moon's dark umbra shadow is simply too far away from Earth's surface. As a result, observers experience the Moon's antumbra, the shadow that extends beyond the Moon's. At C2, the start of the annular eclipse, the Sun appears as an extremely brilliant ring – an annulus – around the Moon.

Because the Sun is not totally eclipsed, the corona and prominences will not be visible in an annular eclipse. Baily's Beads may be visible just before and after annularity, so be on the lookout.

Baily's Beads Annular Solar Eclipse Safety

Eyes Only:
- For safe annular solar eclipse viewing, solar eclipse glasses are required for the entire annular solar eclipse event, C1 to C4.

Optical Aids:
- For safe annular solar eclipse viewing, solar eclipse filters are required over the front lenses of your optical aids during the entire annular solar eclipse event, C1 to C4.

For Camera Only and Camera and Telescope Modes:
- Do *not* remove your solar filter on the front of your camera's viewfinder if applicable, lens or the front/aperture of your telescope to photograph Baily's Beads! It must stay on for the entire annular eclipse.
- During annularity, the Sun is still dangerously bright, and without a solar filter in place your camera could be severely damaged and even catch fire.
- Without a solar filter in place, your eyes will be injured if your viewfinder is not closed and you accidentally look through the viewfinder.

The shutter speed for Baily's Beads, if they are present, will be different from those of a total solar eclipse, as your solar filter will be on the front of your camera's lens or over the front/aperture of your telescope. Additionally, the Sun won't be totally eclipsed and will therefore be brighter. Start with the settings from Figure 14.4 and SAAS.

Annularity is the amount of time the Moon is completely within the disk of the Sun and can last from a fraction of a second to a maximum time of 12 minutes, 29 seconds. When annularity finishes at C3, a partial solar eclipse will be visible once again with the Moon moving off the disk of the Sun at C4, ending the annular eclipse. Solar eclipse glasses and solar filters can be removed when you stop looking at the Sun and you have moved your camera and/or telescope completely off of the Sun.

Like a total solar eclipse, the entire annular eclipse sequence can take several hours from start to finish.

Hybrid Eclipses

Very rare hybrid solar eclipses are also described as annular-total eclipses. This is because a hybrid eclipse can appear as an annular eclipse and total eclipse at different locations along the hybrid eclipse's path. Hybrid eclipses occur when Earth's curvature brings locations that are in the path of

annularity-totality into the Moon's umbra and antumbra shadows. As with total and annular eclipses, the entire C1 to C4 sequence may take several hours from start to finish.

Hybrid solar eclipse maps will look the same as those for total and annular eclipses.

As described by NASA and AAS, hybrid solar eclipses at C2 begin as an annular eclipse, become a total eclipse for a brief time, and then revert back to an annular eclipse before it ends at C3. On rare occasions, a hybrid eclipse at C2 may begin as an annular eclipse and end as a total eclipse, or vice versa.

Hybrid Solar Eclipse Safety

Note that extreme caution has to be observed in a hybrid solar eclipse. This is due to the rapid transition from totality to annularity or vice versa that can occur along the eclipse path. Annularity requires the use of approved and certified solar eclipse glasses with certification ISO 12312-2 for your eyes and approved and certified solar filters for the front of each of your camera's lenses, camera viewfinder if required, telescope, telescope finder scope and optical aids. This transition may occur very quickly, so your solar eclipse glasses and solar filters must be readily accessible for use.

You definitely want your viewfinder closed or capped so that no light can come through, and use live view, computer screen if applicable or EVF for the entire eclipse.

In a hybrid solar eclipse, a partial solar eclipse begins at C1, requiring an approved and certified solar filter for the front of your camera lens, camera viewfinder if required, telescope, telescope finder scope and each optical aid used in addition to approved and certified ISO 12312-2 solar eclipse glasses for your eyes.

At C2, annularity-totality, there may be a quick transition involved where the observer will see totality and annularity depending on your location. Annularity requires approved and certified solar eclipse glasses with certification ISO 12312-2 for your eyes and approved and certified solar filters for the front of each of your camera's lenses, camera viewfinder if required, telescope, telescope finder scope and optical aids for viewing the annular eclipse phase.

After totality-annularity ends at C3, a partial solar eclipse unfolds until C4, when the Moon has completely moved off the disk of the Sun thus ending the hybrid solar eclipse. Solar eclipse glasses and solar filters can be removed when you stop looking at the Sun and you have moved your camera and/or telescope completely off of the Sun.

The next hybrid solar eclipse takes place on April 20, 2023. *Sky & Telescope* magazine, the *Observer's Handbook*, NASA.gov and AAS.org will likely have solar eclipse safety guidance for safely viewing and photographing this rare type of eclipse. Use these resources to be safe.

As stated by EclipseWise.com, http://www.eclipsewise.com/solar/SEprime/2001-2100/SE2023Apr20Hprime.html,

"The solar eclipse of 2023 Apr 20 is one of the rare hybrid solar eclipses. In this particular case the eclipse path starts out as annular. Further down the track it changes to total and then back to annular before the path ends."

Your observing location will determine the eclipse sequence you will experience and therefore dictate how to observe and photograph it. EclipseWise.com and other references will have the details of the hybrid eclipse available for cities and geographic locations within the eclipse path. You will be able to view listed cities as well as click on a location and/or enter coordinates to see eclipse details.

If you do not completely understand what you need to do to be hybrid solar eclipse safe, contact an appropriate organization.

Partial Solar Eclipses

The last type of solar eclipse is a partial solar eclipse, and it is the most common type. A partial solar eclipse map will be the same as the other solar eclipse maps, except it will not have a path of totality or annularity, as there is none. The partial eclipse map will show the geographic area of partial eclipse visibility marked by lines showing the percentage of the Sun eclipsed for observers located within these boundaries. Partial solar eclipses can vary from a very small percentage of the Sun being eclipsed to covering the majority of the Sun. No corona or prominences will be visible.

Partial Solar Eclipse Safety

For the entire partial solar eclipse, C1 to C4, photographing and viewing require an approved and certified solar filter for the front of your camera lens, camera viewfinder if required, telescope, telescope finder scope and each optical aid used in addition to approved and certified ISO 12312-2 solar eclipse glasses for your eyes. These must remain in place for solar eclipse safety during the entire eclipse, as there is no totality and the Sun will remain dangerously bright. Use the initial camera settings from

Figure 14.4 for a start and SAAS to photograph the partial eclipse. Solar eclipse glasses and solar filters can be removed when you stop looking at the Sun and you have moved your camera and/or telescope completely off of the Sun.

You definitely want your viewfinder closed or capped so that no light can come through, and use live view, computer screen if applicable or EVF for the entire eclipse.

Camera Types for Solar Eclipses

Put bluntly, nothing beats a modern DSLR camera for safely taking solar eclipse astropics in Camera Only and Camera and Telescope modes. CSC cameras should perform well also.

Partial and annular eclipses afford the luxury of time to take astropics using other camera types but aren't recommended due to solar safety concerns and their limitations. But during totality, time is of the essence, and the ability to use live view and instant SAAS of individual exposures will result in memorable astropics of the event. CSC cameras should be capable as well, but the author has no experience with these cameras.

For solar eclipse safety, all other camera types should only be used in Camera Only mode during totality of a total solar eclipse.

The author bases this candid assessment on having used a DSLR versus a film SLR, video tape recorder and smartphone for numerous solar eclipses. Owners of smartphones and tablet/iPad users should refer to the Chapter 23 section on "Solar eclipse – Smartphone Photography."

Users of other camera types – film and pocket cameras – can use the settings provided in this chapter for totality as a starting point for your total solar eclipse images and SAAS.

With a video-capable DSLR using an approved and certified solar filter for your lens(es) and/or telescope, it is possible to switch from video recording to individual shots and vice versa. Depending on your software, it is possible to extract and process individual frames from the video. This may be something you want to consider.

Camera Only

For a solar eclipse event, you have to decide in advance precisely what you want to photograph. Do you want to concentrate on the ghostly corona – the

Sun's million-degree outer atmosphere – or a wide view of the eclipsed Sun, stars and planets that may be visible? Because totality is so fleeting, you do not want to spend time changing lenses and refocusing. Thus, one lens for the solar eclipse event is highly recommended. Remember too that each lens needs an approved and certified solar filter of proper size on the front of each lens. Annularity and partial solar eclipses will be far more leisurely in terms of time available to photograph, as compared to totality.

To be able to photograph the solar disk, corona and prominences in any detail, a long focal-length lens is needed. For first-time eclipse (lunar and solar) astrophotographers, the author strongly recommends a zoom telephoto to get the most flexibility and capability. The use of a 200 to 500-mm telephoto zoom lens for two total solar eclipse events has proven to be very capable. For the 2017 total solar eclipse, a 1.7x tele-extender for 850-mm focal length was used and in 2019 just the 200 to 500 mm was used. Cropping the 2019 images provided very satisfactory results.

For both events, the 200 to 500 mm allowed for close in astropics of the inner and outer corona, prominences, Baily's Beads, the Diamond Ring and in 2019 Earthshine on the face of the New Moon. Being able to zoom in and out was extremely valuable in capturing different views of the totally eclipsed Sun.

A gimbal head on a carbon fiber tripod was used with great success for 2019, as this set up handled the heavy and large lens and camera with ease. The eclipse was only 14 degrees above the horizon. A higher altitude – above the horizon – eclipse would work with this rig, but it would have to be tested beforehand to ensure freedom of movement of the rig.

A 28 to 300-mm telephoto zoom lens would be a good choice for wide-angle and zoomed in solar eclipse pics. This set up would be more compact, probably less expensive and allow for a good range of pics covering the inner and outer corona plus wide-angle view of stars and planets present in the Moon's umbra.

At totality the corona is as bright as the full Moon, which translates into fast shutter speeds even with an ISO that is 100-200. Annular and partial solar eclipses will be bright as well, so fast shutter speeds will be the order of the day.

Reviewing the references as well as the settings information for the provided images will get you started. Fast SAAS is the order of the day.

Table 14.1. Solar Eclipses with Camera Only

Camera Type	Partial	Annular	Total	Hybrid
Smartphone	NO	NO	Corona-Totality	Corona-Totality
Tablet	NO	NO	Corona-Totality	Corona-Totality
Pocket	NO	NO	Corona-Totality	Corona-Totality
Film SLR	YES	YES	YES	YES
CSCs	YES	YES	YES	YES
DSLR	YES	YES	YES	YES
Video	YES*	YES*	YES*	YES*
CCD/CMOS	YES*	YES*	YES*	YES*

* If Camera has lens capability

Camera and Telescope

Prime focus is the author's recommended method for using a telescope that is equipped with a proper solar filter on the front/aperture of the telescope and a camera – preferably a DSLR – to photograph solar eclipses. This will give you as wide a view possible of the Sun and Moon, especially if you use a reducer as well.

Depending on your telescope's optical system – a small aperture, fast focal ratio refractor is recommended – and camera, you may or may not be able to get the entire Sun-Moon in your camera. In advance of an eclipse, you can take astropics of the Moon or the Sun (with a safe solar filter attached to the front/aperture of your telescope) with your planned setup to see the exact photographic coverage you will obtain.

It isn't recommended that eyepiece projection or barlow/extender methods be used in a total solar eclipse during totality, as this will prohibit full coverage of the corona. You may want to use these methods during partial solar eclipses (including partial eclipse phases during annular, total and hybrid eclipses) to capture detail along the Moon's limb. If you want detail in prominences during totality even in prime focus mode you can successfully use cropping to highlight prominences present.

The Sun and Moon will show movement in your telescope and camera. Depending on your setup you may be able to move your telescope manually or have your mount track the duo. If your mount has solar tracking rate capability use it, but it isn't a hard-and-fast requirement. If you want to have your mount track, you will have to accomplish daytime polar alignment, discussed in Chapters 6 and 7.

Always decide what to do before eclipse day and practice.

Table 14.2. Solar Eclipses with Camera and Telescope. Prime focus is recommended, and a reducer may be required to obtain full solar disk coverage.

Camera Type	Partial	Annular	Total	Hybrid
Smartphone	NO	NO	NO	NO
Tablet	NO	NO	NO	NO
Pocket	NO	NO	NO	NO
Film SLR	YES	YES	YES	YES
CSCs	YES	YES	YES	YES
DSLR	YES	YES	YES	YES
Video	YES	YES	YES	YES
CCD/CMOS	YES	YES	YES	YES

Lunar Eclipses

Now that we have covered the Sun – pun intended! – let's turn our camera and telescope to lunar eclipses. The author has lost count of how many lunar eclipses he has seen and photographed during 50-plus years of sky watching.

These beautiful nighttime spectacles require no eye or camera protection and are wondrous when the Moon is totally eclipsed or undergoing a deep partial eclipse. Penumbral eclipses may be short in duration, while total and partial lunar eclipses can go on for hours.

Total Lunar Eclipse

Total lunar eclipses begin with the shadow of the Earth's very faint penumbra enveloping the Moon. Seeing the penumbra with the unaided eye is a challenge but is far easier to photograph. The appearance on the Moon's limb of the dark and easy-to-see (and photograph) shadow of the umbra is quite a sight.

As the umbra envelops ever greater portions of the Moon, colors will begin to develop. These colors can be hues of red, orange, yellow and even brown. At totality the umbra completely covers the Moon, and visible colors will be at their peak. For a total eclipse in which the Moon travels close to or actually on the centerline path of the Earth's umbral shadow and there-

fore through its deepest part, it can exhibit a vivid orangish-red or "copper penny" color. When viewed against a darkened sky with stars nearby, it is striking in appearance.

If the Moon is at the edges of the umbral shadow, colors can be less vivid and show some shades of white in the overall appearance. The surrounding sky may not be as dark either. It is still a worthy event to see and photograph.

After totality, the umbra will move across the Moon and exit. The penumbra might become visible after this, and shortly afterwards the event is over.

Like their total solar eclipse counterparts, each total lunar eclipse is unique. The positioning of the Moon in the umbra as well as the transparency of the Earth's atmosphere will be the main factors for what colors we will see and photograph. The only reason we see color in total lunar eclipses is due to the passage of sunlight through Earth's atmosphere which then falls upon the surface of the full Moon. If the Earth had no atmosphere there would be no sunlight streaming through, no color, and the full Moon would be black and likely invisible. The Earth would be at "New Earth" phase as seen from the Moon with no sunlight reflecting off of the planet's oceans and clouds to also illuminate the Moon.

Future astronauts on the lunar surface or in lunar orbit during a total lunar eclipse would experience a total solar eclipse caused by the Earth. They would see a red ring of light circling the entire limb of the Earth comprised of all the sunrises and sunsets taking place during the total lunar eclipse, especially during totality. The outer solar corona and maybe even the inner corona would be visible. What a view that would be! The crew of Apollo 12 saw this as they were returning to Earth in November 1969.

The transparency of our planet's atmosphere is dependent on how much volcanic

debris, aerosols and other airborne particles are in the atmosphere and their distribution. Atmospheric scientists have monitored total lunar eclipses to check on the condition of the Earth's atmosphere. Volcanic eruptions can make a big impact on the transparency of Earth's atmosphere and the amount of sunlight that can pass through it. A prime and personally experienced example was the 1991 major eruption of the Philippines' Mount Pinatubo. A total lunar eclipse in 1992 witnessed and photographed from the island of Guam was extremely hard to see during the totality phase and exhibited a deep, dark brown color. This was the first time the author had ever seen this exhibited in a total lunar eclipse.

Partial Lunar Eclipses

For partial lunar eclipses, the event will lead off with the ghostly penumbral eclipse followed by the curved dark umbra. It is always enthralling to see the ever-expanding dark curve of the umbra as you realize that that is our planet's shadow, just like we see at sunrise and sunset. The Greeks realized that our planet had to be spherical in order for the Earth's shadow to look the way it does during lunar eclipses.

Sometimes the Moon will pass sufficiently far into the umbral shadow, so some slight coloring will appear. These circumstances make for some excellent astropics.

After reaching maximum coverage of the Moon for each partial eclipse event, the umbra will retreat and exit the Moon with the penumbra following to end the event.

Penumbral Lunar Eclipses

The ghostly penumbral lunar eclipses can be a challenge to photograph due to the penumbra possibly not being visible to the eye. If the penumbra moves sufficiently deep to be near the umbra, you might be able to see it visually. Using a camera and/or telescope will probably pick up the subtle shading of the penumbra shadow, especially if you take astropics centered on the scheduled start and end times for the penumbral eclipse.

Lunar Eclipse Maps

These have a few differences from solar eclipse maps, including:

- Lunar eclipses take place at night and are observable to the whole hemisphere experiencing nighttime.
- They depict the Earth in a rectangular format showing the wide area coverage of the eclipse, with key events annotated.
- They show the Moon's path and envelopment through and within the Earth's penumbral and umbral shadows. Times are provided for the Moon's entry and exit of these shadows.
- The total time duration for each phase of the eclipse is also provided.

To help establish the visibility and details of a lunar eclipse at specified locations, NASA's Lunar Eclipse Page provides a Javascript Lunar Eclipse Explorer. You input a specific geographical region, then either a city or your

latitude, longitude and time zone. You then select the eclipse type and date of eclipse and you are provided with eclipse predictions that tell you all you need to know about the eclipse event.

This information will complement your astronomical software, which can provide sky views visible from your specified location. Other references from publications we have discussed for solar eclipses will also be available for each lunar eclipse occurrence.

Lunar Eclipse Photography

In photographing lunar eclipses, you just repeat what you did for solar eclipses minus the solar filters and solar eclipse glasses. You will also be shooting at night or near sunrise or sunset depending on the lunar eclipse event particulars. Use the initial settings for the provided figures and SAAS.

The following descriptions for lunar eclipse events apply to both modes.

Total Lunar Eclipse

When the penumbra makes first contact with the bright full Moon, perhaps you will see shortly thereafter very slight and light gray shading. You want to take a pic at first contact and a few more as the penumbral eclipse progresses.

At the start of the partial eclipse phase you will see the dark and curved umbra appear, another pic to take. As the partial eclipse phase progresses, the full Moon gets deeper and deeper into the umbra. At the first hint of color you will want to take some astropics and SAAS. This color can change and/or become more vivid especially when getting close to totality.

Be sure to take note of the surrounding sky as more stars will begin to appear. You will want to get an astropic of the totally eclipsed Moon hanging in the sky surrounded by a star field.

After totality the umbra slowly moves off the Moon, followed by the penumbra to end the event with the reappearance of the full Moon.

Partial Lunar Eclipses

These events can barely eclipse the Moon with the umbra or go far into the umbra to produce some color. Use the above partial eclipse procedures and the following initial settings and SAAS.

Penumbral Lunar Eclipse

The penumbra will be present in all eclipses at their beginning and end. Occasionally the Moon undergoes a penumbral eclipse only and presents a challenge to see it visually and then photograph it. Try initial settings for a Full Moon and SAAS.

Camera Only

The guidance for photographing the Sun and solar eclipses applies to photographing lunar eclipses, as the Sun and Moon are the same apparent size in the sky. Of course lunar eclipses occur at night or near sunrise and sunset depending on the eclipse circumstances. But, you will be shooting a very bright object, the full Moon as the eclipse event starts, so ISO will be low, probably about 200, and the shutter speeds fast. As the eclipse progresses, especially for deep partial and total lunar eclipse events, you will probably have to adjust ISO and shutter speeds.

To photograph the penumbra and umbra you will want to use long focal length lenses to pull in shadow detail on the Moon and surrounding stars and possibly planets near the Moon at totality. Wide-angle lenses will be the name of the game for a wider angle view of the totally eclipsed Moon and the surrounding star field in a darkened sky.

You will want to photograph the surrounding sky in a total lunar eclipse, because there are few night sky spectacles more beautiful than a totally eclipsed copper penny-colored Moon suspended in a dark sky surrounded by stars. Some of the stars in the constellation that the eclipse takes place within will be visible and if you're lucky, maybe even the Milky Way.

Also consider including the surrounding landscape and horizon in your totality astropics, as this can produce some very nice blending of Earth, Moon and sky.

Mounting your camera on a tripod should be sufficient to take all of your astropics, as the shutter speeds and ISO can be set to allow no trailing or blurring.

As always SAAS.

Location: At sea Azamara Pursuit
Camera & Mode: D810a w/ 28-300mm lens at 300mm f/5.6 on tripod
Camera Only.
ISO: 400
Exposure: 1/1600 second
Processing: Mac Photos
Comment: This pic was taken during a total lunar eclipse off the coast of
Argentina.

Fig. 14.18. Moon's ghostly penumbra shadow (Image by the author)

Location: At sea Azamara Pursuit
Camera & Mode: D810a w/ 28-300mm lens at 300mm f/5.6 on tripod
Camera Only.
ISO: 400
Exposure: 1/1600 second
Processing: Mac Photos
Comment: This pic was taken during a total lunar eclipse off the coast of
Argentina.

Fig. 14.19. The Moon's umbra shadow (Image by the author)

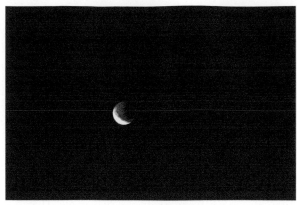

Location: At sea Azamara Pursuit
Camera & Mode: D810a w/ 28-300mm lens at 300mm f/5.6 on tripod
Camera Only.
ISO: 3200
Exposure: 1/125 second
Processing: Mac Photos
Comment: Note the coloring that has appeared. This pic was taken during
a total lunar eclipse off the coast of Argentina.

Fig: 14.20. The Moon's deep umbra shadow just before totality (Image by the author)

Location: At sea Azamara Pursuit
Camera & Mode: D810a w/ 28-300mm lens at 34mm f/5.6 on tripod
Camera Only.
ISO: 3200
Exposure: 1/2 second
Processing: Mac Photos
Comment: Totality with surrounding stars. This pic was taken during a total
lunar eclipse off the coast of Argentina. On land this type of exposure can be
taken for a much longer exposure and bring out many more stars.

Fig. 14.21. Totality and star field (Image by the author)

Location: Shenandoah National Park, Virginia
Camera & Mode: D5200 DX with 55-200mm f/4-5.6 lens at 55mm f/4 Camera Only.
ISO: 400
Exposure: 2 seconds
Processing: Mac Photos
Comment: Totality in pre-dawn. Framing makes this pic, which was published.

Fig. 14.22. Totality in pre-dawn (Image by the author)

Location: Shenandoah National Park, Virginia
Camera & Mode: Apple 5c (!) handheld using Night Cap Pro Camera Only.
ISO: 3200
Exposure: 1/15 second
Processing: Mac Photos
Comment: Didn't think it could be done but there it is with a dinosaur smartphone!

Fig. 14.23. Totality (Image by the author)

Table 14.3. Lunar Eclipses with Camera Only

Camera Type	Penumbral	Partial	Total
Smartphone	NO	POSSIBLY	POSSIBLY
Tablet	NO	POSSIBLY	POSSIBLY
Pocket	YES	YES	YES
Film SLR	YES	YES	YES
CSCs	YES	YES	YES
DSLR	YES	YES	YES
Video*	YES	YES	YES
CCD/CMOS*	YES	YES	YES

* If Camera has lens capability

Camera and Telescope

Photographing a lunar eclipse with Camera and Telescope can produce some very nice astropics of the Moon's shadow advancing along the lunar surface and enveloping craters, maria and other lunar features. The deepening eclipse will change the appearance of the Moon, which you will want to photograph. But it will be at totality that you want to focus your efforts, as the color, hues and shading can be quite spectacular.

Prime focus will give you the widest possible angle for your camera-telescope setup while using eyepiece projection and barlow/extender will get your best closeups of the interplay between lunar features and the Earth's shadow. You will have time to switch back and forth from different camera-telescope setups, as totality can last for over an hour in some eclipses. Decide on what you want to do beforehand and put it in your eclipse plan.

You should have polar aligned your mount prior to the eclipse so it should track the Moon well enough for your anticipated initial exposure settings. If your mount has lunar tracking rate capability, use it, but it isn't a hard-and-fast requirement.

As always, SAAS.

Location: Shenandoah National Park, Virginia
Camera & Mode: D5200 at prime focus of 80mm f/5 short tube refractor
mounted on equatorial mount Camera and Telescope.
ISO: 800
Exposure: 1/2000 second
Processing: Mac Photos
Comment: These settings are applicable to penumbral eclipses, penumbral
eclipse phases in partial lunar eclipses and penumbral eclipse phases in a total
lunar eclipse.

Fig. 14.24. The Moon's ghostly penumbra shadow (Image by the author)

Location: Shenandoah National Park, Virginia
Camera & Mode: D5200 at prime focus of 80mm f/5 short tube refractor
mounted on equatorial mount Camera and Telescope.
ISO: 400
Exposure: 1/250 second
Processing: Mac Photos
Comment: These settings are applicable to partial lunar eclipses and partial
eclipse phases in a to-tal lunar eclipse.

Fig. 14.25. The Moon's umbra shadow (Image by the author)

Location: Shenandoah National Park, Virginia
Camera & Mode: D5200 at prime focus of 80mm f/5 short tube refractor
mounted on equatorial mount Camera and Telescope.
ISO: 400
Exposure: 1/2 second
Processing: Mac Photos

Fig. 14.26. The Moon's deep umbra shadow shortly before totality (Image by the author)

Location: Shenandoah National Park, Virginia
Camera & Mode: D5200 at prime focus of 80mm f/5 short tube refractor
mounted on equatorial mount Camera and Telescope.
ISO: 400
Exposure: 1 second
Processing: Mac Photos

Fig. 14.27. Totality (Image by the author)

Table 14.4. Lunar Eclipses with Camera and Telescope Prime Focus and Barlow/Extender/Eyepiece Projection

Camera Type	Penumbral	Partial	Total
Smartphone	POSSIBLY	YES	YES
AFOCAL METHOD			
Tablet	NO	NO	NO
Pocket	YES	YES	YES
Film SLR	YES	YES	YES
CSCs	YES	YES	YES
DSLR	YES	YES	YES
Video	YES	YES	YES
CCD/CMOS	YES	YES	YES

Have an Eclipse Plan

If you have looked at the NASA and MrEclipse.com websites for upcoming eclipse information and eclipse maps, subscribe to *Sky and Telescope* or other similar magazines or have the annual *Observer's Handbook,* you should have plenty of notice for when solar and lunar eclipses will occur and where. You can also determine the type of eclipse, your viewing location, the local date and time at your specified viewing location and other logistics. Using these resources will help you to establish an eclipse plan as far in advance as possible.

It can really help to think about and visualize what you want to do astropic-wise for an eclipse. During total solar eclipses, many of us umbraphiles confess to experiencing what the author describes as "Primal Awe" – the sheer magnificence and primal emotions of being in the Moon's umbral shadow and seeing the totally eclipsed Sun with its glorious corona. Seasoned total solar eclipse chasers have confided to "failing to take off solar filters during totality," "being mesmerized," "a primal feeling deep within me." You will probably experience something like this as well, especially during your first total solar eclipse. You may want to concentrate on watching your first total solar eclipse, and taking time to get just one photograph of glorious totality.

An eclipse plan forces you to think and plan for the event, write it down, practice it, and then execute it. Without this process, you may be in for a very disappointing outcome. What follows is a recommended eclipse plan,

which of course you can tailor to your personal preferences. While it focuses heavily on solar eclipses because they entail more intensive safety procedures and more equipment preparation, it largely pertains to lunar eclipses as well.

Eclipse Type

- Specify type of solar or lunar eclipse event involved, i.e., partial, total, annular, hybrid, penumbral.
- If a solar eclipse event, perform the following *Solar Eclipse Safety Review:*

 - Review the solar safety information provided in Chapter 12 and this chapter.
 - Review the solar eclipse safety links in Chapter 23.
 - If you do not fully understand any segment of this solar safety information, contact an appropriate organization for clarification.

- Solar Eclipse Safety requirements have been reviewed and are understood.
- Approved and certified proper-size solar filters are available for the front of each camera lens and viewfinder (if required), telescope and telescope finder scope (if used) and other optical aids.
- Approved and certified ISO 12312-2 solar eclipse glasses are available to be used for eyes only.
- Solar eclipse glasses and solar filter(s) were inspected before use according to the manufacturer's guidelines and instructions.

Date

Date of the eclipse for your specified viewing location. You will have to convert from Universal Time to the time zone for your specified viewing location which may change the date. For a lunar eclipse this could involve two consecutive dates over one night.

Timing of Eclipse Events

- Use the event's Eclipse Map and other resources to determine and list the local times at your specified viewing location for eclipse events like C1, C2, C3 and C4.

- Add a time for you to simply look at the eclipse.
- For a total solar eclipse event, add:

 - Time to review Total Solar Eclipse Safety procedures.
 - Totality start and finish times. Time to look for yourself.
 - An event listing for just before and after totality, to be on the lookout for the Diamond Ring and Baily's Beads and recall that viewfinder is closed or capped. Solar filter in place after 2nd Diamond Ring.

- For an annular solar eclipse event, add:

 - Time to review Annular Solar Eclipse Safety procedures.
 - Annularity start and finish times. Time to look for yourself.
 - An event listing to be on the lookout for Baily's Beads just before and after annularity and for the entire eclipse keeping solar filters in place with viewfinder closed or capped.

- For a hybrid solar eclipse event add:

 - Time to review Hybrid Solar Eclipse Safety procedures remembering that annularity and totality will both happen and transition between the two events quickly at locations along the eclipse path.
 - Totality/annularity start and finish times as determined by your location.
 - Time to look for yourself.
 - An event listing for just before and after totality to be on the lookout for Baily's Beads and the Diamond Ring with viewfinder closed. Solar filter in place after 2nd Diamond Ring.
 - An event listing to be on the lookout for Baily's Beads just before and after annularity and for the entire annular eclipse keeping solar filters in place with viewfinder closed or capped.

- For a partial solar eclipse event add:

 - A reminder that all solar filters and solar eclipse glasses must be used from the start until the event ends and you stop looking at the Sun.
 - Partial solar eclipse start and finish times as determined by your location.

Altitude/Azimuth of the Sun or Moon During Eclipse Event

This is done to insure that your specified location will allow observation of the entire eclipse event and will be free of obstructions.

- Position at Eclipse Start:
- Position at Totality/Annularity/Maximum Of A Partial Eclipse:
- Position at Eclipse End:

Planned Astropic Setup and Settings

After deciding which mode you will use and the specific setup to do so, you will want to list in a sequence your planned astropic items of interest and settings. SAAS will definitely be at work here.

- Using the entries from your "Timing of Eclipse Events," list each event, e.g., C1 Start of Eclipse," with the specified camera, lens, and/or telescope setup to be used
- If solar eclipse, approved proper size solar filter on the front of camera lens and viewfinder if required, and/or front/aperture of telescope and telescope finder scope if used.
- Mode to be used
- Recommended ISO. This will likely change during lunar eclipses but likely remain constant during solar eclipses.
- Camera Mode: Manual (M) mode is highly recommended to enable precise control over shutter speed and aperture. Modern cameras have sophisticated auto mode and may work.

 - Shutter Speed – this will vary during the course of the eclipse.
 - Lens Aperture – May vary during the course of the eclipse but author recommends using one lens aperture for simplicity and varying shutter speed only.
 - Focus Mode – Manual. Focusing on the Sun or Moon during the partial eclipse phase is required. Follow previously described focusing recommendations.
 - File Type – RAW. If available, this will give you full image data (no compression with accompanying data loss) during astropic processing.
 - Flash – Off
 - Mounting Type – Telescope, camera tripod, handheld. If you want to have your motorized mount track you will have to accomplish daytime polar alignment, discussed in Chapters 6 and 7.

Other Pre-Eclipse Considerations

- Camera battery and spare(s) fully charged
- Sufficient memory card storage space for large RAW files – have formatted spare memory card ready
- Cable Release
- Comfortable Seating. Do not overlook your comfort as you may be hours long in this process.
- Snacks
- For Solar Eclipses:

 - Wide brim sun hat that allows brim to be folded back so as to not interfere with viewing through camera and/or telescope.
 - Sun pants and shirt
 - Extra clothing layers if cool temps are expected
 - Sun screen
 - Water
 - Neckerchief that can be wetted down for cooling
 - Bug spray

- For Lunar Eclipses:

 - Extra clothing and warm beverage in case of cool temps
 - Extra batteries for red LED headlamp
 - Bug spray

Eclipse Day

- Be at your location early – hours before the eclipse – to enable slow and easy setup, and also to claim a good spot if crowds are expected.
- After setup, check all gear for proper setup and function.
- Take a couple of test shots using setup.
- Review, visualize and practice eclipse plan.
- *Relax and have fun!*
- Execute eclipse plan
- Be prepared for surprises, gear problems, and during a total solar eclipse, totality and Primal Awe. Take time to view totality with your own eyes.

Bottom Line on Eclipses

Practice solar eclipse safety properly and at all times when dealing with solar eclipses. Be mindful of the safety requirements for each type of solar eclipse. If there is anything you do not completely understand regarding solar eclipses contact an appropriate organization prior to observing and photographing them.

Check out the resources we have discussed to determine what eclipses will be upcoming from your viewing location. Make plans to observe and photograph those that will be accessible to you using the information in this chapter and the additional resources listed in Chapter 23. Draft your eclipse plan and rehearse it prior to the eclipse event.

For Total, Annular and Hybrid Solar Eclipse Camera and Telescope Mode, use of a wide field, fast focal ratio small aperture refractor is highly recommended. Smaller is better than bigger telescope-wise in these events.

Consider Astrotourism for your eclipse experience.

Enjoy these marvelous sky spectacles and get some treasured astropics!

Chapter 15

The Stars and Planets

We have now progressed to the point where the stars and planets beckon you to take astropics. We'll look at these two categories of astronomical objects separately, starting off with stars first.

Stars come in a variety of colors and brightnesses and are grouped into 88 individual constellations. Some of these constellations are very small, such as Sagitta the Arrow, to very large, such as Draco the Dragon. They can capture our imagination and leave us in awe, such as the mighty Orion the Hunter, or be famous for their functionality, such as Ursa Minor, which contains Polaris, the North Star.

You can operate in Camera Only mode to photograph whole constellations or zero in on one particular star or stellar asterism – a grouping of stars that appears like a common object or pattern in the sky.

Likewise you can photograph stars using Camera and Telescope mode to get a close up and personal view of single stars, famous stars, double or triple star systems. Prime focus, eyepiece projection and a Barlow/extender will work especially with film SLR, DSLR, CSCs and pure astronomical cameras. A smartphone can photograph the brighter stars in either mode.

© Springer Nature Switzerland AG 2020 279
G. I. Redfern, *Astrophotography is Easy!*, The Patrick Moore Practical
Astronomy Series, https://doi.org/10.1007/978-3-030-45943-7_15

Any camera that uses a lens can photograph the stars. NightCap Camera for iPhones and iPads has a "Stars" mode that the seller says will capture pics of the stars. The newer model smartphones can do so as well quite impressively. Many have taken star astropics with 5c and 6s smartphones handheld. While you can hold either your phone or tablet very steady with practice or against some type of support like a building or car roof (be careful not to scratch the paint!), a tripod mount would be advisable to achieve better steadiness.

Camera & Mode: Apple 5c handheld with Night Cap Pro f/2.4. Camera Only.
ISO: 12,500
Exposure: 1/4 of a second
Processing: Mac Photos

Fig. 15.1. Big Dipper (Ursa Major) and Polaris as seen in Anchorage, Alaska. An old iPhone was able to take this photograph. (Image by the author.)

Just by mounting a camera on a tripod with a wide-angle lens at full aperture, 1600 to 3200 ISO on a moonless night and an exposure commensurate with the "500 Rule" will get you very decent astropics of stars and constellations.

What you want to photograph will dictate what lens you will need to use. If it is a constellation use your references to determine how large it is in terms of degrees and compare that to the degree coverage of your camera and lens set up. Some constellations will be large and wind their way across the sky, while others will be very small. Asterisms can be the same way – large like the Summer Triangle or small like Orion's Belt.

Camera & Mode: D810a 28- to 300-mm f/3.5-5.6 lens at 28-mm f/3.5 on a tripod. Camera Only.
ISO: 1600
Exposure: 15 seconds
Processing: Mac Photos

Fig. 15.2. Fog accents the colors of Orion's brighter stars and creates nice halos around them. (Image by the author.)

The f/2.8 14-mm, f/1.4 35-mm and 50-mm prime lenses work fantastic with stars and constellations. Coupled with a DSLR, CSCs or even film SLR on a moonless and dark sky site the colors and number of stars will surprise you.

Although you do not have to have a motorized mount to shoot stars you can do so, which allows for longer exposures. This will result in more sky detail in the form of stars, perhaps even satellites or meteors in the resulting astropic. Unless you have a truly dark sky site longer exposures can also lead to infringing light cones from light pollution. Depending on the desired composition of your astropic this may or may not be an issue.

A really neat variation on shooting star fields is taking a long exposure of the north or south celestial pole. You just point your camera on a tripod so that the respective pole is centered in your camera and take an exposure of at least 5 minutes to even a half hour. NightCap Camera for iPhones and iPads has a "star trails" mode that the seller says will capture pics of the stars.

The light pollution in the sky and the surrounding environment of your location is the only limiting factor for the length of your exposure. You will see the stars and even the Milky Way, if it is present, form beautiful and colorful arcs. This is an astropic that will get your friends talking.

Camera & Mode: D810a with 35-mm f/1.4 on tripod. Camera Only.
ISO: 2000
Exposure: 10 seconds
Processing: Mac Photos

Fig. 15.3. Orion in full view with a hint of the winter Milky Way. (Image by the author.)

Camera & Mode: D810a 28 to 300-mm f/3.5-5.6 lens at 28-mm f/3.5 on a tripod. Camera Only.
ISO: 2500
Exposure: 461 seconds
Processing: Mac Photos

Fig. 15.4. Picture taken from Shenandoah National Park Big Meadows. This image of Polaris and star trails shows the landscape, star colors and the Milky Way. The sky color is caused by light pollution but still is decent in detail. (Image by the author.)

You will need to consult your software and resources, such as *Sky &
Telescope's* monthly sky chart in their magazine or their website, to see
what is up in the sky. It helps to have some sky recognition and knowledge
of the constellations and the stars that comprise them so you know what is
a worthy astropic candidate and when it will be visible in the sky.

As a reminder you want to try and get your astropics when the object of
your interest is transiting the meridian and therefore at its highest point in
the sky. You may want to do an exposure when your object is low to the
horizon to blend in with it or natural scenery such as trees or buildings.

A trend in Camera Only astropics is called nightscape astrophotography,
also known as landscape astrophotography, and involves taking night sky
astropics that incorporate earthly foregrounds, people, famous landmarks,
etc. Some may be composites – two or more photographs combined into a
single photograph – or they may be single astropics. As you will learn in
Chapter 21, there is nothing wrong with composites as long as they are
identified as such to avoid misleading viewers. This is in the realm of astro-
photography ethics, which we will discuss in Chapter 21.

Nightscape astrophotography can be done with just a camera and a tripod
but can also become quite sophisticated, with setups that are designed spe-
cifically for wide-angle and very large gigabyte photo files. Try your hand

Camera & Mode: D810a 14-mm f/2.8 lens on a tripod. Camera Only.
ISO: 6400
Exposure: 30 seconds
Processing: Mac Photos

Fig. 15.5. Shenandoah National Park nightscape. A brief pulse of red light illumi-
nated the sign while the camera shutter was open. Trees and the skyline were visible
due to light pollution cones. (Image by the author.)

at the basics first before investing money in more advanced capabilities. You'll be surprised at how well basic nightscape astropics can turn out.

Stars with Camera Only

Camera Type	Constellations	Star Fields	Nightscapes	Asterisms
Smartphone	Possibly*	Possibly*	Possibly*	Possibly*
Tablet	Possibly*	Possibly*	Possibly*	Possibly*
Pocket	Yes	Yes	Yes	Yes
Film	Yes	Yes	Yes	Yes
CSCs	Yes	Yes	Yes	Yes
DSLR	Yes	Yes	Yes	Yes
Video	Possibly**	Possibly**	Possibly**	Possibly**
CCD/CMOS	Possibly**	Possibly**	Possibly**	Possibly**

*With use of Nightcap Camera for iPhone/iPad and windows equivalent or latest generation smartphones and tablets.
**With use of camera lenses attached if camera has that capability

Camera and Telescope

Camera and Telescope can take great astropics of stars in prime focus, eyepiece projection and Barlow/extension methods. What method you use will depend on what you are trying to photograph and how close in you want to go. Single stars are easy to photograph, as you just center them in your camera, achieve telescope focus, take your astropic and SAAS.

Your telescope's mount will have to be in sidereal rate and be able to accurately track your object of interest for at least several seconds to avoid a trailed image. You can also consider placing your camera piggyback on the mount using a suitable accessory or the telescope tube itself. This is useful for taking longer exposures with wide-angle and longer focal length lenses if you do not have a motorized Camera Only capable mount.

Single stars can really show their inherent color and brightness in Camera and Telescope mode. You may want to make a collection of single star astropics according to stellar color and brightness. Favorites such as Betelgeuse and Antares are red supergiants and show distinct reddish-orange color. Arcturus is a beautiful star that shows a wonderful orangey color and is a little larger than our Sun. Vega is bright and a glorious blue-white, while Sirius rules the blues.

Camera & Mode: D5200 at prime focus with 250-mm CDK
reflector telescope. Camera and Telescope.
ISO: 800
Exposure: 5 seconds
Processing: Mac Photos

Fig. 15.6. Sirius, the brightest star in the night sky. Secondary mirror support vanes add a nice touch to the pic. If you look closely at the 4 o'clock position there is a star-like object which the author believes to be the very elusive Sirius B, a white dwarf star. Sirius B will be farthest from Sirius and easiest to image starting in 2020. This image was taken December 26, 2013 and was closer to Sirius. Like all prime focus images this is inverted and when corrected lines up nicely with Sirius B's orbital position around Sirius in 2013. You need at least an 6-inch telescope for trying to image the Pup. (Image by the author.)

Stars also like company, as 70% of the stars in the sky come in pairs – doubles – and some even in threes. Seeing these star systems may require larger telescopes to be able to resolve them into individuals. The *Observer's Handbook* has a listing of multiple stars and provides one-stop shopping for the descriptions of these systems. Your software can also provide you information on multiple-star systems.

Seeing these in a telescope eyepiece, especially when different colors are present, is quite mesmerizing. Taking astropics of these stellar systems can be a challenge if they are close together and can be victims of poor seeing that will affect your ability to get a good astropic.

Albireo is a beautiful double star with blue and golden yellow colored stars.

Camera & Mode: D810a at prime focus with 250-mm CDK reflector
telescope. Camera and Telescope.
ISO: 1600
Exposure: 18.3 seconds
Processing: Mac Photos

Fig. 15.7. Secondary mirror supports create a "rainbow" effect due to bright Betelgeuse. In late 2019 this star began a historic dimming which has astronomers wondering what will happen to this red supergiant. Betelgeuse should be on your astropic list. This astropic is from 2013. (Image by the author.)

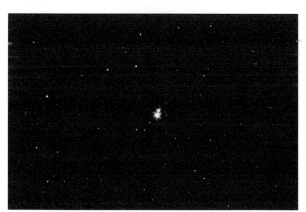

Camera & Mode: D810a at prime focus with 250-mm CDK reflector
telescope. Camera and Telescope.
ISO: 2000
Exposure: 20 seconds
Processing: Mac Photos

Fig. 15.8. Albireo, one of the best doubles in the sky. (Image by the author.)

One of the most amazing double-star views is of Alpha Centauri A and B, two sunlike stars that orbit each other. Alpha Centauri A is known as Rigil Kentaurus (foot of the Centaur) and is the third brightest star in the night sky after Sirius and Canopus. Alpha Centauri A and B, when viewed in a telescope, look like two headlights of a car coming straight at you. They are, in a word, stunning. They are also part of a three-star system with the third component being Proxima Centauri, which is a small red dwarf star and the closest star to the Sun at about 4.24 light years away (over 25 trillion miles). Proxima Centauri also has the closest exoplanet to our Solar System, Proxima b.

If you are up for a challenge you can try to view and photograph Sirius, the brightest star in the night sky, with its white dwarf companion, Sirius B as seen in Figure 15.6. At least a 6-inch telescope and excellent seeing is required. It is worth taking a look when Sirius is visible and sky conditions allow.

Stars will be fairly bright in a telescope and pretty easy to focus in your camera as a result. Again seeing will be a factor in how well the star(s) will photograph. You can use just about any camera type and telescope setup to photograph them. Use the Albireo pic's settings as an initial setting and SAAS.

Table 15.1. Stars with Camera and Telescope Using All Methods

Camera Type	Stars	Multiple Stars
Smartphone	Possibly* Afocal	Possibly* Afocal
Tablet	No	No
Pocket	Possibly* Afocal	Possibly* Afocal
Film	Yes	Yes
CSCs	Yes	Yes
DSLR	Yes	Yes
Video	Yes	Yes
CCD/CMOS	Yes	Yes

*Brighter stars

Photography of Planets

All the planets move across our sky due to their orbits, as well as Earth's, around the Sun. There are five planets that we can see and easily photograph in Camera Only and Camera and Telescope modes – Mercury, Venus, Mars, Jupiter and Saturn. Uranus, Neptune and Pluto (a dwarf planet or the 9th planet, depending on which side you are on) are the far fainter planets.

Some observers report they can see Uranus with the unaided eye, but it requires knowing where it is using a good reference such as your planetarium software to zero in on it, no bright Moon nearby and dark skies. Uranus can be photographed in Camera Only mode with a 50-mm lens and in Camera and Telescope mode. Neptune and Pluto require Camera and Telescope mode to be photographed although Neptune might be imaged in a long focal length lens and a long exposure.

Each planet has its own characteristics, such as color and brightness. Mercury and Venus are visible during the hours of dusk or dawn, as they are always in proximity to the Sun. Venus can be seen and photographed in both modes in broad daylight if you know where to exactly look, but never get too close to the Sun when observing or photographing any astronomical object during the daytime. Heed the chapter's daytime solar safety information that follows.

Mars, Jupiter and Saturn are visible in the night sky as determined by their ever changing positions. The five visible planets and possibly Uranus can be photographed near the Moon and among the background stars and Milky Way in Camera Only mode. All the planets can be photographed in Camera and Telescope mode if you have a telescope large enough to do so.

Camera Only Mode

Here are some warnings to keep you safe from the dangers of the Sun during daytime viewing and astrophotography.

- Never get too close to the Sun with your camera during the daytime when looking for or photographing the Moon or especially Mercury and Venus, which are always near the Sun.
- Always make sure that the Sun is at a safe distance from your camera and that there is zero chance that it cannot enter your field of view.
- Never position your camera so that the Sun is in or can move into your camera's field of view, as permanent eye and camera damage will result.
- Use a building or a hill to totally block out the Sun as an added safety measure. If you cannot block the Sun do not attempt to observe or photograph daytime astronomical objects.
- As an added safety precaution close or cap your camera viewfinder and use Live View only.

You will use the same setup for photographing the visible planets and Uranus as you did for photographing stars. The only difference is that the five visible planets will for the most part be brighter than the stars. There

will be opportunities to photograph the visible planets and Uranus when they are near to each other, the Moon, stars or even DSOs. Checking your software and *Observer's Handbook's* monthly listings as well as the monthly observing guide in *Sky & Telescope* magazine will alert you to any noteworthy planetary and lunar conjunctions.

You may also want to photograph a planet's motion against the background stars during its observing season – the time when it is first visible in the sky to when it fades in the glow of the Sun. Mercury and Venus have observing seasons that will allow them to be seen before dawn or after sunset while the other planets will be first visible in the east and fade months later in the west. *Observer's Handbook* is your best resource for each planet's annual observing opportunities, as there is an individual section that details all you will need to know. Use your software to supplement this information to determine exactly what the planet will look like in the sky. You can then determine what astropic opportunities there may be.

Camera & Mode: D810a 35-mm f/1.4 lens on a tripod.
Camera Only.
ISO: 1000
Exposure: 4 seconds
Processing: Mac Photos

Fig. 15.9. Morning twilight view of Jupiter and Mars. (Image by the author.)

Camera & Mode: D810a 14-mm f/2.8 lens on a tripod. Camera Only.
ISO: 1,000
Exposure: 30 seconds
Processing: Mac Photos

Fig. 15.10. (Top to bottom) Venus, Mars, Jupiter and Mercury in morning twilight with zodiacal light. (Image by the author.)

The same advice on lenses for stars in Camera Only mode applies. Note that a 200-mm or larger telephoto lens might be able to photograph the four main moons of Jupiter using a tripod. Your software and other resources will alert you to the appearance of the four large moons around Jupiter. The Galilean Moons – so named for Galileo, who discovered them with his crude telescope in 1610 – are ever moving in their orbits around the giant planet.

Table 15.2. Planets with Different Backdrops in Camera Only Mode

Camera Type	Planetary & Lunar Conjunctions	Star Fields & Constellations	Nightscapes
Smartphone	Possibly*	Possibly*	Possibly*
Tablet	Possibly*	Possibly*	Possibly*
Pocket	Yes	Yes	Yes
Film	Yes	Yes	Yes
CSCs	Yes	Yes	Yes
DSLR	Yes	Yes	Yes
Video	Possibly**	Possibly**	Possibly**
CCD/CMOS	Possibly**	Possibly**	Possibly**

*With use of Nightcap Camera for iPhone/iPad and Windows equivalent and current generation of smartphones and tablet.
**With use of camera lenses attached if camera has that capability

Here, now, are some warnings about daytime viewing and astrophotography to avoid damage from the Sun.

- Never get too close to the Sun with your telescope when looking for or photographing the Moon or especially Mercury and Venus, which are always near the Sun.
- Always make sure that the Sun is at a safe distance from your telescope and there is zero chance to enter your field of view.
- Never position your telescope so that the Sun is or can move into your telescope's field of view, as permanent eye and camera damage will result.
- Remember, the Sun, Moon and the planets are moving, as is your telescope if it has a clock drive, so don't let it get close to the Sun!
- Use a building to totally block out the Sun as an added safety measure. If you cannot block the Sun do not attempt to observe daytime astronomical objects.
- As an added safety precaution close or cap your camera viewfinder and use Live View Only.

Each planet will present a distinct appearance caused by their color and features visible in the telescope and caught by your camera. Planets are fascinating and frustrating to photograph. Fascinating due to the features we strive to see and photograph and frustrating due to seeing issues causing havoc at times with our astropics. You can go prime focus for pleasing wide-angle views or eyepiece projection and a Barlow/extender to get the maximum detail your telescope optics can deliver. Any telescope and camera type can work to photograph planets, but DSLRs and pure astrocameras will be your best bet due to their capabilities.

Advanced Techniques for Planetary Photography

There are two advanced techniques available for use in planetary astrophotography. They are mentioned here for the sake of completeness and to provide basic information in case you want to move on to such advanced techniques.

The first is the combined use of colored filters with a black and white (monochrome) pure astrocamera to obtain images of a planet that are then combined during processing to obtain a color image. The colored filters, usually red, green and blue (R, G, B) are recorded as separate image files and then combined using software to make up a color image. Some planetary astrophotographers also use a luminance filter to record detail. You

need a filter wheel to hold the filters and rotate through them, recording the separate images. This technique provides the purest planetary image possible, i.e., raw image data in each color channel.

The second advanced technique is known as "stacking" and uses software to select and then "stack" the best images from hundreds or thousands of video images obtained with a pure astrocamera or numerous multiple single images from a camera. This can be done for the Sun (with proper solar filter and procedures), Moon, planets and DSOs, in which using stacking software frames can be sorted to determine the "best frames" and then stacked. This will give the best image possible due to the power of adding all of these frames together in order to maximize detail, sharpness and contrast in a final processed image.

There are references to these advanced techniques in Chapter 23.

The optics of your telescope will be a big factor in what planetary detail you can see, as you will recall from our discussions regarding aperture and focal ratios. The bottom line is that any quality telescope of at least 2-inch aperture will show you the main features of the five visible planets and the colors of Uranus and Neptune. Pluto requires a telescope of at least 8-inch aperture – bigger is better.

Let's take a look at each planet and what it has in store for your Camera and Telescope.

Mercury

The Winged Messenger can be a challenge to find and photograph, as it is always near the Sun at either dawn or dusk and daytime, which is why you *must* be Sun safe and follow the guidance provided. There will be several observing opportunities each year to view and photograph Mercury. Each one will favor either the Northern or Southern Hemisphere due to Mercury's location along the ecliptic.

You can hunt for Mercury starting with its location in the sky as provided by your software or computer GOTO mount. Mercury can be fairly bright visually and seen with your telescope's finder 'scope. The trick is to try and zero in on Mercury at the highest point in the sky so as to not be looking through the thickest part of the atmosphere near the horizon.

Mercury will go through phases, just like our Moon does, so you will see it as a crescent, gibbous and full. It is a golden-yellow color. You will probably not be able to see and photograph anything beyond the disk of Mercury due to seeing conditions, but some amateur astrophotographers have successfully captured surface detail. It is quite an accomplishment to find and photograph Mercury, as you will learn if you try.

Venus

The goddess of many things to the ancient Greeks and Romans, Venus is quite the brilliant view in a telescope and camera. In fact, Venus is so bright it can overwhelm a camera sensor with too long of an exposure.

Venus will usually be higher than Mercury in the hours of dawn and dusk twilight, which will ease seeing issues to some degree and make Venus much easier to spot. Venus is cloud covered, so no surface features will be visible. Some amateurs have used infrared and ultraviolet filters to very successfully photograph atmospheric features on Venus. But the use of filters for photographing the planets is an advanced technique that you might want to work up to.

Venus will exhibit phases, just like Mercury, and can be quite a large crescent when it is close to the Sun. Venus is fairly easy to find and photograph in the daytime, so you should try for when it is crossing the meridian and at its highest. Remember daytime solar safety and follow the guidance provided.

Camera & Mode: D5200 at prime focus with 250-mm CDK reflector telescope. Camera and Telescope.
ISO: 1600
Exposure: 1/400 of a second
Processing: Mac Photos

Fig. 15.11. Daytime crescent Venus with 4% illumination. The Sun was a safe distance from Venus. A high ISO will allow for fast exposure time and limit daytime seeing effects. (Image by the author.)

Camera & Mode: D5200 at prime focus with 250-mm CDK reflector
telescope. Camera and Telescope.
ISO: 100
Exposure: 1/30 of a second
Processing: Mac Photos

Fig. 15.12. Venus in gibbous phase with 41% illumination. Taken minutes after sunset. (Image by the author.)

Mars

Of all the planets Mars is the only one that regularly allows you to see and photograph surface features such as its polar caps, volcanoes and others. Some amateurs have been able to take amazing photographs showing surface features on Mars when it is closest to our planet.

Mars can get quite close to Earth during its roughly 26-month cycle around the Sun. Your references and software will tell you about Mars during each of these close approaches and what can be seen and photographed.

Mars is a challenge to photograph due to its apparent size that varies widely and is hostile to seeing conditions probably more than any other planet. You just have to maximize the time you spend observing and photographing Mars when it makes its closest approach. You will want to use eyepiece projection and Barlow/extender methods coupled with a DSLR, film SLR or pure astrocamera to pull in surface features.

Camera & Mode: D810a eyepiece projection 12.5-mm eyepiece with 250-mm CDK reflector telescope. Camera and Telescope.
ISO: 100
Exposure: 1/30 of a second
Processing: Mac Photos with cropping.

Fig. 15.13. Some detail is visible in this pic of Mars. (Image by the author.)

Jupiter

The king of the planets is big in any telescope compared to the other planets. Details in Jupiter's atmosphere and clouds are visible, as are the four main moons. Your resources can help you identify these features and identify which moons are visible as well as events they undergo, such as casting shadows on Jupiter while transiting across the planet and being occulted by Jupiter as well.

Camera & Mode: D5000 eyepiece projection 12.5-mm eyepiece with 250-mm
CDK reflector telescope. Camera and Telescope.
ISO: 200
Exposure: 2 seconds
Processing: Mac Photos with cropping.

Fig. 15.14. Lots of detail and color in this pic of the Great Red Spot of Jupiter (upper left) and features in the atmospheric bands. (Image by the author.)

Camera & Mode: D5200 eyepiece projection 12.5-mm eyepiece with 250-mm
CDK reflector telescope. Camera and Telescope.
ISO: 800
Exposure: .4 seconds
Processing: Mac Photos with cropping.

Fig. 15.15. Lots of detail and color in this pic, including the shadow of one of Jupiter's four main moons. (Image by the author.)

Saturn

Truth be told, there are few sights in any telescope that can compare with seeing the magnificent rings of Saturn. They are amazing to see in an eyepiece with the ball of the planet dead center. The shadow of Saturn can be seen on the rings, and the planet's movement in its orbit will tilt the rings into a straight line and out to their maximum opening as seen from Earth. Several moons of Saturn are visible, including its largest, cloud-covered Titan.

Some atmospheric features can be seen on Saturn, but the rings are the prominent item to see and photograph.

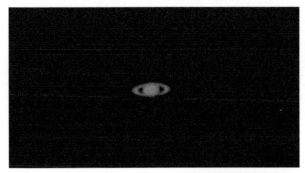

Camera & Mode: D5200 eyepiece projection 12.5-mm eyepiece with 250-mm CDK reflector telescope. Camera and Telescope.
ISO: 800
Exposure: .5 seconds
Processing: Mac Photos with cropping

Fig. 15.16. The rings of Saturn and the shadow of the planet falling on them in lower right take center stage. (Image by the author.)

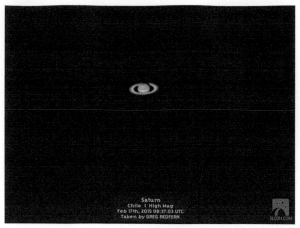

Camera & Mode: SLOOH rental 4-inch refractor telescope with high
magnification and CCD camera. Camera and Telescope.
ISO: Unknown
Exposure: Unknown
Processing: Automatic

Fig. 15.17. Note the detail visible in Saturn's atmosphere. Compare this 4-inch refractor image to that of the previous 10-inch CDK reflector. The vastly superior seeing conditions and planetary photography power of a refractor are self-evident. (Image by the author.)

Uranus

The source of many jokes regarding its name, this ice giant planet can be detected as a very small disk with a greenish color. Depending on the size of your telescope you may be able to detect some of the moons.

Camera & Mode: SLOOH rental 4-inch refractor telescope with high magnification and CCD camera. Camera and Telescope.
ISO: Unknown
Exposure: Unknown
Processing: Automatic

Fig. 15.18. Its green color and some moons of Uranus are visible. (Image by the author.)

Neptune

The blue color of this planet is in keeping with its name. A really small Neptune disk is a challenge to see in small telescopes.

Camera & Mode: Slooh rental 4-inch refractor telescope with high magnification and CCD camera. Camera and Telescope.
ISO: Unknown
Exposure: Unknown
Processing: Automatic

Fig. 15.19. Neptune's blue color is somewhat visible here. (Image by the author.)

Pluto

The way to see, let alone photograph, this denizen of the deep in the Solar System is over the course of several nights. An 8-inch to 12-inch telescope is required, and bigger is better as Pluto is small and dim. Using your references and software point your telescope to Pluto's position in the sky in prime focus mode in order to image a wide field.

Do this again a night or two later and break out a star chart of the area. Your software may be able to zero in on the star field around Pluto. Compare the star field to your image and look for an object that has moved. Pluto will look just like a star in your image except that it moves. You can try other imaging methods with higher magnification but you will still get a star like image.

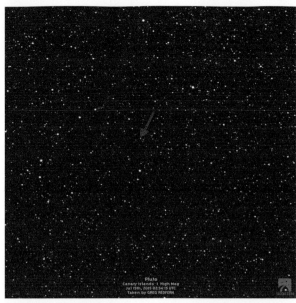

Camera & Mode: Slooh rental telescope with high magnification and CCD camera. Camera and Telescope.
ISO: Unknown
Exposure. Unknown
Processing: Automatic
Comment:

Fig. 15.20. Pic taken on July 15, 2015, to commemorate New Horizons flyby of Pluto. (Image by the author.)

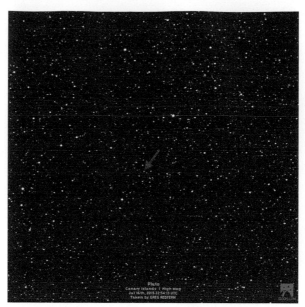

Camera & Mode: Slooh rental telescope with high magnification and CCD
camera. Camera and Telescope.
ISO: Unknown
Exposure: Unknown
Processing: Automatic

Fig. 15.21. Pic taken on July 16, 2015, to commemorate New Horizons flyby of
Pluto. (Image by the author.)

Table 15.3. Planetary Photography in Camera and Telescope Mode

Camera Type	Afocal	Prime Focus	Eyepiece Projection Barlow/Extender
Smartphone	Yes*	No	No
Tablet	No	No	No
Pocket	Yes*	No	No
Film	No	Yes	Yes
CSCs	No	Yes	Yes
DSLR	No	Yes	Yes
Video	No	Yes	Yes
CCD/CMOS	No	Yes	Yes

*Brighter planets

Bottom Line

Use Camera Only mode to capture the beauty as well as the motions of the planets against the starry backdrop. Take advantage of planetary and lunar conjunctions when they occur.

In Camera and Telescope mode start out by taking simple and basic planetary astropics to learn your way around. Use a smartphone or the afocal method, a DSLR or pure astrocamera rigged to eyepiece projection or Barlow/extender to obtain images of the planets.

Eventually if your interest grows in this part of astrophotography you can step up to high resolution planetary astrophotography (also lunar and solar) that will require complete tweaking of your entire Camera and Telescope system to wring out the very best images possible.

Chapter 16

International Space Station and Satellites

The International Space Station (ISS) and some of the thousands of other satellites that circle Earth can be seen visually and photographed with Camera Only or Camera and Telescope mode. The key to doing this is knowing where and when the satellites will pass over your selected viewing location. This is where your astronomical software will pay big dividends.

Your software should have the ability to show satellites in the sky. It may be under "Solar System" or some other category that allows you to select satellites. Your software should also have a "minor body update" feature that automatically or manually updates all Solar System minor bodies such as asteroids, comets and satellites. You can set your display to show satellites, and you may even be able to get an alert when a satellite you are interested in is rising above your horizon and visible.

ISS is as bright as Jupiter and is really something to see in the sky as it silently passes overhead, sometimes even at the zenith, which is the closest and brightest it can ever be for any Earth-bound observer. It is mesmerizing to see a full pass of the ISS when it rises somewhere in the west then transits high overhead and then fades into Earth's shadow somewhere in the east.

Other satellites include the Hubble Space Telescope (HST), rocket bodies used to launch satellites, and a myriad of global communications and spy satellites. If you see a silent wanderer in the night sky you can check your software to see which one it is by noting the time, the path in the sky and estimated brightness. It can be very habit forming to identify these spacecraft when you are out just looking at the stars.

© Springer Nature Switzerland AG 2020
G. I. Redfern, *Astrophotography is Easy!*, The Patrick Moore Practical Astronomy Series, https://doi.org/10.1007/978-3-030-45943-7_16

You can photograph them using Camera Only or Camera and Telescope very easily. You just need to know which spacecraft you want to photograph using which method on a specified date and time so you can be set up in advance. You may already be out under the stars with camera and/or telescope, and if so, you just have to be mindful of the time of the pass and where in the sky it will occur.

Camera Only

Any camera that uses a lens can photograph the ISS. The NightCap Camera for iPhones and iPads has an "ISS" mode that the seller says will capture pics of the ISS and other satellites. You would have to hold either your smartphone or tablet very steady, but a tripod and mount would be advisable to achieve the desired steadiness.

It is best to have your camera with a wide-angle lens mounted on a tripod and pointed in the section of the sky that the spacecraft will be transiting. If ISS is your selected object you can get specific parameters at an inputted location for each pass by going to SpotTheStation.nasa.gov or Heavens-Above.com. This will give you the time, azimuth and altitude for the starting point, mid-point and end point of the ISS. Your software can also give you the path in the sky of the spacecraft.

Photographing ISS passes is the easiest to do, as it is bright and really looks cool in astropics, as you can see. You will be taking a time exposure shot of at least several seconds and perhaps as much as 30 seconds with a 14-mm lens. The trick is to avoid getting too bright of a sky background that overwhelms your astropic. This is most acute when the ISS is making a transit in bright twilight, which will limit how long you can expose before the sky background gets too bright. You will have time to take a quick exposure using initial settings from the astropics you see here and SAAS.

You may even want to video the ISS. This would help alleviate the bright twilight problem, and you could zoom in on the station as it enters into Earth's shadow. It is always a sight to see, as the ISS fades into the night of Earth's shadow. Sometimes you can even see some slight color changes if the ISS is low on the horizon as it fades.

As you develop more experience with your astrophotographer's eye you will be able to get a pretty good estimate of your settings as determined by lens used and flight path of the spacecraft. The ISS will always appear as a bright star regardless of lens focal length used. The 50 mm is probably the largest focal length lens you would want to use.

Depending on the specifics of the ISS pass and your surroundings at your viewing location you can almost make a nightscape astropic. If the ISS will pass near some buildings or trees or perhaps a famous landmark in your area it is well worth the effort to photograph.

Camera & Mode: D810a w/14-mm f/2.8 lens on tripod. Camera Only.
ISO: 2000
Exposure: 55 seconds
Processing: Mac Photos

Fig. 16.1. An ISS winter pass with clouds and the Milky Way. A passing aircraft is also in the image. (Image by the author.)

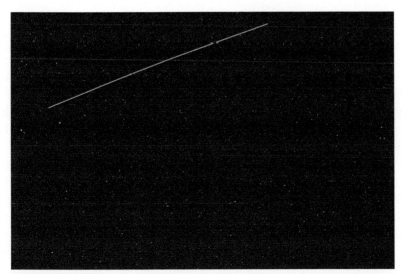

Camera & Mode: D5200 w/35-mm f/1.8 lens on tripod. Camera Only.
ISO: 400
Exposure: 40.5 seconds
Processing: Mac Photos

Fig. 16.2. Christmas night ISS pass to the north. (Image by the author.)

Other satellites will have much higher orbits than the ISS and can be seen quite late at night depending on their orbit and the time of year at your location. Summer months in both hemispheres will afford peak late night viewings and photographic opportunities. A lot of satellites are in a north-south pattern and can be seen traveling almost along the N-S meridian line. A 30-second exposure at ISO 1000 to 2000 with a 14-mm lens might pick up most satellites. You'll just have to take an exposure and SAAS.

Table 16.1. ISS and Satellites with Camera Only

Camera Type	ISS	Other Satellites
Smartphone	Possibly*	Possibly*
Tablet	Possibly*	Possibly*
Pocket	Possibly	Possibly
Film	Yes	Yes
CSCs	Yes	Yes
DSLR	Yes	Yes
Video	Yes**	Yes**
CCD/CMOS	Yes**	Yes**

*With NightCap Camera
**If camera lenses can be attached

Camera and Telescope

Relying on Heavens-Above.com, you can receive emails that indicate when the ISS will be passing near bright stars and planets or transiting the Sun and Moon for a specified observing location. Of course if the Sun is involved it will require the use of a safe solar filter over the front/aperture of your telescope and adhering to solar safety practices described in Chapter 12.

To get a video of the ISS transit of the Sun or Moon you have to be set up well in advance, with Camera and Telescope operating in prime focus. Your mount should be roughly polar aligned and tracking, although with video and the seconds-only transit time this is not essential. Make sure you have the accurate time available so you can count down to the actual transit start time.

As the time for the transit approaches you should have the Sun (with a safe solar filter on the front/aperture of your telescope) or Moon centered in your telescope and already in focus. Several seconds before the indicated start of the transit start your video and watch the LCD or computer screen. You may be able to see the ISS transit, but it is quick and fast! Stop your video a few seconds after the predicted transit end time. Review your video to see if you were successful.

If you got ISS on your video use available software to see the images frame by frame and pick one out for further processing. You can also just do a screen capture of a frame that shows ISS in silhouette.

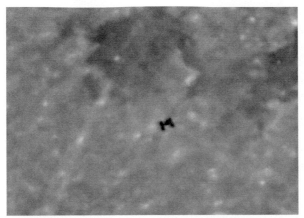

Camera & Mode: D810a prime focus mode 250-mm CDK telescope.
Camera and Telescope.
ISO: Unknown
Exposure: Unknown
Processing: Mac Photos and QuickTime

Fig. 16.3. Frame from ISS Moon transit video. Full video can be seen at https://www.youtube.com/watch?v=TVgO7BGdOrI&list=UUOXz2hbCjV8oPoYhDWdjR YQ&index=3. (Image by the author.)

At night try using an extender, Barlow or low-power eyepiece in eyepiece projection to get more magnification of the ISS. You have to be very precise in aligning your telescope so that the flight path of the ISS will cross your field of view. Make sure your finder 'scope is dead center to your telescope. Then, with a shutter release cable turn on the DSLR video and track the ISS manually for just a few seconds. This actually works!

Table 16.2. ISS and Satellites with Camera and Telescope Using Different Methods

Camera Type	Afocal	Prime Focus	Eyepiece Projection Barlow/Extender
Smartphone	Possibly*	No	No
Tablet	No	No	No
Pocket	Possibly*	No	No
Film	No	Yes	Yes
CSCs	No	Yes	Yes
DSLR	No	Yes	Yes
Video	No	Yes	Yes
CCD/CMOS	No	Yes	Yes

*ISS

Bottom Line

The basics to photographing the ISS and other satellites has been provided in this chapter. You can do quite well using them to get high quality and beautiful astropics.

There are astrophotographers out there that have done amazing work in capturing the ISS on video and camera. Their skills are very advanced and enable them to get incredible detail. When the space shuttle was flying some of these experts were able to photograph the shuttle docked at the ISS! You'd swear you could almost see astronauts out for spacewalks – not really – but the detail was something to see. There are various advanced methods for photographing the ISS and satellites, so check Chapter 23 for further information.

Chapter 17

Asteroids, Comets, Meteors, Fireballs, Bolides, and Meteor Showers

Asteroids and comets are leftovers from the birth of our Solar System 4.6 billion years ago. There are millions of asteroids in the Asteroid Belt, in the space between the orbits of Mars and Jupiter. They are the primary source of meteorites – space rocks that fall to Earth. But we do get space rocks that come from the Moon, Mars and maybe even "dead" comets. Yes, really! Asteroids can come in all shapes and sizes, and the largest ones can be pretty easily photographed. Occasionally they come close enough to photograph their motion across the sky.

Comets are celestial cats that love to play with us. Comets are dirty ice balls that can be many miles across and reside deep in the farthest reaches of the Solar System in the *trillions*. Occasionally one will come close enough to the Sun to grow a tail, due to the heat from the Sun, that can stretch for millions of miles. They can be utterly spectacular in the sky both visually and photographically. Great comets – comets that are very bright with huge tails – are pretty rare. The last great comet in the Northern Hemisphere was Comet Hale-Bopp in 1996-1997. We Northerners are overdue for another great comet. The Southern Hemisphere had the incredible multiple-tail Comet McNaught in 2007. There usually are a number of comets visible to our cameras and telescopes each year that make for pretty astropics.

© Springer Nature Switzerland AG 2020
G. I. Redfern, *Astrophotography is Easy!*, The Patrick Moore Practical Astronomy Series, https://doi.org/10.1007/978-3-030-45943-7_17

Meteors

Have you seen a "falling star," also called a shooting star? Hopefully you made a wish that came true, but in reality what you saw was a meteor. Meteors can be in almost any size, from that of particles of smoke to much larger objects. When they impact Earth's atmosphere, as they do 24 hours a day, seven days a week and have been doing so since Earth was formed, they are traveling so fast that they ionize a column of air in the atmosphere. It is this ionized column of air that you see when a meteor vaporizes. Earth gains millions of pounds of meteoritic dust annually, and you very likely have some in your hair and on your home's roof.

If a meteor is as bright or brighter than the planet Venus, or roughly apparent magnitude –4, the meteor is called a fireball. Fireballs occur every day and night and can be quite spectacular and seen over a wide region. When a fireball occurs over a populated area it usually will prompt calls to the local police, media and posting of videos and photographs.

When a meteor enters Earth's atmosphere and explodes, it is classified as a bolide. Bolides can be fragments of asteroids or comets or they can *be* asteroids or comets! Bolides are producers of meteorites, as when the bolide explodes and is big enough in size, space rocks will fall to Earth along a well-defined strewn field. Depending on where they land usually determines if they can be recovered. Really big bolides can produce impact craters, of which there are 190 on Earth as of this writing in August 2019.

Meteor showers occur each year at specified times as the result of Earth annually passing through large debris streams. These large debris streams in the Solar System are caused by asteroids and comets that shed this debris as they journey around the Sun. Earth passes through these areas and sweeps up bits and pieces, which then impact the atmosphere to create lovely displays of shooting stars. There can be just a few or nearly a 100 meteors an hour, depending on which meteor shower is occurring, the phase of the Moon and the darkness of your observing location. Your resources can provide details on the dozen or so major meteor showers that occur each year as well as several minor meteor showers.

Asteroids

Camera Only

It is possible to photograph the brightest asteroids, Ceres and Vesta, with a camera and lens. You can use your resources and software to zero in on the location of these distant worlds in the Asteroid Belt.

The best time to photograph them is when they are at opposition and closest to Earth, data that your resources and software will provide. Mounting a camera on a tripod is a necessity, as you will want to use a 50-mm focal length lens in a 10 second exposure starting at ISO 1000 to record these asteroids – no smartphones or tablets here. Vesta can be at about magnitude 5+ at its brightest, while more distant Ceres will be at its brightest at almost 7th magnitude.

Once you have determined where in the sky these worlds should be, point your camera and take an exposure and SAAS to determine if you have a dark sky background and good star images. If the Moon is out and near where you are photographing it can affect your ability to get a good image.

The key to finding these worlds in your astropic is a good star chart and good star images in a dark sky background. TIP: Use your computer screen at full brightness to do this search. It is near impossible to do this on a camera LCD. If you can't find them take another exposure the next night or so. Both worlds will exhibit motion against the background stars so they should be easier to find.

Camera and Telescope

You can use any mode of Camera and Telescope to photograph not only Ceres and Vesta but other asteroids that come within your telescope's range. These worlds are so small and so far away that no amateur telescope can produce an image of their disks. You can photograph their motion and brightness.

Prime focus is the easiest and most effective way to photograph asteroids. You can use any camera – less the clumsy and large tablets – to photograph them. The key is identifying them in the field of view just like when using Camera Only. If you have a computer controlled or GOTO mount you can slew directly to the indicated position and try to identify your asteroid of interest visually. Or you can take an exposure of several seconds at ISO 1000 and SAAS to get good stars in a dark background. Once you have a good astropic, try to identify your asteroid of interest. Again, you can try exposures over several nights to detect the asteroid by its motion.--

There will be occasions when an asteroid passes so close to Earth that you will be able to easily record its motion over the course of minutes.

Spooky: The 2015 Halloween Asteroid

Back in October 2015 an asteroid was going to pass Earth at just over 300,000 miles, or a little farther than the distance to the Moon. News of this was widespread, and it was determined that it would be so close that ama-

teur telescopes would be able to see it visually and detect its motion across the sky. The full Moon was pretty bright on Halloween night and near Spooky making the sky bluish in color.

The photographs in Figs. 17.1 through 17.3 show 2015 TB145 (Spooky) taken at prime focus with a Nikon DSLR. The telescope and camera were pointed to the coordinates of Spooky using computer control, and several images were made.

As you can see the motion of Spooky in the sky was readily apparent. The stars are nearly pinpoint, and the motion of the asteroid is the "line" in the following images.

Camera & Mode: D810a prime focus 250-mm CDK telescope. Camera and Telescope.
ISO: 2000
Exposure: 180 seconds
Processing: Mac Photos

Fig. 17.1. Full Moon nearby with Spooky's movement apparent. (Image by the author.)

Camera & Mode: D810a Prime Focus 250-mm CDK telescope. Camera and
Telescope.
ISO: 2000
Exposure: 120 seconds
Processing: Mac Photos

Fig. 17.2. Full Moon nearby with Spooky's movement apparent. (Image by the
author.)

Camera & Mode: D810a prime focus 250-mm CDK telescope. Camera and
Telescope.
ISO: 1000
Exposure: 60 seconds
Processing: Mac Photos

Fig. 17.3. Full Moon nearby with Spooky's movement apparent. (Image by the
author.)

If you stay tuned to the astronomical community you will probably have an opportunity to get a close flyby asteroid like this. Use these settings for your astropics and SAAS.

Comets

Camera Only

Comets can be photographed with a camera depending on how bright they are, especially how bright and long their tail(s) are. Comets are notorious for not living up to predicted expectations. If one appears that may be a possible astropic candidate the only thing you can do is to go out and photograph it and see the results.

You will have to assess how bright the comet is and if there is a visible tail and how bright that is. You will want to try wide-angle lenses to get an overall view in the sky of the comet and its tail, if possible. Then try a longer focal length astropic to get detail in the coma – the visible cloud of material coming off of the comet – and maybe even the tail, if warranted.

Mount your camera on a tripod and use the 500 rule with the lens you are using. You may want to consider using a motorized mount, again, depending on the comet. A 30-second exposure at a decent ISO with an ultra-wide angle should get you some nice astropics. Use the following astropic for your settings on a comet and SAAS.

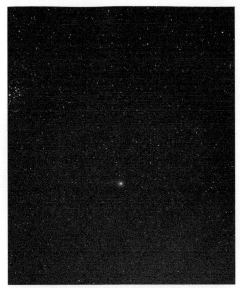

Camera & Mode: D5000 55- to 200-mm f/4-5.6 at 65-mm
f/5.6 on telescope mount. Camera On-ly.
ISO: 3200
Exposure: 46.2 seconds
Processing: Mac Photos

Fig. 17.4. Comet Lovejoy (2014 Q2), with a hint of its tail and the Pleiades showing some nebulosity. Some high clouds were present. (Image by the author.)

ISO will depend on the comet and the condition of the sky where you are located. Bright comets can do well even in light-polluted skies; it all depends on the comet and where it is in the sky with regard to the light pollution.

There has not been a really bright comet in the Northern Hemisphere for a long time. The last two bright comets in the Northern Hemisphere, shown in Figs. 17.5 and 17.6, were photographed using High Speed Ektachrome slides. With digital it will be much, much easier to take an astropic of a bright comet, as you can SAAS. If a bright comet is predicted to appear and really does, the astronomical community will be abuzz about it and provide photographic recommendations that you can consider.

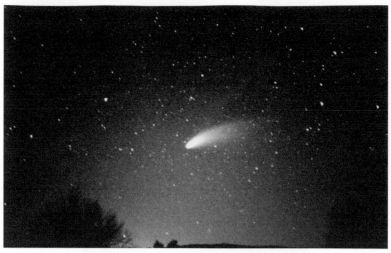

Camera & Mode: Minolta SRT 101 w/50-mm f/1.4 lens on a tripod. Camera Only.
ISO: 400 High Speed Ektachrome (Slide)
Exposure: 8 seconds
Processing: Copied and processed in Mac Photo.

Fig. 17.5. Comet Hale Bopp (C/1995O1). The yellow dust tail and blue ion tail are clearly visible. (Image by the author.)

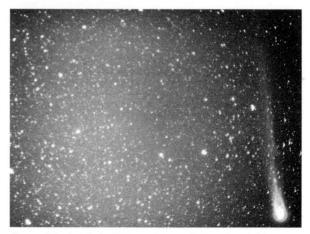

Camera & Mode: Minolta SRT 101 w/ 50-mm f/1.4 lens on a tripod. Camera Only.
ISO: 400 High Speed Ektachrome slide
Exposure: 8 seconds.
Processing: Mac Photo.

Fig. 17.6. Comet Hyakutake (C/1996 B2). A tail disconnection event is clearly visible. The Big Dipper is seen to the left. (Image by the author.)

Camera and Telescope

If you get a comet candidate that you think is worth photographing, try Camera Only mode and see how your astropics turn out. You will also want to use Camera and Telescope mode to try and image the coma and tail of the comet. Prime focus, with a reducer if available, is your best bet to get the widest field of view as well as brightest image.

Depending on how bright the comet is you may be able to image it with a smartphone and pocket camera using the afocal technique. Tablets are out, but every other camera might be worth a try. As always digital is the way to go.

Another nifty trick is to piggyback your longer focal length lenses to your motorized telescope mount or telescope tube/rings. The long focal length lens coupled with the motorized mount will allow you to take longer exposures with a really wide field of view to possibly image the whole comet.

Using your telescope itself will allow you to get close up images of the coma and the tail coming off of the coma. The comet will exhibit its own motion, so in tracking the stars the comet image may be blurry if you expose for too long. You will have to take some images and SAAS. It is an advanced technique, but you may be able to use an auto guider locked on to the comet to try and track it for many minutes of exposure. Try it and SAAS.

As you can see with these astropics of Comet Lovejoy (2014 Q2) you really do not need really long exposures to get decent results.

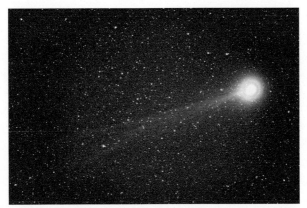

Camera & Mode: D5200 prime focus 80-mm refractor. Camera and Telescope.
ISO: 4000
Exposure: 60.1 seconds
Processing: Mac Photos

Fig. 17.7. Comet Lovejoy (2014 Q2). The image is highly processed to bring out detail in the tail. (Image by the author.)

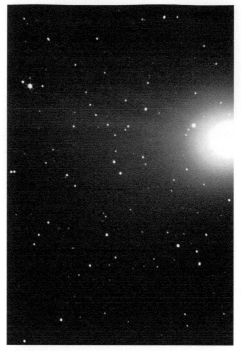

Camera & Mode: D5200 prime focus 250-mm CDK
telescope. Camera and Telescope.
ISO: 4000
Exposure: 120.1 seconds
Processing: Mac Photos

Fig. 17.8. Comet Lovejoy (2014 Q2). This highly processed image brings out detail in the tail. (Image by the author.)

If a really good comet comes along it is worth getting out to try and photograph it as often as you can because comets can change rapidly. In the High Speed Ektachrome astropics shown here, taken with an 8-inch SCT at prime focus, you can see a tail disconnection event, which is when the tail of a comet physically disconnects from the coma of a comet. Pretty wild to photograph! This was not seen visually, due to the camera being at prime focus using an SLR camera body.

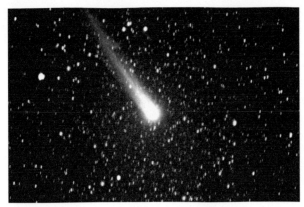

Camera & Mode: Minolta SRT 101 camera body prime focus w/reducer
8-inch SCT on motor-ized mount. Camera and Telescope.
ISO: 400 High Speed Ektachrome (slide)
Exposure: 10 minutes
Processing: Mac Photo

Fig. 17.9. Comet Hyakutake (C/1996 B2). A tail disconnection event is clearly visible. (Image by the author.)

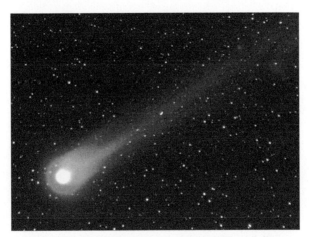

Camera & Mode: Minolta SRT 101 camera body prime focus w/reducer
8-inch SCT on motor-ized mount. Camera and Telescope.
ISO: 400 High Speed Ektachrome slide)
Exposure: 11 minutes
Processing: Mac Photo

Fig. 17.10. Highly processed digitized image showing details in the tail and coma of Comet Hyakutake (C/1996 B2). (Image by the author.)

Table 17.1. Asteroids and Comets with Camera Only

Camera Type	Asteroids	Comets
Smartphone	No	Possibly*
Tablet	No	Possibly*
Pocket	Possibly**	Possibly**
Film	Yes	Yes
CSCs	Yes	Yes
DSLR	Yes	Yes
Video	Yes***	Yes***
CCD/CMOS	Yes***	Yes***

*With NightCap Camera, Windows equivalent software, latest generation smartphone and tablets, and bright enough comet
**With a bright enough asteroid or comet
***If camera lens can be attached

Table 17.2. Asteroids and Comets with Camera and Telescope Prime Focus

Camera Type	Asteroids	Comets
Smartphone	Possibly Afocal	Possibly Afocal
Tablet	No	No
Pocket	Possibly Afocal	Possibly Afocal
Film	Yes	Yes
CSCs	Yes	Yes
DSLR	Yes	Yes
Video	Yes	Yes
CCD/CMOS	Yes	Yes

Photographing Meteors, Fireballs, Bolides, and Meteor Showers

Trying to photograph any of these events is like fishing: "You can't catch a fish unless your pole is in the water." For astrophotographers trying their luck on these events the mantra is, "You can't photograph 'em if the shutter ain't open." These events are best imaged in Camera Only mode, as you want the widest field of view possible for sky coverage. There have been a few lucky astroimagers who were operating in Camera and Telescope mode photographing something else in the sky that caught a meteor in the frame, but the odds of that happening are, well, astronomical.

Singular meteors, fireballs and bolides are chance photographic events during any day or night. Yes, there have been fireballs and bolides – very bright ones – photographed/videoed during daylight hours. Usually these day and night photographs are the result of pure chance. Somebody might have been photographing something else – a football game, stars, a nightscape – and luckily imaged something pretty awesome.

There are people who image the night sky with all-sky cameras in hopes of catching meteors, fireballs and bolides. Security cameras can do the same – again, if lucky.

Your highest probability of imaging any of these events is during one of the major meteor showers of the year, with concentrating on the Perseids in August and the Geminids in December. These major showers are good producers of bright meteors and some fireballs along with a high number of meteors on a moonless night at a dark sky site.

The American Meteor Society and your references will provide you all the information you need to know as to when the peak of a particular meteor shower will be and where the radiant – the area in the sky where the meteors appear to come from – is located. Meteor showers are named for the constellations in which the radiant is located, so pointing your tripod mounted camera with a wide-angle lens in the general direction of the sky a few fist-widths from the radiant is a good start.

Where to point your camera is the "fishing" aspect of meteor showers, as it boils down to pure luck. If you are watching the sky and no meteors are flashing in the section of the sky you are photographing, but you notice a possible repeat pattern of meteors in another section of the sky, try it and see. You've got all night to hopefully get lucky!

Meteors that are part of the shower can appear anywhere in the sky and be traced back to the radiant. Sporadic meteors not related to the shower may also appear in your astropic. Sporadics will not trace back to the radiant and will probably appear at a different angle or aspect than meteors that are part of the shower.

The radiant will move due to the motion of the sky from east to west as the night wears on. Historically meteor showers are at their best in the hours before dawn, when Earth is facing into the meteor stream. Each meteor shower has its own characteristics, so reading up on them and coming up with a plan to photograph them is a good idea.

The NightCap Camera has a meteor shower mode, so if you have an iPhone or iPad and a mount it might be worth a try. DSLRs, CSCs and SLRs are good choices with pure astrocameras not useful unless they can be paired with camera lenses. Even then you will be hostage to having to use a computer with them.

Photographing meteor showers can be a very pleasant experience. Depending on your camera's set up – Astrophotography Rule #1 and #2 – your camera may be capable of being programmed to automatically expose images at a pre-set exposure for a pre-set amount of time or images. So you set your camera on a tripod pointed to your area of interest in the sky at some distance from the radiant. Have the lens wide open and use the 500 rule for your maximum exposure; try about ISO 1000 on a test shot and SAAS. You do not want the sky background so bright that you can't see fainter meteors. If you have a really dark sky you might just let the stars trail during a long exposure and see if you image any meteors.

Remember, the radiant moves across the sky so you may want to move the pointing of your camera as it does, but there is no hard and fast rule. You're fishing for meteor astropics. While the camera is doing all of the work kick back and relax on a nice lounge chair. Have plenty of snacks and drinks and, if cool out, a blanket or a sleeping bag. Just watch and enjoy the sky while the exposures get taken. If your camera can't do this auto exposure for you, just have a nice relaxing chair next to your camera and keep the camera shooting using a shutter release. You can still look at the sky while doing this.

Be on the lookout for dew on your filter or lens as the night wears on. If dew develops try taking your camera to a warm environment like your house or car to warm up the lens or filter and get rid of the dew. Holding your camera up in any wind will remove the dew as well. *Do not* just wipe it off as this could scratch the lens or filter. If you live in a dew-prone environment consider getting a dew heater for your camera by checking online. Using the lens hood can help with dew somewhat.

To see if you got lucky and got a meteor or two (or more if really lucky) just review your downloaded images in a darkened room with the computer monitor at its brightest. Examine each image carefully, as there may be a dim meteor present. If you have the software you can combine all of these images into a nice little video that shows the movement of the night sky. An advanced processing technique is to combine all of your images into one for a composite – making sure you let viewers know it is a composite, per astrophotography ethics.

Camera & Mode: D810a 14-mm f/2.8 lens on tripod. Camera Only.
ISO: Believed to be 2000
Exposure: 30 seconds
Processing: Mac Photos

Fig. 17.11. A bright Perseid meteor. There is a fainter Perseid to the lower right. (Image by the author.)

All in all it is a nice way to pass the time under the stars.

Table 17.3. Meteors et. al. with Camera Only

Camera Type	Meteors, Fireballs, Bolides, Meteor Showers
Smartphone	Possibly*/**
Tablet	Possibly*/**
Pocket	Possibly**
Film	Yes
CSCs	Yes
DSLR	Yes
Video	Yes***
CCD/CMOS	Yes***
ALL SKY ZWO 120	Yes**

*With NightCap Camera in meteor mode, Windows equivalent software, latest generation smartphone and tablets.
**With a bright enough object
***If camera lens can be attached

Bottom Line

Asteroids, comets, meteors, fireballs, bolides and meteor showers each have their own best practices when it comes to photographing them. The key is to determine what you want to take an astropic of and then go about setting up the proper mode and gear to do so. Each of these leftovers from the birth of the Solar System can result in some frustration caused by no luck getting a decent shot or some pretty spectacular astropics. You'll likely experience both with enough time and your camera under the stars.

Comet NEOWISE 2020

At long last the Northern Hemisphere got a bright comet in the form of Comet C/2020 F3 (NEOWISE) that was bright enough to see with the unaided eye. Astrophotographers were elated and besides themselves as NEOWISE really put on a show for months. NEOWISE dominated astrophotography and astronomy websites.

NEOWISE was initially in the morning sky before dawn and then transitioned to the night sky after dusk. It lent itself to both modes but the author could only image in Camera Only due to horizon constraints.

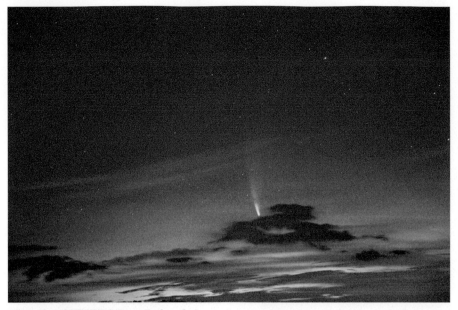

Object Viewed: NEOWISE (Image By the author)
Camera & Mode: D810a 28-300 @85mm f/5 lens on tripod Camera Only.
ISO: 1,000
Exposure: 15 seconds
Processing: Mac Photos
Comment: Nice contrast with clouds and stars.

Fig. 17.12. NEOWISE in the morning. (Image by the author.)

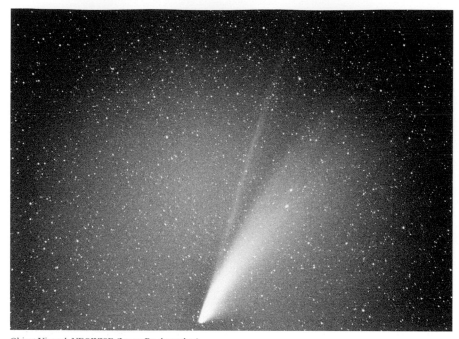

Object Viewed: NEOWISE (Image By the author)
Camera & Mode: D810a 135mm f/2.8 lens on tripod Camera Only.
ISO: 3200
Exposure: 8 seconds
Processing: Mac Photos with stacking of six images using Starry Sky Tracker
Comment: Ion and dust tail prominent even with light pollution. Stacking
REALLY helped bring out detail in this astropic.

Fig. 17.13. NEOWISE in the evening taken with a 52 year-old telephoto lens -the 1st lens ever bought by author. (Image by the author.)

Chapter 18

Aurorae and Glows in the Sky

A bit of a departure here in this chapter, as we are not dealing with astronomical objects per se but rather various phenomena that are seen in the night sky. Some of these glows are in our Earth's atmosphere, while others are out in the Solar System itself. Each of them is pretty amazing to see and photograph but does require special conditions and/or times of the year to see them. Several of them also require very dark skies to be seen. We'll start with the glows in our atmosphere – aurorae, STEVE, airglow and noctilucent clouds (NLCs). Then you'll learn about the zodiacal light, zodiacal band and gegenschein, all of which take place along the ecliptic in the Solar System and are caused by dust – yes, dust.

All of these events will be photographed in Camera Only mode, as Camera and Telescope is not advisable.

Aurorae

Aurorae, or auroras, are well known atmospheric phenomena that take place in the high latitudes of the Northern and Southern Hemispheres, where they are known as the Aurora Borealis and Aurora Australis, respectively. Aurorae can be seen at lower latitudes as well, but it is dependent on the level of solar activity involved as to whether this happens. Aurorae are the result of our planet's magnetic field at the poles interacting with charged

© Springer Nature Switzerland AG 2020
G. I. Redfern, *Astrophotography is Easy!*, The Patrick Moore Practical Astronomy Series, https://doi.org/10.1007/978-3-030-45943-7_18

particles ejected or literally blown off the Sun by solar storms and other related solar events.

Aurorae can be seen year round, depending on one's latitude and the season for the observer. Aurorae are major astrotourism attractions, with annual trips to Iceland, Alaska and other favored viewing locations. The good news is that you really do not have to travel to see them unless you are in lower latitudes, where they are quite rare.

Camera & Mode: Nikon E5700 w/ 8.9-mm f/2.8 (adjustable lens) on tripod. Camera Only.
ISO: 400
Exposure: 8 seconds
Processing: Mac Photos

Fig. 18.1. 2003 Aurora in Virginia. (Image by the author.)

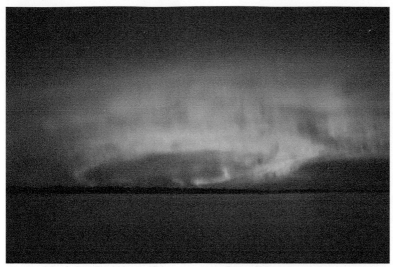

Camera & Mode: D810a w/ 14-mm f/2.8 lens on tripod. Camera Only.
ISO: 2000
Exposure: 3 seconds
Processing: Mac Photos

Fig. 18.2. Aurora viewed at sea in Alaska on the *Star Legend*. (Image by the author.)

If you are interested in trying to view and photograph the aurora your best bet is to monitor the various websites and social media outlets that track them. Usually if the Sun has some kind of event that has the potential to produce aurora the word will get out. You can sign up for personalized alerts, but you can also check the National Oceanographic and Atmospheric Administration (NOAA)'s Space Weather section, which tracks aurorae via a dedicated website. The "Aurora 30 Minute Forecast" updates Northern and Southern Hemisphere aurora forecasts continuously. In addition NOAA has a "Three Day Aurora Forecast" website for longer range planning. See Chapter 23 for these websites.

TIP: Unless you are lucky enough to be in the midst of a full blown aurora event, where it is lighting up your skies, it is very possible that aurorae are out there on the northern (or southern for our readers down under) horizon, but you cannot see them with just your eyes. Aurorae can have varying hues that our eyes cannot detect all that well. Couple that with a dim event low on the horizon and you may miss it with just a visual check.

If the NOAA or other alert methods says that there are aurora in your area but you do not see it, try taking some pics of the northern (southern down under) horizon using the settings provided above and the photo tips to follow.

STEVE

While you are aurora chasing be on the lookout for a bright purple-white filament. It will look distinctly different than the aurora because it isn't an aurora. If you see this in the sky consider the possibility that you are seeing a STEVE – Strong Thermal Emission Velocity Enhancement – event. It is very common for a STEVE event to be seen with an aurora. It was in 2018 that scientists figured out what a STEVE was, even though it had been photographed and observed for decades by aurora observers. STEVE is caused by extremely hot particles traveling very rapidly in a stream moving along magnetic field lines that are different from those of the aurora. If you think you are seeing a STEVE event check the STEVE website listing in Chapter 23.

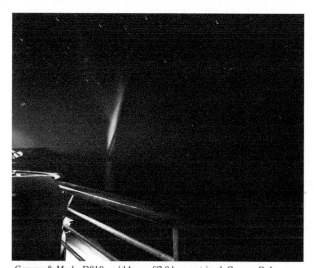

Camera & Mode: D810a w/ 14-mm f/2.8 lens on tripod. Camera Only.
ISO: 4000
Exposure: 6 seconds
Processing: Mac Photos

Fig. 18.3. A STEVE event seen at sea in Alaska on the *Star Legend*, with an incredible auroral display. (Image by the author.)

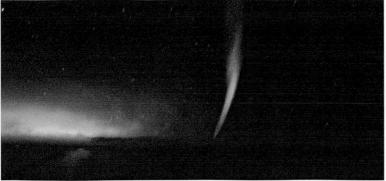

Camera & Mode: D810a w/14-mm f/2.8 lens on tripod. Camera Only.
ISO: 4000
Exposure: 8 seconds
Processing: Mac Photos

Fig. 18.4. At sea in Alaska on the *Star Legend,* with the STEVE and aurora. (Image by the author.)

For photographing an aurora you'll need a tripod with either a wide-angle or 35- to 50-mm lens. A fixed tripod should be fine, but if you want to try motorized go ahead and experiment. Aurorae can cover a small or large area of sky and be just about anywhere. They might be right over you or hugging the horizon. The amazing thing is how fast they can change their shape and colors.

Just point your camera – any type may be able to photograph bright aurora – at the aurora if you see it. If not, but you have an alert for your area, remember the aurora tip and point your camera towards the area of the sky involving the alert. Use the settings of the astropics above for your initial settings and then SAAS.

Airglow

Here's another atmospheric glow that you might think is an aurora but isn't – airglow. This glow comes from the Sun's daily ultraviolet light ionizing the oxygen and nitrogen molecules in our atmosphere. During the night airglow occurs when recombination of these ionized particles takes place and gives off light in the process. Airglow can be blue, red, green and yellow. Green will be the brightest color and the one our eyes can see best.

Airglow is tough to see and requires very dark skies.

Airglow can be distinguished from aurorae pretty easily, as it can occur anywhere on the planet, is usually near the horizon and will not have the appearance of the aurora. But you will need dark skies and a clear horizon for your best chances at photographing this specter in the sky.

If you see what you suspect may be airglow try the following photographic set up. Like the aurora, you'll need a tripod with a wide-angle lens up to 35 to 50mm. You may want to try an exposure with various lenses, as a 14-mm might not provide sufficient detail and a 50-mm might be too small a field of view.

Try ISO 5000 to start and point your camera at the area of interest. Take your exposures and SAAS. To determine if you have photographed airglow you may want to examine your astropics using your computer screen at full brightness and a dark room, as the airglow may be hard to see on a camera LCD.

NLCs

These are an incredible sight, looking for all the world like blue-white electrical arcs in the sky! Noctilucent clouds are normally visible in both hemispheres from 45 degrees to 65 degrees latitude. In 2019 in the Northern Hemisphere NLCs were seen much farther south and actually set records for the lowest northern latitude sightings.

The NLC season for the Northern Hemisphere runs May through August, while for the Southern Hemisphere it is November through February. NLCs are best viewed after sunset or before sunrise, from 90 minutes to two hours. NLCs, like aurora, may occur along the horizon or be higher in the sky.

NLCs are way up there in the atmosphere at an altitude of at least 50 miles (the mesopause) and are our planet's highest clouds. We see them because they are still being illuminated by the Sun at that altitude, even though the Sun has set for you. NLCs are particles of ice that have been covered by meteoritic dust, or really meteoritic smoke! Of course this ties in to our topic from the last chapter and is proof positive of all that cosmic debris making its way into our atmosphere and on the ground.

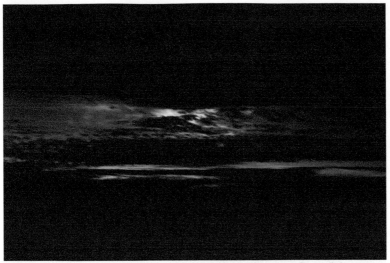

Camera & Mode: D810a w/ 28- to 300-mm f/3.5-5.6 at 82-mm f/5 on tripod. Camera Only.
ISO: 2000
Exposure: 1 second
Processing: Mac Photos

Fig. 18.5. NLC viewed at sea from the *Azamara Pursuit*. (Image by the author.)

For NLCs use the same photographic setup that you used for the aurora and airglow. NLCs will be far easier to spot than airglow, and the aurora may be in the sky with NLCs so be on the lookout.

You will have to be mindful of the sky getting brighter before sunrise and getting darker after sunset as you prepare to photograph NLCs. NLCs are fairly bright, so use the settings of the NLC astropic above as your start. As always, SAAS.

The Zodiacal Light

We leave the atmosphere behind and head out into the Solar System, specifically along the ecliptic. The "false dawn" and the "false dusk," collectively known as the zodiacal light (ZL), awaits your camera and lens. Seen during specific times of the year, this specter in the sky really catches your attention when viewed in a dark sky site with no Moon and an unobstructed horizon. The zodiacal light is seen in deep twilight for about two hours before sunrise and after sunset.

Best described as having a pyramidal or elongated form, the zodiacal light will extend from the appropriate horizon in a broad band that tapers at its top to an actual tip. It is very distinct and easy to see with the unaided eye when the sky and horizon are clear.

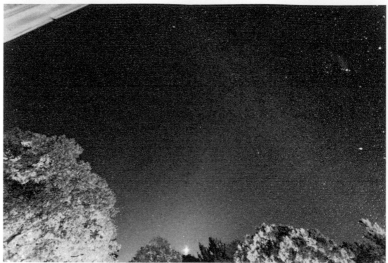

Camera & Mode: D810a w/ 14-mm f/2.8 lens on tripod. Camera Only.
ISO: 3200
Exposure: 30 seconds
Processing: Mac Photos

Fig. 18.6. Zodiacal light in Skyland, Shenandoah National Park, above brilliant Venus, with the winter Milky Way going through Orion at upper right. (Image by the author.)

We see the zodiacal light due to sunlight reflecting off of countless bits of dust that are located in the inner Solar System aligned with the plane of the ecliptic. They stretch through the Solar System near the Sun at their densest and brightest all the way beyond Mars. This dust comes from the formation of the Solar System 4.6 billion years ago, comet and asteroid debris and material launched from impacts on moons and planets.

Your references, especially the *Observer's Handbook,* will specify the dates that the zodiacal light is best viewed from each hemisphere. Generally speaking these periods of prime viewing are as follows.

Late February into early May, with the best viewing around the March Equinox:

Northern Hemisphere Evening (W) deep twilight
Southern Hemisphere Morning (E) deep twilight
Late August through early November, with the best viewing around the
September Equinox:
Northern Hemisphere Morning (E) deep twilight
Southern Hemisphere Evening (W) deep twilight

Just like the other events described in this chapter a camera on a tripod is
a requirement. Use the settings from the supplied astropics as your starting
exposure and SAAS. The zodiacal light is pretty easy to see if there is no
Moon and you have a clear and unobstructed horizon. You will probably be
able to see the ZL on your camera's LCD if it has one. If not, check your
exposure on your computer. Be on the lookout for the ZL paired with other
objects in the sky, such as planets or other sky sights such as the Pleiades.

Zodiacal Band and Gegenschein

If you find yourself at a very dark sky site and had luck with photographing
the zodiacal light, go for broke and try to photograph two very elusive
events known as the zodiacal band and gegenschein.

When the sky is completely dark look across the ecliptic from where you
saw – and hopefully photographed – the zodiacal light. You may be able to
see a very faint band of light across the constellations in the ecliptic – the
zodiacal band. At local midnight on the meridian, where the ecliptic crosses,
there may be a faint glow known as the gegenschein, or "counter glow."

Even if you cannot see either of these visually, and you are at a dark sky
site, it may be worth trying to photograph the constellations that the ecliptic
passes through to possibly nab these two. Your software will show you the
line of the ecliptic and where it crosses the meridian. All you need to do is
point your camera in the sky at the areas indicated.

As for photographing the zodiacal band and gegenschein – yep, same set
up, camera and tripod. Use a wide-angle lens up to a 35-mm. Use ISO 3200
to 5000 and the Rule of 500 for your lens exposure time. SAAS. You want
the constellations of the ecliptic in the center of your exposure as you work
your way from the ZL to local midnight. Center the constellation that is at
the meridian-ecliptic meet up to try for the gegenschein. Use your computer
at full brightness and in complete darkness to scrutinize your astropics.

When you are looking at your astropics to see if you got airglow, the
zodiacal band or gegenschein, do some quick astropic processing, as we
discuss in Chapter 21, before you completely give up the ghost. It is possi-

ble that by boosting some of the processing tools such as brilliance, contrast and others, you may tweak your way into having some good astropics of these ghosts of the sky.

Table 18.1. Aurora and Sky Glows with Camera Only

Camera Type	Aurora, STEVE, NLCs, Airglow	Zodiacal Light/Band, Gegenschein
Smartphone	Possibly, Less Airglow	Possibly*
Tablet	Possibly, Less Airglow	Possibly*
Pocket	Possibly, Less Airglow	Possibly*
Film	Yes	Yes
CSCs	Yes	Yes
DSLR	Yes	Yes
Video	Yes**	Yes**
CCD/CMOS	Yes**	Yes**

*Zodiacal light only and if it is bright enough
**If camera lenses can be attached

Bottom Line

If you have the opportunity to see and photograph in Camera Only mode the glows we have discussed in this chapter, it is time and effort well spent. A full blown aurora/STEVE/NLC event will leave you spellbound and in awe. The zodiacal light will be a worthwhile photographic pursuit as the night begins or ends. The other glows described will be ghostly apparitions in the sky that tease you as to whether they are or aren't there.

Chapter 19

The Milky Way

There are few celestial sights that will elicit such a raw and primal emotion within you as seeing the Milky Way from a dark sky site. It, like totality of a solar or lunar eclipse, leaves you in complete awe and wonderment. Unfortunately, it is difficult in North America to find truly dark skies to see our home galaxy. It is estimated that 80 to 90 percent of the population in North America cannot see the Milky Way due to light pollution.

With that being said it is possible to do so. As we discussed in Chapter 10, an online search of nearby federal, state and local parks can be helpful.

© Springer Nature Switzerland AG 2020
G. I. Redfern, *Astrophotography is Easy!*, The Patrick Moore Practical
Astronomy Series, https://doi.org/10.1007/978-3-030-45943-7_19

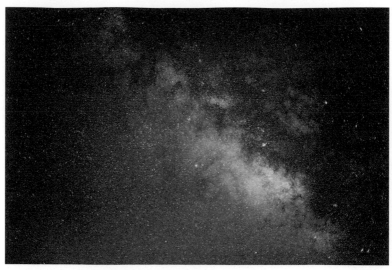

Camera & Mode: D810a w/ 50-mm f/1.4 lens on tripod. Camera Only.
ISO: 4000
Exposure: 5 seconds
Processing: Nikon RAW File processed in Mac Photos

Fig. 19.1. Summer Milky Way. Taken on June 25, 2017, at Big Meadows in Shenandoah National Park, Virginia. (Image by the author.)

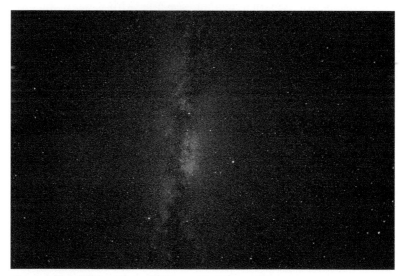

Camera & Mode: D810a w/ 14-mm f/2.8 lens on tripod. Camera Only.
ISO: 6400
Exposure: 30 seconds
Processing: Nikon RAW File proceeded in Mac Photos

Fig. 19.2. Summer Triangle Milky Way. Pic taken at Big Meadows in Shenandoah National Park, Virginia. (Image by the author.)

Also, if you are on a cruise ship in the middle of an ocean the Milky Way can be photographed in Camera Only mode with great results and backdrop.

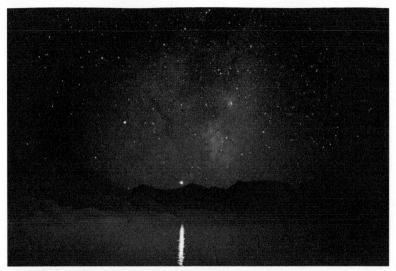

Camera & Mode: D810a w/ 35-mm f/1.4 lens on tripod. Camera Only.
ISO: 1000
Exposure: 8 seconds
Processing: RAW Nikon file processed in Mac Photos

Fig. 19.3. The Milky Way as seen at sea on the *Azamara Pursuit* in the Chilean fjords. Venus rises with the galactic center of the Milky Way over a mountaintop, and Venus is reflected in the water of the fjord. (Image by the author.)

If you happen to find yourself on astrotourism travel it is definitely worth determining if there are any dark sky sites available.

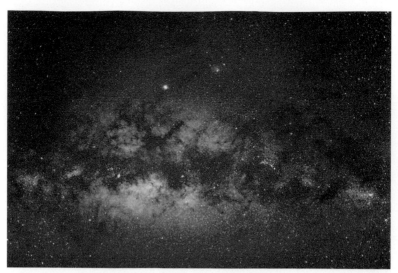

Camera & Mode: D810a w/ 35-mm f/1.4 lens on tripod. Camera Only.
ISO: 3200
Exposure: 13 seconds
Processing: RAW Nikon file processed in Mac Photos

Fig. 19.4. The Milky Way in the Atacama Desert. This amazing astropic of our galaxy was taken in one of the most pristine dark sky sites on the planet. (Image by the author.)

Depending on your location, if you are in the suburbs or on a seashore, you might be able to get some of the milky band that spans across the sky in summer.

Camera & Mode: D810a w/ 14-mm f/2.8 lens on tripod. Camera Only.
ISO: 4000
Exposure: 5 seconds
Processing: Mac Photos

Fig. 19.5. Suburban summer Milky Way. Even with a 10-day-old bright Moon nearby the Milky Way is visible. (Image by the author.)

Camera & Mode: D810a w/ 14-mm f/2.8 lens on tripod. Camera Only.
ISO: 2000
Exposure: 10 seconds
Processing: RAW Nikon file processed in Mac Photos

Fig. 19.6. Seaside nightscape of the summer Milky Way. Even with some light pollution in the foreground the Milky Way was able to be seen. (Image by the author.)

To photograph the Milky Way is really quite easy to do if you have the right location, camera and lens mounted on a tripod. A motorized tripod is not required, but you can certainly use one if you so choose. All of the astropics shown were taken on a plain old tripod. If you are in a dark sky site any camera has the potential to photograph the summer Milky Way, which is when it is at its brightest and largest span across the sky. How well it performs in doing so depends totally on the camera and lens used.

The Milky Way is best photographed with a DSLR or CSC coupled with a wide-angle or 35- to 50-mm lens, as you can see from the foregoing astropics.

That being said, it should be possible to photograph the Milky Way when it is at its brightest using a smartphone and tablet with the previously described astro-enhancement software and/or the latest generation of these cameras. For NightCap Camera "stars mode" is recommended.

A pocket camera with a good lens should also be able to image the Milky Way.

Film cameras using ISO 3200 film – currently the highest ISO film available, as was discussed in Chapter 2 – should be able to easily image the Milky Way. Film grain due to the higher ISO might be an issue. Film camera users will have to try and see.

Pure astrocameras outfitted with regular wide-angle and 35- to 50-mm lenses should be able to easily image the Milky Way.

The provided settings from the preceding astropics are a good starting point for photographing the Milky Way, from which you can then SAAS.

Using your software and other resources, you can determine when the Moon is out of the sky, which is a must to get the best possible Milky Way astropics from any location.

You can also determine the orientation of the Milky Way by using your software and resources. The Milky Way does change its appearance in the sky depending on where you are located and what time of the year it is. This is where your software pays big dividends, as you can set it for your actual or anticipated location, time and date, and get a view of what the Milky Way will look like in the sky.

Your software should have a "Milky Way" category that allows for a variety of ways to present the view of our galaxy on your display. Use the "Realistic View," as it best represents what you can see and photograph in the sky. For either hemisphere summer is peak time for the Milky Way, as it can span across the entire sky. At the equator is a pretty unreal view also, as our galaxy can span across the entire sky.

The Milky Way is also visible in the winter but is not as resplendent as in summer. The winter Milky Way keeps the winter constellations company and makes for a very nice framing, especially with Sirius.

Camera & Mode: D810a w/ 14-mm f/2.8 lens on tripod. Camera Only.
ISO: 5000
Exposure: 30 seconds
Processing: NEF RAW processed in Mac Photos

Fig. 19.7. The winter Milky Way, with the pic taken in the Indian Ocean aboard the *Nautica*. This image was highly processed to bring out the Barnard's Loop of hydrogen gas visible just above Orion and all of the stars and dust in the winter Milky Way. (Image by the author.)

If you look carefully at the astropics of the Milky Way in this chapter you will notice "reddish-pink" areas and dark wispy tendrils that populate the images. These are emission nebulae and dark nebulae (pl. for nebula). Emission nebulae are regions where newborn stars are emitting intense radiation that causes the hydrogen gas in the nebulae to illuminate in hydrogen alpha light. You may recall that the Nikon D810a DSLR, modified DSLRs and Canon's new CSC astrocamera have a sensor that is sensitive to this light, so these regions in the Milky Way stand out. The dark nebulae are regions where gas and dust abound to block out the background stars. Dark skies are really needed to image these areas; they are spectacular in their size and shapes.

Each of these features is a deep sky object (DSO), as technically anything beyond our Solar System is classified as such. Unless you have access to a large aperture telescope, with the exception of galaxies, all of your DSOs are going to be in the Milky Way. DSOs are the subject of our next chapter, so we will defer on discussing them. We will also defer on having a Camera and Telescope mode for this chapter, as the use of a telescope on the Milky Way in all likelihood puts you in the realm of DSOs.

Table 19.1. Milky Way with Camera Only

Camera Type	Milky Way
Smartphone	Possibly*
Tablet	Possibly*
Pocket	Yes
Film	Yes
CSCs	Yes
DSLR	Yes
Video	Possibly**
CCD/CMOS	Possibly**

*With use of Nightcap Camera for iPhone/iPad and Windows equivalent or latest generation devices.
**With use of camera lenses attached if camera has that capability

Bottom Line

From a dark sky site in the summer the Milky Way is bright and big in length and breadth. Using a tripod with any camera type, an ISO of 3200, a wide angle and a 35- to 50-mm focal length lens using the 500 Rule exposure length should get you some very nice astropics of our home galaxy.

Chapter 20

Deep Sky Objects

As we discussed last chapter the Milky Way will be the source of all your DSOs with the exception of other galaxies. You would have to have a pretty large telescope to make out DSOs in other galaxies, although it is possible to see some in a few of the closer galaxies, such as the Andromeda Galaxy (M31), Triangulum Galaxy (M33) and the Large and Small Magellanic Clouds.

Each DSO will have a designation from one or more star catalogs, such as Messier (M) and New General Catalog (NGC), which are the most popular. There are a myriad of catalogs and some are for specific DSO types. You can learn about these DSO catalogs by using the resources provided in Chapter 23. Your software, depending on your settings, will show DSOs in the sky display, using a specified symbol for each type of DSO.

For the Milky Way, if you use "realistic view" you can actually see some of the galaxy's DSOs displayed. Clicking on the DSO or its symbol should bring up information about its physical and astronomical parameters followed by a verbal description of its history and other pertinent information.

A really good way to learn the DSOs in your sky is looking at your software display for a particular time of year and identifying the DSOs present. Find them in the sky and then read up on them. A really good and representative catalog for DSOs is the Messier Catalog, named for the French comet hunter Charles Messier (1730-1817). He compiled a catalog of over a hundred DSOs in the late 1700's to help him in his search for comets. With his catalog he could quickly determine which comet candidates were not part of it and therefore were a good possibility of being comets. He and other comet hunters, even today, find potential candidates by scanning the sky

© Springer Nature Switzerland AG 2020 347
G. I. Redfern, *Astrophotography is Easy!*, The Patrick Moore Practical
Astronomy Series, https://doi.org/10.1007/978-3-030-45943-7_20

looking for faint and fuzzy objects. When one is found the first thing to do is to eliminate any known DSOs or comets. That's where software and a computerized telescope mount come in handy.

It also helps to look at DSOs with binoculars, as a lot of them are visible in a pair of 7x50s and more capable telescope finders. The key is to know where they are in the sky so that in Camera Only mode you know where to point in the sky to take an astropic. Your location will determine what DSOs you can see, so you have to be aware of that when preparing to photograph DSOs in either mode.

Camera Only

Some bright DSOs in the band of the Milky Way can be photographed with cameras on a fixed tripod, as we saw in the last chapter. The key is knowing which DSOs are in your image. This is where matching up your astropic to your software or references will help. As you shall see these same DSOs can be photographed in far greater detail using Camera and Telescope mode.

The Andromeda Galaxy and the Large and Small Magellanic Clouds (LMC and SMC) can be photographed with various lenses on a fixed tripod, as you can see.

Camera & Mode: D810a w/ 35-mm f/1.4 lens on tripod. Camera Only.
ISO: 2000
Exposure: 10 seconds
Processing: RAW Nikon Mac Photos

Fig. 20.1. The LMC and SMC. The pic was taken in Chile. Black and white was used for effect and to counter bad white balance due to the light pollution clearly in the frame. (Image by the author.)

Camera & Mode: D810a w/ 35-mm f/1.4 lens on tripod. Camera Only.
ISO: 2000
Exposure: 10 seconds
Processing: Mac Photos

Fig. 20.2. The Orion nebula. (Image by the author.)

These DSOs also photograph very nicely with telephoto lenses, but you would need a motorized mount or a motorized telescope mount in piggyback operation, as the exposures necessary would cause trailing when using a fixed tripod.

A few DSOs besides those in the bright segment of the Milky Way and the three mentioned galaxies will be in the range of your camera lenses. Most of these will be star clusters, such as the famous Double Cluster in Perseus. In the Southern Hemisphere the incredible Omega Centauri globular cluster can be imaged and looks like a fuzzy star.

Use the settings from the foregoing astropics for your own and SAAS. If you find yourself in a location that has some light pollution you may have to use a shorter exposure.

Table 20.1. DSOs with Camera Only

Camera Type	DSOs Described
Smartphone	Possibly
Tablet	Possibly
Pocket	Possibly
Film	Yes
CSCs	Yes
DSLR	Yes
Video	Possibly*
CCD/CMOS	Possibly*

*With use of camera lenses attached if camera has that capability.

Bottom Line

Smartphones or tablets would not be a good choice for the DSOs, but if that is all you have, try and see. If a pocket camera has a decent lens and manual settings it might be able to photograph the described DSOs. DSLR/CSCs with the described lenses would be the best choice for DSOs, although film cameras could image them as well. Pure astrocameras and video with the mentioned lenses could also be used to image these.

Camera and Telescope

Some DSOs, such as the Orion Nebula, are pretty bright, as it can be seen visually, while distant quasars are dim and difficult to see. Start by taking photographs of the "easier" – read brighter – DSOs that are provided here; then you can try your hand at more challenging DSOs.

Regardless of your telescope's optical system you should be able to take astropics of the brighter DSO's using the afocal method for smartphones and pocket cameras. You would want to use a low power eyepiece and focal reducer to get as much of the DSO in the image as possible, as well as the most light possible through the eyepiece. Tablets once again are just too cumbersome.

For all other camera types prime focus method with a focal reducer, if you have one, is the mode to use, as you want all the light and field of view you can get. In this mode your telescope will provide its widest field of view with the brightest light output possible.

If you have a GOTO mount, or any motorized equatorial or alt-azimuth mount, make sure it is polar aligned and synchronized so you can use it to find your DSO of interest *and* take an astropic of it. This is so important it must be stated again – make sure it is polar aligned and synchronized. If you do not do this at the very start of your DSO imaging session none of the following imaging methods will work – none of them. Unless you star-hop (manually finding your DSO using stars nearby it) you won't find them, and your exposures will be trailed pretty quickly. So take your time and get aligned.

All of the following astropics were taken with a Nikon D810a at prime focus of a 250-mm Cassegrain Dall-Kirkahm reflector telescope, with a focal reducer for an f/9.2 focal ratio. These are single exposures taken with just the mount tracking on its own after polar alignment.

Camera & Mode: D810a Tak M250 primary focus w/reducer for f/9.2.
Camera and Telescope.
ISO: 5000
Exposure: 240 seconds
Processing: Nikon RAW Mac Photos

Fig. 20.3. Dumbell Nebula, M27, a famous planetary nebula. (Image by the author.)

Camera & Mode: D810a Tak M250 primary focus w/reducer for f/9.2. Camera and Telescope.
ISO: 5000
Exposure: 240 seconds
Processing: Nikon RAW Mac Photos

Fig. 20.4. Lagoon Nebula, M8 – one of the best astropic subjects there is. (Image by the author.)

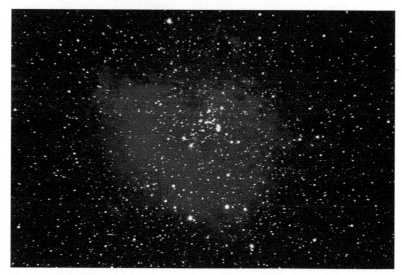

Camera & Mode: D810a Tak M250 primary focus w/reducer for f/9.2. Camera and Telescope.
ISO: 5000
Exposure: 240 seconds
Processing: Nikon RAW Mac Photos

Fig. 20.5. Eagle Nebula, M16. The famous Pillars of Creation are in the lower left of the nebula. (Image by the author.)

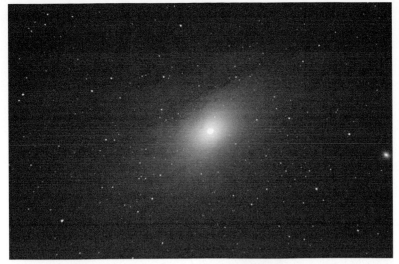

Camera & Mode: D810a Tak M250 primary focus w/reducer for f/9.2. Camera and Telescope.
ISO: 5000
Exposure: 30 seconds
Processing: Nikon RAW Mac Photos in black and white.

Fig. 20.6. Andromeda Galaxy, M31. Note the stellar-like nucleus with spiral arm dust clouds. One of M-31's two elliptical companion galaxies, M-110, is visible to the right. Galaxies are really best seen in black and white astropics. (Image by the author.)

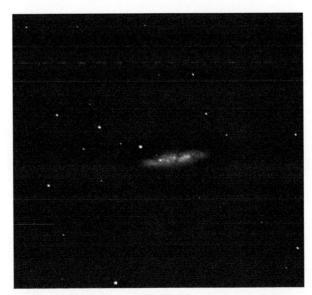

Camera & Mode: D810a Tak M250 primary focus w/reducer for f/9.2.
Camera and Telescope.
ISO: 5000
Exposure: 155.6 seconds
Processing: Nikon RAW Mac Photos

Fig. 20.7. Supernova 2014J in M82 is the bright star on the left in the galaxy. (Image by the author.)

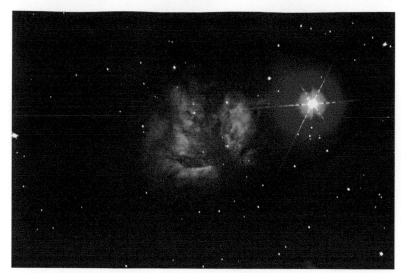

Camera & Mode: D810a Tak M250 primary focus w/reducer for f/9.2. Camera and Telescope.
ISO: 3200
Exposure: 300 seconds
Processing: Nikon RAW Mac Photos

Fig. 20.8. The aptly named Flame Nebula, NGC 2024. (Image by the author.)

As you can see from the astropics shown you should be able to get enough exposure time with a properly aligned mount to get decent astropics without guiding. If you want to go for longer exposures you essentially have two choices – manual guiding or auto guiding. We've discussed this previously but go into a bit more depth here.

Manual Guiding

This method harkens back to the days of pre-computer astrophotography, where astronomers sat hunched over a guiding eyepiece with illuminating crosshairs focused on a guide star. With a control paddle in their hands they could move the telescope as required to keep that guide star centered. The guide star was selected as being very near their object of interest and as bright as possible, so they could guide the telescope for many hours. This is a very demanding and fatiguing experience. Your eyes get tired as does the body from being in one position. Add in cold or heat/humidity, and it is an ordeal.

With digital cameras the manual guiding ordeal is far less intense, as today's exposures are nothing like the past. As a beginner astrophotographer

equipped with a digital DSLR/CSC/pure astrocamera you really shouldn't be pressing too far beyond 5 minutes with most DSOs. In reality you can get very decent DSO astropics in far less exposure time, as you can see in the astropics included in this chapter.

Auto Guiding

Auto guiding is the same procedure as manual guiding except that an auto guider – a small digital camera – "talks" to the mount via auto guiding software to automatically make needed corrections. A guide star is selected by you, locked onto with the auto guiding software, which then feeds corrections input to your telescope via an ST-4 cable plugged into your mount – if it is so equipped.

To manually or automatically guide you need one of two things, a guide telescope or an off-axis guider (OAG). Both of these do the same thing – provide a means of getting a necessary guide star while your camera is taking an exposure – but in very different ways.

A guide telescope is a second telescope that is either attached to your prime telescope, usually using scope rings or affixed in some manner to your mount. It does not have to be large, as its primary purpose is to allow for the guiding of the main telescope in order to take longer exposures with a camera. To make necessary corrections to the telescope mount you place either a manual guiding eyepiece or an auto guider on the guiding telescope to find and lock on a guide star. Using this system you have to make sure that the guiding telescope is precisely aligned with the main telescope, as any small errors in their alignment will cause the tracking to be off, with trailed images being the result. You also have to have a sturdy enough setup for the guiding telescope to prevent telescope tube flexure – a condition where the guiding telescope changes its alignment with the main telescope due to flexing in the tube caused by being in different positions. Again this condition can cause trailed images.

Using this option you have to make sure that your mount can handle the increased payload weight and that your setup is sturdy and precisely aligned.

With the other option an off-axis guider is physically attached to your telescope and camera. The light from the telescope passes through the OAG, where a small prism interrupts the light path. Either a guiding eyepiece or an auto guider is placed at the top of the OAG, and a guide star is selected. This option is far less complicated and probably less expensive. Its main issue is that the field of view is small and may result in finding a guide star that could be dim and hard to see. It takes patience and practice, but this method works well with SCTs and smaller payload capacity mounts.

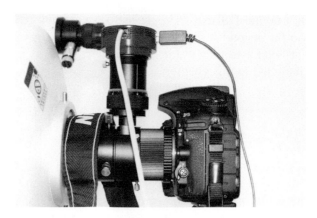

Fig. 20.9. Omegon OAG with ZWO 120 auto guider and Nikon D810a DSLR hooked up for prime focus method. (Image by the author.)

To summarize, as a beginning astrophotographer your choices of exposure options for DSOs are as follows:

- *Short exposure using just the inherent tracking ability of the telescope's mount.* You can test to see how long your exposure can be before trailing starts by taking exposures of varying time and see the results. At some point you will notice trailing in your images, so taking exposures just below that timeframe will set the maximum exposure for your DSO images using just the mount with no corrections.
- *Manual guiding using either OAG or guiding telescope.* Using either method you are at the guiding eyepiece manually inputting to your telescope mount the corrections necessary to keep your guide star centered. With digital capability you really shouldn't have to be at the guiding eyepiece too long – that is up to you, your DSO object and resulting images.
- *Auto guiding using either OAG or guiding telescope.* The same process as manual guiding – OAG or guide 'scope – except that an auto guider is doing the work for you at a far faster rate. It is heavily reliant on the auto guider and its software, your ST-4 cable and inputs to your telescope mount and of course your telescope mount itself.

In Chapter 7 we discussed some solutions to help you with auto guiding, specifically the use of the ZWO ASiair for DSOs. This is an elegant way to solve several problems at once, and as long as you are using a telescope mount that can be controlled by the unit, it will help you immensely in Camera Only and Camera and Telescope modes for DSOs.

DSOs Imaged With Camera Attached Piggyback To Mount or Telescope Tube

One other method of getting DSO images with greater detail is to mount just your camera with a long focal length telephoto lens in place of a wide-angle lens to either your telescope tube or telescope mount piggyback and take exposures. As we discussed in Chapter 7 you have to find the proper accessories that allow you to securely attach the camera to your mount or telescope tube.

This method is far more forgiving of alignment errors and can produce some very pleasing wide-angle view astropics of nebulae, star clusters and the brighter galaxies, as you can see in the images shown. If your mount is properly aligned you should be able to image for a longer period of time than through the telescope at prime focus.

The following astropics were taken with a Nikon D810a attached to the telescope mount using the described lens. These are single exposures taken with just the mount tracking on its own after polar alignment. As you can see this setup is more than adequate, and it takes some pretty decent astropics.

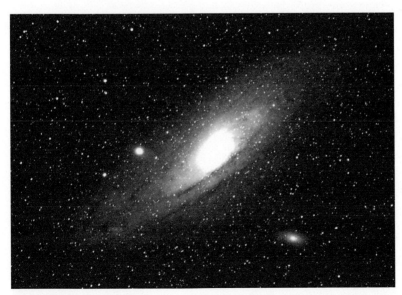

Camera & Mode: w/ 200- to 500-mm f/3.5-f/5.6 lens w/1.7x tele-extender at 850-mm f/9.5 on telescope mount. Camera Only.
ISO: 3200
Exposure: 240 seconds
Processing: Nikon RAW Mac Photos

Fig. 20.10. An unguided exposure of the great galaxy Andromeda, M31, with its spiral arms, dust lanes, star clouds and two satellite galaxies, M32 (top) and M110 (bottom. (Image by the author.)

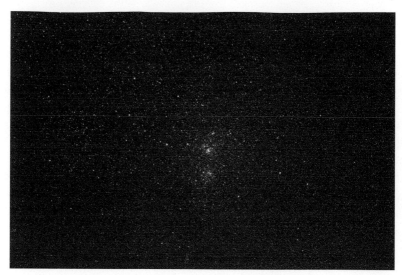

Camera & Mode: D810a w/ 300-mm f/4 lens on telescope mount. Camera Only.
ISO: 1000
Exposure: 120 seconds
Processing: RAW Nikon Mac Photos

Fig. 20.11. Unguided exposure of Perseus Double Cluster. (Image by the author.)

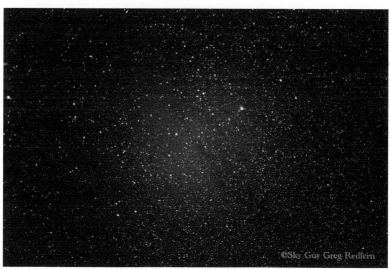

Camera & Mode: D810a w/ 300-mm f/4 lens on telescope mount. Camera Only.
ISO: 3200
Exposure: 300 seconds
Processing: RAW Nikon Mac Photos

Fig. 20.12. Unguided exposure of the California Nebula. (Image by the author.)

Camera & Mode: D810a w/ 200- to 500-mm f/3.5-f/5.6 lens
w/1.7x tele-extender at 850-mm f/9.5 on telescope mount.
Camera Only.
ISO: 5000
Exposure: 240 seconds
Processing: RAW Nikon Mac Photos

Fig. 20.13. Unguided exposure of the Rosette Nebula. (Image by the author.)

Camera & Mode: D810a w/ 200- to 500-mm f/3.5-f/5.6 lens
w/1.7x tele-extender at 850-mm f/9.5 on telescope mount.
Camera Only.
ISO: 5000
Exposure: 240 seconds
Processing: RAW Nikon Mac Photos

Fig. 20.14. Unguided exposure of the Orion Nebula (M42) region, with Orion in center, M43 on the left, and NGC 1977 (the Running Man Nebula) at the top. (Image by the author.)

Camera & Mode: D810a w/ 300-mm f/4 lens on telescope
mount. Camera Only.
ISO: 2000
Exposure: 180 seconds
Processing: RAW Nikon Mac Photos

Fig. 20.15. Unguided exposure of M42 (Orion), M43, NGC 1977 (Flame Nebula) and Horsehead Nebula. The pic is highly processed to bring out nebulosity and finished in black and white. (Image by the author.)

Remote Imaging

If you want to take DSO astropics with the absolute least amount of effort and the absolute maximum in comfort, remote imaging is the way to go. As you might recall this is when you rent out a telescope located at a premium dark sky site and use it via the Internet to take astropics of objects you designate.

This method is used mainly for access to objects such as comets, asteroids and mainly DSOs that are located in the Southern Hemisphere or for when dark skies are required in the Northern Hemisphere. It really is fun to use and produces pretty amazing results, as you can see. As discussed in Chapter 4, there are several companies out there for you to check out.

Camera & Mode: CCD mounted on Slooh rental telescope.
ISO: Unknown
Exposure: 300 seconds
Processing: Automatic

Fig. 20.16. Quasar 3C273, which is 2.5 billion light years from Earth! (Image by the author.)

Table 20.2. DSOs with Camera and Telescope Prime Focus with Focal Reducer

Camera Type	DSOs as Subjects for Photography
Smartphone	Possibly, if DSO is bright and using afocal method w/low power eyepiece
Tablet	No
Pocket	Possibly, if DSO is bright & using afocal method w/low power eyepiece
Film	Yes
CSCs	Yes
DSLR	Yes
Video	Yes
CCD/CMOS	Yes

Table 20.3 DSOs with Camera and Lenses Using Motorized Telescope Mount

Camera Type	DSOs as Subjects for Photography
Smartphone	Possibly with bright DSO & an accessory that can attach camera to mount
Tablet	Possibly with bright DSO and an accessory that can attach camera to mount
Pocket	Possibly with bright DSO and an accessory that can attach camera to mount
Film	Yes
CSCs	Yes
DSLR	Yes
Video	Possibly*
CCD/CMOS	Possibly*

*With use of camera lenses attached if camera has that capability

Bottom Line

Take what you have and see what you can get......

Tablets would not be a good choice for DSOs using a telescope – just too bulky. But if you can find an accessory that can attach your tablet to the mount or telescope, try and see. Smartphones and pocket cameras could possibly image bright DSOs using the afocal method. All other camera types could do well with a telescope using prime focus and a focal reducer.

For using the telescope's motorized mount with smartphones and tablets employ zoom lenses with an accessory if you can find one that can attach the devices to the mount or telescope. With this setup you *might* image the Andromeda Galaxy and the Orion Nebula and a few other bright DSOs. But this is an option only if there is no other camera available to you or you are seeking a challenge!

If a pocket camera has a decent optical zoom lens and manual settings it might be able to photograph bright DSOs. You would be limited, like smartphone and tablet users, and the same advice given above applies.

DSLRs/CSCs using a wide variety of lenses would be the best choice for DSOs, although film cameras with high ISO film could image them as well. Pure astrocameras that can use regular lenses could image DSOs piggyback and at prime focus with a reducer.

See how far you can go with what you've got....

Chapter 21

Process, Print, and Post Your Astropics

You have come to the point where you should have taken astropics with your camera and it is time to see the results. If you used film you need to send them to a commercial processor or develop them yourself, which we will not discuss here. If you went digital for your astropics then you will be using some sort of software to process them.

The really good news is that there are a lot of astrophotography processing software choices. The really bad news is that there are a lot of astrophotography processing software choices. The really, really good news is that basic processing software for astropics is available and not that difficult to use in order to obtain pretty good results, as you have seen in this book.

All of the astronomical images in this book were processed using the photo processing software that came with Macbook Pro or the Nikon freeware available for Nikon digital cameras. No doubt better processing results could be obtained through more powerful and in most cases more expensive and complicated processing software. But this book is about astrophotography basics, and the results herein show what is possible using basic digital processing software commonly available with computer and camera purchases.

As you progress in experience taking astropics you may want to become more advanced in your processing skills as well. If you want to upgrade to more advanced software do your research by reading about the products out there and trying them out via the free trial use periods that some of them offer. Some software is astronomically oriented while others are not. Some

© Springer Nature Switzerland AG 2020

G. I. Redfern, *Astrophotography is Easy!*, The Patrick Moore Practical Astronomy Series, https://doi.org/10.1007/978-3-030-45943-7_21

astrophotography masters use multiple software products to produce their images. You will have to see what works for you by trial and error.

Before you process your first astrophoto you have to decide how you will keep track of it and quite possibly the hundreds if not thousands that may follow in the years to come. Do yourself a favor and institute an astrophoto filing system with astropic #1. Thousands of astropics and years later you will be so glad you did. See the following suggestions on how to do so.

Keeping Track and Backup

In the old days of wet film and before computers – yes, such a time did exist – hand printed astrophotography logbooks were the order of the day. Each shot was laboriously assigned a number with columns assigned to object ID, ASA, exposure, astrophoto method used and results/comments.

Digital astrophotography – and computers – has made this method obsolete, as in a single night you might take dozens or more of images. So how do you keep track of them all? Fortunately your camera and computer will do the lion's share of the work for you.

Digital cameras record image information for each exposure. Your camera's manufacturer will have this image metadata collection capability built in to the digital camera's image processing. Each image should include date, time, unique number, ISO, lens used, exposure time, f/stop, file size and type, i.e., RAW or JPEG.

This image metadata information should be retrievable using just about any type of processing or viewing software, whether it is that of the camera's proprietary or third party brand.

There should be an "Info" or "i" button feature in your software you click to display the metadata for each exposure. Leaving this Info button active while viewing each astropic will result in a display of its metadata information.

Okay, now that you know what the camera and computer do with your astropics what should you do? There are a number of filing protocols you could use, but we are all about basics. The easiest thing to do is to create a folder for each astropic session you undertake. Use the date and perhaps imaging location in the folder's name and store each image obtained for that session in it. You should label each image with the object's name and camera exposure ID. Nikon assigns a "DSC sequence number" to each image, and you want to keep that intact so you can always pair it up to the original exposure.

Your images for an astrophoto session will be on a removable memory card or internal storage. You will in all likelihood download these to your computer for processing. Some computers will have a slot for memory cards which makes for fast and easy downloads. You will also want to make a backup of your astropics by perhaps using one of the Cloud services available, a separate storage medium or keeping the memory card itself. You do not want to lose your astropics when your computer fails, which it will someday.

Oh, and do *not* delete images from your camera or memory card until you are certain you have a good download of them to your computer and backup. It is a good habit not to delete anything until you have viewed all of the images at home, even the "bad ones."

Processing Astropics

Your first step in processing your astropics is to determine if your smartphone, tablet, pocket camera, CSC, pure astrocamera or DSLR – whichever digital camera(s) you use – has in-camera image processing capability that you can use (Astrophotography Rules #1 and #2). You may be able to process your astropics in your camera and download them to your computer for retention. This will be your only option if you do not have a computer or other astropic processing capability.

Nikon's D810a and other DSLRs and CSCs, including those of other brands, have in-camera menu options that you can use for taking an astropic that will require the camera to process the exposure. Astrophotography Rules #1 and #2 apply big time here, as you need to know what these features are, what they do, how to access them and process the results. These features are proprietary to the camera brand (and type) you use, so they will not be part of image processing software you ordinarily use on your computer.

These in-camera options can be used and the resulting image downloaded to your processing platform for further processing using your software. Peruse all of your camera's features and determine which ones are applicable for your astroimaging. Take some exposures, process in-camera and then download to process further.

Your computer will have far more image processing power than what is in your camera, but you have to rely on the camera's processing power for in-camera features. RAW images, which have no compression or image alteration and which is what you should always use for your astropics, can be quite large, at 70 to 80MB per image! Even computers can take some time for making processing adjustments, as we will discuss in a bit.

Once again, Astrophotography Rules #1 and #2 – Read the Manual – must be applied to the image processing software that you intend to use. Knowing how your processing software works, its in and outs, is essential to obtaining the very best possible astropics as a result of your imaging sessions. And you can't do that unless you know how it works.

If you are already a digital photographer it is quite likely that you are familiar with and perhaps proficient in digital image processing software. If so, you are way ahead in the processing game. The only real differences between regular photography and astrophotography is the nature of your camera subject and probably far longer exposures than what you are used to. Photons are photons no matter where they come from, and they interact with your camera of choice in the same way, whether they are of people, terra firma or the Universe.

Here's another point to remember. As a beginner your astropics are being taken as part of a new hobby or extension of one you already have in astronomy or photography. Your astropics in all probability are not being taken for strict scientific purposes or analyses. It is always possible that your astropics could capture something that might be of interest, such as a very bright fireball, a transient astronomical event or even something strange in the sky. But your primary purpose is to learn the practice of astrophotography and enjoy the astropics of your labor.

If you grow in your interest to the point of wanting to take images for astronomical/scientific purposes, there is a whole field that awaits you as a citizen scientist. You can contribute to the study of the planets, comets and asteroids. You can gain access to research-grade instruments through the telescope rental process and take images and process them using required processing software. A broader discussion is beyond our purview here, but now you are aware of the possibilities.

Whatever imaging processing software you use it will have a variety of tools. These tools may make changes to the image being processed by use of a sliding tab, clicking of arrows or input of an actual increment. There will probably be a histogram to tell you about the overall characteristics and therefore quality of your image. You should read about histograms and how to interpret them using the resources listed in Chapter 23.

Proprietary Nikon image processing freeware for Mac OS and Windows OS is supported by Nikon on its website and includes software updates. This freeware has been used with the Nikon D810a astrophotography dedicated DSLR. Capture NX-D software was designed for Nikon DSLRs and Nikon's RAW format for processing "regular" photographs taken with Nikon DSLRs. In addition to the tools for regular photographs there is an "Astro Noise Reduction" tool used for astrophotography to reduce signal

noise caused by longer exposure astrophotographs. For longer exposures noise from the electronics and sensor – including their temperature increase – can show up in an image as extraneous pixels. This tool works to remove this noise. Most digital processing software should include a noise reduction tool, so this should be part of your processing.

Other tools you will use for your astropic processing will adjust image(s) for brightness, contrast, white balance (sky background) and overall appearance, vignetting, shadows and brilliance. We will address the issue of "how much is too much" in processing your astropics when we discuss astrophotography ethics later in this chapter.

With all of the processing software and computers out there we can only provide some defining basics as to how to approach astropic processing. These basic guidelines will apply to processing astropics regardless of the software and hardware you will use. Combine these guidelines with your knowledge of how your software works – Astrophotography Rules 1# and #2 – and you are on your way from file to photo.

First Look

Every single astronomical image you take adds to your overall experience as an astrophotographer. Each image also helps develop what we call your astrophotographer's eye. From the moment you decide to take an astropic of an object, perform your setup to do so, and look at the initial and final result, you are developing your astrophotographer's eye.

As the number of images and hours spent taking and processing them add up you will develop a feel for how to set up, frame and analyze your astropics. You will eventually know what setup will work and what looks right in your framing of the exposure and its result. What to keep and what to delete will become second nature to you, but you have to have some proven criteria to go by to develop your astrophotographer's eye. That is what the remainder of this chapter is all about.

You have just finished a long and tiring astrophoto session. If you applied SAAS during your session you will have already gotten an idea of what your images look like and how many you have. It helps to look at your images on your digital camera's LCD, but we strongly recommend that you do not delete any image until you have looked at a session's results on a computer screen.

If you are really tired after your astrophoto session it may be best to get some rest and start your processing when you are refreshed. If you can't wait and want to get that "first look," then carefully complete the download process into the session folder you should have created.

During this first look and when processing your images you will want to use all of the brightness that your computer display has to offer. Why? Because many astropics will be somewhat dim, and you want to see the image with the most light available. Make sure the image is viewed in full screen with 100% display brightness. You want to see all of the image, to look it over and see what you have. Be mindful of possible meteors and satellite tracks or a "what is that!?" candidate while looking them over.

Do your first look and all processing in complete darkness. Having sunlight, bright lamps or even a single light source can really hamper your ability to see your images in full detail. You need a "dark room" to view and process digital images just as in days gone by of wet film. Your computer display should also be aligned with your line of sight, so that you are not looking at your images at an angle that can make them a bit dimmer.

What to Look For

Browse through the images to see how many you have and to get a feel as to their initial quality. If you have multiple images of the same object see if you can determine which of them is the best. Do *not* delete any images during this first look unless you know for certain that you have a "bad" exposure. Examples of images worthy of deletion are those where you have no image at all due to some kind of error, or one where the image is defective due to focus issues, camera misalignment, obliterating light source, trailing, etc.

Even with these images you want to fully understand what happened to cause their failure. This is how you learn from mistakes to avoid repeating them. Every single image has a story to tell, whether it is one of success or failure – Astrophotography Rule #10. Learn from each astropic. Follow these steps to determine first look image quality and thereby decide which to process further and which to delete.

Brightness

Is the image hard to see?

If you have multiple images of the same object, which one is the brightest before any processing? If you have one image that is better than the others, concentrate on that one, first.

Is it possible to increase image brightness for one image over the others to a satisfactory level using your software's tools? Try increasing brightness via the appropriate tool – brightness, exposure, contrast. Analyze the result against the other images to determine which one to keep for further processing.

Quality of Image Composition

Is your framing of the object of interest where you want it? Is it off center or not completely filling the frame? Use the crop and tilt adjustment tools to adjust as necessary.

Focus

Use "Zoom in" to analyze star images or the object itself to see if the focus is sharp, soft or if trailing is present. Do this for all of your images but especially if you have multiple images of the same object. Seeing might have been better in one image over others. Choose the image with the best focus.

Image "Jitters"

Look for what we call "EKG lines" – movement caused by wind, bumping the camera/telescope or mount issues. Choose the image devoid (hopefully) of these.

White Balance

As part of your camera's setup for an astropic session you should have set white balance on auto. This is the best setting for a beginner and works well, as you can see in the astropics in this book, most of which were set at auto initially and perhaps changed in processing. If there isn't an auto setting your camera should have "Sunlight," which is a good starting point.

Which image has the most appealing and accurate representation of the sky? You may have light pollution or a bad white balance that can be corrected to some degree by adjusting the various tools to achieve a pleasing but accurate perspective.

After doing this first look at multiple images to get to a best one to work on, do the same process for the remaining single exposure images. After completing first look you should have the "best of the best" images to work with in your processing efforts.

Your deleted astropics should remain in the "deleted files" or trash, depending on your software and OS. It's a good idea to permanently delete them only after you have finished first look and subsequent processing. Your images from the session will remain on your memory card/device storage until you remove them. Some software will ask if you want to delete images

from your camera after importing (downloading). You should not do this until you have completed processing. You can always delete them yourself later.

As you will learn through time and experience, getting one or two decent astropics to work with from a session that entails 20-plus exposures from a Camera Only session, or one decent image from a 10-plus image session at the telescope, is a good haul. Oh, and truth be told, the first shot in Camera Only mode may be the best. But even so Astrophotography Rule #8 – "More is Better" applies, and taking many astropics is key to every session.

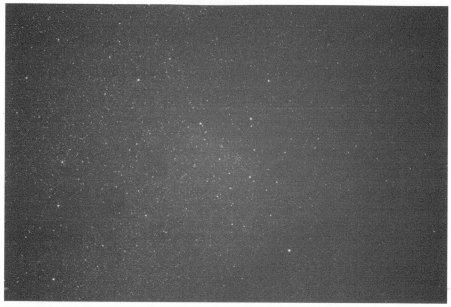

Camera & Mode: D810a w/ 300-mm f/4 lens. Camera Only on telescope mount.
ISO: 1000
Exposure: 120 seconds
Processing: None

Fig. 21.1. Unguided exposure of the North America Nebula, NGC 7000. (Image by the author.)

This image looks DOA – dead on arrival – due to lackluster colors, dimness and a lot of background sky glow. But by going through basic processing and using the power of black and white it turned out to be pretty decent, as you can see in Fig. 21.2.

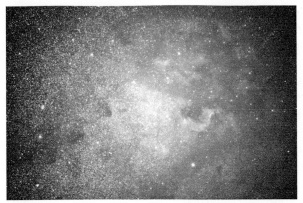

Camera & Mode: D810a w/ 300-mm f/4 lens. Camera Only on telescope
mount.
ISO: 1000
Exposure: 120 seconds
Processing: RAW NEF in Mac Photos

Fig. 21.2. Unguided exposure of the North America Nebula, NGC 7000. (Image by
the author.)

TIP: Use of black and white (B&W) can be very effective when an image
looks good, but poor sky background can't be reduced to a pleasing and
accurate look. As you shall see later in the chapter B&W can be very power-
ful in bringing out hydrogen-alpha light by maximizing use of the "red
channel" and then converting to B&W.

Processing

Following the first look process there will be – hopefully – some RAW
astropics to process. Not knowing the layout of the software you will be
using the following are recommended basics to be applied to each image.
You will develop your own image processing workflow as you gain experi-
ence and your astrophotographer's eye.

From Astrophotography Rules #1 and #2 you should know what your
software recommends as to how to proceed with processing an image or if
astrophotography specific software, an astropic. Follow the recommenda-
tions if there are any. If not, here is an approach using basic image process-
ing software previously described.

First up should be maximizing the brightness of the image through the
following tools usually in this order: brilliance, exposure, contrast, shad-
ows, highlights, brightness and black point adjustments.

Make adjustments with one tool to get the image to where you are satis-
fied and proceed to the next tool.

Have patience during adjustments. Be very aware as to making sure that an adjustment made is an adjustment fully completed! The combination of your computer OS, its processing power and memory, image processing software complexity, and image file size can add up to a wait between inputted tool adjustment and its completion.

There should be some form of notification by the computer/software that an inputted adjustment is being processed. A spinning symbol, a blinking color palette or some other method should let you know the computer is working on the adjustment and when it has completed it.

Do not attempt multiple adjustments at the same time, as you risk the computer freezing or the software even closing on its own. This can sometimes happen during just one adjustment. If this happens repeatedly it may be an indicator of a computer or software issue, and you should troubleshoot to determine the cause. Image processing requires computer processor power and memory, as your computer may heat up in an image processing session! Also try to be on main power and not battery power. Make sure other applications are closed to get all the memory and processing power you can for the task at hand.

Here is an example of what can be done to take a finished image and make changes to increase contrast to maximum. The Moon really benefits from this, as you can see in the following. Note the changes made to the tools to achieve maximum contrast.

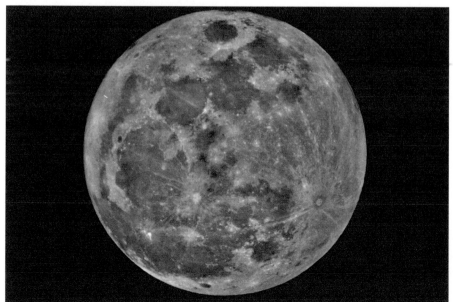

Camera & Mode: Nikon D810a prime focus with 250-mm CDK telescope with reducer f/9.2. Camera and Telescope.
ISO: 160
Exposure: 1/125 of a second
Processing: Mac Photos

Fig. 21.3. Full Moon (Image by the author.)

Fig. 21.3a. Mac Photos Tool Settings

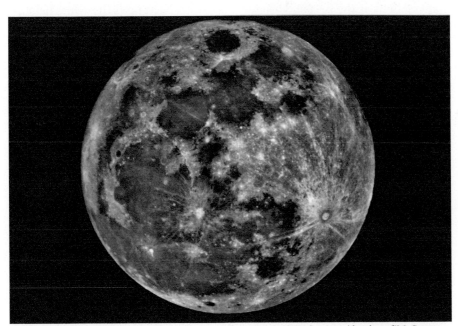

Camera & Mode: Nikon D810a prime focus with reducer f/9.2 250-mm CDK telescope with reducer f/9.2. Camera and Telescope.
ISO: 160
Exposure: 1/125 of a second
Processing: Mac Photos

Fig. 21.4. Full Moon of Fig. 21.3 at maximum constrast. (Image by the author.)

Fig. 21.4a. Mac Photos Tool Settings

Experiment with each of the various tools to achieve a resulting image that you think is the best and brightest possible. Next up is the white balance tool that is an important determinant for what your image's overall appearance will take. The key is to obtain an image that is not overly brown, blue or some other color. You *do not* change the intrinsic color that is in the RAW image by adding in color but work to obtain the right color temperature and tint that reflects as best you can the true nature of the sky.

Sometimes "auto white balance" or even "direct sunlight" just doesn't cut it, and you have to work to get it right. Trust your ever improving astrophotographer's eye to guide you as to what looks best. There are advanced techniques to do white balance settings for your camera before imaging, but they are beyond our purview of basics.

If you cannot get a good white balance, which will happen sometimes for a color image, consider making the image black and white. You'd be amazed at how a really poor white balance for a color image due to nearby light pollution sources becomes a stunning black and white image.

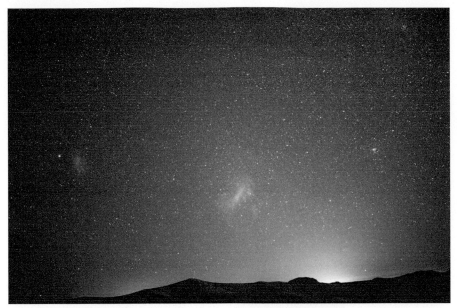

Camera & Mode: D810a w/ 35-mm f/1.4 lens on tripod.
ISO: 2000
Exposure: 10 seconds
Processing: RAW NEF Mac Photos

Fig. 21.5. LMC and SMC. Localized light pollution is readily apparent in this astropic, taken from Chile. (Image by the author.)

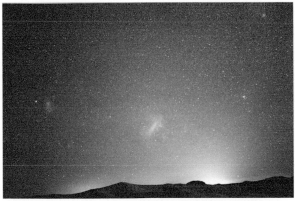

Camera & Mode: D810a w/ 35-mm f/1.4 lens on tripod.
ISO: 2000
Exposure: 10 seconds
Processing: RAW NEF Mac Photos

Fig. 21.6. Extensive processing of the pic shown in Fig. 21.5 reduced light pollution somewhat and brought out details in the LMC and SMC. The color version was not presentable but looks decent in B&W. (Image by the author.)

White balance adjustments – and all of the color adjustments, really – require remembering Astrophotography Rule #9 – "Keep the Color Real." But using B&W allows for the maximizing of native color in the image to bring out detail, contrast and a pleasing appearance.

Case Study: Image Processing End States

The following is a case study of what can be done in the processing of a RAW image, which as you recall, is an image taken and saved with no compression. A single RAW digital image was taken of the region in Orion that contains the Flame Nebula and Horsehead Nebula. This is an area that is rich in hydrogen gas and dust, as you can see. The original image was taken with a long lens on a telescope mount. The RAW image on "first look" did not seem very promising, but was processed as detailed below to avoid deletitis.

Camera & Mode: D810a w/ 200- to 500-mm
f/3.5-5.6 w/1.7x tele-extender at 650-mm f/9.5 on
telescope mount – unguided.
ISO: 3200
Exposure: 240 seconds
Processing: Mac Photos

Fig. 21.7a. Original RAW image of the Flame Nebula and Horsehead Nebula. Following Figures processed with Mac Photo (Image by the author.)

Fig. 21.7b. Processed RAW image for "Normal" view.

Fig. 21.7c. Composite image with R(ed), G(reen), B(lue) channels.

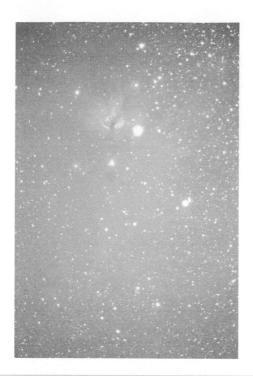

Fig. 21.7d. R(ed) channel is processed for best view.

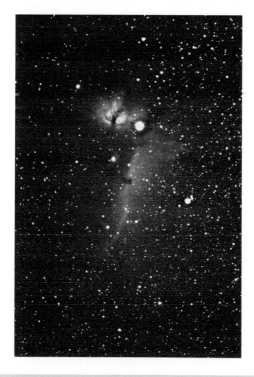

Fig. 21.7e. Final result in black and white.

To summarize the RAW images were processed in the following workflow:

- To a best "normal view." See **Fig. 21.7b**.
- Using the "normal view" for each individual color channel (RGB) to make a composite view. See **Fig. 21.7c**.
- Using the "normal view" to make adjustments using just the red color channel. See **Fig. 21.7d**.
- And finally a nice black and white image based on the red channel view. See **Fig. 21.7e**.

Astrophotography ethics were adhered to in this whole process. This sequence shows the power of digital processing and how even though no color was added to the original RAW file it is possible to fully enhance the image's hydrogen alpha light. It also shows the power of a black and white image.

Your software should have tools available to make adjustments for vignetting, sharpness, luminance, and others, including file conversion. This tool converts your processed RAW image into a JPEG or other image file type. You should also have the ability to undo all tool adjustments in order to return your image to its original RAW format as well as individual tool reset.

"Batch processing" should be available as an option in order to take the saved adjustments of one image and apply it to others you specify. This might work with images taken in the same sky conditions around the same time. It should not be applied to all images because quite frankly each astropic is unique as to time and space and requires (usually) unique and singular processing.

Your image processing software should also have a "Cropping" tool that enables you to resize an image to make it smaller or larger. The cropping tool should also have a means to straighten or rotate images as well. These tools will be very useful for putting the finishing touches on your astropics. You can frame, enlarge or reduce size, and rotate your astropic until you get it the way you want. This is usually the last step in your processing.

Here is an example of enlarging an astropic using the cropping tool. The figure was taken of the full Moon with a 200- to 500-mm zoom telephoto at 500 mm. The last step was to enlarge the image using the cropping tool. You do not want to enlarge an astropic to the point where you start to blur the image. If this happens you have gone too far in your enlargement. Enlarge until just before the pic starts to go "soft" in detail, i.e., blurry.

Camera & Mode: w/ 200- to 500-mm f/3.5-f/5.6 lens at 500-mm f/5.6 on a tripod. Camera Only.
ISO: 200
Exposure: 1/200 of a second
Processing: Mac Photos

Fig. 21.8. Cropped full Moon. (Image by the author.)

Now examine Fig. 21.9, which is not cropped and was taken right after the previous pic to compare images between the two lens setups. It is apparent that the cropped 500 mm has better image quality than the native 850-mm image. It is just a bit soft. A bit more precise focusing might have helped, but the 500 mm still has better "presence."

Camera & Mode: w/ 200- to 500-mm f/3.5-f/5.6 lens w/1.7x tele-extender at
850-mm f/9.5 on a tripod. Camera Only.
ISO: 200
Exposure: 1/200 of a second
Processing: Mac Photos

Fig. 21.9. Full Moon not cropped. (Image by the author.)

Cropping is useful, but remember when enlarging not to overdo it.

If you take a series of astropics of the sky in Camera Only mode using the same lens that are overlapping there is a powerful freeware tool you should be aware of. *Autostitch* has the ability to process multiple images into a single panorama image and makes it so easy to do. You download the *Autostitch* freeware to your computer, install, and when ready, just upload files to the freeware. If the multiple images can be processed *Autostitch* will produce a single panorama image. The power of this freeware is seen in the following astropics which were processed using some of the images in this book with others.

Your best chance at being able to create a panorama with *Autostitch* is to use the same lens and settings while photographing overlapping sections of the sky. *Autostictch* can handle a large number of images.

Fig. 21.10. Milky Way Panorama Shenandoah National Park. (Image by the author.)

This wide panorama of the Milky Way was made from multiple 50-mm lens images.

Fig. 21.11. Black and White Milky Way Panorama Shenandoah National Park. (Image by the author.)

This close up panorama of the Milky Way was made from two 50-mm lens images.

Fig. 21.12. Milky Way Panorama Chile. (Image by the author.)

This wide panorama of the Milky Way was made from two 14mm lens images.

Don't be in a hurry! Processing images should be done when you have a lot of time to devote to the process, and it should be fun to do, not a pain. Oh, you will get frustrated and talk to yourself a lot. But you will also be all smiles when you see the final results and maybe, just maybe, want to make a print of your astropic or share it via social or traditional media outlets.

Printing Astropics

Step one of printing out an astropic is making sure you can find the right image file name. Make sure that images are properly named and filed for easy retrieval. With 15,000 images it is not hard to lose an image! Make sure you make retrieval possible when you process your images.

Determining if you want to do your print at home on your printer or send it out to a commercial printer comes next. Printers and photo grade paper have come a long way from the early days of their introduction. You have a variety of printer purchasing options available to you, and even printers used primarily for word processing can do a decent printout of an astropic. Just use highest quality printing output (not too big of a size to save ink if color jet printer) and glossy photo paper.

Astrophotos can be commercially printed into a large wall-sized canvas-type print – no frame – that is quite nice to hang in home or office. This can be done effortlessly online through major warehouse retailers and others. The file is received and made into the specified size and style and mailed right to your door. The price is reasonable and the results pretty amazing. You want to do this with your best astropics because any flaws present will show up clearly on a larger scale.

Post Online with Social Media or Traditional Media

We live in a computer and smartphone connected world, where anything can go online in seconds after it has been witnessed or created. Social media giants such as Twitter, Pinterest, Facebook, Instagram, Shutterfly, You Tube, Flickr and a host of others allow you to create your own account and post astroimages to your heart's content. Camera manufacturers have online web pages for users of their cameras and lenses to post their work, and National Geographic has a "Your Shot" web page for posting as well.

All of the above plus blogs, vlogs, and chat rooms abound with astronomy and astrophotography as their focus. It pays to follow the astrophotography masters, their web pages and accounts to see and learn from their posted work. There are astrophotographers who sell their work online as well.

Some DSLRs even have WiFi capability, so if you can reach the Internet you can post online. You shouldn't post images without a first look and processing unless it is something newsworthy, such as catching the moment Antares goes supernova. You want to be appreciated by those who look at your work and not overwhelm them with sheer numbers of astropics. "Quality is better than quantity" is the mantra to follow here.

If you think you have a really good or unusual astropic you may want to consider sharing it with more than just social media. Give some thought to sending it to news media such as TV, radio, newspapers or an astronomy publication website. A local angle works well if you are in an area that has a number of news outlets. You have to be honest in your assessment as to the newsworthiness and appearance appeal of your submission. Better not to send a lot of astropics than sending something all the time.

This is a partial listing of online websites for sending your best work to. You may or may not get a response from them concerning receiving your submission, but they will follow up if you get their attention for possible publication.

Astronomy Picture of the Day (APOD)
Earth and Sky.org
Popular Science.com
Earth Picture of the Day (EPOD).org
The Planetary Society.com
Skyandtelescope.com
Astronomy.com
Space.com
Universe Today.com
Local and national news – especially weather – outlets
National/State/Local Parks

Almost every entity online or in print has "Contact Us" or "Submit Your Photo" information provided somewhere on their web page or newspaper information page. Try to find a "Science" or photo-news contact point or follow their instructions for photo submission. Again, run of the mill astropics probably won't make the cut, but eclipses, picturesque Milky Way nightscapes, close and colorful planetary/lunar conjunctions, bright comets and fireballs might improve your chances.

Astrophotography Ethics

Submission of your astropic to a news outlet, other entity or just posting online is the perfect time to introduce you to astrophotography ethics. If an entity decides to post online or print an astropic of yours you will see some legalese in their offer to you to do so. You will have to state that the submitted work is yours, that you own the copyright, and in some cases, words to the effect that no significant alterations to the original photograph were made – more on that in a moment.

If you have been, or will be around the astropic online scene for any appreciable amount of time, you will see astropics that are flat out false in their representations of the sky. Impossible alignments of the Moon and Sun, several images composited together to make one, over enhancement of color to border on the ridiculous and not supplying proper credit to the original astrophotographer. Each of these transgressions if committed would be a breach of astrophotography ethics.

If you are submitting the image for publication to an entity, paid or not, or depicting science data with it, you have to be very careful to maintain the integrity of the submission. If you do anything to the original it should be stated for clarity. Science data should be pretty straightforward.

It is a fine line to use software tools and advanced methods such as stacking and composite images to create astropics. Is your image for science or art/aesthetic purposes? You can do one or the other, but do not intermingle them unless you directly state having done such.

You as the astrophotographer can do what you want with an image of yours as long as if you dramatically change the original composition from what it was in the sky you tell your audience that you did so. This is completely legit to do. Adjustments to color that was already in the image but needed improvement or an image not correctly captured due to sky conditions that can be improved upon through the use of tools is, for the most part, accepted in the community. Your astrophotographer's eye and experience within the community will help you develop a good feel for astrophotography ethics.

Bottom Line

Trial and error, practice makes perfect and adherence to astrophotography ethics are the unwritten rules of the astrophotography community. Astrophotography sessions using one or both modes of operation and processing the fruits of your labor – astropics – will help you along the way. As time goes by and the astropics taken increase you very likely are going to find yourself becoming afflicted, or even possessed by the astrophotography bug. Learn about the symptoms and what you can do about them in our last chapter.

2020 Mosaic Capable Software Update

If you are interested in a fairly easy to use and powerful astropic processing software that includes mosaic capability, check out Astro Pixel Processor https://www.astropixelprocessor.com. You can obtain a 30-day free trial to see if it works for you.

The following mosaic of Orion and the winter Milky Way was compiled with this software using seven images all taken at the same time with the same image setup. Following the creation of the mosaic image it was highly processed to bring out the hydrogen alpha and dark nebulae features and converted to black and white like days of old.

Camera & Mode: D810a 35-mm f/1.4 on tripod. Camera Only.
ISO: 3200
Exposure: 15 seconds
Processing: Astro Pixel Processor used for RAW mosaic, final in Mac Photos.

Fig. 21.13. 7 Image Mosaic Of Orion-Milky Way (Image by the author.)

2020 Mac OS Stacking Software Update

For Mac OS users who do solar, lunar and planetary imaging there is GREAT NEWS. A freeware image processing program called SiriL https://www.siril.org was discovered online in late 2020 that will do image registration and stacking. Time only allowed cursory exploration and use of this freeware program but it showed excellent possibilities for Mac OS users. The one image of Mars was taken with the ZWO120 and frames were stacked. Seeing was not great BUT it is the best image to date the author has obtained of the Red Planet. Be sure to check it out.

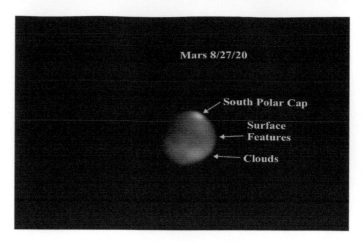

Chapter 22

The Astrophotography Bug

We have come to the point in the book where we transition from talking about photographing the Universe and the equipment and techniques needed to do so to getting a bit philosophical.

It is time now to give you the other side of astrophotography – the deeply personal and philosophical side you experience in taking astropics over a long time. If you get to this point, you have undoubtedly caught the "astrophotography bug."

You already have the first symptom of the astrophotography bug – wanting to learn about taking pictures of the Universe that you yourself take. No matter how that first successful astropic turns out you will remember and cherish it always. You will probably have that astropic decades from its exposure date.

As a newcomer to astrophotography you will likely be initially overwhelmed by all that is needed to learn to get those first astropics. You may or may not have the necessary camera and equipment to operate in either or both modes of Camera Only and Camera and Telescope. That is okay. Proceed in researching what you want to do as your first venture in astrophotography. What is needed? What is the cost? You are not in a race against time, and make sure you do not get in a race with impatience. You probably won't win that race against yourself, but you could lose it by making a wrong choice as to equipment or some other astrophotography aspect. Time is on your side. The Universe is going nowhere other than just getting bigger through its accelerating expansion every single second. Hey, more to photograph, right?

© Springer Nature Switzerland AG 2020

391

G. I. Redfern, *Astrophotography is Easy!*, The Patrick Moore Practical Astronomy Series, https://doi.org/10.1007/978-3-030-45943-7_22

The good news is that just about anything you buy photograph or telescope wise – if you buy quality – can pretty much always find some use even decades later. Sure, technology will always advance, but even old odds and ends can find their place as you saw in my NEOWISE astropic taken with a 52-year old telephoto lens. You are probably going to find that taking pictures of the Universe is addicting – another sign of the astrophotography bug. With each astropic you take there is the thrill of capturing photons from some object in the Universe. You select the object, date, time and Earthly location and then perform the set up for an astropic session. Whichever mode you are operating in the moment comes when you start your exposure.

When you activate your camera's shutter you are recording moments in time that will never be repeated again in your life or that of the Universe. Each moment of time that passes during your astropic exposure transfers information to your camera from the Universe that perhaps no one else is capturing at that moment. That is powerful. It becomes a driving force to want to continue doing so and getting better at it.

As we have discussed, each and every exposure you take is a learning experience. It may be a pleasing one that produces an "Oh, wow!" image or one that causes some verbiage by you that may not be suitable for others. But you will wait with eager anticipation to see the result of each and every one of your astropic exposures.

Another astrophotography bug symptom, and one you have to be very wary of, is letting frustration get a hold of you. There isn't an astrophotographer ever who has not dealt with frustration. Frustration from fatigue caused by a long astrophoto session in cold or hot weather that didn't yield a successful image. Frustration from sky conditions where cloud cover was the name of the game during a big astronomical event – talk to eclipse lovers who paid thousands to see a cloudy sky – or seeing conditions not worth a single exposure for lunar and planetary astropics.

Another big frustration contributor: "I wish I had a bigger or better…" insert here camera, telescope, lenses, observing location, etc. You also can't change weather or seeing/sky conditions; you just have to deal with them and know that it is part of the astrophotography equation. Be content with what setup you have and strive to take the very best astropics you can with it.

There is nothing wrong with wanting better. It can be a positive driving force. Take your wish(es) and develop a plan to make them come true. It may take time to get the money for what you desire, but you can keep taking astropics in the meantime and gaining more experience and developing that astrophotographer's eye.

A very common symptom that is perhaps one of the hardest to overcome as you go about living your life is finding more time to devote to astrophotography. Unless you are independently wealthy and do not need to work at a job or go to school, have no friends, no family, and no other interests, you will find yourself juggling to find time for astrophotography.

Where you are in life – young teenager, student, in the military, starting a career or finishing one, family and children, economic situation – will probably determine how much time you will have for the Universe. The solution is to make the most of whatever amount of time you have. Quality and not quantity is the goal. Try to work astrophotography into your life as you probably do with everything else. Use your references, such as the *Observer's Handbook* or *Sky & Telescope* magazine to know when astropic opportunities will be happening. Set aside time for opportunities that fit with your overall schedule.

If you have astropic session time that has been scheduled, but weather or sky conditions ruled it out, use that time to study and learn about the Universe, sky and astrophotography. The Chapter 23 resources can easily accommodate many hours of thoughtful study.

You may be able to take classes in astronomy and (astro)photography online or at a local college. Joining a club and finding out what local resources you may have available can lead to significant enhancement of your pertinent knowledge and polishing of skills. Think outside the camera body for these types of opportunities.

Astrotourism

As we have discussed previously there exists a whole industry dedicated to providing astronomy-related travel. Decades ago you could find land and sea travel tours for total solar eclipses very easily. But today there are far more companies doing not just total solar eclipse tours – including seeing totality from an aircraft at 30,000 feet(!) – but astronomical facilities, dark sky site expeditions, astrophotography camps, aurora observing trips, observatory-telescope rentals and someday spaceflight sightseeing.

Obviously there are monetary costs involved in each one of these travel endeavors, but they can be very rewarding and result in memories (and astropics) of a lifetime. Cruise ships provide an excellent opportunity to see dark skies and astronomical facilities as well as astronomical events.

You can find astrotourism opportunities in the various astronomy magazines and related websites well in advance of the planned events. Such advance notice can help with budget costs, as payment is usually made

incrementally over a length of time with a down payment to secure a reservation and a payment schedule. You do have to read the fine print as far as refund and trip cancellation policies.

Fig. 22.1. Selfie taken at the Tropic of Capricorn, Atacama Desert, Chile. Taken during a Sky and Telescope 2019 total solar eclipse tour. (Image by the author.)

Odds are high that your beginner's interest in astrophotography will develop into a lifelong passion. As time goes on and your astropic portfolio grows, and your astrophotographer's eye reaches development, you will find a rare peace in this world as you collect photons from the Universe. It comes from knowing that you are part of the Universe you are photographing and a realization of what it is you are photographing as well. The symmetry of the Universe unfolds before you and your camera with each astropic you take. At times during your longer exposures – especially with meteor showers and DSOs – you can't help but wonder what is out there when looking at the stars.

The sheer beauty of the night sky that you will see and photograph will add to this inner serenity. It becomes part of you if you pursue photons from the sky long enough. The sky becomes a partner in your life that will always be there when you come calling with your camera, your eyes, and yes, your heart.

The Masters

There are definite masters in the field of astrophotography that are not professional astronomers. Most have been in the pursuit of photons from the universe for a long time, and they are very, very good at their craft. You are

going to hear from several of them offering advice they have for beginner astrophotographers. Their comments seem a fitting way to finish this book on astrophotography basics by providing sound advice to you based on their extensive experience. See Chapter 23 for more resources on these masters.

Mia Stålnacke

Fig. 22.2. Photograph of Mia Stålnacke. (Copyright © Mia Stålnacke, used with permission.)

Without a doubt Mia is one of the most accomplished master astrophotographers, as her aurorae and nightscape astropics are, well, out of this world. Located in Sweden, Mother Nature provides her plenty of opportunities to get stunning aurora and nightsky astropics. Her suggestions on how to photograph the aurora were included in the Chapter 18 section of Chapter 23. She is very active on Twitter – @AngryTheInch – where she has over 20,000 followers. In addition to her general advice to all, we specifically asked her to provide input for women who are interested in taking up astrophotography. Hers is very valuable advice for everyone.

Here's some background on her from her website. Based far above the arctic circle in Kiruna, Sweden, Mia was fortunate enough to live where the northern lights frequently light up the night. This shows in her photography, which more often than not features those magical lights in the sky.

Her aim is to show the wonders of the night sky accompanied by Earthly elements – to get people interested in astronomy and start looking up.

Sadly a starry sky isn't that easy to find anymore due to massive amounts of light pollution on this planet. If we, stargazers, amateur astronomers and astrophotographers, grow in numbers maybe we can change that.

She has written a beginner's guide to aurora photography (see Chapter 23 section on Chapter 18).

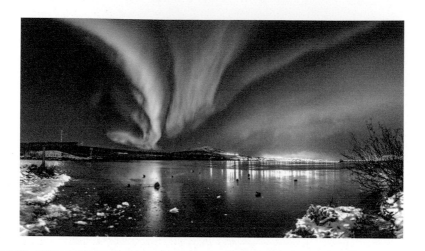

Fig. 22.3. Aurora nightscape. (Copyright © Mia Stålnacke, used with permission.)

Her work has been published in books and magazines, web publications and newspapers. *Forbes* magazine has the latest feature piece.

She has been awarded a NASA APOD, was once named one of the best astrophotographers in Sweden and was shortlisted in the Insight Astronomy Photographer of the Year competition.

Her advice to anyone interested in taking their own photos of the starry night sky is to just do it. Get out there with whatever equipment you happen to have access to and try. If you're just starting out that might be an entry-level DSLR or even just your smartphone.

There's an abundance of tutorials for all types of astrophotography available online; find one that you like and understand and use that as a starting point.

The pictures probably won't come out looking perfect in the beginning, but the feeling when you first see all those stars appear on the screen as the exposure is finished is incredible.

She says she's learned by trial and error, and there were a lot of errors! Many nights spent out in the freezing cold under millions of twinkling stars and dancing veils of northern lights, taking hundreds of pictures while changing the settings slightly every now and then. Eventually it all started making sense to

her, and she could figure out where her ISO, aperture and shutter speed needed to be, depending on the conditions on that particular night.

The way you learn is, of course, very personal, but trial and error is what has always worked best for her. If you prefer having an extensive guide to go by there are many well-written ones available online.

The main point she is trying to make here is, as she initially said, just do it. Don't worry too much about gear when you're starting out. You don't necessarily need the most expensive pro level camera to capture the starry sky, the northern lights or even the Milky Way.

As long as you have a camera where you can manually adjust the settings and focus, a fast (wide aperture, low f-number such as f/1.2 - f/3.5) and fairly wide-angle lens and a tripod you're good to go when it comes to try-ing wide-angle astrophotography!

These days we can even capture the stars, the northern lights and even the Milky Way with a newer smartphone. The quality won't be great, of course, but it's definitely possible.

One more piece of advice from Mia is to spend at least as much time looking up and enjoying the view as you do looking through the viewfinder and taking pictures. Chances are your interest in astrophotography comes from a deep-rooted interest in astronomy, so don't let the technicalities of the photography part ruin that childlike excitement we tend to get when looking up at a starry sky.

One question she gets asked all the time is "What settings should I use for the aurora?" and her answer is always the same: it's next to impossible to say. The tricky but wonderful thing about the aurora is the fact that it is ever changing. It can appear in all shapes and sizes, go from barely visible to an explosion of light and colors in mere seconds.

Your settings will depend on many different factors. If you're this far north (Kiruna, Sweden, far north of the arctic circle) where the aurora can appear all across the sky, your settings and your view will be very different from someone farther south, where the aurora mainly appears as a very faint band on the northern horizon. It will also depend on how fast the lights are moving and how bright they are as well as the amount of light pollution in the area you're in.

When it comes to the super bright, rapidly moving outbursts there's always a bit of luck involved. You never know when there will be a massive colorful corona above you. The thing is, to get that lucky you have to already be out there in the night, ready and waiting.

Some nights you'll get nothing at all, some nights there will only be a faint colorless glow, but some nights you will see sights you'd never believe existed unless you were right there seeing it with your own eyes.

Damian Peach

Fig. 22.4. Damian Peach and one of his telescope setups. (Copyright © Damian Peach, used with permission.)

There would be little argument from those in the know that Damian Peach is perhaps the most accomplished lunar and planetary amateur astrophotographer ever. For decades his astropics and the techniques used to obtain them have been cutting edge. What's more, Damian has been passing on his techniques to others through publications and now via astrophotography & astronomy tutorials available online for a very reasonable monthly subscription. This is a highly recommended resource at a low cost that will help you learn from a master astrophotographer. See Chapter 23 for the link.

According to his website, Damian A. Peach FRAS is a British amateur astronomer, astrophotographer, lecturer and author. Best known for his photographs of a wide variety of astronomical objects, his career in the field spans nearly thirty years.

Peach's passion for astronomy first began in 1988 inspired by books in his school library. He joined the British Astronomical Association (BAA) in 1996 and since then has contributed numerous observations to the various observing sections and also written and co-authored many papers in the organization's journal. He was awarded the organization's prestigious Merlin Medal in 2006. The same year he was also given the Association of Lunar and Planetary Observers (ALPO) Walter H. Haas award for his contributions.

Peach has provided astronomical images for magazines and books throughout his career. His images have been featured in *Astronomy* magazine, *Sky & Telescope, Astronomy Now* and *The Sky at Night.* He has also authored articles on astrophotography for these magazines. Peach has also been a co-author on several professional scientific papers on planetary astronomy, especially regarding his research on Mars and Jupiter. He was one of only a few amateur astronomers to have work featured as part of the national Explorers of the Universe exhibition at the Royal Albert Hall in 2007. His work has also appeared at the Edinburgh Science Festival and the Royal Greenwich Observatory.

Peach's work has also been used by NASA and ESA to illustrate what ground-based telescopes can achieve in photographing the planets, and the support they can provide to professional space probe missions.

In 2011 Peach was crowned overall winner of the Royal Greenwich Observatory astrophotographer of the year competition, and was a prize winning finalist in 2012-2018. He also won first place in the National Science Foundation's Comet ISON photo competition for his image of the comet, which was used by the media throughout the world during the comet's close approach to the Sun.

Peach has also appeared on BBC television in the UK. He first appeared on the BBC's All Night Star Party program in 2003, where he imaged Mars live for the program from the Roque de los Muchachos Observatory, La Palma. Following that he made many appearances as a guest on the BBC's Sky at Night astronomy TV program hosted by Sir Patrick Moore. He has also appeared on BBC news and The Discovery Channel. Peach has also conducted many public talks to both amateur and professional organizations over the past 20 years. In 2015 he was made honorary president of Adur Astronomical Society in the UK.

In 2017 he formed part of a small team of observers who used the famous Pic du Midi Observatory 1.06-m telescope to obtain some of the most detailed ever ground-based images of Jupiter and Saturn. The same year asteroid 27632 was re-named Damianpeach by the International Astronomical

Union (IAU) for his contributions to amateur astronomy. In 2018 he was elected to the board of the Aster Academy scientific committee and also awarded the Astronomical Legaue's prestigious Peltier award again for his contributions to astronomy.

What is his advice? He says that astrophotography can be an immensely rewarding pursuit. From the perspective of the beginner (especially in today's world, where seemingly impressive imagery is everywhere) it can seem at first that achieving such results is probably beyond them. However this is certainly not the case.

Over his more than twenty years in the field he has learned that perhaps the greatest quality anyone can have in starting out is patience. Great results rarely come quickly and will require much trial and error. There will be many disappointing moments in the journey, but as you move forward learning and developing knowledge and techniques your results will start to improve.

The learning curve is undeniably a steep one at first. There are such a multitude of cameras, software and techniques to use its hard to know where to start. He says that this book will have helped send you in the right direction. The rest is lots of patience and experimentation. If something isn't working seek advice or change it. There are countless groups available online to help, and one thing you will find is that the astronomical community is comprised of an enormously helpful group of people.

Some areas of astrophotography are certainly far more taxing than others. Photographing the Milky Way with a tripod mounted camera is quite a different task to taking multi-hour telescopic deep sky images or high resolution imagery of the planets. Regardless of what area of astrophotography you focus on the same comments apply. But of course those more complex areas of the field will take considerably more time and effort to master.

Lastly, and perhaps most importantly, remember, this is about enjoyment! It should be fun and rewarding (though at first there will unquestionably be frustration – especially with the weather!). Astrophotography is without a doubt one of the most rewarding aspects of astronomy and photography in general, and with some time, effort and patience you'll start taking imagery that will amaze family and friends – and every now and then even yourself!

Sean Walker, Associate Editor, *Sky & Telescope*

Fig. 22.5. Sean Walker with his setup to photograph the July 2, 2019 total solar eclipse from Sky and Telescope's site in Chile. (Copyright © Sean Walker, used with permission.)

Sean Walker is an accomplished artist in both the photographic and painting realm. He is a master astrophotographer in his own right, but his collaborative work on an ongoing sky survey is perhaps his crowning achievement. From the MDW Hydrogen-Alpha Sky Survey (MDW Survey, for short) website: "an ongoing project to create a deep, high-resolution, H-alpha image of the entire night sky. The project is being undertaken by three New England-based friends and astrophotographers – David Mittelman, Dennis di Cicco, and Sean Walker (MDW) – using a pair of remotely operated telescopes in New Mexico."

In a word the images are stunning, as is the scope of the survey in the annals of amateur astrophotography.

Walker joined the staff of *Sky & Telescope* in 2000 as the Ad Production Coordinator. A graduate of Massachusetts College of Art, he brought extensive experience with digital and photographic prepress techniques, as well as several years of observing and astrophotography.

In his free time, Walker spent countless hours learning computer image processing techniques, as well as perfecting a few of his own. This attracted the attention of the editorial staff, and a few years later he moved over to assistant editor, specializing in astrophotography and new-product coverage.

Rather than concentrating on one imaging discipline, Walker pursues a multitude of imaging projects, from deep exposures of faint galaxies to capturing high-resolution records of the Sun, Moon, and planets with an ever-changing arsenal of cameras and telescopes. A self-described "gear head," he is constantly testing out or trading astronomy equipment.

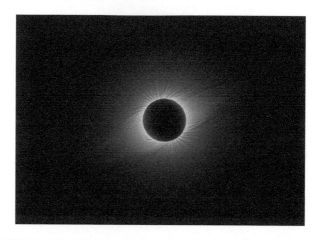

Fig. 22.6. Walker used multiple images he took of the Chilean total solar eclipse to get this final composite image. (Copyright © Sean Walker, used with permission.)

So what's his advice? "Astrophotography is a way to see more in the night sky than is possible with just your eye and a telescope. It's surprising how easy it is to, say, take a sharp photo of the Moon, or star trails over a beautiful landscape. Once you start, it's easy to get hooked!"

Johnny Horne, Contributing Editor, *Sky & Telescope*

Fig. 22.7. Johnny Horne in his observatory. (Copyright © Johnny Horne, used with permission.)

Johnny Horne has been a master astrophotographer for decades. He is quite the gentleman and personifies how one can work in the sky in addition to having a full-time career.

Fig. 22.8. Horne getting his long lens set up and ready to photograph the February 1998 total solar eclipse aboard *Statendam*. (Image by the author.)

Horne retired in April 2016 after 44 years of working as a staff photographer and photo editor for North Carolina's oldest newspaper *The Fayetteville Observer*.

An amateur astronomer since age 10, Horne is a contributing editor for *Sky & Telescope* magazine and has written astrophotography product reviews for the magazine since 1987. He has served on the technical support staff for Sky & Telescope astronomical expeditions to Mexico, Africa, the Caribbean and Iceland.

He photographed Halley's Comet from the Australian Outback in 1986, and his astronomical photographs have appeared in magazines and newspapers worldwide. He makes most of his astronomical images from a backyard observatory he built in 1978 and still uses today.

Since 1989 Horne has written the monthly amateur astronomy column "Backyard Universe" for *The Fayetteville Observer.* He has traveled to five total solar eclipses, most recently to Salem, Oregon, for the August 21, 2017, eclipse.

In 2004 the International Astronomical Union named asteroid 11132Horne in Johnny Horne's honor for his years of public outreach in astronomy. Horne lives in Stedman, NC, with his wife Ann. They have two sons, Adam and Stephen.

His advice? Beginners looking to get into astrophotography today have several advantages over their predecessors two decades ago. Modern DSLR and mirrorless cameras are much better suited to astrophotography right out of the box than the best film cameras. As with conventional digital photography the ability to see the picture immediately after shooting it is transformational.

Exposure, focus and overall image quality can be evaluated on the fly, and appropriate adjustments can be made before the next exposure is made.

Film astrophotography was frustrating, since all film suffered from a condition called reciprocity failure. The problem is that film's response to low levels of light gets less efficient with long exposures. An astrophotographer using film and wishing to double the effective exposure of say a one-minute exposure wouldn't just make a two-minute shot. It would be more likely that the exposure doubling would require a 3 or 4 minute time exposure due to the film's slow response during long exposures. All film suffers from this to a greater or lesser degree. Astrophotographers can decrease the reciprocity effect somewhat by chilling film to subzero temperatures or treating it before exposure in a process called gas hypersensitization.

Even given hypersensitization methods, you would still have to process the film before our astrophoto could be evaluated. This was time consuming and almost always had to be done well after the astrophoto session.

So, he says, if you're worried that you might have to purchase a specialized camera to even begin to take stunning astrophotos, you should realize that you probably already have that camera in your bag. A modern digital camera with interchangeable lenses is the perfect camera to get started.

Using a modern tripod-mounted DSLR camera and inexpensive kit lenses it's possible to record stars much fainter than can be seen with the unaided eye, using exposures as brief as 10 seconds. Longer exposures made with the camera attached to a telescope on a tracking mount can record dramatic colors in nebulae and intricate details in spiral galaxies, even if those features are invisible to a human eye gazing through the same telescope.

Perhaps the most special thing about astrophotos is that they are a look back in time. Nowhere else can your point your camera and record "old light."

Depending on your night sky target, the light you are recording has traveled great distances before being saved as digital files on your memory cards.

A shot of the Moon captures light a little over a second old, while stars and star clusters can send us light from many hundreds of years back in time. Photograph a distant galaxy and you're looking at light millions of years old, long before there was photography or even people to shoot photographs.

Digital photography and modern cameras and lenses have made astrophotography accessible to almost everyone who would like to capture their own piece of the Universe.

Fig. 22.9. Andromeda Galaxy. (Copyright © Johnny Horne, used with permission.)

Final Thoughts

We have come to the point where the book ends and your astrophotography adventure begins. It is fervently hoped that this book has provided you with the information and the inspiration to become an astrophotographer. No one book can cover everything astrophotography wise, but you should feel confident in having the basic information needed to go forth into the night with your camera to collect photons.

Good luck!

Camera & Mode: D810a w/ 35-mm f/1.4 lens on tripod. Camera only.
ISO: 3200
Exposure: 13 seconds
Processing: Mac Photos

Fig. 22.10. Black and white pix of the southern Milky Way in Chile. Local light pollution caused a brownish sky background, but the black and white brings out the beauty of the astropic. (Image by the author.)

Chapter 23

Suggested Reading and Internet Links

The following material is broken down by chapter and by type of source material (longer reads or Internet resources) to better help you navigate the topics covered in this book. Happy reading!

Chapter 1: Introduction

Suggested Reading

General Springer Astronomy books: https://www.springer.com/gp/astronomy
Practical Astrophotography
The Patrick Moore Practical Astronomy Series
Charles, Jeffrey R.
2000

Springer
Budget Astrophotography: Imaging with Your DSLR or Webcam
The Patrick Moore Practical Astronomy Series
Jensen, Timothy J.
2015

Electronic Supplementary Material: The online version of this chapter (https://doi.org/10.1007/978-3-030-45943-7_23) contains supplementary material, which is available to authorized users.

G. I. Redfern, *Astrophotography is Easy!*, The Patrick Moore Practical Astronomy Series, https://doi.org/10.1007/978-3-030-45943-7_23

Springer

Catchers of the Light: A History of Astrophotography
Stefan Hughes
2015
Self-Published (http://www.catchersofthelight.com)

Internet Links

Astrophotography
These links will give you more background on what comprises astrophotography and how you can get started.

> https://www.skyandtelescope.com/astrophotography-guide-free-ebook/

> Astrophotography by Jerry Lodriguss: http://www.astropix.com/index.html

> https://imaging.nikon.com/lineup/microsite/astrophotography/getstarted/beginer/index.html

> https://imaging.nikon.com/lineup/microsite/astrophotography/getstarted/various/index.html

History of Astrophotography
This is the complete Wikipedia entry.

> https://en.wikipedia.org/wiki/Astrophotography

Digital vs. Analogue
This explains in greater depth the difference between the two.

> https://cpn.canon-europe.com/content/education/infobank/introduction_to_digital_photography/differences_between_analogue_and_digital.do

Chapter 2: Cameras

Suggested Reading

Video Astronomy on the Go: Using Video Cameras with Small Telescopes
The Patrick Moore Practical Astronomy Series

Ashley, Joseph
2017
Springer

Internet Links

International Organization for Standardization (ISO)
The more you know ISO, the better you can make it work for you in taking your astropics.

https://www.digitaltrends.com/photography/what-is-iso/

https://www.skyandtelescope.com/astronomy-blogs/imaging-foundations-richard-wright/astrophotography-understanding-iso/?k=X2eLNeXTAu0

Smartphones and Tablets
Learn about the apps that help turn your device into a small astronomical camera. Also see the current lineup of the "best" device. This changes with each new model release.

http://www.nightcapcamera.com/nightcap-camera/

https://itunes.apple.com/us/app/nightcap-camera/id754105884?mt=8

https://www.camerafv5.com

https://opencamera.sourceforge.io

https://www.digitalcameraworld.com/buying-guides/best-camera-phone

Film Cameras
Learn more about the role of film cameras and films currently available. These cameras are not really recommended for astrophotography but you may be interested in them.

https://www.bhphotovideo.com/c/browse/Film-Cameras/ci/9812/N/4288586278

http://time.com/4649032/film-photography-cameras/

https://www.explainthatstuff.com/how-film-cameras-work.html

https://www.lomography.com/magazine/316773-five-films-for-low-light-conditions

Memory Cards

If you go digital, you need to know about memory cards. No card, no astropic.

https://www.popsci.com/memory-cards-explained

https://www.bhphotovideo.com/explora/computers/tips-and-solutions/numbers-your-memory-card

DSLRs

Full Frame Sensor (FX) vs Cropped Sensor (DX). Confused or curious about the difference in sensor size? These links will get you up to speed.

https://www.bhphotovideo.com/explora/photography/features/dx-vs-fx-its-not-debate-its-choice

http://geartacular.com/how-to-guide-astrophotography-with-dslr/

https://www.nikonusa.com/en/learn-and-explore/a/products-and-innovation/the-dx-and-fx-formats.html

Mirrorless Cameras

Mirrorless or CSCs are here to stay, so learn a bit more about them if you are considering a digital camera.

https://www.adorama.com/alc/faq-what-is-a-mirrorless-camera

https://www.bhphotovideo.com/explora/photography/buying-guide/mirrorless-cameras

Canon EOS Ra Astrophotography Dedicated Mirrorless Camera

A great review on Canon's newest digital astrophotography camera.

https://www.skyandtelescope.com/astronomy-equipment/first-look-canons-eos-ra-mirrorless-camera/?fbclid=IwAR09ZPT8h_if-ElTiUKuhvfaL949LjMOy8-Oz_kXA9MjCOoZyLjqAj2t4Kk

Astrophotography Basics

More basic info on DSLRs and their use for astrophotography. Also some DSLR recommendations to ponder and consider.

https://imaging.nikon.com/lineup/dslr/basics/

https://imaging.nikon.com/lineup/microsite/astrophotography/getstarted/camera/index.html

https://skiesandscopes.com/best-camera-for-astrophotography/

Video Astronomy

Get the scoop on going vid for astrophotography from some very good sources.

https://www.mallincam.net/what-is-video-astronomy.html

https://www.skyandtelescope.com/astronomy-resources/observing-with-astrovideo-cameras/

https://astronomytechnologytoday.com/tag/astro-video-camera/

Mirrorless vs. DSLR

More on the debate and a comparison between the two.

https://www.digitalcameraworld.com/features/dslr-vs-mirrorless-cameras-how-do-they-compare

CCD/CMOS Manufacturers

If you are considering going this route, you need to read these links.

http://diffractionlimited.com

https://www.atik-cameras.com

CCD vs. CMOS

If you are considering going this route, you need to read these links.

https://www.atik-cameras.com/news/difference-between-ccd-cmos-sensors/

https://www.skyandtelescope.com/astronomy-blogs/imaging-foundations-richard-wright/ccds-cmos-and-the-future-of-astrophotography/?fbclid=IwAR04YAzTgYgNFQe7HIc7Z-jKEL65z9xbhovhKfiMhXNyo-JsF0M-aTqmR57M

Agena Buyer's Guide to ZWO Astronomy Cameras
By: Brian Ventrudo and Manish Panjwani February 23, 2018
GREAT info on ZWO and the ASI 120 from trusted sources

https://agenaastro.com/articles/zwo-astronomy-cameras-buyers-guide.html

http://astronomy-imaging-camera.com/wp-content/uploads/ASI120-cameras-SkyTelescope2014.pdf

http://astronomy-imaging-camera.com/wp-content/uploads/ASI120-cameras-AstronomyNow2013.pdf

Color vs. Monochrome
Which will it be? This link should help you decide.

https://www.skyandtelescope.com/astronomy-blogs/imaging-foundations-richard-wright/astrophotography-monochrome/

Matching Camera to Optics
A good primer on the subject.

http://diffractionlimited.com/matching-camera-optics/

FOV
A good primer on the subject.

https://www.skyandtelescope.com/astronomy-blogs/imaging-foundations-richard-wright/understanding-field-of-view-pixel-scale/

Pixels
A good primer on the subject.

https://www.cambridgeincolour.com/tutorials/camera-sensors.htm

Modified DSLRs for Astrophotography
If you are considering this as your astrocamera, you want to read these links for valuable info to help you decide.

https://www.skyandtelescope.com/astronomy-blogs/imaging-foundations-richard-wright/modifying-your-dslr-astrophotography/?k=X2eLNeXTAu0pdXJ%2B6SJFkgjffbPJdBb2myBdgtfo4Cg%3D&utm_medium=email&utm_source=newsletter&utm_campaign=sky-mya-nl%0D&cid=DM128790&bid=1249808693

https://www.skyandtelescope.com/astronomy-resources/astrophotography-tips/shooting-with-modified-dslr-cameras/

https://www.astroshop.eu/astrophotography/cameras/astromodified-dslrs/15_35_10_20

https://www.spencerscamera.com/astro-conversions.cfm

http://imaginginfinity.com/dslrmods.html

https://www.lifepixel.com/shop/our-services/h-alpha-camera-conversion/nikon-dslr-h-alpha-camera-conversion?fbclid=IwAR3TUxqucBV9
5v54JcrGJYoyqwldIfZTcrszm_u68LG5BAsvsa9remSOxAY

CCD vs. DSLR
On the fence as to which way to go? Maybe this will help you decide.

https://starizona.com/tutorial/ccd-vs-dslr-astrophotography/

Chapter 3: Lenses

Internet Links

Lens Basics and Astrophotography
Learn more about glass.

https://imaging.nikon.com/lineup/microsite/astrophotography/getstarted/lens/index.html

https://digital-photography-school.com/lenses-101-introduction-camera-lenses/

Cleaning Lenses
Easy does it on the glass. Follow the lens' user manual first, but this should help round out the subject.

https://photographylife.com/how-to-clean-slr-camera-lenses

https://www.bhphotovideo.com/explora/photography/tips-and-solutions/how-to-clean-your-lens-and-filters

Focal Length

A good primer on the subject.

https://www.nikonusa.com/en/learn-and-explore/a/tips-and-techniques/understanding-focal-length.html

Field of View (FOV)

A good primer on the subject.

https://www.photographytalk.com/beginner-photography-tips/7204-focal-length-and-field-of-view-explained-in-4-steps

f Number

A good primer on the subject.

https://imaging.nikon.com/lineup/dslr/basics/19/02.htm

Lens Aperture and f/Stops

A good primer on the subject.

https://www.nikonusa.com/en/learn-and-explore/a/tips-and-techniques/understanding-maximum-aperture.html

Telephoto Lenses

A good primer on the subject.

https://www.howtogeek.com/309838/what-is-a-telephoto-lens/

Infinity Focus

A good primer on the subject.

https://www.bhphotovideo.com/explora/photography/features/who-killed-infinity-focus%3F

Setting Exposure: Rule of 500

More info on the rule.

https://expertphotography.com/500-rule-night-sky-photography/

https://www.scantips.com/lights/stars.html

Chapter 4: Telescopes

Suggested Reading

Using Sequence Generator Pro and Friends: Imaging with SGP, PHD2, and Related Software
The Patrick Moore Practical Astronomy Series
McConahay, Alex
2019
Springer

Internet Links

Choosing a Telescope
Good background to help you decide if you want a 'scope and what kind to pick.

https://www.skyandtelescope.com/astronomy-equipment/how-to-choose-a-telescope/

https://imaging.nikon.com/lineup/microsite/astrophotography/getstarted/challenge/index.html

Optical Terms & Characteristics of a 'Scope
A good primer on the subject.

http://www.united-optics.com/shownew2.asp?hqId=13

Seeing and Transparency
A good primer on the subject.

https://www.skyandtelescope.com/astronomy-equipment/beating-the-seeing/

http://www.damianpeach.com/seeing1.htm

https://www.astroleague.org/content/seeing-and-transparency-guide

Clear Sky Chart

A very useful resource for determining the weather at your location for astronomical observations and astrophotography.

http://www.cleardarksky.com/csk/

Limiting Magnitude

A good primer on the subject.

https://www.astronomics.com/info-library/astronomical-terms/limiting-magnitude/

Telescope Types

A good primer on the subject.

https://www.skyandtelescope.com/astronomy-equipment/types-of-telescopes/

Refractors

A good primer on the subject.

https://lco.global/spacebook/telescopes/refracting-telescopes/

Other Reflector Designs

A good primer on the subject.

https://starizona.com/blogs/tutorials/imaging-with-other-telescope-designs

Remote Telescopes

A good primer on the subject.

https://www.skyatnightmagazine.com/advice/skills/how-use-remote-telescope-astrophotography/

Smart Telescopes

A good primer on the subject.

https://www.digitalcameraworld.com/reviews/vaonis-stellina-smart-telescope-review

https://www.space.com/stellina-smart-telescope-review.html

https://www.space.com/40533-hiuni-smart-telescope-kickstarter.html

Star Testing a Telescope
A good primer on the subject.

https://starizona.com/tutorial/star-testing-telescope-optics/

Collimation
Gotta be collimated for good astropics.

https://garyseronik.com/no-tools-telescope-collimation/

Tube Currents and Mirror Cool Down
A good primer on the subject.

https://garyseronik.com/beat-the-heat-conquering-newtonian-reflector-thermals-part-1/

Chapter 5: Imaging Methods with Your Telescope

Internet Links

Imaging Methods at the Telescope
A good primer on the subject.

http://www.televue.com/engine/TV3b_page.asp?id=85

Eyepiece Projection Calculator
A good primer on the subject.

https://starizona.com/blogs/tutorials/eyepiece-projection-calculator

Afocal
A good primer on the subject.

https://www.skyandtelescope.com/astronomy-equipment/new-products/nexyz-celestrons-new-smartphone-adapter/

Chapter 6: Mountings

Suggested Reading

Astrophotography on the Go: Using Short Exposures with Light Mounts
The Patrick Moore Practical Astronomy Series
Ashley, Joseph
2015
Springer

Internet Links

Tripods
Low-down on tripods.

https://www.bhphotovideo.com/explora/photography/buying-guide/the-tripod-explained

https://photographylife.com/how-to-use-a-tripod

Camera Star Tracking Mounts
A good primer on the subject.

https://www.omegon.eu/camera-mounts/omegon-mount-mini-track-lx2/p,55040

https://improvephotography.com/50390/using-tracking-mount-landscape-astrophotography/

Types of Telescope Mounts
A good primer on the subject.

https://www.texasastro.org/mounts.php

Polar Alignment
If you want to use your GOTO, you need to read all of these links.

https://starizona.com/blogs/tutorials/polar-alignment

http://www.sharpcap.co.uk/sharpcap/features/polar-alignment

Drift Method

https://www.skyandtelescope.com/astronomy-resources/accurate-polar-alignment/

Daytime Polar Alignment

https://www.skyandtelescope.com/observing/daylight-polar-alignment/

Polemaster

https://www.qhyccd.com/index.php?m=content&c=index&a=show&catid=136&id=32&cut=2

Field Rotation

Explains the issue that occurs with Alt/Az mounts during lone exposures.

https://calgary.rasc.ca/field_rotation.htm

Periodic Error

Every mount has it, so learn some more about it.

https://www.celestron.com/blogs/knowledgebase/what-is-periodic-error-pe-and-how-do-i-correct-it

Guiding

Odds are you will eventually get to the point of guiding for long exposures, so this is worth a read.

https://www.skyandtelescope.com/astronomy-resources/guiding-a-telescope-for-imaging/

Chapter 7: Software and Other Needed Accessories

Suggested Reading

Observer's Handbook
You have to have it for a year at a glance of what's happening in the sky.
https://www.rasc.ca/handbook

Star Chart
Never leave home without it.
https://www.shopatsky.com/pocket-sky-atlas

Internet Links

Astronomy Software
A sample of what's out there software-wise.

http://astronomyonline.org/astronomysoftware.asp

Eyepiece Selection
Gotta have 'em if you have a 'scope.

https://agenaastro.com/choosing-eyepieces-for-your-telescope.html

Dew Shields
Good to have one so read up on them.

https://www.skyandtelescope.com/astronomy-resources/
dealing-with-dew/

ZWO ASIAIR
More on ZWO.

https://www.youtube.com/watch?v=yqh-bu-Sws

https://astronomy-imaging-camera.com/asiair/asiair-changing-the-face-
of-astrophotography.html?fbclid=IwAR32v3jnld8yq8TYLbmtYuHa
Swd-o_ifOVEA9AOJ4-8aIpJrElBsIaq162k

https://www.highpointscientific.com/zwo-asiair-review

Chapter 8: Astrophotography Rules to Live By

No Resources.

Chapter 9: Getting Acquainted With the Sky

Suggested Reading

Stargazing Under Suburban Skies: A Star-Hopper's Guide
The Patrick Moore Practical Astronomy Series
Zack, Malcolm; Gannon, Andrew M.; McRoberts, John
2018
Springer

The Backyard Astronomer's Field Guide: How to Find the Best Objects the Night Sky has to Offer
Dickinson, David
2020
Page Street Publishing

Internet Links

Night Sky Network
Useful resource to find astro clubs and astro events nationwide.

https://nightsky.jpl.nasa.gov/clubs-and-events.cfm

https://twitter.com/nightskynetwork

Twilight Definitions
The source on the subject.

https://www.weather.gov/fsd/twilight

Stellar Magnitude
Good resources on the subject.

http://earthsky.org/astronomy-essentials/what-is-stellar-magnitude

http://www.skyandtelescope.com/astronomy-resources/the-stellar-magnitude-system/

http://www.skyandtelescope.com/astronomy-resources/how-many-stars-night-sky-09172014/

Star Colors

Good resources on the subject.

https://www.universetoday.com/24640/color-of-stars/

http://www.atnf.csiro.au/outreach/education/senior/astrophysics/photometry_colour.html

Zodiac

A good primer on the subject.
https://earthsky.org/astronomy-essentials/what-is-the-zodiac

Ecliptic

A good primer on the subject.
https://earthsky.org/space/what-is-the-ecliptic

Star Charts

A good primer on the subject.

http://www.astronomy.com/observing/get-to-know-the-night-sky/2010/10/how-to-use-a-star-chart

Constellations

The official reference on constellations and a discussion of Northern and Southern hemisphere constellations

https://www.iau.org/public/themes/constellations/

http://www.astro4dev.org/blog/2017/03/20/north-vs-south-constellations-moon-phases/

Southern Sky

More on the sky down under.

https://www.skyandtelescope.com/observing/beginners-guide-to-the-southern-hemisphere-sky/

https://www.space.com/40478-stargazing-south-of-the-equator.html

The Milky Way

A good primer on the subject.

https://www.skyandtelescope.com/observing/welcome-back-milky-way/
?k=X2eLNeXTAu0pdXJ%2B6SJFkgjffbPJdBb2myBdgtfo4Cg%3D&
utm_medium=email&utm_source=newsletter&utm_campaign=sky-
mya-nl%0D&cid=DM125348&bid=1220097930

Double Quasar 0957+561

Billions of light years from Earth—good and awe-inspiring read.

https://pages.astronomy.ua.edu/keel/agn/q0957.html

https://www.nasa.gov/content/hubbles-double-take

Celestial Sphere: Seasons

Good resources on the subject.

https://www.rmg.co.uk/discover/explore/prime-meridian-greenwich

http://astronomy.swin.edu.au/cosmos/L/Local+Noon

https://www.space.com/10821-night-sky-changing-seasons.html

http://earthsky.org/tonight/moon-near-celestial-equator-april-26?utm_
source=EarthSky+News&utm_campaign=bd3dc53a45-EMAIL_
CAMPAIGN_2018_02_02&utm_medium=email&utm_
term=0_c643945d79-bd3dc53a45-394691157

https://spaceplace.nasa.gov/seasons/en/

http://astronomy.swin.edu.au/cosmos/S/Seasons

http://stars.astro.illinois.edu/celsph.html

http://www.physics.csbsju.edu/astro/CS/CS.16.html

Daytime Planet Viewing

A good primer on the subject.

https://www.universetoday.com/147457/astro-challenge-adventures-
in-daytime-astronomy/

Chapter 10: Location Matters

Internet Links

Telescope Mobile Platforms
Makes moving your telescope setup easy.

http://www.jimsmobile.com/buy_wheeley_bars.htm

http://www.scopebuggy.com/Gen3/UntitledH.html

Astro-tents
Temporary "observatory" for home or in-the-field use.

https://www.astroshop.eu/instruments/omegon-tent-observatory/p.12278#tab_bar_1_select

http://store.smartastronomy.com/poobte.html

USGS Topographic Maps
Primary reference on the subject.

https://ngmdb.usgs.gov/topoview/

Dark Skies Finder
Check out the light pollution conditions at your location(s).

https://darksitefinder.com

https://www.darksky.org/our-work/conservation/idsp/

https://www.lightpollutionmap.info/#zoom=4&lat=5759860&lon=1619364&layers=B0FFFFFTFFFFF

National Park Service
Primary reference on the subject.

https://www.nps.gov/findapark/index.htm

National Park Service Night Sky Events
Primary reference on the subject.

https://www.nps.gov/subjects/nightskies/events.htm

Chapter 11: It's Astrophotography Time!

Internet Links

A good tutorial on basic imaging.

https://starizona.com/blogs/tutorials/tagged/imaging-basics

Chapter 12: The Sun and More

Suggested Reading

How to Observe the Sun Safely
The Patrick Moore Practical Astronomy Series
Macdonald, Lee
2003
Springer

Internet Links

Solar Viewing
Note: use the advice for partial eclipse phases for solar viewing and solar photography.

https://www.skyandtelescope.com/astronomy-news/observing-news/how-to-look-at-the-sun/

https://eclipse.aas.org/eye-safety

https://eclipse.aas.org/eye-safety/eyewear-viewers

Certified Solar Glasses And Solar Filters
Primary reference on the subject.

https://eclipse.aas.org/resources/solar-filters

https://eclipse.aas.org/eye-safety/optics-filters

https://eclipse.aas.org/resources/telescopes-binoculars

How to Photograph The Sun
Additional information on photographing the Sun.

https://www.bhphotovideo.com/explora/photography/tips-and-solutions/how-photograph-sun

How to Shoot Solar Eclipse Images & Videos
Primary reference on the subject. Note: use the references for partial solar eclipse phase. Be sure to read all of the "More Articles About Solar-Eclipse Imaging & Video."

https://eclipse.aas.org/imaging-video/images-videos

Smartphones are not recommended for Camera Only solar photography. This information is provided for safety purposes only. Note: use the advice for partial eclipse phases.

https://eclipse.aas.org/imaging-video/images-videos

https://eclipse2017.nasa.gov/smartphone-photography-eclipse

Solar Features in White Light
A good reference on the Sun's features in white light.

https://www.skyandtelescope.com/observing/celestial-objects-to-watch/sun/sun-white-light-guide-nearest-star/

Solar Features in Hydrogen Alpha Light
A good reference on the Sun's features in Hydrogen Alpha light.

https://www.skyandtelescope.com/observing/guide-to-observing-the-sun-in-h-alpha092321050923/

Daystar
A trusted source for solar observing equipment.

http://www.daystarfilters.com

Lunt Solar Systems
A trusted source for solar observing equipment.

https://luntsolarsystems.com

Coronado Personal Solar Telescope (P.S.T.)
A trusted source for solar observing equipment.

https://www.meade.com/coronado-personal-solar-telescope-pst.html

Mercury Transits
The source for info on Mercury transits.

http://www.eclipsewise.com/oh/tm2019.html

The Sun
Primary reference on our star.

https://www.nasa.gov/sun

Sunrise & Sunsets
Basic imaging information.

https://www.nikonusa.com/en/learn-and-explore/a/tips-and-techniques/
best-tips-for-sunrise-and-sunset-photos.html

Chapter 13: The Moon

Suggested Reading

The Telescopic Tourist's Guide to the Moon
The Patrick Moore Practical Astronomy Series
May, Andrew
2017
Springer

Mirror-Image or Field Map of the Moon
Illustrated by Antonín Rükl
https://www.shopatsky.com/field-map-of-the-moon

21st Century Atlas of the Moon
Wood, Charles A.; Collins, Maurice J.S. Charles
2012
West Virginia University Press

Internet Links

General Guides on the Moon

http://www.astronomy.com/rapid/2014/01/your-guide-to-the-moon

https://www.skyandtelescope.com/astronomy-blogs/imaging-founda-tions-richard-wright/shoot-moon-astrophotography/?k=X2eLNeXTAu0 pdXJ%2B6SJFkgjffbPJdBb2myBdgtfo4Cg%3D&utm_medium=email&utm_source=newsletter&utm_campaign=sky-mya-nl-190419%0D&cid=DM115322&bid=1128108541

https://www.skyandtelescope.com/observing/take-a-moon-walk-tonight/?fbclid=IwAR1nsWqDCnHODdGseps1f4I3pCxt_a3tdNsz_TJaKCxIwPJ-6MCQqzrtYeU

Earthshine
Primary reference on Earthshine.

https://science.nasa.gov/science-news/science-at-nasa/2005/04oct_leonardo

Lunar Occultations
Primary references on lunar occultations.

http://www.lunar-occultations.com/iota/Graze.htm

https://www.skyandtelescope.com/astronomy-blogs/my-first-grazing-occultation/

Conjunctions
Good reference on the subject.

https://earthsky.org/astronomy-essentials/what-is-a-conjunction

Chapter 14: Eclipses

Suggested Reading

Sky & Telescope's Free Eclipse Photography eBook

2017
Sky and Telescope
A *very* useful resource, and it is free.
https://www.skyandtelescope.com/eclipse-photography-free-ebook/

Totality – Eclipses of the Sun (Third Edition)
Littmann, Mark; Willcox, Ken; Espenak, Fred
2009
Oxford University Press

Total Solar Eclipses and How to Observe Them
Astronomers' Observing Guides
Mobberley, Martin
2007
Springer

Internet Links

Solar Eclipse Safety and Solar Eclipse Photography
Very comprehensive and mandatory reading.

https://eclipse.aas.org/eye-safety

https://eclipse2017.nasa.gov/safety

https://www.nasa.gov/content/eye-safety-during-a-total-solar-eclipse

http://www.mreclipse.com/Totality2/TotalityCh11.html

https://eclipse.aas.org/eye-safety/eyewear-viewers

Pinhole Projection

https://eclipse.aas.org/eye-safety/projection

Certified Solar Glasses and Solar Filters

https://eclipse.aas.org/resources/solar-filters

https://eclipse.aas.org/eye-safety/optics-filters

https://eclipse.aas.org/resources/telescopes-binoculars

How to Shoot Solar Eclipse Images & Videos
Be sure to read all of the "More Articles About Solar-Eclipse Imaging & Video."

https://eclipse.aas.org/imaging-video/images-videos

https://www.nikonusa.com/en/learn-and-explore/a/tips-and-techniques/how-to-photograph-a-solar-eclipse.html

https://eclipse.aas.org/imaging-video/images-videos

Smartphone

https://eclipse2017.nasa.gov/smartphone-photography-eclipse

Solar Eclipses
Excellent references on solar eclipses.

https://eclipse.gsfc.nasa.gov/solar.html

http://www.mreclipse.com/main/preview.html

http://www.mreclipse.com

https://www.nasa.gov/audience/forstudents/k-4/stories/annular-eclipse

https://solarscience.msfc.nasa.gov/chromos.shtml

https://solarscience.msfc.nasa.gov/surface.shtml

https://www.nasa.gov/content/goddard/what-is-a-solar-prominence

https://www.skyandtelescope.com/2017-total-solar-eclipse/eclipse-photography-checklist/

Diamond Ring and Baily's Beads
Good information on these events.

http://www.alpo-astronomy.org/eclipse/observeeclipses/chapter9.htm

Lunar Eclipses
References for these wonderful events.

https://www.skyandtelescope.com/observing/celestial-objects-to-watch/observing-and-photographing-lunar-eclipses/

https://eclipse.gsfc.nasa.gov/lunar.html

https://spaceweatherarchive.com/2018/05/24/lunar-eclipses-and-climate-change/

Chapter 15: Stars and Planets

Suggested Reading

Viewing and Imaging the Solar System: A Guide for Amateur Astronomers
The Patrick Moore Practical Astronomy Series
Clark, Jane
2015
Springer

The World At Night: Spectacular Photographs of the Night Sky
Tafreshi, Babak
2019
White Lion Publishing

NightScapes (ebook)
Dyer, Alan
2018
Amazing Sky Publishing
http://www.amazingsky.com/nightscapesbook.html

Internet Links

Turning Older iPhones into an Astrocamera

https://www.nightcapcamera.com/nightcap-camera/

Constellations
Learn about the 88 official constellations.

https://www.iau.org/public/themes/constellations/

Asterisms
Learn about famous shapes in the stars.

https://www.constellation-guide.com/category/asterism/

Stars
Star names.

https://www.naic.edu/~gibson/starnames/

Names of the brighter stars by constellation.

https://www.naic.edu/~gibson/starnames/starnames.html

Read about some of the more famous stars.

https://www.nasa.gov/mission_pages/chandra/images/alpha-centauri-a-triple-star-system-about-4-light-years-from-earth.html

https://earthsky.org/space/proxima-centauri-our-suns-nearest-neighbor

https://www.skyandtelescope.com/observing/sirius-b-a-new-pup-in-my-life/

https://www.skyandtelescope.com/observing/a-real-scorcher-sirius-at-heliacal-rising/

https://earthsky.org/brightest-stars/albireo-finest-double-star?utm_source=EarthSky+News&utm_campaign=c73b5b2a48-EMAIL_CAMPAIGN_2018_02_02_COPY_01&utm_medium=email&utm_term=0_c643945d79-c73b5b2a48-394691157

Nightscape Astrophotography
More information on taking nightscapes.

https://www.skyandtelescope.com/astronomy-resources/astrophotography-tips/tips-for-shooting-great-nightscapes/

Star Trails
You will love taking star trail astropics.

https://www.skyandtelescope.com/astronomy-blogs/imaging-foundations-richard-wright/shooting-star-trails-astrophotography/?fbclid=IwAR3TBqIqyGLa9mMwIAQzv-UshGhPLEEWzeASEjAKY0R5ZKJIITHzNeC7UGg

RGB Filter Planetary Imaging
Basics on how to do this type of astro-imaging.

https://www.astronomycameras.com/data/editorials/20080320/assets/rgb_planetary_imaging_with_a_monochrome_camera.pdf

http://www.astronomy.com/magazine/ask-astro/2017/02/the-l-in-lrgb-filters

Color Camera Planetary Imaging
Basics on color planetary imaging.

https://www.skyandtelescope.com/astronomy-resources/astrophotography-tips/redeeming-color-planetary-cameras/

Venus
Tips on how to observe Venus using filters.

https://www.skyandtelescope.com/observing/venus-peeps-back-at-dusk/

Daytime Observing
Safe daytime viewing tips.

https://www.space.com/9269-skywatching-tips-observing-venus-staring-sun.html

Pluto
Finding elusive Pluto.

https://www.skyandtelescope.com/observing/lets-find-pluto/

https://earthsky.org/astronomy-essentials/how-to-see-pluto-in-the-night-sky

Chapter 16: International Space Station and Satellites

Internet Links

ISS
Good info to know about ISS and satellites.

https://www.nasa.gov/mission_pages/station/overview/index.html

https://spotthestation.nasa.gov

https://www.heavens-above.com

http://www.skyandtelescope.com/observing/all-night-vigil-with-the-international-space-station/?k=X2eLNeXTAu0pdXJ%2B6SJFkgjffbPJd

B b 2 m y B d g t f o 4 C g % 3 D & u t m m e d i u m = e m a i l & u t m source=newsletter&utm_campaign=sky-jma-nl-180525

Satellites

http://www.skyandtelescope.com/observing/satellites/

http://www.skyandtelescope.com/observing/celestial-objects-to-watch/observing-iridium-flares/

https://www.nightcapcamera.com/nightcap-camera/

Chapter 17: Asteroids, Comets, Meteors, Fireballs, Bolides, Meteor Showers

Suggested Reading

Hunting and Imaging Comets
The Patrick Moore Practical Astronomy Series, Series
Mobberley, Martin
2011
Springer

Internet Links

More info on photographing meteors.

https://www.nikonusa.com/en/learn-and-explore/a/tips-and-techniques/photographing-meteors-fireballs-and-meteor-showers.html?cid=img_en_us:EML:LE:na:061019:eml:P:LE-June10-email:NIghtSkyTips:Meteors:article&ET_CID=2851612&ET_RID=326545324&SC_ID=0032400000mJi8UAAS

h t t p s : / / w w w . a m s m e t e o r s . o r g / m e t e o r - s h o w e r s / how-to-photograph-meteors-with-a-dslr/

https://www.nightcapcamera.com/nightcap-camera/
Meet Spooky.

https://www.huffpost.com/entry/skull-asteroid-death-comet-halloween_n_5bac637be4b082030e782564

Chapter 18: Aurorae and Glows in the Sky

Suggested Reading

Aurora: Observing and Recording Nature's Spectacular Light Show
The Patrick Moore Practical Astronomy Series
Bone, Neil
2007
Springer

Internet Links

The references on Aurorae and their forecast.
https://www.swpc.noaa.gov
https://www.swpc.noaa.gov/products/aurora-30-minute-forecast

Photographing Aurorae

http://www.aurora-service.net/aurora-school/how-to-photograph-the-aurora/

Mia Stålnacke http://photographingspace.com/how-to-shoot-aurora/?ref=2

STEVE

https://solarsystem.nasa.gov/news/355/the-aurora-named-steve/

Airglow

https://www.universetoday.com/112237/how-to-see-airglow-the-green-sheen-of-night/

Noctilucent Clouds

http://earthsky.org/earth/night-shining-clouds-noctilucent-clouds-how-they-form-how-to-see-them

Zodiacal Light

http://earthsky.org/astronomy-essentials/everything-you-need-to-know-zodiacal-light-or-false-dusk

http://earthsky.org/space/what-is-the-ecliptic

Zodiacal Band

https://www.atoptics.co.uk/highsky/zodim3.htm

Gegenschein

http://www.skyandtelescope.com/observing/take-the-gegenschein-challenge101420151410/

Chapter 19: The Milky Way

Suggested Reading

Astronomy of the Milky Way: The Observer's Guide to the Southern Sky (Second Edition)
The Patrick Moore Practical Astronomy Series
Inglis, Mike
2018
Springer

Astronomy of the Milky Way: The Observer's Guide to the Northern Sky (Second Edition)
The Patrick Moore Practical Astronomy Series
2017
Springer

Internet Links

Good sources on imaging our home galaxy.

https://earthsky.org/tonight/milky-way-galaxy-flat-around-horizon-may

https://www.skyandtelescope.com/observing/welcome-back-milky-way/?k=X2eLNeXTAu0pdXJ%2B6SJFkgjffbPJdBb2myBdgtfo4Cg%3D&

utm_medium=email&utm_source=newsletter&utm_campaign=sky-
mya-nl%0D&cid=DM125348&bid=1220097930

https://earthsky.org/favorite-star-patterns/
teapot-of-sagittarius-points-to-galactic-center?utm_
source=EarthSky+News&utm_campaign=c856cd0e29-EMAIL_
CAMPAIGN_2018_02_02_COPY_01&utm_medium=email&utm_
term=0_c643945d79-c856cd0e29-394691157

Night Skyscapes
Info on panoramas.

https://amazingsky.net/2019/06/25/how-to-shoot-and-stitch-nightscape-
panoramas/?fbclid=IwAR0N5GaaZ2Q8GEaHTkcQfK9oh9dSvE23W0
LzLjegRPDgO7-QWuByoLaL9Xo

Chapter 20: DSOs – Deep Sky Objects

Suggested Reading

*The 100 Best Astrophotography Targets: A Monthly Guide for CCD Imaging
with Amateur Telescopes* The Patrick Moore Practical Astronomy Series
Kier, Ruben
2009
Springer

Imaging the Messier Objects Remotely from Your Laptop
The Patrick Moore Practical Astronomy Series
Adam, Len J.
2018
Springer

*Making Beautiful Deep-Sky Images: Astrophotography with Affordable
Equipment and Software*
The Patrick Moore Practical Astronomy Series
Parker, Greg
2007
Springer

Deep-Sky Video Astronomy
The Patrick Moore Practical Astronomy Series
Massey, Steve; Quirk, Steve
2009
Springer

Internet Links

DSO Catalogs
What you need to know about DSO catalogs.

http://www.messier.seds.org/xtra/supp/cats.html

Trailed Star Images
Got trails? Then this is for you.

http://www.astropix.com/html/i_astrop/Diagnosing_Trailed_Stars.html

Guiding
Good resource.

https://www.skyandtelescope.com/astronomy-resources/guiding-a-telescope-for-imaging/

Remote Telecopes
Good resource.

https://www.skyatnightmagazine.com/advice/skills/how-use-remote-telescope-astrophotography/

DSOs with A DSLR
Good resource.

https://www.skyandtelescope.com/astronomy-resources/astrophotography-tips/deep-sky-with-your-dslr/

DSO Stacking
Good resource on an advanced topic.

http://www.nightphotographyworkshop.com/articles-tutorials/stacking-app-review-best-stackers

Chapter 21: Process, Post and Print Your Astropics

Suggested Reading

Lessons from the Masters: Current Concepts in Astronomical Image Processing
The Patrick Moore Practical Astronomy Series
Gendler, Robert et al.
2013
Springer

Inside PixInsight
The Patrick Moore Practical Astronomy Series
Keller, Warren A.
2016
Springer

Internet Links

Useful information on astropic processing help and tutorials.

https://www.skyandtelescope.com/astronomy-resources/astrophotography-tips/deep-sky-with-your-dslr/

http://www.astropix.com/html/j_digit/digtechs.html

https://www.patreon.com/peachastro

Free Image Processing Software
Check this out as you search for processing capability.

https://free-astro.org/index.php/Siril

Mac Image Processing Software
Good resource for Mac OS users.

https://www.macobservatory.com/blog/2018/8/1/getting-started-with-astrophotography-on-the-mac

High Resolution Planetary Astrophotography
Good info on a very important subject.

 http://www.astropix.com/html/i_astrop/Planetary_Imaging.html

Linear vs. Stretched Images
Good info on a very important subject.

 https://www.skyandtelescope.com/astronomy-blogs/astrophotography-
 jerry-lodriguss/linear-vs-stretched-data/

Histogram
Good info on a very important subject.

 https://www.blackwaterskies.co.uk/2013/12/how-to-interpret-
 an-image-histogram/

Signal Noise
Good info on a very important subject.

 https://www.skyandtelescope.com/astronomy-blogs/
 astrophotography-signals-noise/

 https://dslr-astrophotography.com/detailed-overview-noise-
 astrophotography/

White Balance
Good info on a very important subject.

 https://www.nikonusa.com/en/learn-and-explore/s/white+balance+
 astrophotography.html

 https://www.nationalparksatnight.com/blog/2017/6/14/
 how-to-choose-the-right-white-balance-for-night-skies

 https://www.skyandtelescope.com/astronomy-blogs/white-balance/

 https://alphauniverse.com/stories/camera-setup-for-astrophotography/

Astrophotography Ethics
Good background on the subject.

http://www.astropix.com/html/j_digit/ethics.html

https://petapixel.com/2019/05/07/this-milky-way-photo-on-nat-geo-is-raising-eyebrows/

https://twitter.com/FakeAstropix

Chapter 22: The Astrophotography Bug

Suggested Reading

Astronomy Adventures and Vacations: How to Get the Most Out of Astronomy in Your Leisure Time
The Patrick Moore Practical Astronomy Series
Treadwell, Timothy
2017
Springer

Scientific Astrophotography: How Amateurs Can Generate and Use Professional Imaging Data
The Patrick Moore Practical Astronomy Series
Hubbell, Gerald R.
2013
Springer

Internet Links

Access free online education courses.

http://www.openculture.com/astronomy-free-online-courses

Good info from a trusted source.

https://www.skyandtelescope.com/astronomy-resources/astrophotography-tips/

Learn more about the Masters
Mia Stålnacke

http://miastalnacke.com

Sean Walker, MDW Survey

 https://www.mdwskysurvey.org

Damian Peach

 http://www.damianpeach.com

Tutorials

 https://www.patreon.com/peachastro

Johnny Horne

 https://www.fayobserver.com/entertainmentlife/20180825/
 astrophotography-has-taken-johnny-horne-all-over-world

Appendix A

Chapter 2 Modes and Camera Recommendations

Author's Note: Other applicable chapters in the book that discuss Camera Only and Telescope and Camera modes will use a similar format and the definitions that follow.

Here are recommended cameras we discussed in Chapter 2 that can be used in Camera Only and Camera and Telescope modes for a specified astronomical object. Note that the author has not used all camera types but feels that a useful Modes and Camera recommendation can still be applied based on overall experience and knowledge. It is still incumbent upon you to do your research as to what mode and camera is best for what *you* want to accomplish, astrophotography-wise.

If you have one type of camera already, use it as best you can to start and learn about astrophotography in one or both modes. If you don't have a camera or want to upgrade you have to ask yourself the following questions:

- What do I want to photograph?
- What mode - "Camera Only" and/or "Camera and Telescope" - do I want to be able to do?
- How dedicated/serious to doing astrophotography do you think you will be?
- Cost considerations.

© Springer Nature Switzerland AG 2020
G. I. Redfern, *Astrophotography is Easy!*, The Patrick Moore Practical
Astronomy Series, https://doi.org/10.1007/978-3-030-45943-7

Using a smartphone, especially with the newer generations and previously described software, can launch the beginning astrophotographer in both modes and be quite satisfying.

Pocket cameras can be used effectively in Camera Only mode. For Camera and Telescope mode you will have to find hardware that can securely attach the camera to the telescope.

If you want a "Swiss Army Knife" camera - one that can do a little bit of everything astrophotography wise and in both modes - the DSLR, modified DSLR, or CSC with interchangeable lenses is your best bet. They are also the easiest for a beginner as you can take astropics without the need for any supporting software or steep learning curve to operate the camera. You may be able to use astrophotography specific cameras for regular photography as well but it will depend on the camera's sensor. The author successfully uses his Nikon D810a for regular photography even though it is not recommended by Nikon.

The Suggested Reading and Internet Links for this chapter has a link under DSLR to Nikon's website that provides a comprehensive breakdown of Nikon's DSLRs for astrophotography use. The author HIGHLY recommends a thorough review of this link as it is one of the best descriptions available of DSLR cameras applied to astrophotography. This is NOT a commercial for Nikon. If you want a different camera brand check out their DSLR specifications against Nikon's; you should be able to use matching camera specifications for the type of astrophotography described by Nikon.

If a CSC interests you there are a number of superb manufacturers. Be sure to check out Canon's new EOS Ra astrophotography CSC.

Video and CCD/CMOS "Pure" Astrocameras can be used in "Camera Only" mode depending on their specifications and design. The ZWO ASI 120 comes with a small all sky lens and other larger cameras can be used with regular camera lenses through the use of adapters. These camera types provide greater capabilities at the telescope but are dependent on what you want to photograph and the camera's specifications.

Camera Only Recommendations

With a smartphone and tablet (if a tablet is all you have for a camera, remember, it really isn't recommended for astrophotography) you can try to take astrophotographs and even video of anything in the sky and see how the results turn out.

The Moon, sunrise/sunset, the brighter planets such as Venus, Jupiter and Mars at its closest, solar (with proper filter and safety procedures) and lunar eclipses, and the brightest stars are worthwhile efforts to photograph.

Depending on what type of smartphone and tablet you have, you may have even greater capabilities with the software previously described coupled with mountings and accessories to photograph the Milky Way.

Digital and film cameras are a major step up in astrophotography capability. Although the cameras described, including film, have some astrophotography capabilities, it is the DSLR with interchangeable lenses that is the current king of the astrophotography camera realm, as the sky is literally yours to photograph. CSCs are an excellent choice as well. With various lenses as described in Chapter 3 you can photograph the sky, constellations, stars and planets, the Milky Way, some galaxies, DSOs, the Moon/eclipses, Sun/eclipses (with proper filter and safety procedures), satellites, Aurora, meteor showers - the whole cosmic kit and kaboodle.

Camera Only Video is limited as its primary purpose and design is for use with a telescope. Some video cameras can be outfitted with regular camera lenses to monitor the weather, the sky and perhaps meteor/fireball/bolide/aurora activity.

"Pure" astrocameras that come with an all sky lens can be used to monitor the weather, the sky and perhaps meteor/fireball/bolide/aurora activity. Some models can also be outfitted with regular camera lenses and used similarly as a DSLR although this is not their primary purpose.

Appendix Table 1 Camera Only Mode Camera Type Recommendations

Camera Type	All Sky	Planetary/ Lunar	Solar: Using proper solar filter & safety procedures in Chap. 12	DSOs/MW	Eclipses: For Solar Eclipses using proper solar filter & Ch. 14 safety procedures
Smartphone	Yes	Possible	No	Possible**	Yes***
Tablet	Yes	Possible	No	Possible**	Yes***
Pocket	Yes	Possible	No	Possible**	Yes***
Film	Yes	Yes	Yes	Yes	Yes
CSCs	Yes	Yes	Yes	Yes	Yes
DSLR	Yes	Yes	Yes	Yes	Yes
Video	Possible*	Possible*	Possible*	Possible*	Possible*
CCD/CMOS	Possible*	Possible*	Possible*	Possible*	Possible*

(continued)

Appendix Table 1 (continued)

Possible The Moon's disk, phase, and Earthshine; the brighter planets
Possible* If equipped for use with camera lenses.
Possible** If astronomical object is bright enough to be photographed within camera's capability.
Yes*** Solar eclipses – Totality Only

Camera and Telescope

While it is not necessary to have a telescope to take astropics, having one opens up a whole "universe" of possibilities. Depending on what type of camera you have will determine what kind of astropics you can take with your telescope.

As you will learn in Chapters 4 and 5 there is much to consider when contemplating Camera and Telescope mode. As you shall see in Chapter 6 it is possible to piggyback cameras with lenses to the telescope tube and/ or its mounting to take longer exposure astropics than would be possible with just a tripod in Camera Only mode. In Chapter 7 find out what you need to have accessory-wise to mount your camera to your type of telescope - this is very important for being able to operate in Camera and Telescope mode.

Smartphones and pocket cameras have a limited capability at the telescope but can still take very pleasing astropics of a variety of astronomical objects as the following table reflects. Tablets really aren't suitable at the telescope due to their bulk.

All other camera types are capable of taking a wide variety of astropics using different imaging methods. It all depends on what you might already have available camera and telescope wise. Match up your available equipment to the table and read the book to get started.

If you are starting from scratch you can see what is possible in this table and read the book to help you decide how you want to proceed. If you are starting with no camera or wanting to get one for astropic purposes, the author highly recommends going the DSLR/CSC route as you shall read next.

Appendix Table 2 Camera And Telescope Mode Camera Type Recommendations Necessary accessories are needed for successful operation in this mode as discussed in Chap. **7**

Camera Type	All Sky	Planetary/ Lunar	Solar: Using proper solar filter & safety procedures in Chap. 12	DSOs/ MW	Eclipses: For Solar Eclipses using proper solar filter & Ch. 14 safety procedures
Smartphone	Yes*	Yes	Yes	Possible*	Yes
Tablet	No	No	No	No	No
Pocket	Yes*	Yes	Yes	Possible*	Yes
Film	Yes*	Yes	Yes	Yes	Yes
CSCs	Yes*	Yes	Yes	Yes	Yes
DSLR	Yes*	Yes	Yes	Yes	Yes
Video	Yes**	Yes	Yes	Yes	Yes
CCD/CMOS	Yes**	Yes	Yes	Yes	Yes

Yes* If camera is piggybacked on telescope tube or placed on telescope mount.
Yes** If camera is piggybacked on telescope tube or placed on telescope mount and is equipped for use with camera lenses.
Possible* If astronomical object is bright enough to be photographed within camera's capability.

Camera Only and Camera and Telescope Mode Table Definitions

Yes Camera type recommended for listed astronomical object
No Camera type not recommended for listed astronomical object
Possible Camera type can possibly be used for listed astronomical object if specified conditions, marked with an asterisk, are met.

All-Sky (Comprised of the following)

Auroras and other sky phenomena
 Stars
 Constellations
 Bright planets

Meteor/Showers, Asteroids, Comets, Bolides and Fireballs
Sunrise/Sunset
Moonrise/Moonset and Moon shots
Satellites

Planetary/Lunar

The planets
 The Moon
 Solar (with proper solar filter and safety procedures as described in Chapter 12)
 Full disk
 Sunspots and other features

DSOs/MW (Deep Sky Objects/Milky Way)

Star Clusters
 Nebulae
 Galaxies
 Milky Way

Eclipses

Solar (with proper solar filter and safety procedures as described in Chapter 14)
 Lunar
It is in your best interest to read this whole book, absorb it and give careful consideration as to how you want to proceed before making any purchases, especially for your camera. Take your time, enjoy the thought process you will go through and the hopeful "test drives" you can take of cameras, lenses and telescopes to reach your buying decisions.

Index

© Springer Nature Switzerland AG 2020 449
G. I. Redfern, *Astrophotography is Easy!*, The Patrick Moore Practical
Astronomy Series, https://doi.org/10.1007/978-3-030-45943-7